Authentic Assessment of the Young Child

Celebrating Development and Learning

SECOND EDITION

MARGARET B. PUCKETT
Texas Wesleyan University

JANET K. BLACK
Texas A&M International University

Merrill,
an imprint of Prentice Hall
Upper Saddle River, New Jersey *Columbus, Ohio*

Library of Congress Cataloging in Publication Data
Puckett, Margaret B.
 Authentic assessment of the young child : clebrating development and learn-
ing/Margaret B. Puckett, Janet K. Black.—2nd ed.
 p. cm.
 Includes bibliographical references and index.
 ISBN 0-13-080271-9
 1. Educational tests and measurements. 2. Early childhood education—Evalua-
tion. 3. Child development—Evaluation. I. Black, Janet K. II. Title.
LB3051.P69 2000
372.126'4—dc21 99-35056
 CIP

Cover photo: Image Bank
Editor: Ann Davis
Production Editor: Julie Peters
Production Manager: Laura Messerly
Design Coordinator: Diane C. Lorenzo
Editorial Assistant: Pat Grogg
Electronic Text Management: Marilyn Wilson Phelps, Karen L. Bretz, Melanie King
Cover Designer: Jeff Vanik
Illustrations: Christine Haggerty
Director of Marketing: Kevin Flanagan
Marketing Manager: Meghan Shepherd
Marketing Coordinator: Krista Groshong

This book was set in Zapf Calligraphic by Prentice Hall and was printed and bound by
R.R. Donnelley & Sons Company. The cover was printed by Phoenix Color Corp.

©2000, 1994 by Prentice-Hall, Inc.
Pearson Education
Upper Saddle River, New Jersey 07458

Photo Credits: Nancy P. Alexander, pp. 2, 30, 40 (top and bottom), 58, 78, 106, 113, 134, 169,
178, 187, 266, 290, 297, 305, 314, 317; Scott Cunningham/Merrill, p. 150; Sargeant Hill, pp.
46, 56, 117, 246, 253, 293; Anthony Magnacca/Merrill, pp. 242, 268; Barbara Schwartz/Mer-
rill, pp. 34, 109; Anne Vega/Merrill, pp. 10, 86, 202, 262; Todd Yarrington/Merrill, pp. 82, 126,
157, 163, 248, 270, 271; and David Young-Wolff/Photo Edit, p. 256.

Printed in the United States of America

10 9 8 7 6 5 4 3 2

ISBN: 0-13-080271-9

Prentice-Hall International (UK) Limited, *London*
Prentice-Hall of Australia Pty. Limited, *Sydney*
Prentice-Hall of Canada, Inc., *Toronto*
Prentice-Hall Hispanoamericana, S.A., *Mexico*
Prentice-Hall of India Private Limited, *New Delhi*
Prentice-Hall of Japan, Inc., *Tokyo*
Prentice-Hall (Singapore) Pte. Ltd., *Singapore*
Editora Prentice-Hall do Brasil, Ltda., *Rio de Janeiro*

To early childhood educators everywhere who, on a daily basis,
find precious moments to celebrate the uniqueness of each learner

and

To our children and grandchildren, whose growth, development,
and learning have always been a source of joy and enlightenment to us.

◇ ◇

About the Authors

Margaret B. Puckett is Professor of Education and Chair of the Elementary and Early Childhood Education department at Texas Wesleyan University in Fort Worth, Texas. She has taught courses in Child Development, Early Childhood Education, Elementary Education, and Day Care Administration at the University of North Texas, Texas Tech University, and Tarrant County Junior College. She has taught children two-years-old through grade three, and has worked in school administration.

Dr. Puckett received her B.S. from the University of Texas at Austin, an M.S. in Child Development from Texas Women's University, and her Doctorate from the University of North Texas. Through funds for faculty enrichment provided by the Richardson Foundation, Dr. Puckett has studied child care and education in Israel and England.

She is a past president of the Southern Early Childhood Association, the Texas Association for the Education of Young Children, and the Forth Worth Area Association for the Education of Young Children.

She has been honored with the Outstanding Alumnus in Early Childhood Education Award by the University of North Texas, and the Texas Wesleyan University Faculty Recognition Award for excellence in teaching, research, and professional outreach. She is co-author of *The Young Child: Development from Prebirth Through Age Eight*, published by Merrill/Prentice Hall, and *Teaching Young Children: Introduction to the Early Childhood Profession*, published by Harcourt Brace.

Janet K. Black has twelve years of experience teaching young children from ages three through eight in public schools in Ohio and Illinois. She has also taught preservice and inservice teachers for twenty years at universities in Ohio and Texas. Currently she is Program Development Coordinator for South Texas, Texas A&M International University in San Antonio, Texas.

Dr. Black received her Ph.D. in Early and Middle Childhood Education from The Ohio State University where she was recipient of the Outstanding Graduate Student Award for Research and Creativity from the College of Education. She also was named a Promising Researcher by the National Council of Teachers of English. Dr. Black has published in such journals as *Young Children*, *Dimensions*, *Language Arts*, and *Research in the Teaching of English*. She is co-author of *The Young Child: Development from Prebirth Through Age Eight*, published by Merrill/Prentice Hall.

She is listed in *Who's Who in American Education* and *Who's Who of American Women*. She is active in community affairs and the arts.

Preface

It is a pleasure to provide this second edition of *Authentic Assessment of the Young Child: Celebrating Development and Learning*. When the first edition was written, considerable concern existed among early childhood educators over the excessive amount of testing taking place in earlier and earlier grades. Professional associations and scholars around the country were admonishing us to explore alternatives to standardized testing. The first edition of this text was written to encourage practitioners to blaze new trails through more "authentic" assessment practices.

While widespread use of standardized tests with young children has not abated, today many practitioners are employing more learner-centered approaches in their classrooms and have used a variety of strategies to observe, follow, and assess individual student achievements. From the experiences of these practitioners we have grown more sophisticated in our assessment practices. This second edition of *Authentic Assessment of the Young Child* has been expanded to include new information drawn from the scholarship and experiences of the intervening years between the first and second editions.

STRUCTURE AND PHILOSOPHY OF THIS TEXT

This text is divided into three sections:

Part I provides an overview of authentic assessment as it is now regarded by scholars in the field. It also provides a theoretical basis for assessment designed to derive essential developmental information about individual students and from which curriculums and pedagogy can be enriched. We explore the various theoretical bases that undergird a learner-centered approach to assessment and curriculum planning.

Contemporary developmental issues such as the current focus on early brain growth and development and the interrelationship between earliest experiences and social and moral competence have been included in this text as they relate to assessment and curriculum decisions. In addition, the sociopolitical influences that drive assessment practices are discussed. As an advance organizer, we have

provided for the reader our basic assumptions underlying authentic assessment that have been drawn from our own early childhood classroom teaching experiences and, in recent years, from studying and guiding this process through work with our student teachers in public school classrooms.

Part II of this text provides in-depth discussion of the types of information that educators need if they are to implement quality authentic assessment strategies. A comprehensive chapter on child development and learning sets the stage for focusing on individual learners. The perspectives of Piaget, Vygotsky, Gardner, and others are examined in the context of assessment practices, along with descriptions of widely held expectations for child development in the early years. The chapter on cultural and developmental diversity has been expanded to broaden the reader's perspectives on linguistic and socioeconomic factors, gender, and ableness. This section also addresses the standards movement and the interface of professional content area standards with developmentally appropriate practices.

In Part III, having laid the groundwork through exploration of background information needed to implement authentic assessment, we describe the planning process in detail with numerous illustrations to assist the reader in conceptualizing a coherent assessment plan. A new chapter devoted solely to portfolio development and uses has been added to this section. The chapter on portfolios describes a three-tiered system for portfolio development designed to make the assessment process manageable. The chapters on collaborating with individual students to promote self-reflection and intrinsic motivation, and collaborating with parents, round out a comprehensive, learner-centered approach to assessment in early childhood education.

The final chapter provides suggestions for advocating for quality authentic assessment practices and provides a preliminary list of resources to guide these practices. Three appendices detail information in a succinct and practical way. In addition, a glossary of terms is provided at the end of the book.

ACKNOWLEDGMENTS

We are always grateful to the many who contribute to our expanding understanding and knowledge about child development and learning. While they cannot all be named here, we are especially grateful to our students and colleagues at Texas Wesleyan University and Texas A & M International who have shared their expertise and their experiences and assessment strategies with us. Truly, we are all members of a unique community of learners. Special appreciation is extended to Carlos Martinez, associate professor of Education at Texas Wesleyan for his expertise and guidance with the research and discussions of learner diversity. With a heavy but grateful heart, appreciation is extended to the late Dr. Ronald Reed, whose love of scholarship was shared through his ongoing interest in and encouragement of this project.

We are indebted to those who, through their adoption of the first edition, provided valuable and insightful suggestions for the second edition. We also extend appreciation to those who reviewed the revised manuscript: Cecelia Benelli, Western Illinois University; Suzanne E. Cortez, Northern Kentucky University; Robert G. Harrington, University of Kansas; Donna S. Quick, University of Kentucky; and Wayne Reinhardt, Edmonds Community College (WA).

Finally, we wish to acknowledge the unending patience and gentle guidance of our editors—Ann Davis, Julie Peters, and Pat Grogg—without whom this text could not have come to completion.

Discover the Companion Website Accompanying This Book

The Prentice Hall Companion Website: A Virtual Learning Environment
Technology is a constantly growing and changing aspect of our field that is creating a need for content and resources. To address this emerging need, Prentice Hall has developed an online learning environment for students and professors alike—Companion Websites—to support our textbooks.

In creating a Companion Website, our goal is to build on and enhance what the textbook already offers. For this reason, the content for each user-friendly website is organized by topic and provides the professor and student with a variety of meaningful resources. Common features of a Companion Website include:

For the Professor—

Every Companion Website integrates **Syllabus Manager**™, an online syllabus creation and management utility.

- ◆ Syllabus Manager™ provides you, the instructor, with an easy, step-by-step process to create and revise syllabi, with direct links into Companion Website and other online content without having to learn HTML.
- ◆ Students may logon to your syllabus during any study session. All they need to know is the web address for the Companion Website and the password you've assigned to your syllabus.
- ◆ After you have created a syllabus using Syllabus Manager™, students may enter the syllabus for their course section from any point in the Companion Website.
- ◆ Class dates are highlighted in white and assignment due dates appear in blue. Clicking on a date, the student is shown the list of activities for the assignment. The activities for each assignment are linked directly to actual content, saving time for students.
- ◆ Adding assignments consists of clicking on the desired due date, then filling in the details of the assignment—name of the assignment, instructions, and whether or not it is a one-time or repeating assignment.

◆ In addition, links to other activities can be created easily. If the activity is online, a URL can be entered in the space provided, and it will be linked automatically in the final syllabus.

◆ Your completed syllabus is hosted on our servers, allowing convenient updates from any computer on the Internet. Changes you make to your syllabus are immediately available to your students at their next logon.

For the Student—

◆ **Topic Overviews**—outline key concepts in topic areas

◆ **Electronic Blue Book**—send homework or essays directly to your instructor's email with this paperless form

◆ **Message Board**—serves as a virtual bulletin board to post—or respond to—questions or comments to/from a national audience

◆ **Web Destinations**—links to www sites that relate to each topic area

◆ **Professional Organizations**—links to organizations that relate to topic areas

◆ **Additional Resources**—access to topic-specific content that enhances material found in the text

To take advantage of these and other resources, please visit the *Authentic Assessment of the Young Child: Celebrating Development and Learning* Companion Website at www.prenhall.com/puckett.

Brief Contents

Contents

I

Overview of Authentic Assessment of Young Children

1 Authentic Assessment:
An Emerging Paradigm

These are the children of promise—preschoolers, whose boundless energy is matched only by their curiosity and creativity, whose agility is the envy of their parents and teachers, whose openness and expressiveness are always remarkable and occasionally breathtaking. Watching them, it is easy to believe that they can do anything they want to do, be anyone they want to be; it is easy to summon the optimism that yet a new generation is rising to fuel this nation's historical belief in endless possibility.

Years of Promise, Carnegie Corporation of New York

After reading this chapter you will demonstrate comprehension by being able to:

- articulate why authentic assessment has emerged in recent education research and practice.
- outline theoretic and research bases for authentic assessment practices.
- describe sociopolitical influences on assessment practices.
- distinguish the essential characteristics of authentic assessment.
- describe the essential interconnection among curricula, teaching, and assessment.

CONTEMPORARY SOCIAL AND EDUCATION REALITIES

Professionals in education, psychology, sociology, and political science share the view that schooling today is an entirely different enterprise in many aspects than it was in years past, even the recent past. Schools are educating a greater percentage of the total population, socioeconomic and cultural diversity is ever increasing in school populations, families are characterized by greater diversity, with wide ranges in values, goals, and education expectations. Political pressure is increasing to hold schools accountable for student achievement. New insights into early brain growth and development, particularly in the earliest months and years are changing our views of how children learn and how intelligence is defined. Child development research and emerging new knowledge about the long-term effects of certain early experiences have served to focus, in an unprecedented way, public and policymaker attention on very young children. The information age as well, has profoundly widened our knowledge universe and altered the content of subjects to be taught. Technology itself has increased our ability to not only access information but also to communicate across what until now have been insurmountable barriers and distances. Yes, schooling today is different from the past.

Educators are being challenged to consider what life will be like in the 21st century and to answer questions about what knowledge and skills today's learners must acquire to be effective citizens in an era that will be marked by unimaginable change. Business leaders and futurists who forecast the future generally address changes expected in political structures; economics; immigration and population trends; social welfare and family life; education; and science, health, and medicine. For those of us who work with children and families, there is much to consider in preparing children for their future (Carnevale & Golstein, 1983; Cetron & Davies, 1989; Shane & Tabler, 1981; U. S. Department of Labor, 1992). Among the skills and characteristics most frequently identified as essential for tomorrow's citizens are the following:

◆ Basic reading, writing, and computation skills, and the disposition to use these skills as tools to communicate effectively through oral, written, and technological means and to efficiently manage their personal lives

◆ The ability to learn skills, which includes learning how to access and select wisely from vast amounts of emerging new information

◆ The ability to think critically and efficiently

◆ Creative problem-solving ability and the confidence to pursue the unknown

◆ A broad knowledge base that includes knowledge and skills in many and varied content areas

◆ The ability to relate to others in positive and productive ways, which includes interpersonal skills of cooperation, collaboration, and negotiation

◆ Positive self-regard complemented by worthy personal goals and self-determination

◆ A sense of shared democracy in a global society that is growing increasingly smaller, yet more and more complex

Some experts suggest that the knowledge generated during the twentieth century exceeds that accumulated from all previous centuries! In this era popularly referred to as the information age, individuals are going to have to be able to collect, analyze, synthesize, structure, store, and retrieve information in a selective and discerning manner. Preparing today's students for a future in a highly technological world, a diminishing globe, and a "loaded" information age requires new paradigms for teaching and thoughtful consideration of how best to prepare students for the future. Implicit in new paradigms for teaching is the need for different, more informative ways of determining what students know and are able to do.

Opportunities to communicate, collaborate, and think in critical and analytical ways exist every day in every classroom and at every grade level. However, most traditional pedagogies and numerous calls for education reform, particularly those associated with evaluating student progress and program effectiveness often fail to support these valuable education opportunities. Take for instance, students planning, organizing, and collaborating on a project to develop a mural depicting their recent field trip to the planetarium. As these students pursue their work, they are practicing cooperation, negotiation, critical thinking, problem solving, and perspective taking—all skills and characteristics deemed essential to the citizen of the 21st century. Further, "school skills," enhanced cognitive abilities, and a broadened knowledge base are developing. As this project proceeds, the students:

◆ recall and reflect on important impressions and concepts from the field trip.

◆ share mutual and individual experiences and learnings both verbally and in writing.

◆ establish what the project will entail, which involves numerous cognitive and social tasks relating to space perception, color and texture, artistic components, appeal, labels and other print components, message, organizing behaviors, cooperating, negotiating, perspective taking, participating in a community of learners, and experiencing democracy in action.

◆ determine what elements of the project each student might pursue and in what sequence.

◆ assemble necessary materials and supplies.

◆ engage in mural construction.

◆ engage in both formative and summative evaluations of their individual and collective contributions.

◆ compare and analyze the relationship of the ongoing and final product to the original experience and their individual understandings of it.

Certainly not lost in this endeavor are the content area opportunities to read, write, and solve mathematical problems; acquire scientific information; and explore the visual arts. But how can a teacher assess, grade, or test the outcomes of such a complex and multifaceted project? Simply assigning a grade for level and quality of participation fails to acknowledge the skills, information, and potential long-term outcomes of such an endeavor.

Typical paper-and-pencil tests or standardized measures that usually employ multiple-choice, true-false, and short-answer questions are inadequate. Most such tests focus on inert, discrete bits and pieces of knowledge, often memorized but neither contextualized nor applied. In the mural project, knowledge and skills are being applied. To assess knowledge and skills developing through endeavors such as this requires a "marriage" of curriculum, teaching and learning, and assessment. *When curriculum, teaching, student participation, and assessment are all integral parts of the learning experience, then critical learning that occurs during such meaningful classroom endeavors are measured in what has now come to be called authentic assessment.*

Gardner (1991a), in his view of the school of the future, proposes that the lines between assessment and curriculum need to be redrawn or perhaps blurred. The younger the child, the more blurred the lines should be. In such a school, the "teach-and-test" model of assessment is replaced with an apprenticeship and con-textualized model of teaching and assessing. This model embeds assessment in the context of the teaching-learning relationship. As such, student success is truly a shared responsibility, and through this sharing both instructor and learner benefit.

Gardner (1991a) describes the apprenticeship model of teaching and assessing as one in which assessment takes place almost entirely within the natural context of a particular craft. The assessment is based on a prior analysis of the skill involved in the particular craft, but it may also be influenced by many subjective factors. In this view, the personal views of the teacher and the relationship of the teacher with the learner and the learner's needs are integral to the assessment process. We are reminded by Gardner that this form of assessment has existed over the years in areas such as art, music, athletic performance, and certain areas of scientific research. Such assessment is characterized as authentic because it is directly aimed at individual student outcomes.

What Is Authentic Assessment?

This book is about authentic assessment of young children, so named because of its intimate relationship with the ongoing daily curriculum and the focus on individual student development, performance, and products. Authentic assessment is compatible with the prevailing philosophy in early childhood education that emphasizes whole child development. This philosophy includes not only cognitive and academic achievements, but also development in other domains—physical/motor, language, social, emotional, and moral. The whole child perspective is sensitive to human diversity and takes into consideration knowledge of the various contexts in which individual children grow, develop, and learn. Implicit in the whole child perspective is an understanding and sensitivity to the needs of

children with disabilities and of children from diverse cultural and socioeconomic backgrounds. Curriculum and assessment are interwoven and carefully crafted to be age- and individually appropriate, as well as relevant, meaningful, and useful to the learner both in and out of school contexts.

The concept of authentic assessment is a relatively new one. *Authentic assessment is the process of observing, recording, and otherwise documenting the work that children do and how they do it as a basis for educational decisions that affect individual learners* (NAEYC, NAECS/SDE, 1991; Northwest Regional Educational Laboratory, 1991; Grace & Shores, 1991). Authentic assessment differs from program evaluations and accountability measures in that it assigns priority to the needs and accomplishments of the individual learner rather than on measures of program outcomes based on test scores of large groups of learners. It differs from testing by directly measuring actual performance in a skill, subject, or content area. Authentic assessment provides continuous, qualitative information that can be used by the teacher to guide the instruction of individuals. Authentic assessment:

- ◆ emphasizes *emerging* development.
- ◆ focuses on individual strengths and uniqueness.
- ◆ is based on sound principles of child growth and development.
- ◆ emanates from authentic (logical, meaningful, relevant, and applicable) curricula.
- ◆ is performance based.
- ◆ recognizes and supports different intelligences and diverse learning styles.
- ◆ is reflective and analytic.
- ◆ is ongoing and occurs in many contexts.
- ◆ is collaborative with learners, parents, teachers, and professional specialists as needed.
- ◆ is intertwined with instruction.

Some states and school districts now incorporate authentic assessment strategies in their student progress reporting policies. Such strategies include not only written, but oral presentations and quizzes, performance assessments, portfolios of student products, and a variety of types of evidence of student performance. While it is true that most elementary and early childhood education programs still rely heavily on "teach and test" strategies and assorted commercially prepared tests, new insights invite us to redefine the purposes and goals of assessment which we hope to do in this text.

Authentic assessment takes into consideration multiple factors influencing individual student outcomes, such as those mentioned in the preceding discussion. Authentic assessment differs from traditional one-size-fits-all forms of tracking student progress such as report cards issued at six to nine-week or semester intervals, and periodic teacher-created or standardized tests that are typically formatted as multiple-choice, true-false, or short-answer questions. In some schools,

authentic assessment has been used to replace these more traditional forms, but more often, it is used to augment them.

Authentic assessment as prescribed in this text is responsive to (1) prevailing theories and classical research (particularly the works of Piaget, Vygotsky, Erikson, and Bronfenbrenner) about how young children grow and develop, (2) new insights relating to child growth and development, such as those relating to early brain development and learning theory, and (3) sociopolitical influences like those outlined above, particularly school reform and standards-setting efforts that have influenced content, pedagogy, and assessment of student achievement over the past decade. Let us briefly consider each of these as topics, keeping in mind that our goal is to define authentic ways to describe and assess student growth and development and academic progress and achievements.

PREVAILING THEORY IN EARLY CHILDHOOD EDUCATION

It is now common knowledge that young children cognitively process information differently from older children and adults. Based primarily on the research of Swiss biologist and psychologist Jean Piaget (1926, 1952, 1963), educators now recognize that young children construct meaning from their interactions with objects and people.

Cognitive-Interactionist Theory

Piaget proposed a cognitive-interactionist theory in which both inherited traits and environmental opportunities together influence cognitive development. Meaning occurs as young children engage all of their sensory and motor capabilities, hear and employ language in many contexts, experience real events, explore concrete materials, and interact socially with others. This theory explains the very design and nature of the early childhood classroom, with its learning centers, concrete hands-on materials, manipulatives, varied art and construction media, realia, sociodramatic props, picture books, and many interactive opportunities. In these settings, learning occurs through both spontaneous and facilitated discovery, through interaction, inquiry, and dialogue, and through use of information and emerging skills. Through these experiences, children construct knowledge and understanding—hence, the concept of constructivism and the paradigm for constructivist pedagogy and curricula.

The constructivist approach to teaching is derived from the Piagetian perspective. In this approach curriculum starts with the interests of the learner, building new information and experiences on the learner's prior knowledge and experience. It capitalizes on the child's immediate curiosity and initiative. As Kamii (1990) emphasizes, when curiosity and initiative are present we know that mental activity is taking place. "The overriding cognitive goal in the constructivist framework is that children *think*" (p. 24).

Building on children's interests and prior experiences, constructivist curricula are rich with meaningful and relevant activities specifically designed to encourage thoughtful exploration, inquiry, invention, solutions to problems and dilemmas, new discoveries, and expanding interests and curiosities. Constructivist educators value the interactive process in which children explore and use materials to gain knowledge and understanding and interact with their classmates and teachers who both facilitate and challenge the learning process. Constructivist classrooms are generally arranged in working centers or minilaboratories in which children engage in firsthand experiences with a variety of tools for learning. Activities and materials in each of the centers are strategically selected to facilitate learning in all content areas and to promote self-directed and autonomous thinkers. Educators are trained to observe and facilitate learning by providing appropriate instruction and scaffolding to further each child's learning.

Constructivism, the notion that meaning is constructed within the mind of the doer/learner, finds further amplification in the works of Russian psychologist Lev Vygotsky (1934/1962, 1978). While Piaget portrayed learners as constructing meaning primarily through their own actions on the environment, Vygotsky emphasized the importance of the child's culture and social contexts as sources of guidance and support for learning. Others, adults and children, provide assistance or scaffolding for the learner that encourages and supports new learning. Vygotsky also emphasized the importance of language to cognitive development, demonstrating that when children are provided words and labels they form concepts more readily. He believed that thought and language converge into meaningful concepts and assist the thinking process. Vygotsky advanced the concept of the *zone of proximal development* (ZPD) which refers to the point at which children are on the verge of understanding or being able to do something and all they need is a clue or other assistance to follow through on their own. This theory is demonstrated in classrooms in which social interaction is encouraged, where teachers converse with children and use language to mediate their learning, where children are encouraged to express themselves both orally and in writing, and where conversation among members of the group is encouraged and valued. These concepts are explored more fully in Chapter 8.

Psychosocial Theory

In addition to cognitive theory, the classic psychosocial theory of Erik Erikson (1963) prevails today. In Erikson's theory of healthy personality development, the individual experiences eight stages from birth to maturity in which the resolution of certain psychosocial oppositional crises is expected to occur. The first four stages are of particular relevance to our focus on young children.

Beginning at birth with the oppositional crises of *trust vs. mistrust*, the human personality is confronted with forces within the family, culture, and society that support or impede development. It is hoped that the scales are tipped toward a healthy sense of trust, which occurs when infants experience warm, nurturing, supportive, predictable, and trustworthy environments and relationships. The

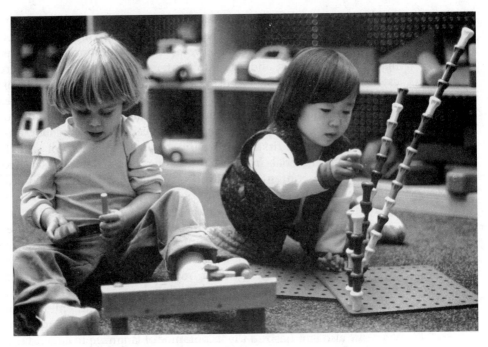

Autonomous thinking is encouraged when children can make choices.

child who learns to trust others during infancy can more successfully grow in self-trust. In later childhood, having resolved successfully subsequent opposi- tional crises, the child grows in the ability to successfully "mistrust" through dis- cerning choices and decision making. Successful resolution of trust vs. mistrust crises lays the foundation for later psychosocial development, particularly the second crisis. This crisis arises at about age two, that of opposition between *auton- omy and shame or doubt.*

Autonomy is the desire to be self-directing or self-governed. This stage is char- acterized by attempts on the part of children to do more and more for them- selves, such as choosing what clothing to wear, dressing themselves, resisting transitions from family time to bedtime, fastening seat belts, feeding themselves and choosing certain foods over others, and learning to manage toileting as neu- rological control over bowel and bladder emerges. The successful resolution of this crisis depends on adult-child relationships that encourage rather than dis- courage or punish these early attempts at self-government. Erikson's theory sug- gests that adults need to find that important balance between meeting the child's ambivalent needs for both dependence and independence and control and free- dom, without leading the child toward feelings of inadequacy, shame or doubt.

Building on the foundations of trust and autonomy, the third of Erikson's psy- chosocial stages is that of *initiative vs. guilt,* which emerges between three and six years of age. During this psychosocial crisis, children are attempting to undertake

and pursue ideas of their own making; planning and carrying out a variety of tasks and play themes; and enlisting others through conversation, questions, sociodramatic play, and idea exchanges. Play with others, particularly, sociodramatic play, is especially important during this period as children become less egocentric and more socially active with their age mates. The opposite of initiative is a sense of guilt, which emerges when children are unsuccessful in their initiations or when adults fail to recognize the significance and importance of children's efforts or respond to their efforts in disparaging or nonsupportive ways.

The fourth stage that is important to teachers of young children is that of *industry vs. inferiority*. During this period, from about ages six to eleven, children are seeking to be engaged in what they perceive to be "real" tasks, as opposed to make-believe and pretend. Interest in how things work, in constructing and creating from a variety of media, writing to communicate, reading for information and other school skills development, carrying out helpful and meaningful chores and tasks, and a need for a sense of accomplishment mark this psychosocial stage. Children who experience frequent or embarrassing frustrations and failures during their early attempts to grow more proficient at home, in school, or in social interactions, develop a sense of inferiority. Tipping the scales toward the positive side of these psychosocial oppositional crises is a major goal of developmentally appropriate practices in the education of young children. Addressing the psychosocial dimensions of early development is an important focus in authentic assessment. We will keep these developmental needs in mind as we get into later descriptions of authentic assessment strategies.

Contextualistic Theories

Emphasis in recent literature on the contexts in which children grow and develop has led early childhood educators to pay closer attention to the social, cultural, and economic aspects of children's lives (Bronfenbrenner, 1986, 1989; Cole & Cole, 1993; Mallory & New, 1994). The contexts of children's lives affect not only cognitive development and academic achievement, but all other developmental domains as well. Bronfenbrenner's ecological (or contextualized) theory is of particular interest to early childhood educators. This theory proposes ever-widening circles of influence on children, expanding out from parents and family to neighborhood, school, faith-related institutions, and community agencies, to the media, local governments, and the dominant beliefs and ideologies of a society. Children's experiences in these various contexts and their subsequent development and behaviors are shaped by the reciprocal interaction of the child and the environmental contexts. Bronfenbrenner's ecological theory helps us recognize that there are numerous and diverse pathways by which children grow, develop, and learn.

Developmentally Appropriate Practices in Early Childhood Education

While the concept of developmentally appropriate practices is not a theory in the strictest sense of the word, it is a construct by which we examine and explain

what we do and why. The concept of developmentally appropriate practices in early childhood education was forwarded by the National Association for the Education of Young Children through its position statement, first published in 1987 and revised in 1997 (Bredekamp, 1987, 1997). The concept of developmentally appropriate practices has served to focus early childhood educators on a common goal for planning and implementing programs for young children. The positive influences of developmentally appropriate practices on child development has been extensively documented over the past decade (See Dunn & Kontos, 1997, for a review of these studies). As you shall see, developmentally appropriate practices have critical implications for the manner in which child growth, development, and learning are assessed.

In its most recent edition of *Developmentally Appropriate Practice in Early Childhood Programs* (Bredekamp & Copple, 1997), developmentally appropriate practice is defined as resulting:

> . . . from the process of professionals making decisions about the well-being and education of children based on at least three important kinds of information or knowledge:
>
> 1. what is known about child development and learning—knowledge of age-related human characteristics that permits general predictions within an age range about what activities, materials, interactions, or experiences will be safe, healthy, interesting, achievable, and also challenging to children;
> 2. what is known about the strengths, interests, and needs of each individual child in the group to be able to adapt for and be responsible to inevitable individual variations; and
> 3. knowledge of the social and cultural contexts in which children live to ensure that learning experiences are meaningful, relevant, and respectful for the participating children and their families. (pp. 8-9)

Developmentally appropriate practices take into consideration the particular needs of children who may be developmentally delayed or have disabilities. Developmentally appropriate practices are inclusive and sensitive to the capabilities and strengths of each child. They also are sensitive to and promote cultural understandings and mutual respect among all members of the community of learners. Anti-bias curricula are employed in DAP classrooms (Brown & Conroy, 1997; Derman-Sparks, 1989; McCracken, J. B., 1993; Neugebauer, 1992; Roach, Ascroft, Stamp, & Kysilko, 1995).

An anti-bias approach to early childhood education goes beyond simply teaching about different cultures. Rather, anti-bias programs provide environments that reflect sensitivity to and respect for all members of the group regardless of gender, race, ethnicity, or ableness. Such environments include materials, books, puzzles, dolls, sociodramatic play props, bulletin boards, and so on, that reflect diversity among children and adults and avoid stereotyping about race, gender, or ability. Interactions with and among children and their families promotes understanding of differences and similarities and mutual respect. Anti-bias curricula are intellectually honest and teach children how to resist bias in other contexts.

These prevailing theories undergird the philosophy and pedagogy suggested in this text. Each is further elaborated throughout the text. Authentic assessment practices are based on our best understandings about how young children grow, develop, and learn. The practices suggested in this book are compatible with constructivism, healthy psychosocial development, and developmentally appropriate practices. In addition, practices suggested in this book are discerning and responsive to new insights regarding child development and learning.

NEW INSIGHTS IN CHILD DEVELOPMENT AND LEARNING

Educators are influenced and guided by emerging research in their own and allied disciplines. New insights are derived from many sources—primary among them are the biological and behavioral sciences, and the reflections and research of practicing teachers. When we examine current professional literature and emerging research we find the following topics rising in importance and offering new insights into our teaching/learning/assessing practices:

recent brain growth and neurological development
cognitive types and learning styles
the importance of social and moral competence

Let us take a brief look at these topics.

Early Brain Growth and Development

Stunning advances in recent years in the fields of neuroscience and technology have resulted in new knowledge about the brain and how it develops. Technologically sophisticated tools such as high resolution ultrasound recordings, magnetic resonance imaging (MRI), positron emission tomography (PET) scan, and brain electrobiology chemistry and analysis capabilities have facilitated precise study of the brain's development and functioning. This research has shed light on the biological origins of conscious and unconscious behaviors by examining how brain cells process information at the molecular level and how literally billions of neuron and glial support cells become organized into elaborate networks that process complex forms of information and behavior. This research reveals that the human brain becomes "wired," at an astounding rate during the early months and years of development, and is dependent on specific types of experiences during certain developmental time periods (or "windows of opportunity"). The first three years are critical, and until about age ten the brain continues to create sophisticated neurological connections. After such time, weak or unused connections are biologically pruned or disengaged (Caine & Caine, 1994, 1997; Shore, 1997; Sylwester, 1995).

We will discuss this process and its implication for classroom practices more fully in Chapter 3. The point to be made here is that acknowledging this early criti-

cal development means rethinking the type, quality, and timing of earliest experiences, and acknowledging that earliest experiences have implications for lifelong outcomes. This recognition by scientists of the importance of the early months and years in human growth and development has brought unprecedented public and political attention to early childhood education (Newberger, 1997). As we shall see, the implications of this new public awareness and the important role professionals must play in early education can have profound implications for both curriculums and assessment. Caine and Caine (1994) said it nicely:

> Teaching in the traditional way, dependent on content and the textbook, is demanding but not very sophisticated. Teaching to the human brain, however, based on a real understanding of how the brain works, elevates teaching into a challenging field requiring the finest minds and intellects. (p. viii)

Learning Theory, Learning Styles, and Cognitive Types

Not unrelated to brain growth and neurological development is our increasing understanding of the common and individualistic ways in which human beings acquire information and retain and use it at will, and how young children pursue and respond to new knowledge, hone certain skills, and are motivated to learn. A number of theories about intelligence and learning have emerged in recent years (Dunn & Dunn, 1987; Dunn, 1996; Gardner, 1993a, 1993b; McCarthy, 1981; Sample, 1992).

One familiar theory suggests that environmental, emotional, sociological, physical, and psychological stimuli affect the learner's success in learning (Dunn and Dunn, 1987; Dunn, 1996). For instance, nuances in the physical environment associated with learner preference and performance include visual characteristics such as the amount and type of lighting—soft, natural, or bright lighting, or color and aesthetic features of the classroom decor that can range from visually "busy" to simple and uncluttered; arrangement of furniture and spaces for learning, or tactile characteristics as altered through the use of rugs, cushions, soft seating, and other textural elements. Auditory features associated with learner preference and performance include type and amount of background noise—the "hum" of student talk as they work productively, music, and quiet or noisier surroundings. Additionally, the temperature of the learning environment affects learning.

Learning theory also addresses cognitive styles in which children are described as visual, auditory, or tactile/kinesthetic learners, benefiting best from instruction that provides appropriate sensory input. Creative and perceptual styles are described by McCarthy (1981, 1997) in which learners are typed according to four ways of responding to perceptions: feeling and reflection; reflecting and thinking; thinking and doing; or creating and acting. We will address the concept of learning styles throughout our discussions of authentic assessment.

Multiple intelligence theory (MI) (Gardner, 1991a, 1991b, 1993a, 1993b, 1998) addresses at least eight types of intelligences and suggests that teaching strategies must respect individual student proclivities if all students are be given the chance

to succeed in school. Gardner's different intelligences, which are described more fully in Chapter 3, include linguistic, logical-mathematical, spatial, bodily-kines-thetic, musical, interpersonal, intrapersonal, and naturalist intelligences. In a recent publication in which he reflected on his own theory of multiple intelli-gences Gardner lamented:

> When I visit an "MI school," I look for signs of personalization: evidence that all involved in the educational encounter take such differences among human beings seriously; evidence that they construct curricula, pedagogy, and assessment insofar as possible in the light of these differences. All the MI posters, indeed all the refer-ences to me personally, prove to be of little avail if the youngsters continue to be treated in homogenized fashion. By the same token, whether or not members of the staff have even heard of MI theory, I would be happy to send my children to a school with the following characteristics: differences among youngsters are taken seriously, knowledge about differences is shared with children and parents, children gradually assume responsibility for their own learning, and materials that are worth knowing are presented in ways that afford each child the maximum opportunity to master those materials and to show others (and themselves) what they have learned and understood. (Gardner, 1998, p. 66)

By learning about these differences and strengths among learners, educators can become sensitive to individuality and vary curriculum content, teaching strategies, environments, and expectations as needed to help individuals succeed. Authentic assessment strategies help teachers identify children who need a differ-ent approach so that curriculums and classroom social, physical, and temporal environments can be adjusted. We are not suggesting that teachers should try to address in any one classroom the multitude of individual differences that all of these theories suggest. Authentic assessment strategies however, focus teachers on the individuality of children and each child's emerging capabilities so that cur-ricular modifications can be made as need arises. Generally speaking, curricula that are meaningful, engaging, and relevant to learners, and classroom environ-ments that are sensitive to physiological and psychological needs of children are most likely to support learning in all types of learners.

Importance of Social and Moral Competence

An important goal of education for the 21st century is the development of indi-viduals who are socially and morally competent, who can function effectively in a democratic society. Contemporary scholars are focusing attention on the types of relationships and experiences that lead students toward social and moral compe-tence (DeVries & Kohlberg, 1990; DeVries & Zan, 1994, 1995; Greenberg, 1991; Katz & McClellan, 1997; Katz, McClellan, Fuller, & Walz, 1995; Kohn, 1993, 1996). The psychosocial dynamics of the group or classroom determine the types of experiences children will have that either enhance or impede this development. The manner in which rules are established and maintained, the expectation and emulation of mutual respect, and opportunities for children to reflect on appro-

priate and inappropriate interactions with others determine the extent to which the classroom supports the development of social and moral competence.

Because children are meaning makers, they need opportunities to experience and learn a variety of prosocial skills such as cooperation, perspective-taking, problem-solving, negotiation, empathy, and altruism in meaningful and relevant ways. They need to participate in establishing rules that have logical and clear reasons to exist, and they need to be involved in dialogue about what it means to others as well as themselves, when important rules are compromised. Frequently, "classroom management" emanates from the top down, and employs predetermined rules with various consequences for infractions, from punishments of increasing severity for each subsequent mishap, to rewards such as stickers, stars, ribbons, food, parties, or other tangibles for compliance.

Current scholars emphasize an approach to classroom interactions and guidance that focuses on the child as a social meaning-maker and uses classroom situations to teach or guide children toward self-directed prosocial behaviors. This approach is *authoritative,* along the lines of that described by Baumrind (1972) in her well-known research and delineation of parenting styles (authoritative, authoritarian, or permissive), and is *constructive* in that it both elicits cognitive engagement and guides children toward self-directed prosocial decision making. Social and moral competence develops when children are personally and actively involved in developing solutions to problems, dialoguing and negotiating, and arriving at compromises and consensus. In this context, the tenets of democracy and the elements of personal and fulfilling social and moral competence are supported.

Inasmuch as our focus is on whole child perspectives, it is most fitting that authentic assessment address not only progress toward cognitive goals, but emotional and social development as well. In classrooms where students are interactive and engaging in conversations, dialogue, debate, group projects, and decision making, progress toward social and moral competence can more readily be assessed. In Chapters 3 and 8 we will discuss further the assessment of social and emotional development and pedagogical characteristics that support this development.

SOCIOPOLITICAL INFLUENCES ON ASSESSMENT PRACTICES

In addition to prevailing developmental theories and new insights derived from emerging child development and education research, assessment practices respond to a variety of sociopolitical influences. If you were an elementary or secondary school student during the 1980s and '90s, you experienced many changes brought about by what was then known as the "school reform movement." Changes such as year-round schooling, multi-age classes, school-based before- and after-school programs, increased use of computers in classrooms, greater emphasis on academic achievement in reading, writing, mathematics, and science; reduced emphasis in the arts, physical education, and vocational training; and tightened graduation requirements resulted from school reform legislation.

You may have experienced smaller class sizes than your counterparts in previous years, greater racial and ethnic mix among classmates, and more inclusive opportunities for classmates with disabling conditions who until then had been assigned to separate special education programs.

Your school progress was not only evaluated through tests and report cards, but you might have been introduced to the concept of portfolio development to showcase your work. You most certainly took a number of standardized tests over the course of your school years. You might have been aware of a trend toward site-based management of individual schools—a practice that included teachers, parents, and sometimes students in making decisions about an individual school. Classroom teachers were being subjected to state-administered competency examinations to either become or remain certified to teach. While some of these programs existed to some degree around the country before the school reform movement, they were not widespread or discussed and debated as they came to be during that era and the ensuing years. A review of the reform proposals of the 1980s and '90s and their antecedents is beyond the scope of this text. However, some more recent events growing out of the reform efforts are worth addressing as they relate to current discussions about alternative assessments of student progress.

National Education Goals

In 1989, then-President George Bush convened the nation's governors in an Education Summit Conference in Charlottesville, Virginia, to hammer out national education goals. As a result of this summit meeting the National Governors Association set forth goals in 1990 for improving education in the United States. Figure 1.1 delineates the eight national education goals set forth during this summit meeting. At the same time, a National Education Goals Panel was formed to develop methods by which progress toward these goals might be measured, and the U.S. Department of Education launched its America 2000 project to urge all states and communities to formally adopt these goals. In 1994, Congress passed the Goals 2000: Educate America Act requiring states to develop education reform plans and set voluntary standards for student performance, curricula, teacher preparation, and appropriate and sufficient resources to assure that all children have the opportunity to learn.

The School Readiness Goal

The first national goal stated, "By the year 2000, all children in America would start school ready to learn" (National Education Goals Panel, 1991). Three objectives accompany this first goal:

1. All disadvantaged and children with disabilities will have access to high quality and developmentally appropriate preschool programs that help prepare children for school.

Figure 1.1
The National Education Goals
Note: From *The National Educational Goals Report,* 1997, Washington, DC: Author.

THE NATIONAL EDUCATION GOALS

Goal 1: Ready to Learn

By the year 2000, all children in America will start school ready to learn.

Did you know...that between 1993 and 1996, the percentage of 3- to 5-year-olds whose parents read to them or told them stories regularly increased from 66% to 72%?

Goal 2: School Completion

By the year 2000, the high school graduation rate will increase to at least 90 percent.

Did you know...that 3,356 students drop out of school each day, and that within two years high school graduates can expect to earn 25% more than dropouts?

Goal 3: Student Achievement and Citizenship

By the year 2000, all students will leave grades 4, 8, and 12 having demonstrated competency over challenging subject matter including English, mathematics, science, foreign languages, civics and government, economics, arts, history, and geography, and every school in America will ensure that all students learn to use their minds well, so they may be prepared for responsible citizenship, further learning, and productive employment in our Nation's modern economy.

Did you know...that in 27 states the percentage of 8th graders who scored at the Proficient or Advanced levels on the National Assessment of Educational Progress (NAEP) mathematics assessment increased?

Goal 4: Teacher Education and Professional Development

By the year 2000, the Nation's teaching force will have access to programs for the continued improvement of their professional skills and the opportunity to acquire the knowledge and skills needed to instruct and prepare all American students for the next century.

Did you know...that between 1991 and 1994, the percentage of secondary school teachers who held an undergraduate or graduate degree in their main teaching assignment decreased from 66% to 63%?

2. Every parent in America will be a child's first teacher and devote time each day to helping his or her preschool child learn; parents will have access to the training and support they need.

3. Children will receive the nutrition and health care needed to arrive at school with healthy minds and bodies and the number of low-birth weight babies will be significantly reduced through enhanced prenatal health systems.

Figure 1.1, *continued*

Goal 5: Mathematics and Science

By the year 2000, United States students will be first in the world in mathematics and science achievement.
Did you know...that only Korea outperformed the U.S. in 4th grade science in a recent international assessment?

Goal 6: Adult Literacy and Lifelong Learning

By the year 2000, every adult American will be literate and will possess the knowledge and skills necessary to compete in a global economy and exercise the rights and responsibilities of citizenship.
Did you know...that fewer adults with a high school diploma or less are participating in adult education, compared to those who have postsecondary education?

Goal 7: Safe, Disciplined, and Alcohol- and Drug-free Schools

By the year 2000, every school in the United States will be free of drugs, violence, and the unauthorized presence of firearms and alcohol and will offer a disciplined environment conducive to learning.
Did you know...that threats and injuries to students at school decreased over a 5-year period?

Goal 8: Parental Participation

By the year 2000, every school will promote partnerships that will increase parental involvement and participation in promoting the social, emotional, and academic growth of children.
Did you know...that parental involvement in school declines as children get older?

This goal has become known as the "readiness goal" and is further defined by the National Task Force on School Readiness and the National Association of State Boards of Education (1991):

> [A child's] readiness for school requires an emerging facility to experience and shape one's environment, rather than the mastery of discrete facts and skills. Professional opinion and common sense agree that a child's readiness for school is enhanced by good physical health, ability to speak and listen, a degree of emotional stability and independence, and social skill. (p. 10)

Further, the authors of this NASBE publication assert that:

◆ School readiness is more than academic knowledge. Readiness is based on children's physical health, self-confidence and social competence.

- ◆ School readiness is not solely based on the capacities of young children. Readiness is shaped and developed by people and environments.
- ◆ School readiness is not solely determined by the quality of early childhood programs. Readiness also depends on the expectations and capacities of elementary schools.
- ◆ School readiness is not solely the responsibility of individual parents. Communities have a stake in the healthy development of young children—and an obligation to support families. (pp. 6-7)

Goal I validates what professionals in early childhood education have believed for years, that children's earliest mental and physical well-being and early cognitive and psychosocial experiences are related to later success, and that parents play a vital role in their children's development and learning. The readiness goal has served to alert parents, teachers, and policymakers to the importance of the early formative years, and the critical need for earliest experiences to be developmentally appropriate.

Standards-Based Curricula and Assessments

The school reform movement and the Education Summit of 1989 also precipitated a movement toward standards-based curricula and assessments. In recent years, state boards of education have focused considerable time and energy on the development of content and performance standards that can be aligned with some form of assessment to exact school accountability. While such an effort has for many become a tedious and often unwieldy exercise, there is no question that defining what students should know and be able to do can be helpful in the development of curricula and assessment strategies. When framed and stated in broad terms, standards can be helpful by providing both focus and parameters for content and skill expectations. Stated in narrow terms, however, content and performance standards run the risk of constricting curricula, ignoring the individuality of learners and the social and economic characteristics and needs of diverse populations.

The current standards movement began with the publication, *A Nation at Risk: The Imperative for Educational Reform*, the report of the National Commission on Excellence in Education (1983), in which the authors challenged educators and policymakers with the following statement:

The educational foundations of our society are presently being eroded by a rising tide of mediocrity that threatens our very future as a nation and a people.... We have, in effect been committing an act of unthinking, unilateral educational disarmament. (p. 5)

Thus began a tidal wave of state-by-state reform movements such as those listed above, and a firestorm of public criticism of schools and education in general, criticism that has not abated.

While educators argue for a less simplistic perspective, politicians frequently cite poor test scores as proof that school children are not getting adequate education and taxpayers are not getting their money's worth. It follows then that legislatures would enact laws that attempt to hold schools accountable for student learning outcomes. These laws often require that states define grade and content area competencies and methods for testing student progress and achievement. State, district, and individual school test scores are often made public by state and local news media through which states, school districts, and individual schools are compared, ranked, and rated.

Overlapping this trend and perhaps bringing reason to it through expert input has been the flurry of activity among national professional subject matter organizations to establish standards in their own areas. The National Council of Teachers of Mathematics (NCTM) (1989) had already published its *Curriculum and Evaluation Standards for School Mathematics* in 1989, pre-empting the standards movement which soon emanated from the 1989 Education Summit. Soon to follow, and to some extent modeled after the NCTM standards, were the National Science Teachers Association (NSTA) and the American Association for the Advancement of Science (AAAS) who each attempted to identify standards and benchmarks for science education. Other subject areas followed—civics, theater, music, art, dance, language arts, social studies, and history. Each content area included standards for kindergarten through Grade 12. Professional early childhood educators use such standards as guides for planning developmentally appropriate curricula and assessment strategies. Professional standards and their relationships to authentic assessment are further described in Chapter 5.

Concerns Associated with Widespread Use of Standardized Tests

A standards-based curriculum provides a framework for determining student progress by setting target goals for learning. Unfortunately, assessment of student progress toward standards-based targets has led to over-reliance on standardized tests, often with high stakes consequences. This is particularly troublesome when the test content and the standards are not parallel. The nature of multiple-choice tests (the most common form of standardized test used in classrooms) limits the scope of the material that can be tested. Some drawbacks to steady use of multiple-choice tests have been outlined by Wiggins (1998). The following are some of his concerns:

◆ Because of the generic nature of the test, alignment with instructional aims is virtually impossible.

◆ Students are deprived of opportunities to deal with other forms of tasks and questions.

◆ Students receive an "anti-intellectual" message that suggests that the expected answers to test questions are more important than are opportunities to challenge and be challenged, or to justify their own answers.

◆ When tests are administered at the end of the year, results can have no impact on teaching and learning; the feedback is too late to be useful.

◆ When students merely select from multiple choices, there is no way to know what students are able to do or how they will use the knowledge that is being tested.

◆ When students are compared with a normative group, children who fall below the norm on a standardized test are at a distinct disadvantage as their differences are often exaggerated by the manner in which tests are normed to begin with. (pp. 229-230)

The sheer numbers of standardized tests that students are subjected to is equally troubling. It was estimated that during the 1986–87 school year, 93 million to 105 million standardized tests or test batteries were administered to 39.8 million elementary and secondary public school students. That translates to an average of 2½ tests per student per school year (Medina & Neill, 1990). Now, more than a decade later, this number has remained fairly steady (Neill, 1997), and could increase as political pressure for greater accountability mounts in state legislatures and Congress. The plethora of tests to which today's students are subjected include achievement, competency, and basic skills tests to fulfill local and state testing mandates; tests to identify or qualify students for compensatory or special education programs; screening tests for prekindergarten and kindergarten placement; college admission tests; Graduate Equivalency Degree (GED) tests; and the National Assessment of Educational Progress tests mentioned above. As this book goes to press, Congress continues to debate the merits of a voluntary national examination to be administered to children in grades 4 and 8 to score achievements in reading and mathematics. The proposal is politically controversial on several fronts, including (1) whether the tests are needed in the first place; (2) whether the tests will be fair given the diversity of students in each grade across the nation, including children with disabilities; (3) the potential for misuse of the results for tracking, placement, promotion, and retention decisions; and (4) the likelihood of curriculums becoming overly focused on the narrow contents of the tests (Association for Supervision and Curriculum Development, 1997; International Reading Association, 1997).

In U.S. schools, tests are used to select specific types of instruction, to identify slow learners or accelerated learners, to provide educational and vocational guidance, to screen for admission to private schools, and to selected vocational and professional schools. Standardized testing has been used to determine grade and program placement, to determine who graduates from high school, to assess the quality of teachers and teaching, to compare schools and school districts, and to precipitate and evaluate school reform efforts. Quite clearly, standardized testing has come to "dominate the educational landscape in contemporary America" (Medina & Neill, 1990, p. 3). Yet little, if any, data reveal widespread improvement in the educative process resulting from this ever-increasing use of tests and its profusion of test data (National Association of State Boards of Education, 1997; National Center for Fair and Open Testing, 1998; Neill, 1997; Perrone, 1991; U. S. Department of Labor, 1992).

Concerns regarding large-scale, high stakes testing of students become increasingly troublesome when such testing is mandated in early childhood classrooms. Too often the limited content of the test becomes the content of the curriculum, which is often characterized by rote memorization activities, paper-and-pencil tasks, and skill-and-drill "reviews" accompanied by pressures from both teachers and parents for children to learn content and skills more appropriate for older children. The effect of test-driven curriculums at the early childhood level is profound, depriving young children of broad based, hands-on, experiential learning and imposing developmentally inappropriate schooling experiences on them. Such practices result in curriculum deprived classrooms and knowledge deprived learners. The potential injury to self-confidence, self-esteem, and motivation to learn that result from these practices have been well documented (Bredekamp & Shepard, 1989; Charlesworth, 1989; Elkind, 1979, 1986, 1987; Fleege, 1990; Hilliard, 1975; Kamii, 1990; Medina & Neill, 1990; NAECS/SDE, 1987; NAEYC, 1988a, 1988b). Figure 1.2 shows appropriate uses and technical accuracy of assessment.

Concerns Associated with Retention Practices

A by-product of overuse and misuse of standardized tests during the elementary grades has been a trend toward holding children back, either through "red shirting" (enrolling in kindergarten at age 6 instead of age 5), or retention, which may require a child to repeat prekindergarten, kindergarten or first, second, or third grade. Frequently, children who are retained are placed in a between-grade class, referred to variously as "transition class", "developmental placement", "junior kindergarten", "junior first grade", and so on. Such practices are intended to give the child time to grow and become developmentally more mature. Unfortunately, these practices have caused curriculums to be adjusted upward toward the older children in the classrooms, often mimicking the next more advanced grade level, further disadvantaging the children who are the age for which the grade is intended. These children are consequently perceived as "slow" or as needing additional tutoring or "time to grow," when indeed, they are functioning and performing at an age-appropriate level. All too frequently these practices also disenfranchise children with developmental delays or other special needs—children who could benefit from inclusion with their agemates in a developmentally appropriate context.

Research is extensive on the deleterious effects of these practices (American Academy of Pediatrics, 1995, 1997; Bredekamp & Shepard, 1989; Gredler, 1984; Meisels, 1986, 1987, 1989; Shepard & Smith, 1985, 1986, 1987, , 1989a, 1989b; Walsh, Ellwein, Eads, & Miller, 1991; Willer & Bredekamp, 1990). Summarizing the main points of these and other studies, we find that:

◆ Children gain little, if any, academic benefit from being retained.

◆ Retention either produces no difference or causes some harm to social-emotional outcomes for children.

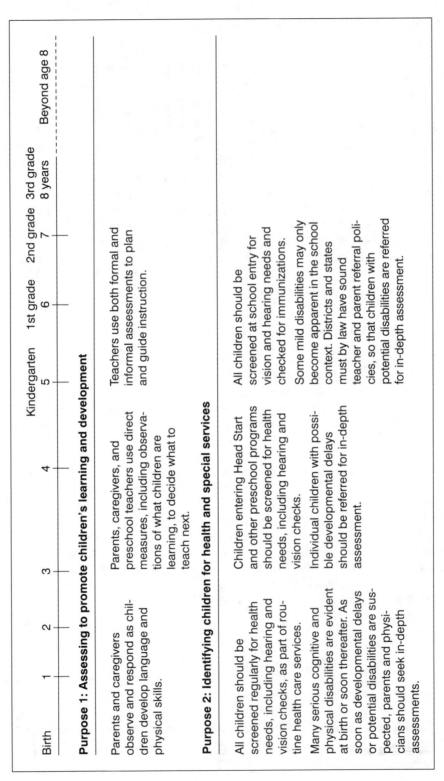

Birth | 1 | 2 | 3 | 4 | Kindergarten 5 | 1st grade 6 | 2nd grade 7 | 3rd grade 8 years | Beyond age 8

Purpose 1: Assessing to promote children's learning and development

Parents and caregivers observe and respond as children develop language and physical skills.

Parents, caregivers, and preschool teachers use direct measures, including observations of what children are learning, to decide what to teach next.

Teachers use both formal and informal assessments to plan and guide instruction.

Purpose 2: Identifying children for health and special services

All children should be screened regularly for health needs, including hearing and vision checks, as part of routine health care services.

Many serious cognitive and physical disabilities are evident at birth or soon thereafter. As soon as developmental delays or potential disabilities are suspected, parents and physicians should seek in-depth assessments.

Children entering Head Start and other preschool programs should be screened for health needs, including hearing and vision checks.

Individual children with possible developmental delays should be referred for in-depth assessment.

All children should be screened at school entry for vision and hearing needs and checked for immunizations.

Some mild disabilities may only become apparent in the school context. Districts and states must by law have sound teacher and parent referral policies, so that children with potential disabilities are referred for in-depth assessment.

Figure 1.2
Appropriate Uses and Technical Accuracy of Assessments Change Across the Early Childhood Age Continuum (Birth to Age 8)

Purpose 3: Monitoring trends and evaluating programs and services

Because direct measures of children's language and cognitive functioning are difficult to aggregate accurately for ages from birth to 2, state reporting systems should focus on living and social conditions that affect learning and the adequacy of services.	Assessments, including direct and indirect measures of children's physical, social, emotional, and cognitive development, could be constructed and used to evaluate prekindergarten programs, but such measures would not be accurate enough to make high-stakes decisions about individual children.	Beginning at age 5, it is possible to use direct measures, including measures of children's early learning, as part of a comprehensive early childhood assessment for monitoring trends. Matrix sampling should be used to ensure technical accuracy and to provide safeguards for individual children. Because of the cost of such an assessment, states or the nation should pick one grade level for monitoring trends in early childhood, most likely kindergarten or first grade.

Purpose 4: Assessing academic achievement to hold individual students, teachers, and schools accountable

	Before age 8, standardized achievement measures are not sufficiently accurate to be used for high-stakes decisions about individual children and schools. Therefore, high-stakes assessments intended for accountability purposes should be delayed until the end of third grade (or preferably fourth grade).

Figure 1.2, *continued*

Note: From *Principles and Recommendations for Early Childhood Assessments* (pp. 20–21), by L. A. Shepard, S. L. Kagan, & E. Wurtz (Eds.), 1998, Washington, DC: National Education Goals Panel.

◆ A high proportion of children retained one or more years later drop out of high school.

◆ Retention decisions are often biased, as children most likely to be retained are boys with summer birthdays, children physically small for their age, and children of minority groups.

◆ More developmentally appropriate practices and less formal, didactic instruction with young children is more promising for all children.

Numerous professional organizations have published position statements regarding inappropriate testing and retention practices with young children. These organizations include American Federation of Teachers, Association for Childhood Education International, International Reading Association, National Association of State Boards of Education, National Association for the Education of Young Children, National Association of School Principals, National Association of School Psychologists, National Black Child Development Institute, Southern Early Childhood Association, and numerous state task forces. A list of publications and position statements is provided in Chapter 10.

The Place of Standardized Tests in Early Childhood Education

Is there a legitimate place for standardized tests in early childhood education? Widespread testing of student performance is generally employed to exact accountability from school districts and individual schools and sometimes individual teachers. Many critics of widespread testing for the purpose of holding schools accountable to taxpayers cite as possible alternatives random sample testing for student outcomes at selected grade levels. This makes sense given the exorbitant costs in dollars and lost instructional time. In Chapter 7, we will describe the "aggregated" portfolio, which might also serve the purposes of evaluating school and classroom performance outcomes while providing important information for improving curriculum and teaching. But there are times when standardized tests serve an important purpose, and that is in the identification of children who may have specific developmental and education needs.

When teachers or parents suspect that an individual child may have a learning or developmental problem, diagnostic testing may be necessary. Such tests are administered by a qualified professional who carefully selects the test (or preferably several different tests) to determine the specific developmental or learning issues confronting the child. Following such diagnostic testing, specific recommendations can be made about the types of learning and other experiences the child needs. Focused and objective observation of children in the classroom helps to identify children who may need diagnostic testing and additional professional assistance. We discuss the use of standardized test information in Chapter 6.

IDENTIFICATION, INTERVENTION AND INCLUSION OF CHILDREN WITH SPECIAL NEEDS

More than 20 years ago Congress enacted PL 94-142, the Education for All Handicapped Children Act of 1975, requiring states to ensure that all school-age and some preschool age children with disabilities receive a free appropriate public education, and establish a Child Find program in each state for children from birth through age 21 to identify those who are eligible for education, health, or social service programs. In 1986, the enactment of PL 99-457, amended this act and extended services to preschool children ages three through five years and provided incentives for states to serve infants and toddlers, as well. In 1990, the Act was further amended and renamed through PL 101-476, the Individuals with Disabilities Education Act (IDEA). Part C (known as Part H until July 1998) of the IDEA provides services specifically for birth through age two and provides funds to states to develop, establish, and maintain a statewide system that offers early intervention services for this age group. The law basically provides for three groups:

1. children who have a measurable developmental delay in one or more of the following areas: cognitive, physical, language/communication, social, emotional, or adaptive or self-help behaviors

2. children who have a diagnosed physical or mental condition that could result in a developmental delay (e.g., Down syndrome, multiple sclerosis)

3. at-risk children who must experience early intervention to prevent a developmental delay

The law recognizes the importance of the family in the child's development and thus provides that families may receive services that help them promote the healthy development of their children. Such services may include family counseling, guidance on working with school- or behavior-related issues, and involves families in collaborative efforts to design and implement early intervention programs. The law requires that services for these very young children be provided in *natural environments,* defined as settings that are natural or normal for the child's peers who have no disability. As such, the law encourages a family-centered approach to early identification and intervention and requires the development of individualized family service plans.

Part B of this law requires state education agencies to provide all eligible children ages three through five with early intervention programs. Evaluation of a child's eligibility for these services is based on:

poor performance on hearing, vision, and speech or other screening activities that are routinely administered by school personnel as part of the Child Find activities

a need to determine whether a student exiting the early intervention program needs available preschool services

a parent or legal guardian makes a referral for evaluation.

In these cases, a multidisciplinary team evaluates the student to determine if special education services are required. The committee, usually composed of an administrator, evaluator, classroom teacher, parent, and other professionals when appropriate, meet to assess the student's eligibility for services. Eligibility falls under the broad classification of "preschool" or under specific disabling conditions: behavior disorder; aural, visual, mental, or speech/language impairment; or specific learning disability. Services for preschool children must be provided in the least restrictive environment to the maximum extent possible, and where a regular preschool program in not available in a particular public school, opportunities for participation in preschool programs operated by other public agencies, or another elementary school or a private program are provided.

The early childhood educator plays an important role in early identification and assessment of young children who may qualify for intervention programs and services. As you shall see later in this text, ongoing observation and assessment of student performance, processes, and products, provides concrete evidence that can be used to obtain services for children who need them. Data collected through authentic assessment strategies can be combined with formal assessments administered by school licensed diagnosticians or other professionals. Figure 1.3 provides criteria for good assessment.

BASIC ASSUMPTIONS UNDERLYING AUTHENTIC CURRICULUMS AND ASSESSMENT

Our quest for authentic assessment can be based on assumptions relating to several aspects of the education process: (1) early childhood education (birth through age eight), (2) learning, (3) knowledge, (4) teaching, and (5) assessment, all of which are delineated in the following lists. You will see the assumptions played out throughout this text as we examine the construct of authentic assessment and propose strategies for carrying it out.

Assumptions About Early Childhood Education

◆ Young children have an innate need to know and, therefore, are competent, eager to learn, and trustworthy learners.

◆ Within a supportive and enriched setting, young children can initiate and direct their own learnings.

◆ Young children construct knowledge while interacting with adults, one another, and with meaningful materials and realia.

Figure 1.3
Criteria for Good Assessment
Note: From Developmentally Appropriate Assessment: A Position Paper by the Southern Early Childhood Association, 1998, Little Rock, AR: Author. Copyright 1998 by the Southern Early Childhood Association. Reprinted by permission.

- Assessment must be *valid*. It must provide information related to the goals and objectives of each program.
- Assessment must deal with the whole child. Programs must have goals and assessment processes which relate to children's physical, social, emotional, and mental development.
- Assessment must involve observations across time and in a variety of settings. This helps teachers find patterns of behavior and avoid quick decisions which may be based on one-time behavior by children.
- Assessment must be continuous and ongoing. Children should be compared to their own individual course of development over time rather than to average behavior for a group.
- Assessment must use a variety of methods and sources. Gathering a wide variety of information from different sources enables informed and professional decisions.
- Assessments must be used to modify the curriculum to meet the individual needs of children in the program.
- Assessment must involve parents. Parents and extended family members provide information that is both accurate and beneficial in program planning.

◆ Young children develop physically, emotionally, socially, and intellectually at different rates.

◆ The first eight years are critical ones in total development.

Assumptions About Learning

◆ Learning proceeds from the concrete to the abstract through (1) active exploration and inquiry, (2) enriched learning environments, (3) social contexts that encourage interaction among learners, and (4) adult or older child scaffolding.

◆ The mind must be engaged if learning is to occur.

◆ There are different intelligences involved in learning: linguistic, logical-mathematical, spatial, musical, bodily-kinesthetic, interpersonal, intrapersonal, and naturalistic (Gardner, 1983).

◆ All learning has its foundations in early childhood.

Assumptions About Knowledge

◆ Knowledge is rooted in the language, beliefs, and customs of different cultures.

Young children have an innate need to know and are competent, eager, and trustworthy learners.

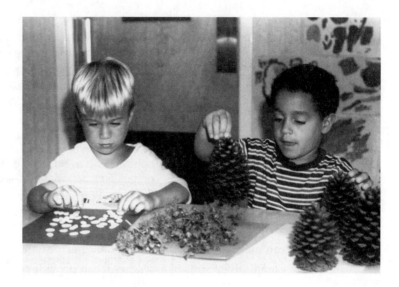

♦ Different kinds of knowledge exist: physical, logical-mathematical, and social-conventional (Piaget, 1952).

♦ Both products and processes are important to the acquisition of knowledge.

♦ Problem solving supersedes rote memory of facts if knowledge is to be meaningful and sustained.

♦ New knowledge builds on prior knowledge and experience and is influenced by the individual's perceptions.

♦ Knowledge is more efficiently acquired in meaningful contexts.

♦ The acquisition of knowledge is a lifetime process.

♦ It is impossible to define a particular body of knowledge that is essential for everyone to acquire.

Assumptions About Teaching

♦ Specialized training and skills are essential to teaching young children.

♦ Teaching is child-centered rather than curriculum or skill-and-drill focused.

♦ Teaching occurs in individualized (apprenticeship) and small-group situations.

♦ Teaching is cognizant of and responsive to emerging research and new knowledge about child growth, development, and learning.

♦ Teaching is cognizant of and responsive to the ever-growing knowledge pool in all curriculum areas.

♦ Teaching acknowledges diverse cultures and unique learning styles.

♦ Teaching and assessing are both ongoing and interconnected.

Assumptions About Assessment

◆ Comparing assessment results across populations is of little value.

◆ Authentic assessment is not a reflection of inherent capacities, but of emerging capabilities and the individuals' interactions with the environment.

◆ Authentic assessment is rooted in scientific evidence from the developmental, cognitive, and neural sciences.

◆ Authentic assessment in context provides valid information about the learner and the educative process.

◆ Authentic assessment considers different intelligences, diverse learning styles, and varying contexts in which learning occurs and reflects our best understanding of human variability.

◆ Authentic assessment rooted in knowledge of child growth and development can make valid predictions of later performance.

◆ Qualitative forms of assessment can provide objective and reliable data about the learner.

◆ Developmentally appropriate assessments are derived from developmentally appropriate curricula and vice-versa.

◆ Authentic assessment provides opportunities for both the learner and the teacher to reflect on goals and ways to achieve them.

OVERVIEW OF THIS TEXT

The chapters that follow will introduce you further to a new era of assessment, inviting you to join the authors in celebrating the growth, development, and learning of children through meaningful and relevant practices. This book is divided into three sections. Section I provides a historical, theoretical, and philosophical overview of authentic assessment. In Chapter 2 you will explore the authentic assessment paradigm and be given suggestions for how to get started. Section II provides an in-depth discussion of the background information needed to implement authentic assessment with young children. Its chapters focus on the need for knowledge of child development and learning styles (Chapter 3), knowledge of diversity among children in school (Chapter 4), and knowledge of content areas and how the integrated curriculum supports learning and authentic assessment (Chapter 5). Section III, Authentic Assessment Strategies, provides the how-to part of this text, beginning in Chapter 6 with developing a "grand plan" for assessment and integrating assessment strategies into daily teaching practice. Because authentic assessment involves the individual learners in their own assessment, chapters 7 and 8 describe the development and use of student portfolios and how to promote self-assessment in young children. Chapter 9 describes how parents become working partners through collaboration that promotes

authentic assessment. Finally, as professionals, our opportunities to communicate the effectiveness of authentic assessment to colleagues, school administrators, legislators, and other policymakers are explored in Chapter 10. Additionally, an extensive list of resources available to students, parents, and educators to enhance the authentic assessment endeavor is included in Chapter 10.

REVIEW STRATEGIES AND ACTIVITIES

1. Review the position statements of various professional education and psychology associations. Compare their concerns and their suggestions for assessing the progress of young children in school. (See Chapter 10 for a list of these position statements.)

2. Select a number of current child development or early childhood education journals (see Chapter 10 for a list of resources), and locate and read articles that discuss new insights in child development and learning, sociopolitical influences on early childhood education, standards-based curriculum and assessment, and authentic assessment. Discuss the information in these articles with your classmates; share your findings during class discussions.

3. Discuss with your instructor and classmates the advantages and disadvantages of using standardized tests with young children. Consider how and for what purposes test scores are or can be used.

2

Implementing Authentic Assessment with Young Children

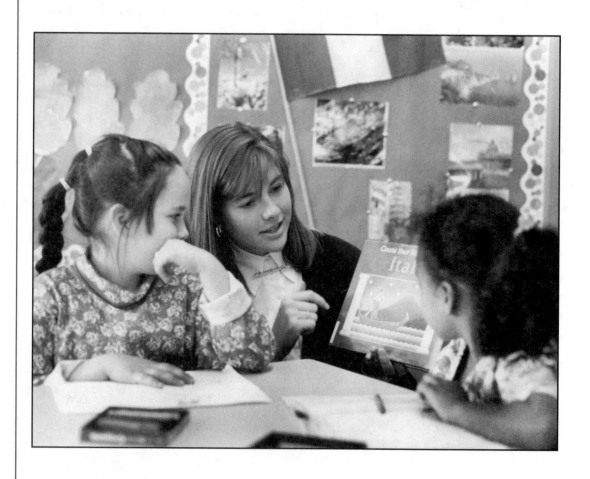

Less done well is more.
Anonymous

After reading and studying this chapter, you will demonstrate comprehension by being able to:

- state the rationale for gradual implementation of authentic assessment.
- describe initial authentic assessment strategies a beginner can use.
- identify what additional background information you need to effectively implement authentic assessment.
- distinguish between formative and summative evaluations.

TEACHERS' STORIES

SAM JOHNSON is in his first year of teaching a mixed-age class of twenty-four six-, seven-, and eight-year-olds. Planning for their learning needs and documenting their learning in all curricular areas require much before- and after-school time. Although the changes in Sam's school and in his classroom are exciting, at times he feels overwhelmed. His wife, Alicia, is setting up her medical practice, which also consumes a great amount of time and energy. They both worry that the demands of their professions are taking important time away from their family, which includes two young children.

Sam's principal, Sharon King, is pleased with the efforts of her staff to restructure their school. The components of site-based management and restructuring take time, more time than anyone expected, and Ms. King worries about her staff and the long hours they spend at school. She does not want her staff to become burned out and discouraged as they attempt to implement such promising innovative practices as mixed-age classroom communities, integrated language arts, and authentic assessment.

SUSAN HUTSON teaches in a state that has a number of prescribed learning goals for each grade level. Her school district has segmented these learning goals into many skills and subskills. As part of the site-based management process, teachers at each grade level have been charged with new forms of assessment for measuring these skills. Susan discovers that she is spending a large portion of the school day assessing each child on these various skills and subskills. It seems that all she does is focus on minutiae. Her frustration builds as she has less time for teaching and for planning, because recordkeeping takes a great deal of after-school time. She is beginning to question whether it is necessary to assess and document every small detail of a child's development and learning.

These vignettes describe some concerns and problems that teachers may encounter as they attempt to implement authentic assessment. Learning about and implementing authentic assessment is a complex, ongoing, frustrating (at times), but exhilarating and gratifying experience. Acknowledging and expecting these challenges prevent teachers from becoming discouraged and defeated.

The purpose of this chapter is to present some of the basic components of the authentic assessment process. In this chapter, you will be encouraged to reflect on the skills you have in relationship to outcome goals and those you may want to begin to develop to practice authentic assessment. Sections II and III of this book describe background information and implementation information. This chapter emphasizes that teachers need to (1) begin slowly, (2) do a self-assessment to determine if additional information is needed, and (3) understand the process of authentic assessment and realize that it can be implemented in a variety of ways.

START SLOWLY

In the field of education, innovative ideas often are implemented too rapidly. Teachers usually are not given time to reflect on the rationale for the innovation or to examine their current practice and its relationship to the new idea. Time also is generally not provided for gradual implementation of the innovation with the understanding that there must be opportunities to experiment and refine during the process of change and thereafter.

Because of rapid implementation and lack of preparation, reflection, and refinement, teachers often do not develop a commitment to an innovation. They perceive that it must be implemented immediately and then feel a sense of failure if the changes do not appear to deliver all that was promised. No wonder teachers have said, "I tried that and it didn't work." It is important that teachers *start slowly* in implementing the process of authentic assessment so that they become committed to it.

First, teachers may need to learn more about authentic assessment in general. This text was written for that purpose. Additional readings are suggested in Chapter 10. Reading books and articles, viewing videos and films, listening to tapes, and visiting schools and classrooms where authentic assessment is taking place can also be beneficial. Reflective thinking—the act of thinking about the aspects of teaching according to educational, technical, and ethical standards, including current assessment practices in your classroom and school—can be useful in deciding where to begin. As indicated in the epigraph at the beginning of the chapter, opportunities to discuss these thoughts and your experiences with other professionals are critical to the authentic assessment process.

Teachers often view teaching, learning, and assessment as separate tasks. Information is taught, learned, and *then* assessed. However, the process of authentic assessment considers development, learning, teaching, and assessment as ongoing, continuous, interrelated, and all occurring at the same time (see Figure 2.1). For most teachers, this viewpoint probably involves developing a new mind-set, one that constantly requires us to simultaneously ask two questions: (1) Given the purpose of this learning experience and the children's behavior, what are the children indicating that they are learning? (2) What do I need to do to help children extend or refine this learning? To make these questions operational, teachers need to acknowledge the importance of knowing about:

◆ children's development and learning styles (Chapter 3)

◆ diversity among children and families (Chapter 4)

◆ subject-matter standards and the integration inherent in the learning process (Chapter 5)

◆ the actual strategies for the authentic assessment of young children (chapters 6, 7, 8, and 9).

Figure 2.1
Authentic Assessment
Represents Teaching, Learning,
and Assessing as Ongoing and
Intertwined.

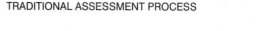

TRADITIONAL ASSESSMENT PROCESS

Teach ⟶ Learn ⟶ Assess

AUTHENTIC ASSESSMENT PROCESS

Undoubtedly, you already know something about one or more of these areas. Plan to focus your first efforts in an area where you have an interest or knowledge base.

Begin in an Area Where You Have Confidence

As mentioned previously, it can be overwhelming for most teachers to implement this process with *all* children in their classroom, *all* day long, and in *all* developmental domains and subject matter areas. Consequently, it is best to begin with an approach that is manageable and in areas where you feel a level of comfort and confidence. You will discover over time that the skills and competencies you are developing are becoming more ongoing and all-encompassing. In so doing, your ability to authentically assess young children will eventually extend into the total school day and involve all of the children in your classroom.

You can begin the process of authentic assessment in a number of ways; however, it is important to remember that there is no single correct way. You may select a variation of ideas described here, or you may choose a completely different approach. Some possible approaches follow.

Ongoing Assessment (Kid-Watching) in a Developmental Domain or Curricular Area

Some teachers may be particularly interested in ongoing assessment by kid-watching in a certain developmental domain or subject matter area. Kid-watch-

ing (Goodman, 1978) is informal but *informs* teacher observation of children in a variety of situations within the classroom and school, including the lunchroom, the outdoor learning center, and during transition times. Some teachers may wish to focus upon aesthetic and artistic development, intellectual development, physical development, or development of social responsibility. Other teachers may enjoy concentrating on a particular curricular area such as reading, writing, science, social studies, or mathematical thinking. Because of the explosion of knowledge that has expanded the traditional curricular context, some teachers may wish to choose areas such as computer literacy or problem-solving skills.

Given that development and learning occur in an integrated fashion, whatever area is selected, teachers should engage in ongoing assessment (kid-watching/informed observation) of as many children as possible in as many settings as possible. For example, if teachers choose to focus on children's developing social responsibility, the children can be observed and assessed in the classroom, the lunchroom, the gym, and the outdoor learning area. They can be observed in a variety of group contexts, including pairs, small groups, large groups, mixed-age groups, and beyond the classroom. Teachers who begin in the area of mathematics, for example, can provide opportunities for children to demonstrate their mathematical knowledge in a number of contexts: classroom learning centers, various classroom management tasks (such as the lunchroom count, distribution of materials), the gym, the cafeteria, the outdoor learning center, and during class sharing times.

Ongoing Assessment (Kid-Watching) During a Thematic Project

Another assessment approach that can be used is kid-watching during thematic units or projects. This approach organizes learning experiences around a central idea or theme and can be useful in helping teachers realize the integrated nature of teaching, learning, and assessment. For example, one classroom is engaged in a thematic project on traditions. Several children decide to conduct a class survey on the most popular traditions of the class population. During this experience, the teacher has the opportunity to observe and assess the following:

◆ children's problem-solving skills (deciding what questions to ask and how to conduct the survey)

◆ their oral and written communication skills (how to ask the questions, record the responses, and graphically represent the information)

◆ their awareness of various traditions from a variety of cultural groups represented within the class (broadening their cultural awareness)

◆ their social responsibility skills (cooperating and deciding who is going to do what and when)

◆ mathematics skills (tabulating and presenting results)

Teachers need to create time in their schedules individually and with other professionals to review the artifacts of the authentic assessment process and to identify learning, developmental, or behavioral concerns.

Ongoing Assessment (Kid-Watching) Focusing on a Small Group of Children.

A third assessment approach emphasizes in-depth observation of a small group of children. This strategy helps the teacher get to know a few children very well in all aspects of their development and learning. The teacher focuses exclusively on a small group of children for a period of several weeks to a month. Then the teacher moves on to concentrate on another group of children. The in-depth knowledge gained from the first group provides a firm basis for the continued assessment of these children throughout the school year. In addition, the skills the teacher develops by assessing and observing the first group are extended to the second and subsequent groups of children. After this concentrated focus on one group of children, the teacher can plan meaningful and informative in-depth conferences with the parents.

These approaches are not the only ways to begin the authentic assessment process. You may think of others. Detailed information in Chapter 3 through Chapter 9 can assist you in deciding how to begin observing and documenting development and learning in young children.

REFINE, STRENGTHEN, THEN ADD TO EXISTING COMPETENCIES

As teachers refine and strengthen their observation and assessment skills in areas where they feel a level of comfort and confidence, their competence in assessing will increase. This sense of competence will prove helpful during the next step of implementing authentic assessment. This stage includes selecting a new developmental domain, curricular area, thematic project, or group of children to observe and assess. For example, if teachers have observed the physical development of the children in their class, they may decide they need more skill in evaluating the integration of learning and development and may choose to work on assessment through the implementation of a thematic project or through integrated language arts. The integrated language arts approach combines instruction in the various components of the language arts—reading, writing, speaking, and listening—and also integrates the language arts across the curriculum.

Set Aside Scheduled Times for Individual Reflection and Group Discussion

Regardless of what approach teachers select, it is critical that there be time and opportunity for reflection and dialogue. Teachers need time to review the artifacts of the assessment process: their observation notes; checklists; conference reports; children's projects, products, and portfolios; and video and audiotapes. They need time (1) to think about where children are in their learning, where they have been, and where they should be going; (2) to identify patterns of learning and particular areas of interest; and (3) to begin to pinpoint learning, developmental, and behavioral concerns. Teachers also need time to reflect on their role

in the teaching/learning/assessing process. More specific information regarding this process will be addressed near the end of this chapter as well as in Chapter 6.

Essential to the success of the authentic assessment process is that teachers set aside uninterrupted time for thinking and reflection. Regularly scheduled times need to be provided schoolwide several times a week when teachers can give focused, reflective, and uninterrupted attention to the authentic assessment process, perhaps during the school day at planning time or before or after school. It can be most helpful if times are created for regularly scheduled meetings for teachers at each grade level *and* also across grade levels to share successes, problems, and materials and to validate perceptions of children's development and learning with other teachers and staff. The knowledge and support gained through such sharing facilitates the teachers' ability to implement authentic assessment. In addition, collaborative relationships are established with other teachers and staff that can enhance the learning process for children. For example, the process of a group of teachers sharing information about a particular child resulted in gathering further information and developing strategies designed to keep the child in regular education rather than opting to recommend the child for special education placement.

In summary, teachers need to begin the authentic assessment process slowly. They should begin in areas where they feel a level of comfort and confidence. They need to strengthen and refine what they are already doing well and then gradually add new skills to their existing competencies. In addition, time must be built into the teachers' schedules for individual reflective thinking. Time must also be provided for discussion and dialogue with other professionals regarding the authentic assessment process. These important steps can be helpful in preventing the kinds of problems described in the vignettes at the beginning of the chapter.

Determine If Additional Information Is Needed

As teachers begin to engage in the authentic assessment process, or perhaps even before, they may become aware of the need for additional information. As indicated in Figure 2.2, there are several areas in which background information is necessary and helpful in implementing authentic assessment. To determine what additional knowledge they may need, teachers need to ask themselves three questions:

1. Do I have sufficient knowledge about children's development and learning?
2. Do I have sufficient knowledge about curriculum content?
3. Do I need more knowledge about developmental benchmarks?

Do I Have Sufficient Knowledge About Children's Development and Learning?

Teachers may discover that they need more information or need to become more current in their knowledge about children's development and learning. They

1. **Knowledge of child development and learning styles?** (Read Chapter 3 for more information.)

 Physical development and well-being?
 Comments:

 Aesthetic and artistic development?
 Comments:

 Intellectual development (language and literacy)?
 Comments:

 Social-emotional development?
 Comments:

 Development of social responsibility?
 Comments:

 Awareness of age-appropriate expectations?
 Comments:

 Awareness of individually appropriate expectations?
 Comments:

2. **Knowledge of diveristy among children?**
 Comments:

3. **Knowledge of curricular areas and the integration of learning?**
 Mathematics?
 Comments:

 Reading?
 Comments:

 Writing?
 Comments:

 Science?
 Comments:

 Social studies?
 Comments:

 Fine arts?
 Comments:

 Technology/information systems?
 Comments:

Figure 2.2
What Additional Information Do I Need to Implement Authentic Assessment?

4. **Awareness of how to measure children's learning?**

Observation and other informal assessment strategies?
 Comments:

Scaffolding/mediating/questioning/conferencing strategies?
 Comments:

5. **Information on how to make learning in my classroom more purposeful, based upon real-life events?**

Are children in my class developing a sense of themselves as

 Readers?

 Writers?

 Communicators?

 Mathematicians?

 Problem solvers?

 Collaborators?

Figure 2.2, *continued*

may need more information concerning widely held expectations and generalizations about aesthetic and artistic development, emotional and social development, intellectual development, physical development and well-being, and the development of social responsibility. In addition, teachers may discover that they need to learn about strategies and techniques that will help them understand individual aspects of development, including learning styles and specific types of intelligences. Many teachers are discovering that children from diverse cultural and ethnic backgrounds can have different orientations toward learning. These teachers often realize that they need more information not only about various cultural perspectives regarding learning, but also about strategies for involving the parents in the education of their children. These topics are addressed in depth in Chapters 3 and 4.

Do I Have Sufficient Knowledge About Curriculum Content?

Because authentic assessment is ongoing, teachers may need assistance in understanding the continuous and interrelated nature of learning and assessment. In addition, teachers may discover that they need help in understanding the integration/connectedness/braiding of development in learning in and across the developmental domains as well as the curricular areas. Understanding the integration of both content information and skills may be another area in which teachers need support. As teachers realize the nature of integration, they begin to understand that instruction and assessment in one setting can produce multiple

learnings and assessments in a variety of developmental and curricular areas. This awareness increases the teacher's competency and efficiency in the authentic assessment process because the teacher realizes that many learnings and assessments can be achieved simultaneously.

Teachers may also discover that they cannot teach and assess every aspect of development and learning. Susan Hutson, introduced in one of the opening vignettes, was terribly frustrated because teaching many subskills and then assessing the minutiae used up her valuable planning and teaching time. Teachers may need help deciding what is important to teach and assess. What learning experiences do children actually need to become productive and competent citizens in an ever-changing world? Chapter 1 indicated that futurists suggest that children need to know how to communicate, to cooperate and collaborate, and to problem solve.

Do I Need More Knowledge About Developmental Benchmarks?

Teachers may need assistance in becoming aware of the benchmarks of development and learning in the various curricular areas. Benchmarks are the standards based on research evidence by which changes in children's development and learning are noted or marked, providing teachers with direction in facilitating the next step in children's learning. Teachers may need assistance in learning how to discover individual children's zone of proximal development (Vygotsky, 1978). Recall that the zone of proximal development refers to the level of learning that the child can reach if assisted by adults or more astute children. Teachers may need information on how to extend or clarify children's learning. The process of assessing the child's zone of proximal development can point out a need for more knowledge of the role of teachers as scaffold builders who facilitate concept development and as mediators who help establish concepts of relative importance in children's learning.

After thoughtful reflection and using Figure 2.2 to determine if additional information is needed, teachers may wish to address some of the areas in depth. Extended background information regarding the areas mentioned in the preceding discussion is the focus of the next two sections in this book. In addition to implementing the process of authentic assessment slowly and determining if additional background information is needed, teachers must know "how to" implement authentic assessment.

IMPLEMENTATION OF THE PROCESS OF AUTHENTIC ASSESSMENT

Implementation of authentic assessment begins with knowing how to make the process manageable, internalizing a framework for authentic assessment, under-

Clothing with pockets can hold pencils, pens, sticky notes, address labels, three-by-five-inch note cards, small note pads, and other materials useful for jotting down comments and observations during the ongoing assessment process.

standing limitations, and comprehending the role of authentic assessment in the total evaluation process.

Make It Manageable

Teachers will need to think through their management and recordkeeping system in implementing the authentic assessment process. Again, there is no one correct way to operate. It is important for teachers to select a management procedure that works for them. Observing children in action and making notes on conversations, conferences, and children's products are essential to the authentic assessment process. To make note taking easier, teachers may find it convenient to wear clothing with pockets to hold writing tools, sticky notes, address labels, and three-by-five-inch note cards. (See Figure 2.3.) A cobbler's or carpenter's apron or colorful smock with several pockets provides immediate access to these note-taking materials. To record important pieces of information, the teacher should write the child's first name and last initial, identify the context, note the date, and record the comment about the child's learning or behavior. This comment should be brief but adequate for the teacher to remember the learning or behavioral inci-

Figure 2.3
Convenient Sticky Notes
Facilitate On-The-Spot Recording
of Observations.

Child's name _____Jeremy Benton_____

Monday 11 - 2 - 00
 date
Jeremy B.
context: Block Center
observation: Aware
of concept of gravity
with trucks on ramp.

Tuesday 11 - 3 - 00
 date
Jeremy B.
context: Block Center
observation: J. explains
gravity to Juan G. and
Maria, who attempt.

Wednesday 11 - 4 - 00
 date
Jeremy B.
context:
observation:

Thursday 11 - 5- 00
 date

Friday 11 - 6 - 00
 date

dent. The teacher can add to the information at a later time, if necessary. The sticky note, address label, or note card on which the comment was recorded can be attached to or dropped in the child's folder.

Various recordkeeping sheets for recording observations are available from publishers or can be developed by the teacher. These need to be used judiciously to avoid creating a burden of recordkeeping and paperwork for the teacher.

Accessibility of children's folders and storage of their work need to be carefully planned. Some teachers use colored folders for various groups of children. For example, one teacher conferences with a different group of five students each day of the week about their reading. Each group has its own color of folders: Monday, green; Tuesday, red; and so on. Each child in the Monday group has a green folder that contains a list of books read, a response sheet to those books, and other items that the child and teacher choose to include. The teacher's sticky notes can be included as reminders of topics to discuss with the child. As suggested in this example, children need to become actively involved in their own

recordkeeping. These procedures take time to implement but ultimately save the teacher time and energy. In addition, there is a benefit to the children as they begin to take responsibility for their own assessment.

Internalizing Ongoing Authentic Assessment

Along with planning a management system, teachers need to internalize the place of the authentic assessment process within the total evaluation system and ultimately, in ongoing improvement of the curriculum. An initial planning strategy is illustrated in Figure 2.4 in which various components of the framework for implementation of authentic assessment can be kept in mind. The more one refers to this strategy, the more it becomes an internalized way of thinking about individual needs and assessment strategies. As you can see from Figure 2.4, many questions are addressed when planning authentic assessment. A more detailed discussion of each follows.

Where Did the Student Start?

Teachers need to obtain baseline information about where children are in their learning and development. This information may be obtained from a variety of sources: observations, previous records, developmental checklists, and conversations with the child, parents, and other teachers.

Where Is the Student Going?

Is the student at the awareness, exploration, inquiry, or utilization stage in the learning cycle? This question encompasses a number of areas (Katz & Chard, 1989, pp. 20–42):

1. What knowledge is the child acquiring? Knowledge includes ideas, facts, and concepts.
2. What skills is the child developing? Skills include such areas as physical, social, communicative, and cognitive—including reading, math, science, social studies, and so on.
3. What dispositions is the child developing? Dispositions include attitudes, personality traits, curiosity, creativity, resourcefulness, responsibility, initiative, interests, effort, mastery, and challenge seeking.
4. What feelings is the child developing? Feelings of success, positive self-esteem, empowerment, and autonomy as a learner are essential components in the authentic assessment process.

If a child does not feel successful, changes or adjustments must be made. Otherwise, feelings of self-esteem and efficacy will fail to develop, resulting in a disengaged learner. Disengaged learners, of course, are not as successful in school and subsequently develop negative feelings toward themselves and school. Dis-

- Where did the student start?

- Where is the student going? Is the child at the awareness, exploration, inquiry, or utilization stage?
 What knowledge (ideas, facts, concepts) is the child acquiring?
 What skills (physical, social, communicative, cognitive—including math, science, social studies) is the child developing?
 What dispositions (attitudes, personality traits, curiosity, creativity, resourcefulness, responsibility, initiative, interest, effort, mastery, challenge seeking) is the child developing?
 What feelings (success, positive self-esteem, empowerment, autonomy) is the child developing?

- Does the child need more background information?

- Are there other concerns or situations (nutrition, health, family concerns, etc.)?

- Does the child need more challenging information?

- Is it really important that the child learn this now, or should the information be learned later?

- Do adjustments need to be made for learning styles or modalities?
 Auditory, kinesthetic, visual?
 Learns best alone, in pairs, in small groups, in large groups, or a combination of these?
 Types of intelligences?

- Is instruction or learning environment appropriate?
 Age appropriate?
 Individually appropriate?
 Culturally appropriate?

Figure 2.4
Framework Questions for Authentic Assessment Planning
Note: The first part of this figure is from *Engaging Children's Minds: The Project Approach* (pp. 20-42) by L. Katz and S. Chard, 1989, Norwood, NJ: Ablex. Copyright 1989 by L. Katz and S. Chard. Adapted by permission of Ablex Publishing Co.

engaged learners often engage in disturbing and off-task classroom behaviors and are at risk of later dropping out of school.

Guidelines for Facilitating Learning and Development

The following questions can serve as guidelines for determining what needs to be done to facilitate learning and development:

1. Does the child need more background information?

2. Is the child affected by nutrition or health problems or family problems?

3. Does the child need more challenging information?

4. Is it really important that the child learn this information now, or could the child be more successful with this learning later?

5. Do adjustments need to be made for learning styles? Is the child primarily a visual, auditory, or kinesthetic learner? Does the child seem to prefer learning alone or in groups or pairs? Is the child a reflective learner? Does the child indicate a tendency for expressing intelligence from a particular frame of mind: linguistic, musical, logical-mathematical, spatial, bodily-kinesthetic, intrapersonal, or interpersonal? (Gardner, 1983)

6. Is the instruction or learning environment appropriate—age appropriate, individually appropriate, and culturally appropriate?

Preventing Analysis Paralysis

Remember the vignette at the beginning of the chapter about Susan Hutson? She was experiencing "analysis paralysis" (Katz, 1980, p. 56). Analysis paralysis occurs from attending to excessive detail, which results in the inability to function effectively or to concentrate on the more important aspects of a situation. Focusing on minutiae is counterproductive and impedes the implementation of the authentic assessment process. Time spent on irrelevant details takes away from focused teaching and instruction and more meaningful assessment. Such extraneous assessment practices often are not related to the context of learning and are an imposition on both the teacher and child. Administrators and teachers need to make sure that both assessment and instruction are relevant, important, and meaningful.

Teachers may choose to employ more extensive assessment with those children whose learning behaviors are not understood. If questions about the child's learning and behavior cannot be answered by the classroom teacher, more intensive individual diagnostic assessment by other professionals may be necessary. Policies regarding preprimary intervention and inclusion strategies may require more detailed screening and assessment. An example of such in-depth assessment is shown in Figure 2.5. This type of detailed, comprehensive assessment should be administered in collaboration with parents, school diagnosticians, counselors, psychologists, social workers, nurses, or other trained professionals. If the classroom teacher refers a number of children for further evaluation, learning expectations for the class could be developmentally inappropriate. The teacher then may need to adjust curriculum and expectations of children.

Using Information from Mandated Tests

The use of group standardized tests with young children is strongly discouraged among scholars in education and child development specialists (National Associa-

I. Physical development and well-being

 A. Health status

 1. Early health (prenatal, infancy, early childhood)
 2. Childhood diseases
 3. Accidents or trauma
 4. Hearing
 5. Vision
 6. Allergies
 7. Dental health
 8. Motor development: coordination, strength, agility, endurance
 9. Height/weight percentile
 10. Other health categories

 B. Routines

 1. Personal cleanliness/hygiene
 2. Self-care capabilities
 3. Nutrition and eating habits
 4. Rest and sleep routines
 5. Play and recreation opportunities

II. Family life characteristics and routines

 A. Economic status

 B. Family language

 C. Number of adults in the home

 D. Proximity to extended family members

 E. Siblings and sibling relationships

 F. Family ideals and goals

 G. General atmosphere in the home

 H. Family recreation

 I. Disciplinary practices in the home

 J. Child's attitudes or feelings about family/home

Figure 2.5
Example of Comprehensive, Detailed Assessment

tion for the Education of Young Children, 1988a, 1988b; National Association of State Boards of Education, 1988, 1995, 1997; National Commission on Testing and Public Policy, 1990; Perrone, 1991; Southern Early Childhood Association, 1996). Numerous studies have documented the deleterious effects of mass standardized testing of young children and education practices (Kamii, 1990; Meisels, 1987, 1992; Neill, 1997; Shepard & Smith, 1985, 1986, 1987; Wiggins, 1998). Yet, some politicians and policymakers, and some ill-informed educators still believe that such tests do no harm and can lead to improvement in schooling outcomes.

As described in Chapter 1, many states have mandated the use of specific standardized tests at selected grades and at specific times during the school year. While the results of these tests are generally used to establish the overall achievement records of students in a school district, individual school, grade, or subject/content area, when scores are provided in a timely fashion, the data provided may be helpful to the teacher in instructional planning.

Group scores can provide a gestalt perspective (albeit rudimentary) from which teachers can establish a class profile, identifying areas of strength and areas of weakness in the class as a whole. Specific knowledge or skill areas can be identified that need additional attention or modified pedagogy. Curriculum then, can be adjusted on the basis of information provided by this class profile while still being responsive to emerging interests and capabilities of individuals. Individual student scores can help the teacher identify individual student strengths or weaknesses as portrayed by a particular testing instrument. Individual scores also can be combined with other data from authentic assessment practices to develop individualized enrichment plans to meet identified needs or to identify students needing closer observation and perhaps formal diagnostic screening.

Teachers must be cautious when using information from group standardized test scores. No student should be classified, labeled, grouped, tracked, or subjected to intensive remediation on the basis of one standardized test score. Student assessments and subsequent pedagogical adjustments must always include information from a variety of sources. Some children are simply good test takers; others are not. The standardized test scores can augment other information about what children know and are able to do, but must not constitute the only information upon which instructional decisions are made.

Teachers will want to avoid some of the following common mistakes in the use of standardized test information:

The well-known *halo effect*, in which high-scoring students are thought to be more knowledgeable, skilled, or competent than they may actually be able to demonstrate in other contexts.

The *deficit effect*, in which low-scoring students are thought to be less capable than is true when they are assessed in other contexts.

The *subject-success effect*, in which a content area is thought to have been sufficiently covered in the curriculum and hence, mastered by the students.

The *skill/drill effect*, in which it is thought that students will improve through repeated practice and drill over the same material or skill areas covered by the test.

One can readily see how each of these mistakes leads to distorted student expectations, which are followed by developmentally inappropriate education practices. The use of group standardized tests with young children is risky business, and must be entered into with caution and a clear understanding of the purpose of the test and its limitations for improving the learning experience or outcomes for young children. Where teachers have no choice about whether to use group standardized tests, they must strive to maintain developmentally appropriate

classrooms and curricula and avoid limiting young children's experiences to "pre-
pare for the test." Information derived from group test scores must be used judi-
ciously and in a manner that serves the long-term best interests of children.

Plan for Summative Assessments

For the most part, authentic assessment is formative in that it takes place as learning
occurs and can provide immediate feedback to the student and teacher about both
student knowledge and skills and the effectiveness of the pedagogy being employed.
Formative assessments assist both teacher and learner in determining the next steps
to take or subsequent goals to set to achieve certain learning outcomes. Formative
assessments, as has been stated earlier are ongoing and occur in many contexts.

However, authentic assessment is not just formative in nature. Summative
assessments which should occur at specified intervals throughout the school year
can provide a broad and cumulative picture of student performance and achieve-
ments over time, and can determine if long-range goals are being met. Summa-
tive assessments can also be used as a class or program evaluation strategy to
determine if school or district goals are being met.

Individual student summative assessments should take place no more than
three times a year, usually once every three months. Reviews of the child's fold-
ers, portfolios, teacher notes, and input from the child and parent are used. Fig-
ure 2.6 includes the types of questions addressed through summative assess-
ments. Portfolios are methods of collecting children's products and documenting
the emerging process of children's learning (see chapters 6–9). The summative
assessment process includes five steps:

1. Identify the child's strengths.
2. Document evidence of progress in learning and development.
3. Identify concerns.
4. Identify strategies to promote continued development.
5. Celebrate emerging development with the child and parent.

These summative evaluation questions should be addressed approximately every
three months:
1. What are the child's strengths?
2. What evidence is there of the child's progress?
3. What are concerns about the child's learning, development, and behavior?
4. What are strategies needed to promote continued learning and development?
5. How will this evaluation be shared with and involve the child and family?

Figure 2.6
Summative Evaluation Questions

This chapter has given you preliminary strategies to begin implementing an authentic assessment process. Sections II and III will provide more specific information and additional strategies for developing a comprehensive authentic assessment program. Remember the quote at the beginning of the chapter, "Less done well is more." Proceed slowly and build on your existing strengths.

REVIEW STRATEGIES AND ACTIVITIES

1. Use the form in Figure 2.2 to identify what additional information you need to implement authentic assessment. Check Chapter 10 for helpful resources.

2. Begin to think about how you might manage your system of authentic assessment, for example, student observation/collaboration time, recordkeeping, analysis of assessment data, storage, and so on. Share and compare your ideas with a classmate.

3. Interview professionals who use authentic assessment in their classrooms. What suggestions do they have for making authentic assessment successful for both students and teachers?

4. Begin a "kid-watching log." Observe young children in many contexts, engaged in many types of activities and interactions. Record language, physical characteristics, social and emotional responses, and problem-solving efforts. Discuss your observations with your classmates or colleagues in teaching. What can you learn about age and individual characteristics of young children from these observations?

Background Information Needed to Implement Authentic Assessment

3 The Basic in Authentic Assessment

Understanding Child Development and Learning

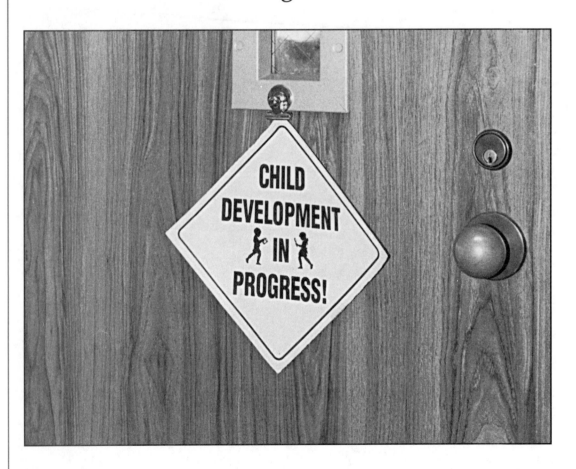

Assessment programs which fail to take into account the vast differences among individuals, developmental levels, and varieties of expertise are increasingly anachronistic.
 Howard Gardner, *Assessment in Context: The Alternative to Standardized Testing*

What is basically lacking in teacher preparation, and contributes much to educational failure, is a sound and profound grounding in human development as a critical underpinning of the educational enterprise.
 Irving E. Sigel, *What Teachers Need to Know About Human Development*

We must point out . . . that just as emotions are critical to learning, learning and the expansion of knowledge are critical in forming positive emotions.
 Renate Caine and Geoffrey Caine

After reading and studying this chapter, you will demonstrate comprehension by being able to:

- relate principles of early childhood development and learning to the authentic assessment process.
- describe the generally accepted patterns of behavior and development in young children.
- discuss the importance of early identification and intervention with children with special needs.
- describe learning styles theory and discuss how identification of student learning styles can facilitate the authentic assessment process.
- describe multiple intelligences theory, and discuss how awareness of individual intellectual profiles facilitates the authentic assessment process.
- explain why learning about child development is ethically responsible and ongoing throughout one's career.

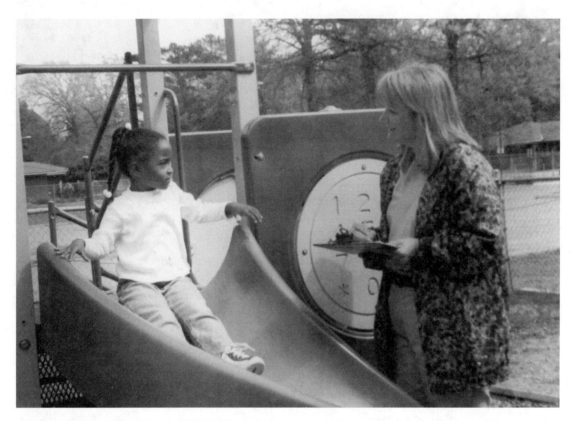

Knowing about children's development and learning is critical to accurate and authentic assessment.

KNOWLEDGE ABOUT CHILDREN'S DEVELOPMENT AND LEARNING

In Chapter 1, we introduced the concept of developmentally appropriate practices in early childhood education. Such practices depend on the teacher's knowledge and understanding of both the common and individualistic characteristics of children at each age period. This understanding assists teachers in designing early education experiences from which children will derive the greatest benefit and that will serve their best interests in the long run. To be developmentally appropriate, authentic assessment of young children must also recognize and be based on age-appropriate expectations. Such expectations are cognizant of many factors in human development that contribute to the uniqueness of each individual and of the diversity and wide range of abilities and interests among the members of a grade or classroom group.

Whole Child Perspective

Too often when we think of young children in a school or early education setting, we think primarily about their cognitive development or what knowledge and skills they will be learning that will prepare them for school. Many parents and teachers focus on school (or academic) knowledge and skills as indicators of achievement or maturity. "My child knows his ABCs and can count to 20," boasts the proud parent of a five-year-old. "The children in my class are doing so well at learning rhyming sounds and even some of the letter sounds," reports the kindergarten teacher. Both may be acceptable accomplishments during the early childhood years, but they do not begin to represent the vast array or amount of learning, or the impressive growth and development that has taken and is taking place.

Growth and development occurs unevenly yet concurrently in the physical/motor, psychosocial, cognitive, and language domains. Inherent in much of this growth and development is the acquisition of knowledge and skills in the academic domains of literacy, math, science, social studies, and the arts. Recognizing this, professional early childhood educators take a whole-child perspective that observes and facilitates growth, development, and learning in all these areas. All growth and development is interrelated and interdependent; so while a child may "know" certain rhyming sounds as indicated by the kindergarten teacher, the ability to recognize those sounds is as dependent on health, and individual auditory acuity, past experience with language, (i.e., conversation, songs, verses, and stories), and current engagement in activities that promote such discrimination, as it is on cognitive development or pedagogy. Hence, experience (past and present), physical development (health, sensory, and motor integrity), language development (oral, written, shared), cognitive development (prior experience and existing mental structures), and current level of engagement are all involved in the child's ability or inability to recognize rhymes or recite letters and numbers. Assessment of the young child takes into consideration all of these developmental determinants.

It is not the intent of this chapter to describe fully the growth and development characteristics in each of the domains or school content areas; however, a brief overview along with the appendices at the end of this chapter, may provide the template for discussions about assessment of young children. You may wish to refer to the resources listed under the heading Child Development in Chapter 10 for references which provide comprehensive coverage of child growth, development, and learning. For now, let's take a brief look at each domain.

Brain Growth and Neurological Development

Advances in the fields of neuroscience and technology have uncovered information which affirms what early childhood educators have asserted for years—that development during infancy and early childhood profoundly affects later development and can determine potential life outcomes. Unlike researchers of the past who relied on naturalistic observations and behavioral studies to describe

growth, development, and learning, researchers today are seeking to explain behaviors (both conscious and unconscious) through biological studies of brain cells and cellular systems. Utilizing very sophisticated technological tools such as high resolution ultrasound recordings, magnetic resonance imaging (MRI), positron emission tomography (PET) scan, and precise brain electrical and chemical analyses, scientists are now able to describe how the brain in its earliest formative stages becomes organized and subsequently maintains or alters this organization. Modern technology has made it possible for scientists to witness how, where, and when neurological connections occur and to observe this process as it is occurring in the brain.

This is phenomenal and is increasing our understanding about the timing and the influence of experience on brain growth and neurological development. We are now able to identify "windows of opportunity," or periods when certain experiences have the greatest effect on the brain's formation of intricate nerve connections. This information accents the importance of early environmental influence and the need for appropriate early intervention with infants and young children who are at-risk for developmental delays—premature and low-birth-weight infants; infants prenatally exposed to drugs, maternal stress, or undernutrition; and infants and young children living in homes where the opportunities for healthy and appropriately stimulating development are limited by poverty, abuse, neglect, negative or demeaning interactions, or violence. Understanding how the brain grows and becomes neurologically wired prepares parents and early childhood educators to interact wisely with infants and young children and to provide developmentally appropriate experiences—experiences gauged carefully to nurture and sustain emerging neurological development.

The brain's organizational and functional complexity is truly awesome. Beneath the human skull is an organ that controls numerous bodily functions and activities including both voluntary (walking, speaking, dancing) and involuntary (heartbeat, breathing, body temperature). Different parts of the brain control different functions; for instance, the cerebral cortex at the uppermost region of the brain controls perception, thought, memory, problem solving, and so on. The cerebral cortex has two hemispheres each made up of four lobes that are composed of numerous folds that develop according to different, yet predictable, sequences. Each hemisphere is specialized to perform different functions (Sperry, 1964). The left hemisphere processes language and analytical information; the right hemisphere specializes in nonverbal, visual–spatial information, though for the most part, the hemispheres are interdependent and collaborate on most tasks through the help of the corpus callosum, a thick band of neurological tissue that connects the two halves of the cerebral cortex.

The frontal lobes of the brain are the site of some uniquely human abilities such as self-awareness, initiative, and morality. The frontal lobes also receive and coordinate messages from the other lobes of the cerebral cortex. The occipital lobes at the back of the brain receive and process visual information; the temporal lobes, above and behind the ears, receive and process aural information and are where permanent memories are stored. The parietal lobes at the top of the head

receive sensations of touch and process motor activity. In addition, the hypothalamus and amygdala react to stress and control emotions; the thalamus, hippocampus, amygdala, and basal forebrain play a role in memory and learning (Morris, 1988; Shore, 1997). Insult or injury to any of these areas affects its ability to perform its assigned functions.

The brain is made up of seemingly infinite numbers of cellular units, intricately interconnected and engaged in an infinite array of electrochemical activity. It has been reported that during the first week of prenatal development, neurological cells form at a startling rate of 250,000 a minute. At birth, the brain's 100 billion or more neurons and glial cells have formed more than 50 trillion connections or synapses (Sylwester, 1995). This represents a massive interconnecting, or "wiring" process in which neurons grow axons (generally a single long fiber) and dendrites (many short fibers branching out from the neural cell body) that send and receive messages to and from other locations in the brain as critical connections (or synapses) occur.

At the end point of each axon, neurotransmitters—amino acids (e.g., glutamate); monoamines (e.g., dopamine, serotonin); and peptides (e.g., endorphins) are stored in vesicles waiting to be released during a synapse when they travel across synaptic space to communicate with the next neuron (see Figure 3.1). For each chemical there is a matching receptor site on the other side of the synaptic space. Neurotransmitters play a role in regulating or adjusting the sensitivity of portions of the nervous system, exciting or toning down responses and activity levels.

From the embryonic period through the earliest years of a child's development, the brain forms trillions of connections (or synapses), forming a network of astoundingly complex neural pathways in which axons connect with dendrites and chemicals (neurotransmitters) carry impulses across the brains circuitry. Connections that are used repeatedly during the child's daily experiences are reinforced and become part of the brain's permanent wiring. Connections that are

Figure 3.1
Neurons Connecting with
Other Neurons

not used frequently enough, on the other hand, are pruned or rerouted to another compensating or perhaps less appropriate or debilitating connection.

By age three the number of synapses is reported to be twice that of an adult, an enormous number that holds steady throughout the child's first ten years (Shore, 1997). After age ten, synapse density gradually declines, and by adolescence, the brain has discarded about half of the synapses that were present in the early years. Thereafter, and throughout life, the brain continually and actively produces and eliminates synapses. The brain's pruning process is based on a "use it or lose it" system. Positive and negative experiences during early childhood determine how that child's brain will function as an adolescent and adult. How well a child (and later adolescent and adult) can think and learn, respond to stress, and control emotions depends on this early wiring process.

The brain's neurological development depends on specific types of experiences during certain developmental time periods (or "windows of opportunity"). The first three years are critical and until about age ten, the brain continues to create sophisticated neurological connections (Caine & Caine, 1994; 1997; Shore, 1997; Sylwester, 1995). Table 3.1 illustrates the windows of opportunity for specific types of learning and the experiences associated with facilitating that learning.

Physical/Motor Development

The physical and motor development of young children reveals a great deal about their overall health and neurological integrity. Classroom teachers have not always been trained to observe and assess the health and physical characteristics of young children, though many do, either intuitively or perhaps systematically. Classroom observations should focus on the following:

◆ general health and well-being

◆ height and weight

◆ gross and fine motor coordinations

◆ sensory integrity, particularly vision and hearing

◆ speech development

General Health and Well-Being

Healthy children are robust—energetic, alert, enthusiastic, and playful. Observable characteristics of overall good health include strong and well-coordinated motor abilities; bright, clear eyes; acute hearing; soft, smooth skin; lustrous hair; sturdy fingernails and toenails; clean, strong, and decay-free teeth; and relative freedom from allergies and disease. Healthy children have been immunized against common communicable diseases and receive regular pediatric health examinations. Healthy children have developed age-appropriate personal habits of cleanliness. Healthy children play hard, sleep well, have good appetites

(though, as with adults, they exhibit specific food preferences and aversions), and generally are better equipped to handle excitement or stress. Healthy children are also better equipped to benefit optimally from education experiences.

Absenteeism is a sign of frequent or chronic illness or accidents. Absenteeism can also be symptomatic of child abuse or neglect. Teachers should pay attention to the attendance profiles of children who are frequently absent, and follow school or district policies in obtaining professional health care consultation or child protective services, if needed.

Teachers should make a habit of observing for general health characteristics in individual students and be prepared to help children and families pursue profes-

Table 3.1
Windows of Opportunity in Early Brain Growth and Neurological Development

Age	Developmental Domain	Essential Experiences
0-2	Social Attachment	Consistency of care that is warm, nurturing, and predictable. Gentle, loving, dependable relationship with one or more primary caregivers. Immediate attention to physiological needs for nourishment, elimination, cleanliness, warmth, and exercise and attention to discomforts and symptoms of illness, and to psychological needs for comforting and enjoyable interactions.
0-3	Control of Emotions/ Ability to Cope with Stress	Age- and individually-appropriate expectations. Responsive and empathic adults who understand and relate in positive and accepting ways to the child's unique personality traits, including play preferences, styles of interacting, expressions of emotion and moods. Assistance and coaching in understanding and learning to modulate emotions. Instructive, constructive guidance that teaches alternatives rather than punishes. Psychologically safe (nonthreatening and free of stress) interactions with adults. Playful engagement with others, both adults and children.
0-2	Vision	Early and regular vision examinations by professionals. Varied and interesting visual fields accompanied by verbal interactions that label and describe. Toys and personal belongings that enlist interest in color, shape, texture, size, movement, and other qualities.
0-5	Motor Development	Opportunities to use emerging muscle coordinations in a safe and encouraging environment. Play equipment and toys that engage both large and small muscles. Encouragement and positive feedback for physical/motor effort.
0-3	Vocabulary	Enriched and engaging verbal interactions: singing, talking, chanting, sharing picture books, stories, tales, poetry. Interactions that label and describe objects and experiences as they occur. Social interactions that encourage all efforts to communicate and provide responsive feedback. Opportunities to pretend play and to both watch and interact with other young children.

(continues)

Table 3.1, *continued*

Age	Developmental Domain	Essential Experiences
0-10	Language	Enriched and engaging conversations that explore a variety of topics and employ interesting vocabulary, expressions, inflections, and sentence structures. Many and varied firsthand experiences. Social interactions with other children. Positive encouragement and focused responses and feedback for all attempts to communicate: speaking, listening, writing. Varied and interesting experiences with good literature, music, poetry, and drama.
0-10	Second Language	Focused and responsive verbal interactions in both native and second languages. Verbal interactions that label, describe, and extend opportunities to use language. Encouragement and positive feedback for all efforts to communicate, verbally and in writing. Opportunities to interact and converse with others who speak the second language. Shared stories, songs, dance, and other cultural artifacts and traditions.
1-5	Mathematical and Logical Thinking	Daily/weekly schedules and routines that are predictable. Playthings and curriculum materials that encourage mathematical and logical thinking: i.e., manipulatives that can be arranged, rearranged, sorted, grouped, sequenced, counted, and used to create and construct in a variety of ways. Many and varied opportunities to solve "real-life" problems; formulate hypotheses; experiment with solutions; challenge answers. Adult-child interactions that employ inquiry, reason, logic, and analytic thinking.
3-10	Music	Enjoyable and engaging experiences with many types of music and in varied contexts: at rest, during work and play periods. Both shared and privately enjoyed musical experiences: singing and being sung to; rhythm and dance; music and dance programs and special events. Opportunities to explore and learn to play a musical instrument.

sional health care when it is needed. Working with the school nurse or health-care professional, teachers can determine an appropriate course of action for each individual incidence of illness or accident, and for appropriate responses to chronic poor health. Appropriate adaptations of schedules and routines, classroom environments and furnishings, and curriculum and activities can be made when teachers are aware of and sensitive to individual health-related needs. Assessment practices that consider the general health and well-being of children recognize when children are able to do their best work, and when assessments may provide inadequate or incorrect information.

Height and Weight

Children who are at the extremes for their chronological age in height or weight may need further assessment by a health-care professional. Factors such as general health, nutrition, prior or chronic illness, medications, amount and quality of

rest and recreation, psychosocial dynamics at home and in early childhood pro-
grams influence overall health and growth profiles. Generally speaking, healthy
four-year-olds range in height from forty to forty-five inches and gain 2½ to 3½
inches a year until about age six. Weight ranges are much wider among children
from thirty-two to forty-two pounds, gaining four to five pounds a year until
about age six. By age six, children have reached about forty-five inches in height
and will gain two to three inches over the next two or three years. Six-year-olds
range in weight from around forty to fifty pounds and will gain about five
pounds per year for the next three years.

Gross Motor Coordination

Young children usually develop gross motor coordinations before skilled fine motor
control. In fact, children with delayed gross motor development are likely to exhibit
delayed fine motor skills. Observation of gross motor coordination should focus on
posture; balance; eye–foot coordination; rhythm and symmetry of walking, run-
ning, skipping, climbing stairs, and other gross motor movement; flexibility, agility,
strength, and endurance. Other observations can include body awareness (knowl-
edge of one's body and what it can be willed to do), spatial awareness (awareness
of one's body's occupation of space), directionality (understanding of directional
concepts: forward, back, up, down, left, right, and so on), and laterality (an internal
sense of left and right and other directional orientations). When children are less
coordinated or skilled or appear delayed in any of these areas, often simply provid-
ing more opportunities for activities that require the use of large muscles (running,
climbing, dancing, marching, jumping, crawling, rolling, and so on) and games and
activities that engage motor coordinations with spatial and directional thinking
promotes this development. Keep in mind that most children today do not have as
many opportunities to play freely outdoors as did children of the past. They spend
more time in sedentary activities that fail to provide opportunities to coordinate
and strengthen the large muscles and the cardiovascular system. Yet gross motor
integrity is prerequisite to other aspects of growth and development including gen-
eral health and well-being, body awareness, fine motor coordinations, self-image,
self-confidence, social skills, and cognitive development. As such, early identifica-
tion of children with gross motor delays or disabilities is necessary.

Children generally follow a predictable pattern in large motor development
similar to that proposed by Gallahue, (1993):

Reflexive movement phase (prenatal to four months old) in which sensory information
and motor activity are being integrated and cognitively interpreted.

Rudimentary movement phase (birth to two years old) in which certain primitive
reflexes become neurologically inhibited as the brain matures and motor coordina-
tions enter a "precontrol" stage.

Fundamental movement phase (developing from age two to seven) in which basic
motoric stability, locomotion, and manipulation skills emerge.

Specialized movement phase (from age seven to fourteen and up) in which movement
patterns become well integrated, coordinated, mechanically correct, and efficient.

Each of these phases may be described in terms of stages defined as initial, elementary, mature, or (sports skill) advanced. Figure 3.2 illustrates a portion of Gallahue's Fundamental Movement Pattern Assessment Instrument (FMPAI), which is based on this developmental paradigm.

Fine Motor Coordinations

Fine motor coordinations depend on and build on prior development of gross motor coordinations and strength. Observations of fine motor controls should focus on refinement and coordinations of muscles of the extremities which include use of the arms, hand, and fingers, oral motor skills involving the use of the lips, mouth, tongue, facial and jaw muscles, and the muscles of the ankles, feet, and toes. Observation in the classroom should pay particular attention to eye-hand and eye-foot coordinations, prehension, dexterity, and handedness, speech characteristics and facial expressions, and ankle and foot coordinations.

This development is revealed to the teacher by the manner in which children use and construct with a variety of manipulatives and construction materials, such as large and small beads and string, pegs and peg boards, puzzles, small counting objects, building blocks, crayons, pencils, and other art media, keyboarding at the computer, turning the pages of a book, and self-help skills, such as managing clothing, eating, and toileting, and through their speech. Ankle, foot, and toe coordinations are less obvious but may be observed as children participate in movement and dance activities that involve such tasks as pointing toes, shaking feet, rotating or twisting the foot from the ankle, use of the feet to move or retrieve objects that are out of reach, amount of "tripping over their own feet" or other objects, and so on. Fine motor coordinations emerge over time and are encouraged through experiences that require the use of both the larger and smaller muscles of the body.

Sensory Capabilities

The young child uses five senses (vision, hearing, smell, touch, and taste) to receive, interpret, and respond to stimuli in the environment. Pediatric health professionals and early childhood educators pay close attention to the sensory capabilities of young children and recognize that optimal growth and development is influenced by optimal sensory functioning. Early detection of sensory impairments is essential because many are treatable when found during the early stages of growth and development.

There are three important reasons for early detection of hearing and vision impairment: (1) to expeditiously obtain appropriate diagnosis and treatment, (2) to protect the child from psychosocial and learning difficulties or failures, and (3) to avert inappropriate labels (i.e., "behavior problem", "slow learner", "mental retardation") that often occur when children are unsuccessful in school due to vision or hearing impairments. Failure to identify sensory impairments places children at risk for failures in school and in their social interactions, and can skew inferences drawn from assessments of school performance and achievements.

	FUNDAMENTAL MOVEMENT SKILLS TOTAL BODY/CLASS OBSERVATION CHART																								

Class _____ Grade _____ Observer _____

| Mark the proper overall stage rating (I, E, M, S)* for each skill in the space provided.

*I. initial stage
E. elementary stage
M. mature stage
S. sport-skill stage

NAME | STABILITY SKILLS | | | | | | | | LOCOMOTOR SKILLS | | | | | | | | | | MANIPULATIVE SKILLS | | | | | | | |
|---|
| | Static Balance | Dynamic Balance | Body Rolling | Dodging | Springing/Landing | Axial Movements | Inverted Supports | Transitional Supports | Running | Jump for Distance | Jump for Height | Jump from Height | Hopping | Skipping | Sliding | Galloping | Leaping | Climbing | Throwing | Catching | Kicking | Trapping | Dribbling | Volleying | Striking | Ball Rolling |
| |
| |
| |
| |
| |
| |
| |
| |
| |
| |
| |
| |
| |
| |
| |
| |
| |
| |
| |
| |

Figure 3.2

Fundamental Movement Pattern Assessment

Note: From *Developmental Physical Education for Today's Children* (2nd ed., p. 588), by D. L. Gallahue, 1993, Madison, WI: Brown & Benchmark. Copyright 1993 by Brown & Benchmark. Reprinted with permission.

Vision

Vision and hearing are most critical to learning and should be among the first assessments to occur when children enter early childhood programs. Children with potential visual impairment may exhibit one or more of the following symptoms or behaviors:

red or swollen eyelids
squinting
unusual sensitivity to light
tearing or drainage from one or both eyes
excessive blinking or grimacing
eyes that do not track or align properly
frequently rubbing the eyes
complaints of headaches, difficulty seeing, or blurry vision
frequently bumping into objects and people
holding face very close to books or table work
avoiding tasks requiring near visual work
twisting or tilting head to get a better view
closing or covering one eye to view an object
unintentionally intruding on others' "personal space"
awkward and uneven drawing and writing
lack of visual curiosity

Vision assessment with children who do not yet read, who speak another language, or who are mentally challenged usually relies on the Preschool E Chart. For this test, the child stands a distance starting at 40 feet and working down to 20 feet from the chart and—with a card covering one eye, then the other, then neither—tells the examiner which way the "legs on the table" are pointing. The child can point with the hand or entire arm. When children are able to identify letters of the alphabet (around four to six years), their vision can be assessed using the familiar Snellen eye chart. This is the test most often seen in the opthalmologist's office. Following standardized procedures, the child reads the requested lines (which are designated as 200 foot-line, 100 foot-, 70 foot-, and so on) first with one eye covered, then the other, then with neither covered. Vision acuity is always stated as a fraction with the top number representing the distance in feet the child stood from the chart. The bottom number of the fraction represents the last line of the chart that the child could read correctly. The child who is said to have 20/20 vision has read the 20-foot line from 20 feet away. Generally, preschool children who score 20/50 on two screenings, or older children who score 20/40 or worse in one or both eyes should be referred to a physician for corrective care.

Classroom arrangements and teaching strategies can accommodate visually impaired children in some of the following ways:

◆ Provide clear sound-related cues to signal transitions (a musical chord that signals time to put materials away and prepare for lunchtime; a whistle on the

playground that signals time to return to the classroom, a song or verbal directive that signals group assembly time, and so on).

◆ Be certain to use auditory cues consistently and predictably.

◆ Provide the severely visually impaired with a buddy or buddies who assist them in the use of the physical environment and learning materials.

◆ Maintain a stable or fixed physical arrangement of the room with wide traffic pattern spacing to help the children find their way about the room and locate needed learning materials.

◆ Place materials consistently in the same location for easy access.

◆ Pay close attention to the lighting needs of the visually impaired avoiding shadows, glares, or other lighting distractions and providing sufficient light to perform required tasks.

◆ Eliminate clutter and watch for furnishings that can be bumped into or stumbled over.

◆ Create labels and signage in which letters and other symbols are large and clear and can be read by the child who has limited sight.

◆ Enrich the curriculum with activities that use the other senses—hearing, taste, touch, smell, kinesthetics.

◆ Make certain that the pitch of the print of all reading material is large and bold enough to avoid eye strain.

◆ Provide books with large print, even spacing, high contrast, and colorful artwork.

◆ Provide classmate readers to read and share books with the visually impaired learner.

◆ Provide a classmate or classroom aide to describe a video, film, school play, or other visual event being experienced by the class.

◆ Provide magnifying devices in all of the learning centers.

◆ Use descriptive language that positively conveys information to children about their efforts and products.

◆ Make certain the child is strategically seated and has work space that maximizes vision.

◆ Encourage independence, social interaction, and participation and best performance in all activities.

◆ Encourage the students to make their unique needs known.

◆ Foster a sense of respect among all classmates for any specialized equipment the student may use.

Hearing

As with vision, hearing impairment can range from limited to complete. Observing children for potential hearing impairments is critical. Too often, children with hearing loss are presumed to be behavior problems or slow learners because they

do not follow directions well. Frequently, these children are reprimanded or punished for failure to comply, when in fact, they did not hear the instructions. To avoid damaging misdiagnoses, teachers should observe carefully for signs of hearing loss. Children with potential hearing impairments may exhibit one or more of the following symptoms or behaviors:

frequent ear infections
drainage from one or both ears
complaints of ear pain or itching
mouth breathing
unusual speech patterns: faulty pitch, volume, tone, inflections
poor articulation
difficulty with certain speech sounds
monotone speech
communication through gestures
tendency to watch the speaker's mouth
frequent requests for repeated statements
inappropriate responses to questions, directions, or requests
failure to respond when spoken to in a normal voice
tilting or turning head toward sound
inability to hear unless volume on audiovisual equipment is very high
difficulty maintaining physical balance
complaints of dizziness
inattentiveness or daydreaming
frustration experienced in social interactions
feelings of inferiority and social rejection
social withdrawal accompanied by solitary activities

Screening for congenital hearing loss occurs during the neonatal period, and at three to six months of age, other tests both informal (observing infant responses to sound) and formal (using electronic devices) are employed. Audiometric assessment is recommended for children suspected of hearing impairment, and can be administered when children are old enough to indicate that they do or do not hear a sound (age three to four). Audiologists are trained professionals who use specialized techniques and equipment to diagnose hearing impairments. Audiometric assessment should occur at least once during the preschool years (ages three to five), and more often if impairment is suspected. Audiometric assessment provides an initial screen that helps to identify children who need further more specialized assessment or referral to an otologist. Sometimes hearing aids are needed. In severe cases of hearing loss, the child may need to learn sign language and lip-reading techniques. Teachers work with the nurse, speech–language pathologist, and other support professionals in the school to determine services needed for children suspected of hearing impairment.

Inclusive classrooms can meet the needs of hearing impaired children in the following ways:

- ◆ Incorporate into the curriculum instruction for everyone on American Sign Language (ASL) and cued speech techniques (a system of hand cues that facilitates lip-reading (see Boggs, 1990).
- ◆ Speak slowly and clearly, articulating precisely when talking to the child.
- ◆ Bend or kneel to children's face level to speak to them; maintain good eye contact.
- ◆ Use body language and gestures to assist communication.
- ◆ Be consistent in the use of gestures or body language cues used to instruct or give directions.
- ◆ Demonstrate tasks first before expecting the student to carry it out.
- ◆ Enrich the curriculum with activities that use the other senses—vision, taste, touch, smell, kinesthetics.
- ◆ Make certain the child is strategically seated and has work space that maximizes vision and hearing.
- ◆ Enlist the help of buddies or classroom aides who can help the children follow instructions.
- ◆ Use appealing and meaningful visual aids.
- ◆ Allow students to use amplifying devices such as head-sets to listen to recorded stories and to participate in singing and other music or movement activities.
- ◆ Use microphones as appropriate; learn to use and assist the children with their specialized equipment.
- ◆ Foster a sense of respect among all classmates for any specialized equipment a child may need to use.
- ◆ Encourage independence, social interaction, and participation and best performance in all activities.

Speech Development

Children who do not hear well often exhibit unusual speech patterns. Because speech is so closely related to hearing, the manner in which a young child talks often provides the first clue that a hearing impairment exists. Speech is also related to fine motor development involving the control of the tongue and facial muscles that are used to form and produce spoken sounds and words. Generally, a trained professional speech–language pathologist provides early speech screening for young children in public schools. This screening can assist teachers and parents in early identification and the prescription of intervention procedures. Early detection of speech impairments and other communication skills—gestures, facial expressions, nonspeech sounds (e.g., laughter, crying, sighing), writing, and signing—is important because the ability to interact with others depends on being able to communicate in some form. The more success children experience communicating with others, the more likely they are to develop optimally socially, emotionally, cognitively, and academically.

Language Development

While speech is defined as the production of vocal sound patterns, language development has to do with the acquisition and utilization of vocabulary, word meanings, and grammar systems. Language has four components: phonology, syntax, semantics, and pragmatics:

Phonology refers to the rules for the formation of spoken sounds (phonemes) and how these sounds are combined into meaningful units (words).

Syntax is the rule system for grouping words into meaningful phrases and sentences. Syntax rules govern the parts of speech (e.g., noun, adjective, verb), the order in which words flow to make sense, and sentence constituents (e.g., verb and noun phrases).

Semantics refers to the meanings attached to words and derived from the manner in which words are used.

Pragmatics determines how language is used in different contexts. Pragmatics involves understanding the reasons that someone talks (to engage others in pleasant conversation, to make a request, to ask a question) and to understand the elements of discourse, that is, turn-taking in conversation, when to begin, maintain and participate, and end communicative interactions, or simply stated, learning the rules of conversation.

Generally, the acquisition of language follows a predictable pattern similar to the following (Nelson & Lucariello, 1985; Pflaum, 1986):

crying as a means of communication
cooing
accidental and experimental vocalizations
social vocalizations and chuckles
babbling and echolalia
pseudo-language (variations in intonations and expressive jabbers that sound like real conversations except that words are not discernible)
holophrases (one-word sentences, e.g., "more" for "I want more")
telegraphic speech (two- or three-word utterances, e.g., "more juice," "all gone juice")
overgeneralized speech (e.g., "milk" used to refer to all beverages)
undergeneralized speech ("teddy bear" refers to one and only one teddy bear; other teddy bears must be called something else)
acquisition of function words (e.g., prepositions) and suffixes (plurals, "ing", and so on)
use of inflections
conversational turn-taking
use of connectives (*and, then, because, so, if, or,* and *but*)
use of compound and complex sentences

The acquisition of language is integral to cognitive, social, and emotional development. Early diagnosis of language impairment is necessary for optimal

development. Delay in the acquisition of language may signal sensory impairment (as discussed previously), neurological impairment (as with cerebral palsy or autism), social or emotional problems, or mental retardation. An otherwise healthy child whose language skills are noticeably deficient for a particular age may need careful observation and assessment to determine if he or she is "language delayed." Because language development generally follows fairly predictable patterns, observation of the child's use of language and both its quality and quantity helps teachers make this determination and decide if further formal assessments are needed.

Cautiously, we attempt to list the behaviors that suggest delay in language development. We are cautious because unlike vision and hearing, language development is an emergent social interactive process that depends on the quality and quantity of communicative interactions the child experiences from birth. When behaviors persist in spite of opportunities to improve and clusters of symptoms emerge, a reason certainly exists to pursue further assessment and intervention measures. Children whose language may indicate developmental delay exhibit a number of the following symptoms or behaviors:

limited vocabulary
poor listening skills
limited interest in words and word meanings
hesitancy in talking or initiating conversations
halting or very soft speech
incomplete sentences and one-word utterances to communicate
unusual word order in sentences
numerous and unusual grammatical errors
frequently misunderstands what others are saying
are themselves frequently misunderstood
may prefer solitary play
may avoid sociodramatic play or group games
may over-rely on gestures, nodding, shaking head, "I-don't-know"-shoulder
 lift, and other nonverbal modes of communication
difficulty engaging in sustained talk
frequently uses nonword utterances (*uh-uh, hmm,* and so on)
infrequently uses questions
uses few descriptive words
difficulty classifying and labeling
difficulty following more than one or two oral directions at a time
difficulty retelling a familiar story
difficulty discriminating between words with similar sounds or similar meanings
difficulty with complete-the-sentence activities during story reading
difficulty sequencing a story
failure to catch a joke or understand and solve a riddle
difficulty recalling or memorizing such information as own address, telephone
 number, parent's full name, place of work, and so on.

limited interest in reading
difficulty dictating phrases, sentences, or stories
avoidance of creative writing activities

Educators must be particularly cautious in identifying speech and language impairments because language has numerous idiosyncrasies. Primary among these variations is the influence of each child's individual cultural background. To understand and assess language development in children, it is essential for educators to be sensitive to the social, cultural, ethnic and linguistic characteristics of students and their families. We should be reminded that the language of the home is the one in which young children begin to make meaning of their experiences and construct knowledge. As well, the language of the home influences the development of social interaction skills. For children whose home language differs from that of the school, language development means acquisition of two (or possibly more) languages. This development poses unique challenges for children, parents, and teachers.

Teachers must keep in mind that negotiating transitions between home and school language expectations is not an easy task for children, for they are having to adapt to different (often competing and contradictory) sets of language rules, as well as academic and behavior expectations. We must also recognize individual differences in the way non-English speaking children acquire English. For instance, some children have been found to go through a "silent period" lasting six or more months in which their own language rests in a "holding pattern" while they acquire English. Other children may mix languages during the learning process and use sentences composed of words from each language. As with all development, each child acquires language proficiency in one or more languages at individual rates and in individual ways.

Some evidence exists that learning one or more additional languages may be easier for younger than older children. Contemporary brain development research suggests that learning a second language along with the first is relatively easy for very young children. The brain develops auditory maps in which a sound that is heard over and over causes neurons from the ear to stimulate the formation of dedicated neurological connections in the brain's auditory cortex. After a while the child loses the ability to discriminate and produce sounds that are not repeated in the language(s) they hear. Once these perceptual maps are formed, the map for one language constrains the learning of another language; hence, it is easy to explain why after about age ten, it becomes more and more difficult to acquire another language and to be able to speak it as the native might (Kuhl, 1994; Kuhl & Meltzoff, 1996).

This new information on early language development has implications for both teaching practices and assessment. It would seem that providing young children rich linguistic environments in which opportunities exist to learn more than one language during the early years is preferable to monolinguistic programs that force children to learn only one language, or pull-out programs in which an identified few are provided tutelage in the mainstream language outside the context

of the regular classroom, and delaying foreign language instruction until the upper grades. We will discuss this topic in greater detail in Chapter 4.

Children with special needs who also have limited English proficiency pose additional challenges. With these children, it is important to make the distinction between communication difficulties associated with the child's particular impairment and the idiosyncratic nature of the child's native language. For the teacher who speaks only English, in addition to consultation with the school's speech–language specialist, collaboration with another teacher or professional who speaks the child's language and with the child's family can initiate the assessment process and assist the teacher in making these necessary distinctions.

In addition, teachers must be sensitive to the norms and language expectations of diverse language communities (Nelson, 1993). Vernacular and dialectical uniqueness exists in all language communities. For children to succeed in school while progressing toward efficient use of Standard American English (SAE), all assessments of language development need to be bias-free. Teachers will need to determine the family's perspective on their child's ways of communicating, observe other members of a particular cultural group, learn from adults who use (or are familiar with) a particular dialect, engage in contextualized observation, and use toys and materials that are culturally appropriate to assist in nonbiased assessment (McLean, Bailey, & Wolery, 1996). As McLean et al. point out, because most standardized tests are normed on the basis of Standardized American English, they are not designed to provide information that is helpful in planning curriculums to enhance language development. Neither is it helpful for determining speech or language intervention needs of children whose primary language is other than English. Assessments that describe how children of diverse cultures and languages actually use language to communicate are preferable. Again, this topic will be discussed more fully in Chapter 4.

Cognitive Development: Piaget's Perspective

Long before children enter early childhood education programs they have been demonstrating an enormous capacity for learning. Their learning is influenced by their genetic makeup; overall physical health and neurological integrity; early attachments and bonding relationships; temperaments; cultural background; experiences and experiential contexts; individual learning styles; and unique intellectual interests and strengths. Cognition involves perception, attention, thinking, memory, problem solving, creativity, and language. Educators rely on the studies of cognitive scientists, brain growth and neurological development research, and classical theories to explain this very complex process of learning and knowing.

Perhaps the most influential body of work regarding how intellectual development emerges is that of Swiss psychologist Jean Piaget. Through his work, educators have come to accept the notion that both heredity and environment influence cognitive development through an interactive process emerging in predictable stages during which the child internally forms concepts and constructs meaning (Piaget, 1952). Piaget's work has been instrumental in impressing on us the fact

that the manner in which young children think, process information, and solve problems is unique and quite different from that of older children and adults.

Piaget's theory of cognitive development describes predictable sequences beginning at birth in which the child forms schema—mental structures by which information is cognitively organized and structured—through sensory and motor activity while in infancy and later through more purposeful interactions with objects. As the child gets older, entering the preschool years and into the early elementary years, knowledge increases as the child is involved in meaningful firsthand experiences, manipulates objects, and interacts with other children and adults. Thinking for the most part, is egocentric and perception-bound. In later childhood, cognitive development is characterized by increasing ability to formulate and test hypotheses, to reason and to employ logic. According to Piaget, young thinkers are constantly mentally organizing and reorganizing their schemata into higher-order mental structures and adapting them to the demands of their environments. Cognitive adaptation is characterized by two processes—*assimilation* and *accommodation*—in which new information and experiences alter or modify existing schema.

The complementary processes of assimilation and accommodation are said to bring about a state of cognitive equilibrium, though this state is short-lived because the learner is constantly being confronted with new information and new experiences, each requiring adaptations. New information, particularly when it contradicts existing schema, results in cognitive disequilibrium and a state often referred to as cognitive dissonance. Cognitive dissonance causes the learner to question (or affirm) currently held notions, and to reconstruct (or reinforce) existing schema. Creating learning situations in which cognitive dissonance occurs causes the learner to pursue further information through questioning and additional explorations and to construct new concepts and meanings. For instance, when young children begin to learn the value of monetary coins, cognitive dissonance often occurs when they learn that the dime, which is smaller than the nickel, actually represents a larger amount of money. Having been perception-bound with size and weight representing hierarchical dimensions, the notion that the smaller coin represents more and not less results in cognitive dissonance. At this opportune moment, activities that involve the use of money (toy or real) in realistic and meaningful ways can advance cognition. Constructivist approaches to curricula provide the catalysts, materials, inquiring dialogue, and meaningful feedback that encourage learners to resolve these cognitive dilemmas.

In terms of assessment practices, Piaget's theory is instructive in that systematic observation of the manner in which children interact with objects and people in the environment, the extent to which they use their sensory capabilities and their motoric abilities to obtain information, and the extent to which they benefit from concrete, firsthand, semiconcrete, or abstract experiences provides critical information about a child's emerging cognitive development. The constructivist approach to curriculum and teaching provides the backdrop for such observations.

In the constructivist classroom, as children become cognitively engaged in their work in learning centers, as they socialize and use language to interact with other

children and with adults, their actions and behaviors provide critical information about their understandings, capabilities, and needs. Keen and focused observation in this context provides authentic information about the individual's current performance, abilities, and progress. Such observation informs curriculum and concentrates its planning on the needs of learners; as such, the curriculum and pedagogy become holistic and child-centered, attending to many developmental domains as well as subject matter or content learning. Both individual and class goals evolve from information derived from this type of observation and assessment.

Cognitive Development: Vygotsky's Perspective

Another theorist whose work has been quite influential in education and assessment in recent years is that of Lev Vygotsky (1936/1962). As introduced in Chapter 1, Vygotsky's study of early cognitive development provided a sociocultural perspective on how children grow, develop, and learn. While Piaget portrayed learners as constructing meaning primarily through their own actions on the environment, Vygotsky emphasized the need to know about and understand the social conditions surrounding the learner. Vygotsky also emphasized the importance of language to cognitive development, demonstrating that when children are provided words and labels they form concepts more readily. He believed that thought and language converge into meaningful concepts and this in turn enhances the thinking process. Vygotsky emphasized the following:

◆ Mental functions vary across cultures due to wide variations in activities that individual cultures emphasize and the tools that they use. ("Tools" refers to a variety of representational systems such as art, systems for counting, writing, diagrams, maps, and most importantly, language.)

◆ To truly understand human behavior we must know how it is formed developmentally.

◆ Child development takes place along two distinct lines, the natural (biological growth and maturation of physical and mental structures) and the cultural line (the use of cultural tools and the stream of consciousness which emerges from participation in cultural activity).

◆ Mental activity can be divided into lower (those mental functions that are shared with other mammalian species) and higher mental functions (those mental functions that are uniquely human, e.g., language, self-esteem).

◆ A general genetic law of cultural development suggests that higher mental functions appear on a social (or interpersonal) plane and then on an individual (or psychological plane) as social experiences become internalized.

◆ Language is instrumental in structuring and restructuring the mind and in forming higher-order, self-regulated thought processes.

◆ Formal education and other cultural forms of socialization are essential in leading the individual toward adulthood.

◆ A zone of proximal development (ZPD), a hypothetical region in which learn-
 ing and development occur. It is the distance between that which a child can
 do independently and that which he or she can do with the help of an adult or
 more competent member of the culture (Berk & Winsler (1995).

As a result of Vygotsky's work, educators now acknowledge that social and
cognitive development are essential partners in the learning process. Knowledge
of growth and development is meaningful only when it is derived from the social
and cultural contexts of individual lives. Further, assessment practices take into
consideration the fact that cognitive functioning is initially created through a
socially interactive or collaborative activity, and becomes internalized thereafter.
Scaffolding, the act of collaborating with children to assist and facilitate their
learning is an essential piece of the cognitive process, and it is during scaffolding
encounters, that educators are best able to ascertain what it is that children know
and can do. Scaffolding activities, then, are essential to authentic assessment.

Scaffolding provides the educator an opportunity to determine the types of
cognitive difficulties (misperceptions, misunderstandings, insufficient prior
knowledge, and so on) that children experience as they perform a particular task.
For instance, a child attempting to build a road bridge with the unit blocks
encounters a failure of the blocks to balance on their pillars, becomes frustrated,

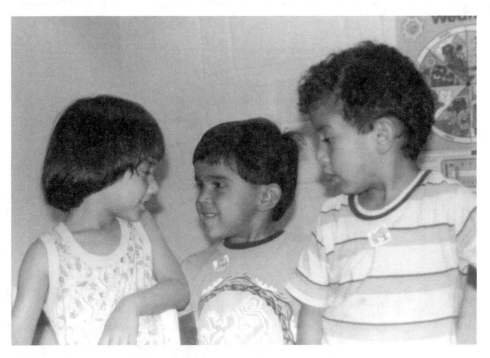

*Authentic assessment requires an understanding of the unique ways children use lan-
guage to communicate with others.*

and exclaims, "I can't do this." The adult can scaffold by guiding the activity with questions such as, "How long is your block that will make the bridge? Are the pillars close enough to one another to hold the bridge block? Do the pillars need to be the same height? What would happen if you tried a different type of pillar? Have you tried a different block for the bridge? What would happen if we. . . . ?" and so on. In scaffolding, the learner and the scaffolder enter into a collaborative effort to solve the problem with the learner being challenged to experiment with a variety of options and the adult observing carefully while staying involved just within the child's zone of proximal development. The scaffolder does not simply supply answers or solve the problem.

Substantial research supports the effectiveness of learning that occurs in meaningful, collaborative interactions such as those between adults and children and children and their classmates. Educators have few explicit guidelines, however, for scaffolding the learning of children. Berk and Winsler (1995) offer a helpful list of the components and goals of effective scaffolding:

joint problem solving
intersubjectivity
warmth and responsiveness
keeping the child in the ZPD
promoting self-regulation

Joint problem-solving activities result in shared cognition as learner and scaffolder test, challenge, and debate their possible solutions. Intersubjectivity refers to the process in which two or more collaborating learners with different perspectives and understandings about a task arrive at shared understanding. Through collaboration, the learners find common understandings and may adjust their thinking to accommodate another's perspective. Warmth and responsiveness are always essential ingredients in the scaffolding process, and as we shall see later in this chapter, new research stresses its positive influences on neurological development. The emotional tone of the learning environment and the social interactions in which children are engaged support or impede the learning process. Staying within the child's zone of proximal development (ZPD) involves two processes (Berk & Winsler, 1995): (1) structuring the environment and the task(s) so that the demands on the learner are appropriately challenging, and (2) constantly adjusting the amount of adult intervention to the child's emerging needs and abilities (p. 29).

Self-regulation emerges when children are allowed to take the lead as much as possible in the resolution of a problem or completion of a task. This means letting the learner struggle a bit before intervening, and intervening only when the child is truly stuck. Intervention should not simply provide the learner the answers, but should encourage and engage the child in the discovery of solutions through a scaffolding process.

The role of language in cognitive development is particularly prominent in Vygotsky's theory. He pointed out that language shapes mental functioning and referred to language as a "tool of the mind." (Vygotsky, 1930–1935/1978) Vygotsky

believed that talking to oneself (that is particularly characteristic of children under age 7), is essential "inner speech" that guides the child's thinking, problem-solving, and internalization of new information. Vygotsky also believed that the central purpose of language is to communicate to another which encourages social contact and interaction. In social contexts, language becomes both an internal organizer of thought and an external source of information as the individual constructs concepts and reality from interactions with parents, teachers, classmates, and the community or society through which culture is transmitted.

Classrooms in which oral language is valued and where children are provided various opportunities to discuss, dialogue, and debate, with one another and with adults, where it is psychologically safe to ask questions and even challenge the teacher's points of view, where children work in small cooperative groupings and in pairs, and are cognitively *and* socially involved in engaging projects, provide the impetus for the higher mental functioning about which Vygotsky wrote. In these classrooms, the sociocultural context provides a dynamic set of determinants to individual learning and academic achievement. Good teaching strategies facilitate and encourage social interaction and talking.

There is an additional advantage to facilitating learning through social interaction. Assessment practices can focus not only on developmental and academic achievements, but also on the contexts that support or impede development and achievement. In such a paradigm, both the individual and the corporate culture of the class are taken into consideration when assessing student performance and progress. By observing and assessing student performance in a socially interactive context, educators can derive enormous information about what students understand, how they are processing information, how they are using what they know to complete assigned tasks or to scaffold the learning of a fellow classmate, their facility with language, their learning styles, and their social and moral competence. By the same token, assessing the context in which learning is taking place, educators can evaluate and alter the teaching/learning strategies and physical and social environment to facilitate optimum learning.

Cognitive Development: Gardner's Multiple Intelligences Theory

Adding to our understanding of cognitive development is Gardner's multiple intelligence theory (1983, 1991a, 1993a, 1993b, 1998) in which he defines intelligence as the ability to solve problems or to create products that are valued in one or more cultural settings. Gardner proposes that there are multiple forms of intelligence. In his book *Frames of Mind* (1983), he outlined seven separate intelligences, and later he added an eighth intelligence (1997). Gardner suggests that human beings have several or all of these eight intelligences, but each of us is unique in the strength we possess in each intelligence area. As well, individuals do not have the same amalgam of intelligences. This view of intelligence is far more encompassing than the limited concept of IQ (intelligence quotient) that has dominated traditional thinking for decades.

Gardner's definition of intelligence challenges traditional assumptions that intelligence depends on genetically predetermined characteristics that are fixed and relatively unalterable, and can be measured by standardized tests. He states, "The standard view of intelligence is that intelligence is something you are born with; you have only a certain amount of it; you cannot do much about how much of that intelligence you have; and tests exist that can tell you how smart you are. The theory of multiple intelligences challenges that view. It asks, instead, 'Given what we know about the brain, evolution, and the difference in cultures, what are the sets of human abilities we all share?' " (Checkley, 1997, p. 9). Gardner's proposed eight intelligences and the manner in which these intelligences are expressed in children and adults are as follows:

1. *Linguistic intelligence* includes sensitivity to meaning, order, sounds, rhythms, and inflections of words. Children who exhibit this type of intelligence listen intently to the words of others, enjoy engaged conversation, playing games with words, creating stories, rhymes, songs, nonsense phrases and sentences, and puns and riddles. These children may spin tall tales, ask many questions, seek adult conversation, and play out unusually rich and elaborate sociodramatic themes. They are creative and expressive writers and usually have exceptional ability to remember names and places and to colorfully and cleverly describe events and personal experiences. This intelligence is characteristic of authors, poets, orators, politicians, commentators, and drama and literary critics.

2. *Musical intelligence* is described as an exceptional awareness of pitch, rhythm, and timbre. According to Gardner, this intelligence can often be observed in infancy when as well as babbling, the infant/toddler formulates musiclike sounds, prosodic patterns and tones, and imitates patterns and tones sung by others with some degree of accuracy. Children with musical intelligence enjoy singing and being sung to; remember and repeat songs and rhythms; often hum, chant, or sing to themselves; are curious about and enjoy experimenting with musical instruments; are often eager to master one or more musical instruments; and are sensitive to sounds in their environment. This intelligence is characteristic of composers and song writers, professional singers, instrumentalists, orchestra and band leaders, orchestrators, and sound-track specialists.

3. *Logical–mathematical intelligence* consists of the abilities to attend to patterns, categories, and relationships. Children with logical-mathematical intelligence have the ability to sort, classify, reason, form logical patterns and relationships, discover analogies, develop hypotheses, infer, calculate, and use numbers effectively. They enjoy activities that involve using numbers, counting, grouping, classifying, ordering, measuring, and estimating. These children ask many questions and enjoy "what if" and "if/then" problems, and analyses of wholes and parts. This type of intelligence is characteristic of scientists, mathematicians, and logicians.

4. *Spatial intelligence* includes exceptional visual perception, the ability to transform one's perception of visual stimuli, and the ability to reconstruct compo-

nents of these perceptions with the removal of the visual stimuli. Children with this intelligence are keenly aware of color, shape, line and form, and can visualize spatial configurations and ideas. They have a good sense of direction and distance, pay close attention to pattern and are often as intrigued by the pictures or types and spaces of print in a book as they are with the story itself. This intelligence is characteristic of interior designers, track and field athletes, golfers, choreographers, stage set designers, architects, and anthropologists.

5. *Bodily kinesthetic* intelligence relates to the capacities of directing one's bodily motions and manipulating objects in a skillful fashion. It is characterized by refined large and fine motor coordinations; balance; agility; strength; speed; dexterity; and expressive, interpretive body language. Children exhibit this intelligence through their interest and skill in rhythm and movement activities, interpretive dance, finger plays, puppetry, mime, use of the balance

Knowing children's learning styles and frames of mind helps teachers facilitate the learning potential of the children and obtain more accurate and authentic assessments.

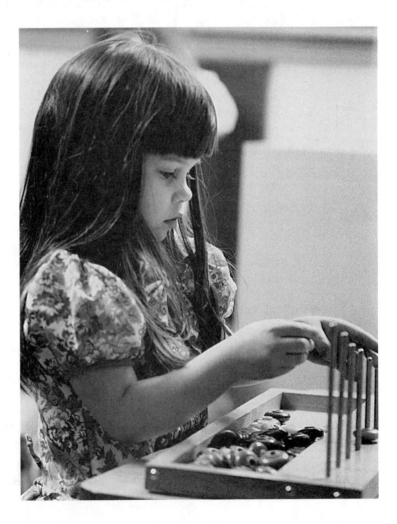

beam and other sports equipment that requires precise movement or coordinations, obstacle courses, swimming, and follow the leader activities. These children tend to be more "fidgety" than others, tapping their fingers, clapping their hands, and rocking about in their chairs. Dancers, tennis players, gymnasts, mimes, surgeons, and mechanics are examples of individuals who possess this intelligence.

6. *Interpersonal intelligence* pertains to the capacity to recognize distinctions among others' feelings, moods, temperaments, motivations, and intentions. Individuals with this intelligence are sensitive to and respond appropriately to facial expressions, tone of voice, and body language. Children with this intelligence are sociable, enjoy the company of others, make friends easily, and are loyal friends themselves. They are skilled in negotiating and conflict resolution, and are usually popular among their peers. These children easily accept guidance when it is just and reasonable, and are keenly aware of injustices to self and others. They enjoy being helpful. Skilled parents, counselors, ministers, and teachers have this intelligence.

7. *Intrapersonal intelligence* involves the ability to access and understand one's own feelings and range of emotions. It is the capacity to discriminate among and label a variety of complex sets of feelings, and to use this discrimination to understand and guide one's own behaviors. Intrapersonal intelligence is demonstrated by the ability to adapt thinking and behavior on the basis of one's own strengths, limitations, moods, temperaments, desires, motivations, and intentions. Children with this intelligence have high self-esteem, a good sense of autonomy, are reasonably self-disciplined, and show aspirations commensurate with their current capabilities. They verbalize their feelings well. These children are introspective and happy with their own company, though they make pleasant companions to others. They know when and how to remove themselves from situations that evoke unpleasant emotions. They enjoy hobbies and often prefer to study independently, but enjoy interacting with and helping others. The "community sage" comes to mind as an individual who possesses this intelligence, but also, counselors, child psychologists, religious leaders, psychotherapists, and perhaps, novelists who can skillfully describe the inner feelings of their characters.

8. *Naturalistic intelligence* concerns the ability to classify nature by recognizing critical distinctions in the natural world among plants, minerals, and animals. This includes the ability to differentiate between ecological, geographic, topological, and anthropological characteristics and phenomena and changes that affect the life and growth of plants and animals, and hence, enhance or impede the capacities of the human organism. Children with this intelligence show an early interest in natural phenomena, bugs and "crawly things," identification, care, and nurture of animals of all sorts, weather phenomena, seeds and plants, trees and their leaves, bark, berries, and so on. Depending on the types of exposures and experiences they have had, they may show an interest in activities associated with astronomy, oceanography, forestry, farming,

health, and physiology. They enjoy describing and classifying natural phe-
nomena and making distinctions between the natural and the unnatural. Indi-
viduals who have this type of intelligence include botanists, anthropologists,
geologists, astronomers, oceanographers, space scientists, physical therapists,
culinary artists and chefs, and members of farming and hunting cultures.

If curricula and assessments are to serve all children well, the acknowledgment
of individual intelligences seems particularly salient. If we recognize that societies
depend on many and varied skills and numerous bodies of knowledge, then we
appreciate more fully the need for integrated and emergent curriculums that can
address many topics, skills, and intellectual proclivities. Certainly, reading, writ-
ing, and arithmetic are important to every student, but only to the extent that
these academic subjects are mastered in such a way as to serve as cognitive tools
for growing and becoming experts in valued areas of intellectual strengths.
Authentic assessment supports this perspective by providing many opportunities
for educators to identify each student's strengths and then plan enriching, inte-
grated curricula that supports many forms of intelligence. Such curriculum and
assessment strengthens learning opportunities for all children while respecting
the proclivities of the individual.

When instruction and assessment focus heavily on the linguistic and mathe-
matical intelligences with little regard for the other six intelligences, which is
common in classrooms today, we run the risk of disenfranchising many learners.
In these situations, children with other dominant intelligences often struggle to
perform, may be negatively labeled ("delayed", "learning disabled", "noncompli-
ant", "bored"), and are likely to develop negative self-concepts and feelings of
incompetence. These children often become classroom behavior problems, lose
interest in learning, and become at risk for dropping out of school. Moreover,
contemporary brain development research suggests that in the earliest grades, we
run the risk of neurological *downshifting* in which synapses between neurons fail
to occur, and if not appropriately stimulated these connections simply do not
grow or the connections that were present may be pruned from lack of use,
resulting in a learner who will not reach optimal development. With this new
knowledge about brain growth and neurological development, the moral impera-
tive of sensitive teaching strategies is unequivocal. Curriculum should never be
too narrowly focused.

Differences in Learning Styles

In recent years, as we have become more aware of the myriad determinants of
learning and academic achievement, scholars have examined a variety of individ-
ual developmental and cultural characteristics that influence learning. We also
have paid closer attention to the elements in the teaching/learning environment
that support or impede student success. According to Dunn, Beaudry, and Klavas
(1989), every child (and adult) has a learning style or individual variation in pre-
ferred modalities of learning. Learning style behaviors include individualistic

responses to sound, light, temperature, design, perception, intake, mobility needs, and persistence. It is thought that these learning styles may be biologically determined. Other learning styles exist, such as motivation, responsibility (conformity), and the need for structure. These styles are thought to evolve over time and are influenced by levels of development and types of experiences children have had.

Knowing about learning styles and how they are manifested during the teaching–learning process guides teachers in developing classroom environments that facilitate and support learning for all children. With this type of integral support for learning, assessment can be based on characteristics more accurately revealed by the learner. Thus teachers of young children provide both quiet and sound-supported learning environments, bright and soft lighting, and seating arrangements that respect needs for mobility and grouping preferences. In addition, teachers create many opportunities for children to use preferred sensory and communicative modalities, movement, singing, listening, talking, watching, envisioning, manipulating, tasting, smelling, and so on. Children are also offered a variety of self-selected or self-initiated experiences that address their preferred learning styles with respect to single or multiple activities, degrees of structure, and preferences for group or independent work.

Interestingly, almost two-thirds of elementary school children prefer learning late in the morning or afternoon and actually do learn better during these times. This information implies that teachers need to provide various learning experiences throughout the school day rather than focus on particular subjects during certain time slots. For example, rather than teach reading and math at the beginning of every school day, teachers should vary the schedule so that the children have the opportunity to experience each subject during their optimum learning times. Dunn and Dunn (1987) report that when teachers organize their classrooms to provide for children's learning styles, evidence of increased achievement and positive behavior begin to appear in as little as six weeks. Research on learning styles supports child development information regarding both age-appropriate and individually appropriate aspects of developmentally appropriate practice.

Psychosocial Development

In Chapter 1, we introduced you to Erikson's (1950) first four stages of healthy psychosocial development, (1) trust vs. mistrust, (2) autonomy vs. doubt, (3) initiative vs. guilt, and (4) industry vs. inferiority. Think of these polar opposites as resting on a balance scale in which the desired outcomes of early growth and development would tip the scales toward the more positive characteristics. Certainly, it is more desirable for children to grow up having a sense of basic trust in themselves as competent and effective individuals than to become insecure, distrusting, perhaps cynical personalities. Likewise, self-governing individuals who can make decisions based on their own emerging sense of right and wrong rather than on the coercive, power-assertive, or peer- pressured wishes of others is far more desirable than those who doubt their intuitions and ability to make reasoned choices. The ability to see tasks to be accomplished and to proceed with

them rather than relying on the permissions and directions of others is far more productive than a fear of reprimand, embarrassment, or failure so intense that taking the initiative is left to others. The desires to know, know how, and to do well are traits far more self-fulfilling and success-oriented than feelings of incompetence, reluctance, and perhaps rejection of diverse experiences and new knowledge. Hence, we can readily see that the development of healthy personalities is an important goal for early education.

Helping children to navigate the psychosocial challenges of the earliest years reasonably well means setting goals that focus on healthy personality outcomes. We can envision an individual who as a result of appropriately nurturing and supportive psychosocial interactions during childhood displays some or all of the following characteristics (Puckett & Diffily, 1999):

◆ realistic self concept, self-acceptance, and positive self-regard
◆ positive regard and acceptance of others
◆ loves and accepts the love of others

Providing opportunities for children to learn in groups can trigger learning that might not occur individually.

◆ emotional intelligence demonstrated through self-understanding, constructive expression of emotions, and empathic understanding of the emotions of others

◆ successful and constructive interrelationships with others

◆ prosocial values orientation and behaviors which include empathy, altruism, generosity, cooperation, moral competence, and effective conflict resolution skills

◆ ability to postpone immediate gratification in favor of ongoing responsibilities and long-term goals

◆ sufficient independence and confidence to project and plan for one's own well being and the safety, care, and well-being of others

◆ a personality free of biases and anti-social behaviors

◆ a democratic orientation to individual responsibilities, group behaviors, and issues of fairness and justice.

Obviously, young children do not display this level of social and emotional maturity. However, elements of each of these qualities can be observed in very young children in emergent forms as they experience socially supportive interactions with adults and playmates. Keeping in mind such long-term goals for psychosocial development, educators develop a classroom dynamic that helps children progress toward them. Adults who support healthy psychosocial development display these mature forms of psychosocial development themselves. Education practices which support healthy psychosocial development are characterized by interactions between adults and children that:

◆ are psychologically sound, caring, stress-free, and supportive.

◆ demonstrate acceptance and appreciation for diversity and individuality.

◆ demonstrate respect through all words and deeds.

◆ employ guidance techniques that teach rather than punish; are authoritative and reasoned, and are structured to bring about intelligent self-control rather than blind obedience.

◆ encourage positive, mutually supportive social interactions among children.

◆ demonstrate constructive conflict resolution.

◆ set individual and age-appropriate expectations for behaviors and achievements.

◆ facilitate productive, constructive play among children.

◆ understand the young child's continuing need for security, protection, and affirmation.

Integral to the previous discussion is the importance of the young child's emerging sense of self, which includes feelings associated with self-concept, self-acceptance, and sense of self-efficacy. *Self-concept* refers to children's overall sense of their physical characteristics, abilities, and personality characteristics. Children's self-concept grows out of the way others respond to their needs, emerging

and mastered capabilities and personal interests, and their attempts at interpersonal interactions. Children reveal aspects of their self-concept when they do things such as:

admire themselves in the mirror

approach a difficult task and exclaim, "I can do it!"

proudly display a writing sample or drawing on the front of their cubby or the bulletin board

share recent photographs of themselves and proudly describe the features and activities in the photo

talk about attempts to help younger siblings put on their shoes or pour a cup of milk

generally describe themselves and their abilities in proud and positive terms.

The extent to which these happy revelations are greeted with positive, affirmative feedback determines the extent to which self-acceptance emerges and becomes seated in the personality. Children reveal *positive self-acceptance* when they say things such as, "I can't do that, but it's okay. Because I'm not big enough yet. Someday, I can do that, okay?" "My mommy says that boys and girls with brown hair are very pretty; I think my hair is pretty. Your hair is brown like mine." "It's okay to be mad (sad, silly) sometimes." "We don't do that at our house because my daddy says it is not right." "I like to skip, but I don't like that 'Hockey-Pockey' song." "It's okay, boys can play with dolls, too." "I don't care if you call me a bad name." Statements such as these reveal an emerging sense of autonomy coupled with a growing sense that to be true to one's own feelings and capabilities is acceptable to self and others. Self-acceptance undergirds a "can do" mentality and helps children meet challenges and setbacks with greater aplomb.

With strong and positive self-regard which is supported through psychologically sound interactions between children and adults, children can grow into a sense of self-efficacy (Bandura, 1977; Schunk, 1990, 1991). *Self-efficacy* is the feeling that what one does matters. It is the sense that one can do what one sets out to do, and that others appreciate both efforts and accomplishments. Mistakes are often viewed as a necessary step toward accomplishing some goal or end product. Children with a sense of self-efficacy show higher levels of trust, autonomy, initiative, and industry; are more willing to take social and intellectual risks; enjoy challenges; and are not set back by minor mistakes or failures. As children get older, self-efficacy becomes domain specific—that is, children can have high levels of self-efficacy in mathematics, but perhaps not so in creative writing. According to Schunk (1990, 1991), self-efficacy is reinforced through (1) social models, (2) the opinions of others, and (3) consistent specific feedback for efforts. Of the three, Schunk suggests that specific feedback for efforts has the greatest impact on learners. This of course, has particular implications for authentic assessment.

It is not difficult to identify children with negative self-concepts, shaky self-acceptance, and an inadequate sense of efficacy. Often these children speak of themselves in disparaging ways, are less inclined to call attention to their accom-

plishments no matter how worthy, fear risks and mistakes, become low achievers, have difficulty in interpersonal relationships, sometimes becoming withdrawn and lonely or the bully, tease, or social dropout. They may taunt those who take their work seriously. The long-range consequences of unchecked low self-esteem can be quite serious, leading to loss of interest in learning and social interactions, perhaps, later school drop-out, and in some cases, cynical and asocial or anti-social behaviors.

Studies of brain growth and neurological development are quite pointed on this topic (Caine & Caine, 1994; Shore, 1997; Sylwester, 1995, 1997, 1998). Mounting evidence suggests that the brain's anatomy is such that emotions emanating from the brain stem and limbic system are more powerful in determining behavior than are the brain's logical/rational processes emanating from the cerebral cortex. This is because many more neural fibers extend from the limbic system to the cerebral cortex, than the other way around.

Memories associated with emotion-evoking experiences are easily recalled. Thus a relevant and meaningful story; emotionally stirring poem, song, or work of art; joyful playtime; or sad, frustrating, or angry interaction are the most memorable experiences. Obviously, experiences that are both positive and affirming while arousing some level of emotion in the learner assist the learning process. Negative emotional experiences, however, while memorable, may impede learning by superseding the memory of more important or useful information. Indeed, some evidence suggests that when children receive undue negative feedback, inappropriate disapproval, teasing, or punishment for normal developmental advances, their development in those areas is slowed, perhaps arrested (Ramey & Ramey, 1996). Again, the implications for authentic assessment practices to support memory and learning are implicit in this information.

Related to the effects of emotion on the brain's neurological development is the increasing evidence of the deleterious effects of stress on infants and young children. Scientists now can gauge children's reactions to stress by measuring the levels and periodic cycles of cortisol in the body. This steroid hormone is elevated when an individual experiences adverse or traumatic events causing the hormone to affect metabolism, the immune system, and the brain. Cortisol alters the brain by making it more vulnerable to processes that can destroy neurons and reduce the number of synapses. Chronic high levels of cortisol in the developing brain has been shown to result in cognitive, motor, and social developmental delays in children (Gunnar, 1996; Shore, 1997). Gunnar found that children who cope best with stress are those who, as infants and toddlers, experienced secure attachments to their primary caregivers and responsive, sensitive, warm, and nurturing interactions. These children seemed to exhibit more resilience in the face of stressful situations later in life.

According to Caine and Caine (1994), neuron growth, nourishment, and interactions are intimately related to the individual's perception and interpretation of their experiences. Thus events or experiences perceived as threatening affect the brain in a different way than say, peaceful, challenging, or boring events do. Teaching and adult–child interactions that employ threat (such as failure, punish-

ment, embarrassment) interfere with the brain's ability to think freely and creatively. Boredom results in fewer synapses, hence, less cognitive development. Young children need complex and enriched yet stress-free classroom environments if they are to reach their potential.

From the foregoing, you can see that there is a lot to think about in terms of how children grow, develop, and learn. No one chapter in a text of this nature can adequately cover this broad field of knowledge and emerging research. For this reason, it is incumbent on every educator to continually avail themselves of what is known about child growth and development. It is an ethical responsibility. Many practices observed in schools today, and touted by some office-seeking politicians, are based on assumptions and information that is either outdated or has long since been empirically refuted. Scholars in developmental and cognitive psychology, sociolinguistics, and education research have provided evidence that has challenged long-held behaviorist perspectives that view human abilities as occurring "in a smooth, probably linear curve of learning from infancy to old age, in a hierarchy of disciplines; and in the desirability of assessing potential and achievement under carefully controlled and maximally decontextualized conditions" (Gardner, 1991a, p. 81). Based on what is now known about child development and learning, educating young children is guided by the following principles set forth jointly by the National Association for the Education of Young Children and the National Association of Early Childhood Specialists in State Departments of Education (NAEYC & NAECS/SDE, 1991, pp. 24–27):

Children learn best when their physical needs are met and they feel psychologically safe and secure. Teachers make sure children's physical needs are met along with their emotional need to feel safe, secure, and accepted. Teachers also strive to maintain continuity between home and school, recognizing the importance of parent support and involvement.

Children construct knowledge. Through their interactions with people and objects children actively discover and construct their knowledge. Understanding this, educators view children's "constructive errors" as developmentally appropriate behaviors and as points of emerging development rather than behaviors that must be immediately corrected by adults. Oral language such as "I wented to McDonald's" is viewed as evidence of a child's ability to construct knowledge about of past tense forms. Similarly, written language such as "I 8 ic krem" (I ate ice cream) is understood as active construction of knowledge about sound and symbol relationships.

Children learn through social interaction with adults and other children. Teachers, parents, and other children play important roles in the learner's construction of knowledge. Social interaction also promotes learning "reciprocity, mutual respect, and cooperation" (p. 26).

Children's learning reflects a recurring cycle that begins at *awareness* and moves to *exploration,* to *inquiry,* and, finally, to *utilization.* Experience and exposure, provide the "subject matter" for awareness. Once children become aware, they need opportunities to explore, manipulate, and bring their own prior knowledge to the experience. Inquiry brings the learner into social and cognitive interactions with others which helps their learning progress from egocentric, perception-bound understanding to more conventional perspectives and knowledge. We know of a child's knowledge

and skills when we observe him or her applying new information and abilities in a variety of other contexts.

Children learn through play. Play provides opportunities for children to construct knowledge through exploration, experimentation, and manipulation; to represent thought; to develop social skills; to develop creativity; and to practice newly acquired skills and knowledge. Play is important in human development and inter-action at all ages, and should be considered to be important in promoting develop-ment and learning in young children throughout the primary grades.

Children's interests and need to know motivate learning. Much of what children learn is dri-ven by their own intense interests and curiosity. Educators respect these interests and use them to develop meaningful curricula that promote development and learning. Teachers continually and strategically introduce new experiences and novel materials to create new interests and learning. Valued dispositions and feelings such as initia-tive, curiosity, sustained attention, self-direction, industry, competence, and love of learning are facilitated in classrooms that encourage child-initiated and self-directed activities based on what children find interesting and challenging, but achievable.

Human development and learning are characterized by individual variation. All children have their own unique genetic makeup, their own individual styles of learning, and their own family life experiences and cultural backgrounds. Programs based on developmentally appropriate practices, including inclusive and mixed-age class-rooms, are believed to provide the environment necessary to take into account these variations and unique aspects of development in young children (Katz, Evangelou, & Hartman, 1990).

LEARNING ABOUT CHILDREN'S DEVELOPMENT IS ONGOING THROUGHOUT ONE'S CAREER

It is not uncommon for educators to lose touch with an expanding knowledge base in the field, or to assume that the child development information they learned during their preservice training is sufficient. They may believe that their teaching is grounded in appropriate child development information and may be unaware that recent research has provided data to support modification or per-haps, elimination of some of their practices.

For example, in the past it was thought that young readers should not use their fingers to point to the words as they read. Children were encouraged to read with their eyes and to fold their hands in their laps to prevent word pointing. Clay's (1977) work in emergent literacy, however, changed that perspective and suggested that such use of fingers or hands to match the text with the reading of a particular word is helpful, not harmful, to developing readers. Similarly, in the past, young children were discouraged from using their fingers to solve mathematical prob-lems. Nevertheless, current research indicates that counting on one's fingers or with concrete objects facilitates learning in mathematics and problem solving (NCTM, 1989; Price, 1989). A third example of the influence of recent child develop-

ment research that has changed practice is that of how children develop phonemic awareness and how the ability to spell emerges (Read, 1971). It is now believed that the young child's developmental (or invented) spelling is a predictable stage that is common among children during early literacy development. Skillfully facilitated through a range of reading and writing activities, this spelling gradually and predictably moves toward conventional spelling. These are just a few examples of how research in child growth and development informs and improves our teaching practices. Knowing about young children's development and learning is a fundamental prerequisite to implementing authentic assessment processes.

KNOWLEDGE OF CHILD DEVELOPMENT IS AN ETHICAL RESPONSIBILITY

Professional educators stay abreast of emerging knowledge in their field not only because it informs and improves practices, but also because it is an ethical responsibility. Would any of us prefer to seek health care from a physician whose practices were based on outdated information? Would any of us argue that the medical practices of our childhood were "good enough" and that we should return to them to improve the outcomes for today's medical patients? Yet, how often have you heard from individuals who are not professional educators that we should return to methods of teaching typical of years gone by. The "back-to-the-basics" type plea assumes that new knowledge is somehow suspect, and that contemporary approaches to teaching are unproved, "soft," and represent a lowering of standards.

These misperceptions make it even more imperative that early childhood educators be adequately and accurately informed and knowledgeable about what serves the long-term best interests of growing and developing children. In this age of accountability, teachers, as well as other professionals, have a responsibility to implement appropriate practices (teaching/assessing) based on current and state-of-the-art research and theory about children's learning and development. Such responsibility is emphasized in the Code of Ethics of the National Association for the Education of Young Children (Feeney & Kipnis, 1989). To ignore this responsibility then constitutes unethical behavior, a lack of professionalism, the promotion of developmentally *inappropriate* practice, and at its most insidious, malpractice. Although this may seem overstated, we believe that this position is more than justified. Continued and long-term lack of attention to child development information by teachers can lead to practices that place children at physical and or psychological risk and that mitigate against the development of competent and intellectually empowered individuals who can become healthy and productive members of society.

SUGGESTIONS FOR KEEPING CURRENT IN THE FIELD OF CHILD DEVELOPMENT

The field of child development is interdisciplinary. It draws its body of knowledge from ongoing research and theory in a variety of fields, including neuroscience, medicine, psychology, sociology, anthropology, linguistics, mathematics, and the arts. This information often first appears in refereed research journals or during professional conferences in which researchers are invited to present their findings. Educators can avail themselves of these journals through area college or university libraries, and should seek professional leave time to attend state and national conferences when time and budgets allow. There are other ways to stay current in the field of child development, education, and assessment. Here are a few:

Join and become an active/participating member in one or more early childhood professional organizations. The National Association for the Education of Young Children (NAEYC) and the Association for Childhood Education International (ACEI) are the most encompassing and representative of the field of early childhood education. (Refer to Chapter 10 for addresses of these and other professional organizations.) These and other professional organizations often have affiliates at regional, state and/or local levels. The NAEYC and ACEI each provide journals (*Young Children*, NAEYC; *Childhood Education,* ACEI) that are included with basic membership as well as other timely publications that may be purchased separately or are included with comprehensive membership. These journals and publications present child development and education research information and refereed articles relating to many aspects of the care and education of children. Read the journals and publications of these and other professional organizations. Share professional journals with your colleagues.

Promote the development of professional libraries within each school to assist other teachers in accessing current child development information.

Form focus groups of professional early childhood and elementary educators to discuss and debate emerging research and literature in your field.

Regularly peruse the holdings of local college and university book stores to ascertain leading authors and topics of textbooks currently in use.

Encourage your local book store proprietor to invite leading educators and writers to lecture about their current work.

Seek relevant inservice training. Encourage your school or district's professional development personnel to address topics relating to contemporary research in child development, early education, and assessment.

Attend or present sessions at professional meetings, conferences, and workshops where current child development, education, and assessment information is shared.

Enroll in undergraduate or graduate programs in early childhood education at a nearby college or university.

Seek an assignment to teach in a school that is working in collaboration with a college or university. School/university centers for professional development are becoming more

common across the country and promote collaborative efforts between public schools and university teacher education programs to enhance the training and opportunities for both preservice and inservice teachers.

Become an on-the-job classroom teacher–researcher. Ongoing observation of young children's behavior and learning can serve as a reference point for questioning child development and learning theories or to affirm one's own theories and assumptions. Reflecting on observations and data collected about children promotes quality formative and summative evaluations. Classroom research helps teachers to develop the observational and descriptive skills that inform practice and ultimately improve curricula, assessment, and learning.

Pay close attention to observed developmental benchmarks or markers that indicate changes in development and learning in children throughout the school year. By observing and keeping records of children's behavior and learning, including developing and reviewing portfolios, emerging development can be charted revealing patterns and milestones.

SUMMARY

In this chapter, we have described the importance of knowing current child development information as a prerequisite to designing and implementing authentic assessment. As you have seen in prior discussions, emerging child development research has precipitated challenges to many widely held views and traditional practices in education. Learning about child development is ongoing throughout one's professional career and is an ethical responsibility. Regardless of the profession, failure to stay abreast of new knowledge in one's field, particularly in those fields concerned with the well-being of our fellow humans, is an abdication of ethical responsibility. We must always strive to find ways to teach that serve the best interest of our clients—children and their families. Failure to do so, means many children will receive less than optimal educations and in some cases, may be subjected to education practices that do more harm than good.

REVIEW STRATEGIES AND ACTIVITIES

1. Join an early childhood professional organization (see Chapter 10 for addresses). Review its journal(s), which are included as part of your membership, for current child development information. Share this information with classmates or colleagues.

2. With the help of a professor or other authority in the field, select and purchase a recently published comprehensive child growth and development textbook to have in your personal professional library as a reference. Identify information that is new to you. What implications for practice (teaching and assessing) does this new information suggest?

3. Organize an early childhood resource room or area at your school, center, or home. Engage some of your colleagues to assist with this project.

 a. Identify a location for storing materials.

 b. Decide what materials will be included (journals, audio and video materials, brochures from professional education and pediatric sources, computer software).

 c. Decide how these materials can be obtained (special funds, contributions, sharing, etc.).

 d. Decide how materials will be organized and accessed by their users.

4. Refer to Chapter 6 regarding observation techniques. Observe children in your class and document your observations with examples of:

 a. how young children construct knowledge

 b. how young children learn through social interaction with adults and other children

 c. how children learn through play

 d. how children's interests and need to know motivate learning

 e. how young children's development varies among individuals and within individuals.

5. Plan to share and discuss this information with your classmates in class or with your colleagues (at your grade level or across grade levels) during your regularly scheduled meetings.

6. Identify how your classroom supports the various learning styles of the children. Share these strategies with your colleagues. Do they have ideas that can help you to meet the variety of children's learning needs?

7. Plan to organize your classroom into eight learning centers that focus on Gardner's multiple intelligences. List materials and activities for each center.

Appendix

Table 3.2
Widely Held Expectations in Aesthetic and Artistic Development

Birth–3 years	3–5 years	5–7 years
Children…		
• may try to grasp writing tools with whole hand.	• may learn to hold writing tools between fingers and thumb.	• continue to develop the ability to hold and use large-size writing and drawing tools.
• may draw randomly and look away while drawing or making marks on a paper or a board. • may begin to make scribbles for pleasure of seeing the results of their actions. • use scribbles, lines, and circles for expression.	• may make marks, draw, paint, and build spontaneously to express self. • may begin to name a person, place, thing, or an action in the drawing. • gradually try making lines and circles repeatedly and with more control.	• may show first attempts at drawing, painting, and building "things." • continue to name what has been drawn, painted, or constructed. • may strive for more detail and realism in artwork. • gradually include more detail and will add more body parts when drawing people.
• may begin to express pleasure or displeasure (laughing, anxiety) when listening to sounds, voices and music.	• may respond to music, art, nature through body movement that is rhythmic, such as rocking, clapping, jumping, or shaking.	• continue to expand and refine responses to a variety of sounds, voices and music.
• may begin to move body to sounds and music. • may make sounds to music without using words ("la, la," "ba, ba,") and may enjoy hearing own sounds.	• use movements that are generally spontaneous, unrehearsed, and inventive. • may be relatively uninhibited about singing and playing musical instruments. • may use both a speaking voice and a singing voice when singing alone, with a tape or with others, and may or may not be able to sing a melody in tune.	• may show imaginative and creative ways of moving and dancing. • are increasingly able to initiate and repeat movement patterns (walk like a lion, slither like a snake). • may engage in "acting out" stories spontaneously. • often continue to be relatively uninhibited about singing and playing musical instruments. • are developing a singing voice but the range will differ; may or may not be able to sing a melody in tune.
• may enjoy pretend games. • may look at, talk to (babble), grasp, bang, or drop toys.	• often engage in pretend play easily and naturally. • may talk to and play with pretend friends, television characters, stuffed and other toys.	• often continue to show lots of imagination and interest in make-believe. • continue to talk to imaginary friends and may greet an imaginary friend or call someone with a striking sense of reality.

Table 3.2, *continued*

7–9 years	9–11 years	11–13 years
Children …. • may continue to develop and refine their ability to use a variety of writing and drawing tools.	• may begin to show an interest in developing a skill and may want to know "how" to use a tool to create a special effect.	• continue to explore and refine use of various tools to create special effects in artwork.
• may begin to show interest in making their artwork realistic. • increasingly develop forms, such as a human form, and repeat it over and over.	• may want and need to see the object or scene as they are drawing and want to make artwork an exact copy of reality. • may become very self-critical of own work (may want hair to "look like" hair).	• may begin to show an interest in perspective or drawing according to scale or to create similar effects. • may focus on the whole effect of a picture or on detail work. • may appear to have little confidence and become self-critical of own artwork.
• expand and refine responses to and express personal preferences for a variety of sounds, voice and music.	• continue to expand and refine responses to sounds, voice and music and are becoming aware of cultural characteristics and of personal preferences of friends.	• may begin to develop particular choices in sounds, voice and music.
• generally like to express ideas and feeling through music and movement. • may begin to show more refined movements as coordination develops. • continue to be able to initiate and repeat movement patterns and may like to move or dance in front of a mirror. • may begin to sing in tune and generally like to contribute to musical activities. • may become better at interpreting musical sounds as being low, high, or related to certain instruments.	• may become somewhat inhibited in music and movement; may show interest in own musical activities such as lip-synch, band, and mime. • continue to develop their sense of coordination, may continue to increase ability to interpret, produce, and reproduce musical sounds.	• are developing more control over singing voice and breathing and may show an interest in joining a group activity such as band, chorus, or musical production—often with friends. • may seem self-conscious at efforts to move or dance and may appear somewhat awkward or uncoordinated because of rapid physical growth. • may continue to be able to interpret and produce musical sounds if encouraged and supported to do so.
• often continue to show their imagination through make-believe, either alone or with a variety or props. • may play the part of a parent or significant other (when playing house or school) and may show signs of cooperative play.	• continue to engage in make-believe and often have a vivid imagination. • may continue to show an interest in making up and performing their own stories, plays, or dances based on reality. • generally like to play and perform, but may prefer playing in groups rather than alone.	• may want to play but at times feel this is no longer proper or "grown-up." • may continue to develop imagination and may be less willing to share ideas publicly.

Table 3.3
Widely Held Expectations in Emotional and Social Development

Birth–3 years	3–5 years	5–7 years
Children… • may demonstrate visible expressions of emotion (temper tantrums).	• may display their emotions easily and appear very sensitive and impulsive (crying fits, "No!").	• may continue to show intense emotions (one moment will say "I love you," and the next, "You are mean.").
• actively show affection for familiar people. • may show anxiety when separated from familiar people and places.	• begin to feel more comfortable when separated from familiar people, places, and things (visiting a neighbor, nursery school, babysitters).	• may appear anxious once again when separated from familiar people and places (beginning school, sleepovers).
• are naturally very curious about other children and may watch and imitate others. • generally play alone, and may or may not attempt to interact with others.	• may play alone or beside others but are becoming more aware of the feelings of others. May be frustrated at attempts to socialize but hold no grudges.	• are learning to cooperate with others for longer periods of time, and friendships may change frequently.
• strive toward independence with support and affection (sitting up, crawling, walking, dressing, feeding, toileting).	• begin to assert independence by saying "No" or "I can do it myself!" May dump a cupful of water onto the floor while looking directly at you. • see selves as family members and as boy or girl in the family.	• continue to develop feelings of independence by becoming able to do certain things (making a simple breakfast or riding a bicycle). • may begin to talk about self and to define self in terms of what they have or own. • may feel they are being treated unfairly if others get something they do not.
• begin to see themselves as people and appear self-centered. • begin to see themselves as strong through directing others: "Sit down."	• see themselves as powerful and creative doers. If the child can't reach something, he or she will get a stool.	• begin to see themselves as bad, good, clever, and may seem very hard on themselves.
• may become possessive of belongings (special people, toys, special times).	• may continue to appear possessive. • may feel if something is shared for a brief period it is gone forever.	• begin to develop the ability to share possessions and take turns.

Table 3.3, *continued*

7–9 years	9–11 years	11–13 years
Children …		
• may continue to show bursts of emotion and impatience less frequently. • may show emotions that are both judgmental and critical of themselves and others.	• may appear relatively calm and at peace with themselves and occasionally become angry, sad, or depressed, but these moments are usually short-lived.	• may begin to show intense emotions, bouts of anxiety, moodiness. Emotions may come close to the surface (cry and anger easily).
• continue to feel some anxiety within the larger community when separated from familiar people, places, things (going to camp, sleepovers, shopping malls).	• often hide feelings of anxiety when introduced to new experiences by appearing overconfident.	• continue to hide feelings of anxiety with friends and family, often appearing overconfident with a know-it-all attitude.
• are becoming more outgoing. • are developing closer friendships with others and may begin to play mainly with children of the same sex.	• continue to be very sociable and spend time with parents, friends of the same sex, and often have a "special" friend.	• generally get along well with their friends and continue to show an interest in having a "best" friend, but fights and arguments may occur from time to time. • start to question adult authority.
• show a generally increased sense of self-confidence. • will eagerly take on tasks and activities likely to be successful but usually will not take risks. • may define self as a particular name, age, size, hair color, or other characteristics ("I'm Elizabeth Anne and I'm seven years old!").	• are generally positive about themselves and begin to understand what they are good at doing; may comment easily, "I can do that" or "I can't do that." • often define self by physical characteristics and possessions as well as likes and dislikes. • often vary between the sexes in their view of what is important in dress and physical appearance.	• sometimes engage in self put-downs—in conversations with others may say, "I can't do anything right!" • may begin to define self in terms of opinions, beliefs, values, and expand sense of self by attempting to copy the culture of current fads (clothes, music, sports).
• are sensitive to criticism and display feelings of success or failure depending on how adults respond to them.	• are sensitive to criticism and display feelings of success or failure depending on how adults and peers respond to them.	• gradually are gaining independence from parental influence. • are sensitive to criticism and display feelings of success or failure depending on reactions of others. • may become self-critical.
• continue to develop the ability to share possessions and to take turns if they understand something is not always "lost" by doing so.	• continue to develop the ability to work and play with others. • may not want to be disturbed when involved in an activity or a game.	• may appear to become possessive with own belongings, especially with younger brothers and sisters. • may view younger brothers and sisters as a bother or a nuisance when involved with peers and feel discriminated against in family situations.

Table 3.4
Widely Held Expectations in Intellectual Development

Birth–3 years	3–5 years	5–7 years
Children… • make direct contact with their environment to the best of their ability—doing, seeing, hearing, tasting, touching, and smelling (put objects in mouth).	• continue to explore the world around them by object manipulation and direct experience (playing). • begin to understand cause and effect ("I fall—I cried—I hurt.").	• continue to learn from direct experience (playing). • expand and refine knowledge with increasing understanding of cause and effect ("I can go to my friend's house if I call home when I get there.").
• are beginning to develop an understanding of language and how it works (imitating sounds, saying words, putting words together). • are learning to name objects and may use the same word for two or more objects (all vehicles called "cars").	• begin to use language to name objects and their own direct experiences of them ("Stove—hot."). • name objects and may find that two objects are alike in some way (cats and dogs are animals).	• continue to expand their understanding and use of language to clarify thinking and learning.
• express themselves through scribbles, lines, and circles. • "read" pictures for meaning; begin to recognize that writing has meaning (writing is intended for communication).	• are developing a sense of how writing and reading work. • combine drawing and "writing"—drawing conveys most of meaning. • play at reading—"read" pictures (telling story from pictures). • begin to read commercial and traffic signs (STOP). • continue to develop an understanding that writing conveys a message.	• are continuing to develop a sense of how writing and reading work. • combine drawing and writing to convey ideas. • understand that print "tells" the story. • develop a basic vocabulary of personal words. • read slowly and deliberately. • will substitute words that make sense when reading.
• are likely to think about time in the "here and now."	• may think of tomorrow as "after my sleep" and use words like "tomorrow" and "yesterday" though not always correctly.	• are developing an understanding of words like "tomorrow" or "yesterday." but may still be unsure about length of time ("Is it ready?" "Are we there yet?").
• are increasingly able to identify familiar faces, toys, places, and activities. • are developing personal choice (a favorite blanket or toy).	• may learn nursery rhymes, songs, and addresses, but without really trying to remember. • begin to assert personal choice in decision-making ("No broccoli!").	• may begin to organize information to remember it (own telephone number, sound-symbol relations). • continue to assert personal choice in decision-making (what to wear to school).
• may be interested in group objects (putting all the large animals to bed and leaving the small ones to play).	• are developing an interest in the number of things. • are increasingly interested in counting although the number may not match the number of objects.	• begin to understand that the number of objects does not change when grouped in different ways. • are developing the ability to match counting 1, 2, 3 with the number of objects.

Table 3.4, *continued*

7–9 years	9–11 years	11–13 years
Children ...		
• may begin to do multi-step problems using objects to manipulate and count (blocks, fingers, buttons). • continue to deepen understanding of cause and effect ("If I don't go right home after school my parents will worry.").	• continue to use direct experience, objects, and visual aids to help understanding. • continue to expand and design understanding of cause and effect ("I can have a pet, if I take care of it.").	• begin to develop ability to "manipulate" thoughts and ideas but still need hands-on experiences. • do some abstract reasoning. • continue to refine understanding of cause and effect ("If I don't get my chores done I can't go out with my friends.").
• continue to expand their understanding and use of language to clarify thinking and learning. • may work with simple metaphors ("My horse runs like the wind.").	• continue to broaden understanding of language and its use to clarify thinking and learning. • may begin to use puns ("A cow is a lawn mooer.").	• continue to broaden knowledge, understanding and use of language to clarify thinking and learning. • often like jokes and words that have double meanings.
• begin to understand and use writing and reading for specific purposes. • may combine drawing and writing, but writing can stand alone to convey meaning. • develop a rapidly increasing vocabulary of sight words. • begin to self-correct errors. • develop the ability to read silently. • increase ability to read aloud fluently and with expression.	• can expand thinking more readily through writing and reading. • continue to increase reading vocabulary. • continue to self-correct errors. • read silently with increased speed and comprehension. (Silent reading speed greater than oral speed may result in oral reading difficulties.) • adjust reading rate to suit purpose (scanning). • expand reading skills to gather information from a variety of sources. • make personal choices in reading for pleasure.	• continue to expand thinking more readily through writing and reading. • continue to increase silent reading rate and time spent at reading. • continue to increase ability to adjust rate and reading to suit purpose (skim, scan, select, study). • continue to broaden their interests in a variety of fiction and nonfiction. • begin to understand that people may interpret the same material in different ways.
• may be learning to tell time and becoming more adept at understanding the meaning of "before," "soon," "later."	• continue to develop understanding of time—year in terms of important events—but may forget dates and responsibilities.	• may be able to talk about recent events, plans for the future, and career aspirations.
• are increasingly able to organize and rehearse information in order to remember, but may still forget. • continue to develop a need for increased ownership in decision-making (games, projects).	• continue to develop the ability to purposefully organize and remember information. • continue to need increased ownership in decision-making (clothing, friends, activities).	• may begin to develop more complex schemes to aid memory. • need ownership in decision-making with the continued guidance of responsible person.
• are developing ideas about lengths and quantities through experiences with blocks, building, drawing, and cooking. • may begin to compare all types of lengths and amounts.	• may use ideas of length to develop an understanding of area and its measurement through artwork, constructing, carpentry, and simple map-making.	• develop ideas about real objects and their properties—length, area, mass, capacity, and volume—through direct experiences and by thinking about those experiences.

Table 3.5
Widely Held Expectations in Physical Development

Birth–3 years	3–5 years	5–7 years
Children… • may experience a period of extremely rapid growth. • develop the ability to move about and to manipulate objects to the best of their ability.	• are experiencing a period of rapid growth. • have a slower rate of small muscle development (hands) than growth and coordination of large muscles (legs).	• may or may not experience a slower rate of physical growth. Large muscles (legs and arms) may be more developed than small muscles (hands and feet). • may increase fine motor skills (handling writing tools, using scissors).
• begin to develop vision by following slowly moving objects with their eyes.	• are usually naturally farsighted.	• usually continue to show farsightedness.
• begin to develop hand-eye coordination—reaching, grasping objects, feeding, dressing.	• continue to develop hand-eye coordination and a preference for left- or right-handedness.	• continue to develop hand-eye coordination. A preference for left- or right-handedness may still be developing.
• begin to recognize concepts of place and direction—up, down, in.	• begin to understand and use concepts of place and direction—up, down, under, beside.	• continue to develop an understanding of direction and place although may confuse right and left, up and down when playing games.
• begin to move about—sit, stand, crawl, walk, climb stairs, walk backwards—to the best of their ability.	• are developing the ability to climb, balance, run, gallop, jump, push, and pull, and take stairs one at a time.	• continue to develop climbing, balancing, running, galloping, and jumping abilities. May have trouble skipping.
• are beginning to identify their own body parts, often through nursery rhymes and games.	• are beginning to identify body parts and words used in movement—jump, wave, hop.	• are growing in their ability to know what and where their body parts are, and how they can be moved and coordinated.
• are unaware of physical strengths and limitations so may attempt activities that could be difficult or dangerous.	• seem unaware of their own physical strengths and limitations and may try potentially difficult or dangerous activities.	• continue vigorous activity, tiring easily, recovering quickly. • tire from sitting rather than running. • develop an awareness of safety with guidance.
• may often change activities. • will move about at own pace, always near a trusted adult.	• may change activities often, although sometimes concentrate on one thing for a long time if interested.	• usually show enthusiasm for most physical activities, and are sometimes called noisy or aggressive.
• are likely to play alone or beside another. • begin to play games like peek-a-boo and hide-and-seek.	• are beginning to take part in group situations, but still play side-by-side rather than "with" others. • may invent their own games and change the roles to suit needs.	• are developing the ability to take part in small group games, and usually begin to play in groups of children of same sex.

Table 3.5, *continued*

7–9 years	9–11 years	11–13 years
Children … • continue to refine fine motor development and may have slower rate of physical growth.	• may experience a spurt of growth before puberty.	• may experience rapid and uneven growth but this occurs at different rates for individual children. Arms and legs may grow rapidly.
• may experience some visual difficulties (eye testing and corrective lenses).	• may experience some visual difficulties (eye testing and corrective lenses).	• may continue to experience changes to eyesight.
• are continuing to develop hand-eye coordination, and may accomplish more complex tasks.	• are continuing to develop hand-eye coordination, and skill level for physical activities may depend on this increase in coordination.	• continue to develop and refine hand-eye skills and integrate them with whole body efforts in sports and games.
• are developing ability to coordinate left and right sides by showing a preference for batting, kicking or throwing, with one side or the other.	• are continuing to develop ability to use either the right side or left side for batting, kicking or throwing.	• continue to refine left/right preference, and may show increasing strength with one hand/arm/foot.
• are gradually increasing in speed and accuracy during running, climbing, throwing, kicking, and catching activities.	• show increased coordination, but growth spurts may begin to interfere. • develop the ability to hit a ball (softball bat, tennis racquet, golf club).	• may show periods of relatively poor coordination and awkwardness. May show some poor posture because of rapid growth.
• are continuing to understand body parts and uses. • are beginning to understand basic ideas of nutrition.	• are developing a more sophisticated understanding of body parts and function as well as basic ideas of nutrition and growth.	• may continue to develop more sophisticated understanding of body parts and functions and begin to get the idea of a simple body system.
• may show more daring, exploring behavior that could lead to accidents. • show times of high energy; become easily tired. • continue to develop awareness of safety with guidance.	• are beginning to develop the ability to pace themselves during high energy activities. • understand safety rules but sometimes take risks.	• continue to enjoy sports and group games. • learn more complex body movements. • continue to develop the ability to pace themselves during high energy activities. • understand safety rules but sometimes take risks.
• continue to show enthusiasm for most physical activities.	• may begin to show a preference for some physical activities over others.	• often vary between the sexes in their interest in physical activities.
• may be interested in playing in groups although the group and the activity probably change often.	• may appear to enjoy more complex group games and simple sports. • may show a strong sense of loyalty to a group or team.	• continue to play in same-sex groups, often engage in more formal team activities, and continue to show great loyalty to group or team.

Table 3.6
Widely Held Expectations in Social Responsibility

Birth–3 years	3–5 years	5–7 years
Children… • appear insensitive to the views of others, yet show interest in them.	• are becoming aware of others and beginning to take part in social play groups. • may play "beside" rather than "with" others.	• are developing the ability to take part in social play groups, and for longer periods of time, increasing awareness of others. • may prefer to play alone at times or with others.
• are generally self-centered in their views. • look at the world mostly from their own viewpoint (may think the sun sets because they go to bed).	• are beginning to see that their views differ from those of others but remain self-centered. • may show aggressive feelings towards others when something does not go their way.	• are developing the ability to see that others have feelings and different views than their own.
• may cry when they see or hear another child crying.	• are beginning to sense when another person is sad, angry, happy.	• may begin to respond to others in times of distress if they are supported and encouraged to do so.
• physically explore the environment to the best of their abilities using their senses (seeing, hearing, tasting, smelling, and feeling). • are natural explorers, eager for new experiences.	• become interested in exploring the environment outside the immediate home. May be interested in growing seeds, weather, seasons, the moon, and sun. • continue to eagerly explore the world around them.	• are developing an interest in the community and the world outside their own. • may begin to show an awareness of basic necessities (food, clothing, shelter). • are beginning to develop an interest in specific issues pertaining to their world (recycling).
• are beginning to distinguish between familiar and unfamiliar faces.	• are becoming more aware of family and social relationships.	• may begin to notice how people are similar and different from one another.
• are becoming aware of their own feelings and respond to others' expressions (become upset if caregiver is also upset).	• may sense another person's unhappiness (such as another child crying) and not know how to help.	• are developing the ability to respond sympathetically to others if they are hurt, upset, or crying.
• begin to recognize consequences follow actions.	• become aware of consequences of own behavior.	• begin to understand consequences of own and others' behavior.

Table 3.6, *continued*

7–9 years	9–11 years	11–13 years
Children ... • are learning to work in groups and are developing the ability to get along with others. • can lead sometimes, and can follow others.	• continue to learn to work in groups if this activity is supported. • may become upset or distressed if they have problems with friends. • begin to understand the idea of the differing contributions of group members to a common goal.	• may show that their relations with friends are increasingly important. • continue to develop the ability to work cooperatively and collaboratively with others.
• are developing the ability to see how others act and what they expect in certain situations. • may be developing close friendships that are helping them learn to understand how others think and feel.	• are developing the ability to take a third-person view, in which they see situations, themselves, and others as if they were spectators, but still do not coordinate these views. • may be developing the ability to see others have different viewpoints but still do not coordinate these views with their own.	• are developing the ability to understand that there are several sides to an issue but are just beginning to show evidence of being able to take others' views into account. Still consider own point of view the right one. • continue to develop the ability to see the worth of others' viewpoints if this is supported.
• continue to develop the ability to respond sympathetically to others if they are supported and encouraged to do so.	• continue to try to develop the ability to respond sympathetically to others but still have difficulty in taking any point of view but their own.	• continue to develop the ability to respond sympathetically to others and may begin to consider other points of view.
• continue to be curious about the world around them and may show interest in learning about other people (food, clothing, shelter). • are developing an interest in and enthusiasm for specific issues pertaining to their world and can define simple actions to help (returning aluminum cans for recycling).	• continue to develop an awareness of how own family meets basic needs. • are developing personal views of important issues and values pertaining to their world and act upon their beliefs (making posters).	• continue to develop an awareness of how family needs affect others. • are becoming more committed to their beliefs and personal views of the world around them (writing letters to newspapers).
• are developing an appreciation for their own and other cultural heritages through special events, festivals, foods, folk songs, and other concrete experiences.	• are continuing to develop an appreciation of their own and other cultural heritages. Can talk about similarities and differences.	• may begin to appreciate the rich multicultural heritage of their own country while cherishing family culture in relation to the whole.
• continue to develop the ability to respond sympathetically to others if this is supported.	• continue to develop the ability to respond sympathetically to others and may try to help them.	• may begin developing the ability to empathize with another's feelings in understandable situations.
• continue to understand consequences of own and others' behavior.	• begin to "weigh" consequences of own actions.	• begin to "test" consequences of own and others' actions.

4

Knowledge of Cultures and Developmental Diversity

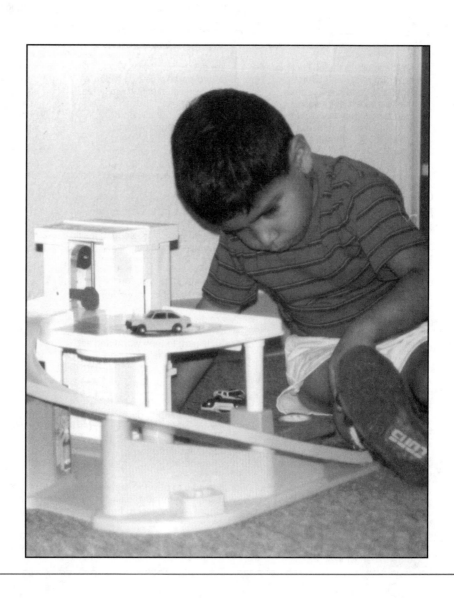

The pluralism we encounter today is somehow different. It has an urgency about it, it demands soul-searching and acceptance of unknown concepts, philosophies, and ways of life. It is this sense of urgency that demands from all educators and in particular from early childhood educators a commitment to redesign and reformulate teaching practices. Education is the key to a strong nation. One of the goals of education is to make people discover and build upon their own strengths. As we transform our educational perspectives through a framework, of cultural responsiveness, we will set the foundation for the United States of the twenty-first century.

de Melendez & Ostertag (1997, p. 4)

No testing program should be tolerated if it leads to classification of people as "not able to learn," and shunts them to a dead-end situation.

National Commission on Testing and Public Policy, 1990).

No single factor can explain academic achievement or the lack of it. Only the analysis of a combination of factors can help us understand how school success is achieved.

Nieto (1996, p. 232)

After reading and studying this chapter, you will demonstrate comprehension by being able to:

- recognize and define many types of diversity represented in early childhood classrooms.
- discuss the need for teachers to know about authentic assessment of diverse populations of young children.
- detail problems inherent in traditional assessment approaches with children from different cultural backgrounds.
- describe appropriate teaching and assessment practices that acknowledge the unique approaches to learning and the strengths of children from varying cultural orientations.
- describe appropriate teaching and assessment practices that acknowledge the unique approaches to learning and the strengths of children with varying special needs.
- describe appropriate teaching and assessment practices associated with gender.

Chapter 3 emphasized that learning about child development is an ongoing, careerlong process and the basis for authentic assessment. An essential aspect of development and behavior that also requires continuing professional commitment and study is that of diversity. In this chapter the concept of diversity encompasses ethnicity and cultural orientations of children, childhood ableness and special needs, gender-related characteristics and expectations, and socioeconomic status and its influences on learning. Assessment can be authentic only to the extent that it truly considers the uniqueness, strengths, dispositions, and diverse backgrounds of each learner.

CULTURAL AND DEVELOPMENTAL DIVERSITY

Through research and everyday experiences in our classrooms we have become increasingly aware of the limitations of using standardized measures of academic achievement—particularly with children of diverse cultures and low socioeconomic status, and children with developmental issues and certain disabilities. For many of these children, our schooling policies and procedures present challenges, if not obstacles to their academic success. The large number of low achievers among certain populations of students is a matter of concern, and can only be addressed by examining the multiple factors that influence achievement in all children—race, ethnicity, culture, socioeconomic status, gender, and ableness.

In this chapter we hope to advance sensitivity to the many ways that children are both alike and different, and to the wide range of background experiences and unique characteristics they bring into the assessment picture. In this context, the concept of developmental appropriateness becomes quite compelling, for such practices support the unique qualities and strengths of each child and engender curriculums, classroom interactions, and assessment practices that enhance—rather than impede—growth, development, and learning in individual children.

Cultural Diversity

In this text, *cultural diversity* refers to the amalgam of beliefs, value systems, attitudes, traditions, and family practices that are held by different groups of people. The term *ethnicity* refers to a particular group's shared heritage that usually includes a common history with distinctive traditions and celebrations. Ethnic groups generally speak a common language and often share common religious beliefs. Whether European American, Jamaican, Latino, African, or Korean, all groups experience and interpret life events such as marriage, procreation, child rearing, education, work and recreation, health issues, and death according to unique cultural points of view. From infancy, individuals internalize and reflect the standards and role expectations of their ethnic and cultural groups. Hence, all children come to school with culturally derived identities and both conscious and unconscious cultural ways of thinking and behaving. These unique ways of

Assessment can be authentic only to the extent that it truly considers the uniqueness, strengths, dispositions, and diverse backgrounds of each learner.

thinking and interacting with others are derived from experiences in various separate but often interactive subgroups within the culture that Banks (1988) refers to as "microcultural groups." The microcultural groups to which all individuals belong include gender, social class, race, ethnicity, ableness, religion, and region. Each of these subgroups functions in unique ways, both interactively and singularly, to influence an individual's self-concept, sense of identity, attitudes, dispositions, and intra- and interpersonal behaviors (Banks, 1988). We will refer to these aspects of diversity throughout this chapter.

The United States contains hundreds of distinct cultural groups. Of these groups, five major ones exist: Native Americans and individuals of African, Latin, Asian, and European decent. Immigration to the United States from around the world continually alters the demographic profile of the U. S. population from that of predominantly white Americans of European descent to one that is more "eclectic" and global. Consider the following information derived from U. S. Census reports: The total U. S. population increased by 12.5 percent between 1980 and 1992. This increase represented a 5.5 percent increase in white people of European

heritage, 65 percent increase in Latinos, and 123.5 percent increase in people of Asian and Pacific Island heritage. One can see from these increases that over the next several years, minorities will become the majority in the United States. It is projected that the proportion of white children younger than eighteen will decline steadily from 69 percent in 1990 to 50 percent or less in 2030. In some areas of the country, this phenomenon has already taken place. Nationwide, recent figures indicate that by 2000, one person out of every three will come from a minority background, and by 2040, the population of Asian and Pacific Islanders will have increased by five times its current population. Projections indicate that people of color will make up more than half of the school population by 2020. This has already occurred in fifty of the ninety-nine largest school districts in the United States (U. S. Bureau of Census, July 1993; U. S. Bureau of Census, September 1993).

Immigrants to the United States

The United States has historically been populated by a mainstream culture that evolved from the goals and values brought by the English settlers who immigrated to this continent during the seventeenth century. These early immigrants eventually dominated the social, economic, and political life of North America and imposed their will on the indigenous or native American Indian (taking land, homes, livestock, and livelihoods), subjecting them to discriminatory practices, and portraying them as uncivilized and savage (Takaki, 1993). These early settlers later bought and brought slaves to the United States and institutionalized a pattern of life that relegated certain populations to servitude and low socioeconomic and political status. At first servants were brought from England, Germany, and Ireland, but over time greater numbers were brought from Africa and the Caribbean. As with the American Indian peoples, the African American slaves were often ill-treated and negatively portrayed by their oppressors. In addition, as with the American Indian, the negative images precipitated unfortunate stereotypes that have persisted over time and have been difficult to allay. Until the Emancipation Proclamation in 1864, slavery was marked by segregation and often violent persecution. While the legislation ended slavery, many injustices and inequalities remained and continue today in both subtle and overt forms. Prejudices, fears, elitism, segregationism, racism, and other "isms" have their origins in this early U.S. history.

Over the years, the United States has taken in more immigrants than any other country. During the colonial days, immigrants arrived mainly from the British Isles and Ireland but soon others began to arrive from Germany, France, Switzerland, Hungary, and The Netherlands. During the mid-1800s, immigrants from China settled on the West Coast, while during this same period, the United States, at war with Mexico over boundary disputes, was annexing large regions of land already inhabited by Mexicans. During the early part of the twentieth century, Italians, Russians, Poles, and other Europeans (many of whom were Jewish) settled in the United States. Since the late 1960s a major wave of new immigrants

has included mostly people from Latin America and Asia. The United States contains basically three distinct immigrant groups: long-term immigrants, recent legal immigrants (including refugees), and undocumented immigrants. While this overview in no way completes the U. S. immigration profile, it does illustrate that as a people, we are in very large part, a nation of immigrants.

Conditions associated with immigration groups can help explain the complex social and educational realities that newcomers experience in the United States. Their unique perspectives on schooling often challenge traditional U. S. assumptions about learning and about family goals and expectations. The following is a partial list of issues encountered by many immigrants that affect their relationships with schools and their children's education:

Oppression by the Dominant Society

Children and families who have lived with a sense of disenfranchisement and powerlessness relate to education institutions in negative and often futilistic ways. Their behaviors often mitigate against positive social adjustment and school success. Educators in turn, respond on assumptions that these children do not want to learn or that their families do not care about their education. There is ample evidence to the contrary, however (Erikson, 1987; Lucas, Henze, & Donato, 1990; Taylor & Dorsey–Gaines, 1988).

Language Barriers

Often the language of the immigrant, such as that of Cambodians, Thais, and Laotians, has little relationship to the English language system or to the Roman alphabet. Some languages such as that of Creole-speaking Haitians and the Hmong have only been codified within the past fifty years or less (Kellogg, 1988). Some immigrants may not have had the opportunity to acquire their own native written language before entering a new country, having relied on an oral tradition. Still others may experience a lack of support systems in the form of interpreters or tutoring or classes in the English language, and school-based education programs for their children such as bilingual or English as a Second Language (ESL) classes, thus they have difficulty acquiring essential communication skills. Many experience prejudice due to their inability to speak English.

Economic Hardships

Language barriers, skill levels, and educational attainments of family members often determine the success with which they are able to obtain sustaining employment. While not all immigrants encounter this hardship, many remain at or below the poverty level. The effects of poverty on children and on school performance has been the subject of numerous research studies. Later in this chapter, we will discuss socioeconomic status as one aspect of diversity in classrooms.

Contrasting Education Practices

Many immigrant children have experienced schooling that emphasized rote memorization. They may have experienced schools in which books, paper, and pencil were not classroom staples as they are in U. S. schools. In their schools, the teacher's authority may have been unquestioned. For some of these children, political indoctrination was the main course of study. They may find their new schools disorienting and unsettling as they encounter more democratic approaches; informal interactions among teachers and children; and unfamiliar teaching strategies such as the use of manipulatives, self-initiated learning, cooperative groupings, play, creative expression, physical education, and field trips.

Disruption in the Homeland

Some immigrants may have experienced years of war, political oppression, or social and political instability in their homelands. Or perhaps, after becoming residents of the United States, may be burdened by uprisings, wars, or natural disasters in their homeland where family members and friends remain. These conditions create psychological trauma that compounds the adjustment process for all members of the family.

Undocumented Immigrant Status

Families and children of undocumented immigrant status deal with long-term stress associated with unsuccessful attempts to enter the country as legal immigrants, separation from their families, and sometimes dangerous circumstances. Although the Supreme Court ruled in 1982 in *Plyer v. Doe* that states must educate the children of undocumented families, sometimes these families delay or avoid interactions with school personnel. In school, these children are often fearful of revealing information that could jeopardize their families and possibly lead to deportation. These fears combined with economic pressures, the necessity to move frequently, and the hesitancy of parents to become involved with teachers or the school, create an often overwhelming state of existence for young children. Again, educators who use mainstream populations as their frame of reference, may mistakenly view these parents as uninterested or irresponsible and their children withdrawn or defiant.

Given the stress (and for some, trauma) of the immigration process, teachers should not be surprised if children exhibit low motivation to learn or act out their anxieties, fears, frustrations, and anger. Immigrant populations represent many complex and diverse situations that pose a number of challenges for their children and families, and for their schools and classroom teachers. While each group is unique, with unique background experiences and life realities, members of the group are people who share many commonalties with others.

Children from immigrant populations may find the expectations in their new schools disorienting and unsettling.

Language and Linguistic Diversity

Increased immigration to the United States, as described above, brings with it large numbers of people who speak languages other than English. In U. S. schools, children whose language is other than English are often at risk for poor academic achievement when placed in monolingual English classrooms. According to recent estimates, 9.9 million students in the United States speak languages other than English (Waggoner, 1994). Actually, the percentage of monolingual English students in public schools has decreased during the past decade while the non-English-language background population has increased (Waggoner, 1993). So dramatic are the current population changes in our country that the need for culturally sensitive instruction and assessment practices for diverse students has become quite compelling. The many languages of today's school populations pose unique challenges for modern day educators. Let's explore some of the implications of multilinguisitic populations for classroom assessment practices.

Cultural Definition of Language

According to Gollnick and Chinn (1990), the cultural definition of language is "a shared system of vocal sounds and/or nonverbal behavior by which members of a group communicate with one another" (p. 211). Nieto (1996) asserts that one's language is inextricably linked to one's culture: "It is a primary means by which people express their cultural values and the lens through which they view the world" (p. 187). Language is the essential instrument of thought and facilitates the development of logical reasoning (Vygotsy, 1962; 1978). It is intimately and interactively related to cognitive development (Piaget, 1926; 1952; 1963). Language allows us to express and share feelings, emotions, and ideas; to record his-

tory; and to project and plan for the future. Language has both verbal and non-verbal properties that are expressed differently in various cultural groups. In short, culture and language are mutually and simultaneously derived, and linguistic expression is unique and often idiosyncratic between and among members of diverse cultures.

The Mutual Dependency of Language and Learning

Vygotskian theory proposes that language is a "tool of the mind" (Vygotsky, 1962; 1978). As such, language plays a major role in cognitive development, because it provides a mechanism for thinking. During infancy before language has begun to emerge, concrete objects and firsthand experiences provide the impetus for the formation of mental concepts and schemes (Piaget, 1963). As language emerges children can use these concepts and schemes to think, to frame ideas, to imagine, and to enhance their understanding of their experiences and of life around them. Language makes it possible for children to convey their needs; share ideas; ask and answer questions; and generally participate in social, emotional, and academic discourse. Language helps children think about and modulate their emotions and self-regulate their behaviors. Through language, learners create strategies for mastery of a variety of mental functions including learning to mentally focus, sustain attention, remember, recall, process new information, problem solve, and develop reasoning ability and a sense of logic. Language is used in speaking, writing, drawing, and song.

The intimate linkage between culture, language, and cognitive development and the mutual dependence of cognition and language on one another, make it imperative that young children have ample opportunity to become proficient in their native language. Recent extensive reviews of research in first and second language acquisition have concluded that the level of proficiency in a child's native language directly influences the ability to become proficient in a second language (Lewelling, 1992). It has also been concluded that young children learn more readily when they are provided instruction through their first language (Krashen, 1992; Nieto, 1996). There is no reason to believe that inability to speak standard English is an impediment to learning. On the contrary, bilingualism (and multilingualism) are ultimately cognitive and academic assets (Nieto, 1996). Some have argued however, that difficulty arises when children give up or lose their ethnic languages in the process of becoming linguistically assimilated into English-speaking classrooms (Wong Fillmore, 1991). This sometimes happens when children are expected to learn English in a sink or swim fashion that often characterizes English immersion programs.

From a study of 1,001 language-minority children, representing many languages, researchers found that the consequences of losing the primary language can be far reaching—affecting social, emotional, cognitive, and educational development of children and exerting a deleterious effect on the integrity of their families and ultimately on the society in which they live (National Association for Bilingual Education, 1991). Wong Fillmore (1991), one of the researchers in this

NABE study, writes:

> What is lost is no less than the means by which parents socialize their children: When parents are unable to talk to their children, they cannot easily convey to them their values, beliefs, understandings, or wisdom about how to cope with their experiences. They cannot teach them about the meaning of work, or about personal responsibility, or what it means to be a moral or ethical person in a world with many choices and too few guideposts to follow. What is lost are the bits of advice the *consejos* parents should be able to offer children in their everyday interactions with them. Talk is a crucial link between parents and children. It is how parents impart their cultures to their children and enable them to become the kind of men and women they want them to be. When parents lose the means for socializing and influencing their children, rifts develop and families lose the intimacy that comes from shared beliefs and understandings. (Wong Fillmore, 1991, p. 343)

Loss of the primary language during bilingual and English-as-a-second-language (ESL) instruction is not inevitable, however. A recent critique of the NABE study has posited that while some bilingual programs impose a *subtractive* experience, it is possible that rather than actually losing the primary language, children may simply exhibit a *language shift*, perhaps due to language preference, and that their parents' monolingualism need not be assumed to remain in a frozen state but also adapts and shifts over time (Rodriquez, Diaz, & Duran, 1995). Comparing Latino children who attended preschool with others who did not, Rodriquez et al. found that in terms of the ability to speak both English and Spanish, the children in bilingual preschool classrooms held an advantage. The children improved in their ability to speak in Spanish *and* their ability to speak English. The researchers suggested that the children in their study appeared to maintain proficiency in Spanish while experiencing an *additive* mode of bilingual education where they became more proficient in English. Other studies have demonstrated positive cognitive gains associated with additive bilingual preschool educational experiences (Diaz, Padilla, & Weathersby, 1991).

It is not difficult for young children to learn a second or even a third language. This is particularly true when children grow up naturally exposed to two or more languages as opposed to being formally instructed. Indeed, children who acquire a second language before puberty are more likely to speak it with its native accent (Krashen, Long, & Scarcella, 1982). Because of the complexity of learning more than one lexicon at a time, children growing up learning more than one language may be somewhat delayed in their vocabulary development in each of the languages. However, these children often have more advanced metalinguistic knowledge than monolingual children; that is, they can think about the linguistic nuances of different languages (Gleason, 1997).

In our society language diversity is not highly valued. Children in our schools are expected to learn Standard American English as expeditiously as possible. This expectation has resulted in pressure on families and children to become linguistically assimilated into a mainstream that speaks standard English. The youngest children in the family are often the most affected by this pressure par-

ticularly if it is imposed before they have developed adequate command of their native language. Many preschoolers are placed in English-only classrooms on the assumption that such an experience will prepare the children for later academic success. This desired outcome, however, has not been empirically demonstrated (Nieto, 1996).

In a classroom context, it appears that successful development of proficiency in the primary language and a second language is directly linked to instructional practices that support native language acquisition while introducing children to a second language. Maintaining the integrity of the first language and its cultural origins while helping children learn another language is preferable, not only from a psychosocial perspective but from a cognitive one, as well, because there is evidence that bilingualism can result in higher levels of cognitive development (Cummins, 1986; Hakuta & Garcia 1989), particularly when children are provided opportunities to develop age-appropriate competencies in both languages (Cummins, 1976; Clarkson & Galbraith, 1992).

Diversity Among English-Speaking Children

English is not spoken identically by all who speak it. In all languages *dialects* exist among various groups of speakers. Dialects are most often associated with region, but can also have origins in ethnic or cultural groups, gender, age, and social class. According to Gleason (1997), language is defined as a set of linguistic features (syntactic, semantic, and phonetic) that are mutually understood by members of a group of speakers, and when two speakers are not able to understand one another they are said to speak different languages. Dialects represent a form of a language that varies from the standard in pronunciation, word usage, sentence structure, and vocabulary (Gleason, 1997). Dialects are also mutually understood though they also vary in linguistic features. Traveling about the United States and listening to various groups of speakers, one becomes aware of the various dialects associated with regions; for example, it is not difficult to distinguish Southern, Eastern seaboard, or Northwestern speakers, yet American English is their common language.

Black English/Ebonics is the most commonly studied English dialect/language. We slash this term because there is some discussion about whether it is a dialect or a language in its own right. *Ebonics* is a term coined in 1973 by a group of black scholars attending a conference devoted to "Language and the Urban Child." The published proceedings of this conference refers to Ebonics as "linguistic and paralinguistic features which on a concentric continuum represent the communicative competence of the West African, Caribbean, and United States slave descendant of African origin. It includes the various idioms, patois, argots, ideolects, and social dialects of black people, especially those who have been forced to adapt to colonial circumstances" (Williams, 1975, Preface, Introduction).

Consider our earlier discussion of the intimate relationship between language and culture. The unique qualities of Ebonics suggests its connectedness with the historical experiences of Africans in America and with Africans around the world

Unique ways of communicating within a cultural group are often expressions of cultural kinship and pride.

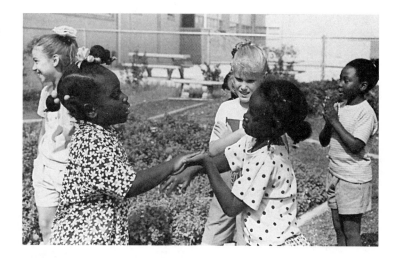

(Smitherman, 1997). Unique ways of communicating within a cultural group such as that of many African Americans are ways of defending a sense of identity and are an essential aspect of cultural pride and liberation (Freire, 1996). Delpit (1995; 1997) reminds us that the linguistic forms that students bring to school are intimately connected with loved ones, and disparagement or negative responses constitute an affront to not only the children, but to their families and community as well.

Today, many scholars of language and of African American culture stress the importance of expanding the concept of Black English from dialect to a language in and of itself, with origins in both West and Niger–Congo African languages and in the enslaved African populations of the early United States. As such, the language has distinguishable rules of grammar and discourse as do other languages (O'Neil, 1997; Perry & Delpit, 1997; Smitherman, 1997). Some common differences between Ebonics and Standard American English have been described in the literature (Baugh, 1983; Smitherman, 1986; 1997). They include the following:

1. *Aspectual "be"*: use of the auxiliary "be" to denote a recurring state or event, such as, "He be smart" and "He bees at his work."
2. *Stressed "been"*: "She been working." The stress on the word "been" denotes that the person being discussed has been working for a long time or very hard or diligently. Without the stress on "been," the message is that the person is working now, in the present time frame.
3. *Multiple negation*: "Don't nobody know how to fix this toy."
4. *Double subjects*: "My teacher, she talks a lot."
5. *Mismatched subject and verbs*: "She do her homework all by herself."
6. *Post-vocalic /r/ deletions*: "floe", "Sista", "Brotha"
7. *Copula absence*: "She pretty."

8. *Semantic inversion:* "bad" meaning "admirable" or "good"

9. *Camouflaged meaning:* "She come fussin at me about my shirt," meaning "She had the audacity to tell me how to wear this shirt."

10. *Consonant substitutions:* "Dat" for "That" or "wif" for "with"

11. *Consonant deletions:* "doing" for "during"

12. *Stress on first syllable:* "Po' lice"

In addition to these language patterns, scholars have described styles of speaking that are common among Black English/Ebonics users (Smitherman, 1997). These styles include call–response sequences and episodic narratives (Michaels, 1981; 1986), which we will discuss later in this chapter. Black English is rich with rhythm, rhyme, metaphor, and repetition and is highly contextualized.

While Black English is associated with race, it is not spoken only by African Americans. Features of Black English are incorporated into the language of other English speakers (Smitherman, 1977, 1986). Children who have internalized the grammatical rules of Black English often find themselves at a disadvantage in school and are particularly penalized on standardized tests that favor Standard English speakers. The language abilities of Black English speakers are often underestimated; indeed, many are misdiagnosed as having language delays or speech disorders (Cole & Taylor, 1990).

Attitudes toward Black English varies among both Standard English speakers and African Americans. Some African Americans may choose to divest themselves of their Black English dialects, opting to speak Standard English only. Others may choose to resist the acquisition of Standard English. Some, who have never been exposed to Black English, have difficulty understanding and communicating with classmates who speak Black English. Still others may become proficient in the use of both Black English and Standard English and use either according to selected contexts. While it is important for both educational and economic reasons for non Standard English speakers to become fluent in the mainstream language, there is no reason to believe that a child's use of Black English is a deterrent to cognitive development (Delpit, 1997). Indeed, as with other languages, allowing young children to use their first language assists them during the learning process and provides rich information and experiences for all children as they develop anti-bias perspectives on all members of their community of learners.

In addition to dialects, *social registers* occur among speakers of both the same and different languages that influence the manner in which language will be used in different contexts. A language social register is a particular form of speech that is employed with certain listeners or in certain social settings. For instance, within the familiarity of home and family, one may use language differently than in other contexts such a school, community meeting, church, or synagogue. Young children do not usually have well-defined social registers, though they may demonstrate an emerging awareness of appropriate and inappropriate uses of language. They learn social registers from the models around them and the coaching and instruction received from their families and later their teachers.

Not unrelated to dialects and social registers are *speech networks*. Speech networks consist of groups of people who come to share similar ideas about styles and uses of communication. In the United States, many people know the sound system, grammar, and vocabulary of a particular language, yet they are members of different speech networks. That is, they have different perceptions about the communication process as reflected in such behaviors as irony, sincerity, attention, disinterest, disapproval, how much emotion should be displayed, body ornaments, clothing styles, and physical arrangements and properties of the communication environment (Erickson, 1987, Nelson, 1993; McLean, Bailey, Wolery, 1996).

If the teacher and student have experienced different dialects, first languages, social registers, and speech networks, there is the likelihood that recurrent miscommunication can occur. This is referred to as *verbal mismatch*. Teachers unaware of this phenomenon in the classroom may tend to view the student as deficient or in need of remediation. A number of studies have described the communication problems in classrooms where children are members of speech networks that are different from the speech network of their teacher.

An example of this incongruence or verbal mismatch is reflected in Michael's (1986) work. During sharing times in first grade, African-American children tended to use a *topic-associating style* of discourse. The teacher's lack of awareness of this style resulted in questions to the children that were thematically inappropriate and seemed to interrupt their thought processes. As a result, discussion topics were fragmented and the semantic intent was frequently misinterpreted. According to Michaels, "The teacher's comments did not build on what the child already knew and so did not provide the extended practice and assistance that would lead to an expanded lexicalized narrative accounting style" (1986, p. 110). Consider the example of kindergartner Deena in Figure 4.1. If her teacher had been aware that topical shifts in African-American dialogue are often indicated prosodically through emphasis and vowel elongation on key words (*Sunday, birthday, friend*) and that exaggerating and lengthening words (*heavy*) indicate building to the main point, the teacher's response would have been different from that reflected in lines 16–20.

Michaels conducted a follow-up interview with Deena as a second-grader, sixteen months after the sharing discourse shown in Figure 4.1. Michaels reported that Deena readily expressed her frustration at being interrupted by the teacher during sharing time: "Sharing time got on my nerves. She was always interruptin' me sayin' 'that's not important enough,' and I hadn't hardly started talkin'" (Michaels, 1986, p. 110). Deena's sister, who is five years older, also recounted the same frustrations during sharing times in kindergarten and first grade.

Amazingly, as Michaels played the tape of Deena's kindergarten sharing to her as a first-grader, Deena could clarify and explain a number of the unstated connections in her discourse. When Michaels asked Deena what her teacher wanted the children to do at sharing time, Deena responded with an example that did indeed reflect the topic-centered discourse desired by the teacher. Michaels states that both Deena and her teacher were working within their own individual schema of what sharing time should be, Deena from a topic-associating perspective and the

The following example is a sharing turn where trouble arises, due to the mismatch between the child's style and the teacher's implicit model. In this case, Deena moves fluidly from topic to topic without making explicit the thematic ties connecting (or separating) the various topics.

```
 1    Deena: Um . . . I  went to the beach / . .  Sunday /
 2                and /   to MacDonalds /
 3                and  to the park /
 4                . . . and / . . I  got this for my / . . birthday //
 5                . . . My  mother bought it for me /
 6                . . and um / . . . I had / . . um / . . two  dollars  for my  birthday
 7                and I  put it  in here /
 8                . . and I  went to  where my  frie-nd /
 9                . .  named Gi Gi /
10                . . .  I went  over to my  grandmother's  house with her /
11                . . . and um / . . . . . she was on my back /
12                and  I / . . and  we was  walkin' around /
13                . . . by my house /
14                . . and um / . . .  she was hea-vy /
15                She ⌈ was in the  sixth or  seventh grade //
16    T :             ⌊ OK I'm going to stop you. I want to talk
17                about things that are really really very important.
18                That's important to you but tell us things that are
19                sort of different. Can you do that? And tell us what
20                beach you went to.
```

Deena here begins with explicit temporal and physical grounding by telling without much descriptive detail what she did on Sunday. She then shifts gears radically to object-focused discourse about a small purse she had brought from home, embedding it in person-oriented talk that shifts focus away from her birthday present to playing with a girlfriend (an activity related only temporally, or through association with the purse, to her birthday). She begins to tell about her activities with her friend but is stopped just before she gets to what, on the basis of her prosody, appears to be the "point" of her discourse, the fact that she was able to carry her friend, fully twice her age, around on her back (and Deena was, at the time, a tiny six-year-old).

Figure 4.1
Mismatched Discourse Between Deena and Her Teacher
Note: From "Narrative Presentations: An Oral Preparation for Literacy" by S. Michaels, 1986, in J. Cook–Gumperz (Ed.), *The Social Construction of Literacy* (pp. 94–116), Cambridge: Cambridge University Press. Copyright 1986 by Cambridge University Press. Reprinted with permission.

teacher from a topic-centered perspective. The result was the lack of a shared sense of topic, narrative style, and signaling conventions. Deena misinterpreted her teacher's attempts at instruction, and the teacher did not understand Deena's topic-associating discourse and thought it lacked planning and organization.

Although Deena was doing very well in reading, mathematics, and spelling, her discourse style at sharing times continued. Michaels wonders what effect this

behavior will have on her ability to write cohesive prose as she enters third and fourth grades.

The next time Michaels visited, the teacher mentioned that she had observed the topic-associating behaviors in several of the children in her room and thought it was rambling and unfocused. A week later, Michaels was in the teachers' room while the children were writing about pets. Antonia, an African-American girl, wrote the following:

> I have a cat and my cat
> never go to the bathroom
> when my cousin eating over
> my house and we went to
> the circus and my cousins
> names are La Shaun Trinity
> Sherry Cynthia Doral

After Antonia read this to the teacher, the teacher chatted with Antonia about her family and the large number of cousins. Thinking of the articles Michaels had shared with her and drawing the parallel between Antonia's writing and her topic-associating discourse used at sharing times, the teacher paused and thoughtfully asked, "Just one thing. What do your cousins have to do with the circus and your cat?" Antonia replied, "Oh my cousins always eat over my house, and they sleep over my house too. And one day last week, we all went to the circus." Antonia's teacher then nodded her head and responded, "Oooh, I see." The teacher mentioned this episode to Michaels later in the day, stating that she believed that Antonia had written an example of topic-associating discourse. "You know, it is a whole lot easier to get *them* to make connections clear, if you assume that the connections are there in the first place," she told Michaels.

Michaels (1986) suggests that this level of awareness can be of practical significance to teachers. Awareness facilitates more culturally responsive pedagogy through informed observation and questioning that can then lead to more authentic documentation of children's true competencies, and hence more authentic assessments of their developmental and academic progress.

In addition to verbal mismatches, there are also examples of misinterpretation of *nonverbal behavior* when teacher and students are from different cultural orientations (Gilmore, 1984; Locust, 1988). Communicative styles include gestures, facial expressions, physical distance, and posture, all of which express meaning as do words. For example, groups within Latino, Native American, and Asian cultures often may not respond to direct questions and may turn their gaze away from the teacher's eyes. The children may assume that the teacher is angry, whereas the teacher may infer that the children are bored, confused, or resistant. In reality, the children are demonstrating respect and deference to persons in authority or of opposite gender.

The Need for Linguistically Congruent Communication and Instruction

To enhance communicative congruence between teachers and students, teachers need to observe children's natural language behavior in a variety of contexts, such as peer talk in lunchrooms and playgrounds and their written work. This ongoing observation of natural language behavior in a variety of contexts throughout the school day reveals "dramatic demonstrations of abilities often unseen and unimagined in school or testing situations" (Gilmore, 1984, p. 384). Through focused observation, teachers come to realize that they have often underestimated children's language competence. This is well illustrated in Figure 4.2

Figure 4.2
The Step MISSISSIPPI

Oral Performance	Description
1. M I SS I SS I PP I	A straight spelling, reciting each letter in rhythmic, patterned clusters, the most concrete form of the rhyme.
2. M I crooked letter, crooked letter, I, crooked letter, crooked letter I, hump back, hump back, I	A spelling that includes a description of metaphorical reference to the physical features of some of the letters. In this version, "crooked letter" refers to S and "hump back" to P. The children sometimes refer to the entire genre of steps as "Kookelater (crooked letter) Dances." The children perform the S in a limbo-like dance movement with one arm forming a crook at the shoulder.
3. M for the money I if ya give it to me S sock it (to me) S sock it (to me) I if I buy it from ya S sock it S sock it I if I take it from ya P pump it P pump it I:::::	This version is often followed by version 2 with a smooth transition. The spelling uses the letters of *Mississippi* to produce the first word of each line in an ongoing narrative.

4. Hey (name), yo,
 You wanted on the phone
 Who is it? Your nigger.
 I bet he wants my lips,
 my tits, my but, my smut.
 My crooked letter, crooked letter, I

A controversial narrative that is only punctuated with parts of the spelling. The play with the narrative rather than the orthography dominates the verbal content. The "crooked letter" by its position in a series of "wants" takes on an ambiguous sexual meaning, especially as the letter is being adorned in dance.

5. Hey, Deedee, yo
 Spell Mississippi
 Spell Mississippi right now
 You take my hands up high
 You take my feet down low
 I cross my legs with that gigolo
 If you don't like that
 throw it in the trash
 And then I'm bustin out
 With that Jordache
 Look in the sky
 With that Calvin Klein
 I'm gonna lay in the dirt
 With that Sergiert (Sergio Valente)
 I'm gonna bust a balloon
 With that Sassoon
 Gonna be ready
 With that Teddy
 I'm gonna be on the rail
 With that Vanderbail
 With the is–M is–I
 Crooked letter crooked letter I

This version of *Mississippi* was performed by fewer individuals and was viewed as an accomplished recitation by peers. The jeans theme made it a favored version of the narrative performance.

Note: From "Research Currents: Assessing Sub-Rosa Skills in Children's Language" by P. Gilmore, 1984, *Language Arts, 61*(4), p. 388. Copyright © 1984 by the National Council of Teachers of English. Reprinted by permission.

In Figure 4.2, Gilmore analyzes a step (chanted talk accompanied by body movement) called MISSISSIPPI that was observed on the school playground. According to Gilmore, children who perform the step MISSISSIPPI demonstrated a variety of language competencies. Yet the children's teachers perceived them as lacking language and literacy skills such as word analysis, rhyming, syllabification, and identification of initial and medial blends. They also considered them lacking in comprehension skills such as identifying main ideas, recognizing semantic differences in homonyms, and developing narrative themes. The teach-

ers also thought these students failed to exhibit good citizenship skills—for example, "listening to or cooperating with each other, getting organized or working in groups" (Gilmore, 1984, p. 387).

In reality, however, Gilmore says that observation and analysis of the step MISSISSIPPI reveals that there are a variety of ways of performing it, reflecting individual creativity in language use and oral composition of the participants as well as language and citizenship skills in peer group contexts. She also maintains that the language event of steps provides an opportunity for the affirmation of self-esteem through the children's incorporation of behaviors that are opposite of expected classroom behaviors, for example, the entire group chants the request to spell MISSISSIPPI rather than a single "teacher." This form is more of a challenge than the polite but threatening request of the teacher, demonstrating student ownership and confidence through bodily movements. Gilmore concludes that close observation of and listening to the step indicate that the children do indeed possess the knowledge of rhymes, syllables, homonyms, spelling, comprehension, good citizenship, cooperation, behaving within a set of rules, and creativity.

Although Gilmore does not imply that street rhymes necessarily should be incorporated into classroom projects, she makes the point that, when assessing children, teachers need to be sensitive to children's behaviors in a variety of contexts, not only their behaviors in classrooms or in testing situations. This sensitivity can facilitate enhanced teacher awareness of children's competencies.

Similarly, Hale (1992) describes the many language skills of African-American children that represent a high level of cognition but are not included on tests. Such competencies include charismatic uses of language, memorized messages, information shared orally, and the overall emphasis on oral tradition rather than written language. Yet, written language has become a prevalent aspect of the language arts program and is the dominant mode in most traditional assessment strategies. Teacher observation of oral language contexts can provide evidence of linguistic competence, and should be an integral part of an authentic assessment process.

When we understand not only the utility of one's native language, but its essential developmental contribution and the deeply personal, cultural and social aspects of it as well, we become sensitive to the many complex and perplexing contradictions that linguistically different children experience in schools. Generally speaking, when children and their teachers share similar languages and cultures, they more readily establish congruent ways of communicating (Au & Kawakami, 1994). Thought processes and learning are facilitated and there are higher levels of academic achievement (Buriel & Cardoza, 1988; Matute-Bianchi, 1991). Because of a profound shortage of bilingual or multilingual teachers in public schools, communicative and instructional incongruities exist between diverse populations of children and their teachers in an unacceptable number of classrooms. Because this issue is not likely to be resolved in the near future, it is incumbent on all teachers to become "diversity literate," culturally sensitive, and knowledgeable about linguistic nuances. Better still, perhaps more of us should be learning to speak and communicate in more than one language.

Socioeconomic Diversity

Increasing numbers of children in the United States live in poverty. In fact, poverty rates among children in the United States are higher than in any other advanced industrial country (Children's Defense Fund, 1998). According to 1996 figures, one in five children is growing up poor and one in 11 is growing up extremely poor with annual family incomes of less than $8,000 (CDF, 1998). It is estimated that one-third of all U.S. children will be poor for at least one year during their childhood. Poverty may last for only a short time for some, but for others, poverty can persist throughout childhood and into adult life. While figures reveal that whites constitute a majority of the poor population, African-American children, Latino children, and children in mother-only families are disproportionately poor (Corcoran & Chaudry, 1997). A recent review of research on the association between the timing, and duration of poverty on children and children's health, achievement, and behavior found that children who live in extreme poverty or who remain poor over an extended period of time appear to suffer the most deleterious outcomes (Brooks–Gunn & Duncan, 1997). This review of research suggests that poverty during early childhood can have a greater effect on children than poverty experienced only during later childhood years.

Children living in poverty are at risk for poor health associated with inadequate nutrition, limited health care, and crowded and often substandard living conditions. Poverty places children at greater risk of falling behind in school than does living in a single-parent home or being born to teen-age parents (CDF, 1998). Compared with nonpoor children, children living in poverty are more likely to suffer anemias and stunted growth, vision and hearing problems, and other physical and mental disabilities, and are more susceptible to diseases such as asthma and pneumonia. These children have lower achievement scores on standardized tests, exhibit more learning disabilities and below grade level achievements, are more often placed in special education classes, and are more likely to drop out of school during adolescence (Sherman, 1997).

Not all children living in poverty are so predisposed; indeed, many manage to do quite well socially and academically. Nevertheless, educators again must be aware of and sensitive to the life realities of children of meager means. Their families may not be able to participate in the life of the school to the extent that other families do. These parents may not know how to "broker the system" on behalf of their own children, to seek the best advantages in terms of placement, tutoring, special enrichment programs, free or reduced-cost school nutrition programs, and home–school collaboration. Where these families have limited educations and resources, they may not be able to assist their children with homework or provide appropriate print and creativity materials or other educationally enriching experiences valued by middle class teachers. Some may be financially unable to provide needed school supplies, appropriate clothing or fees for special events or activities, or transportation to field trips or other off-campus events.

In spite of all of these disadvantages, in an extensive study of social class and parent intervention in elementary education, Lareau (1989) found that among the

working class parents she studied parents made genuine efforts to prepare children for school. Lareau found that low-income parents helped their children by stressing manners and teaching some rudimentary educational skills. These parents believed they were being supportive and helpful in their children's schooling. They viewed schooling, however, as something that took place at school under the supervision of the teacher, and therefore did not perceive their role as one of attempting to intervene on behalf of their children. They "trusted" the school to educate their children. This difference in perception of the role of the school explains why many lower socioeconomic level families participate and interact with schools on a minimal level. In addition, Lareau found that many lower socioeconomic level families draw clear lines between work time and context and home and family times. Unlike their middle class counterparts, these families do not bring work home with them, but leave it at the work site at the end of each work day. The expectation that work takes place at the work site and within a certain designated time frame carries over to their expectation that schooling occurs at school during school hours and in the school building. Hence, the parents have little enthusiasm for homework-related tasks and often resent that family time should be so intruded on.

Culturally responsive pedagogy can improve academic achievement for all children.

Consequently, children from these families may receive little help at home with their homework, not because their parents do not care about their schooling, but because of a particular set of values and distinctions regarding work and family. Teachers who understand and respect this perspective employ non-punitive alternatives to homework.

Educators must also be aware of the issues that confront children living in poverty. Some may come to school hungry, tired, and restless, or emotionally distracted by worries associated with home life. When this occurs, children are less attentive and their performance level weakened. Because poor nutrition affects physical, emotional, and cognitive development in children, meeting basic needs for food, rest, and a stress-free environment may be the first order of business on behalf of these children. Educators may need to acquaint themselves with the resources within the school, school district, and community that are available to assist families in need. It is particularly important that members of poor communities be made to feel welcome in the class and school community and that collaborative communication be established to discuss and determine the types of instruction that will serve their children's best interests (Delpit, 1995). It is equally important that the classroom social, emotional, and academic context is fair and unbiased toward socioeconomic diversity. Considerable research documents the positive long-term effects of stimulating, developmentally appropriate early childhood education experiences for young children from low-income families (Campbell & Ramey, 1995; Schweinhart, Barnes, & Weikart, 1993).

THE NEED FOR CULTURALLY RESPONSIVE CURRICULUMS AND ASSESSMENTS

Cultural orientations to learning may be different from those of European–American teachers. For example, Chinese children traditionally learn through memorization rather than observation, analysis, and comprehension (Ogbu, 1983). D'Amato (1988) reports that the use of competition in the classroom with cultural groups who traditionally focus on cooperation and collaboration can backfire and undermine its intent to motivate. Emphasis on quiet classrooms and written work has failed to acknowledge the importance of oral traditions in learning in African–American cultures (Hale, 1991; 1992). In contrast, teacher emphasis on verbal responses may ignore the nonverbal communication, visual–spatial memory, visual and motor skills, and sequential visual memory abilities of Native American children (Locust, 1988). Suarez–Orozco (1987) reports that certain groups from Central and South America come from cultures that have a success orientation focusing on your name and who you know rather than individual ability and education. It has also been documented that children from both non-Western societies and immigrant minority groups may come from cultures that do not possess certain concepts essential for learning mathematics and other subjects typically taught in classrooms in the United States (Gay & Cole, 1967; Lancy, 1983).

These discrepancies between the orientations to learning of various groups, and the traditional teaching and assessment practices of U. S. schools have prompted some scholars to recommend that providing *culturally responsive pedagogy* will result in improved achievement in school. However, Erickson cautions against overinterpretation of culturally responsive pedagogy because most studies of differences in communication style between home and school have not been designed to directly test a cause-and-effect relationship with school achievement (1987, p. 338). Nevertheless, Erickson does acknowledge that the studies of Au and Mason (1981, 1983) appear to indicate a cause-and-effect relationship between culturally responsive pedagogy and school performance.

Au and Mason's often cited research (1981, 1983) was conducted at the Kamehameha Early Education Project (KEEP) in Hawaii. In the past, native Hawaiian children had not performed well in reading. These children came from the cultural orientation where there was much overlap in speech among family members and in community life, particularly in a speech event called *talk–story*. These speech patterns were not congruent with the mainstream pattern of teacher–child and child–child turn taking during reading groups. In a controlled experiment, Au and Mason compared the mainstream teaching of reading with culturally responsive pedagogy based on the talk–story speech event. Results revealed that the native Hawaiian children in the talk–story, conversational format reading groups demonstrated considerably greater understanding of reading texts than did native Hawaiian children in the mainstream, traditional, turn-taking reading groups. Erickson (1987) suggests that this simple adaptation in instruction, that is, the implementation of culturally responsive pedagogy, reduces culture shock. Erickson states:

> The school's acceptance of ways of acting that the children employ in a mode of interaction that is positively regarded in their community may, even for young children, be perceived by them at some level as a symbolic affirmation of themselves and their community by the school. There may be a chance to feel at home, to feel you know what you are doing, that what others do makes sense. You feel that there is some safety in this new world, and that the teacher likes you. (p. 339)

Erickson (1987) offers an additional explanation for the improvement of school performance where culturally responsive pedagogy is used. Based on cognitive psychology and cognitive theories of reading instruction, the cognitive task structure is facilitated by the use of known conversational patterns with the unknown task of reading a text. This helps children concentrate on the meaning of the text while overlapping conversation in which children repeat and extend others' ideas and provides mutually constructed cognitive scaffolding (Erickson, 1987, p. 339).

The preceding discussion suggests that teacher awareness of children's cultural orientation to learning and the adaptation of instruction to these orientations through culturally responsive pedagogy may indeed promote improved academic achievement in children from groups with varying cultural backgrounds. Such culturally responsive pedagogy leads to more accurate assessments of individual strengths in children.

Children with Special Needs

A discussion of diversity in early childhood education encompasses attention to a wide range of developmental abilities exhibited by young children in early childhood classrooms. Children with special needs present various developmental challenges associated with health, physical disabilities, emotional disturbances, and cognitive development. The passage of Public Law 94-142 in 1975 and its subsequent and most recent reauthorizations (see Chapter 1) has expanded special services for young children with special needs and provided the philosophical and legal impetus for *inclusion* practices. Inclusion is the practice of providing educational experiences for children with special needs in regular classrooms which they would be eligible to attend were they not disabled.

Inclusion practices are based on the assumption that children are more similar than dissimilar regardless of capabilities and all children can learn when provided developmentally and individually appropriate educational experiences. Federal law mandates that educational opportunities be provided for children with disabilities in the "least restrictive environment (LRE)." The law stipulates that regardless of the severity of the disability, an individual is entitled to free access to all educational programs serving nondisabled persons until it is demonstrated that such inclusion is not in the learner's best interest or the best interest of others. While self-contained classrooms for some young children with disabilities exists, as well as, part-day inclusion and pull-out programs (which must also meet the definition for least restrictive environment), the trend is to place children in general education settings. This decision however, must be made on the basis of each child's individual education needs (Smith & Dowdy, 1998).

As illustrated in Figure 4.3, an individualized education plan (IEP) is required for children receiving special education services. Such a plan must by law include certain information. The plan must state the student's present level of functioning, long- and short-term developmental and instructional goals, the types of services

Figure 4.3
Serving Children with Disabilities

Children with disabilities are entitled to the following:

- early screening and identification
- a free and appropriate public education
- parent or parent surrogate consultation
- an impartial due process hearing if the student or his or her parents disagree with the school's decisions
- an individualized education plan (IEP)
- fair and nondiscriminatory evaluation
- confidentiality
- teachers and other professional personnel who have been provided in-service training to help them serve the best interest of the child (PL 94-142).

that will be provided including the extent to which the student will be able to participate in regular educational opportunities, expected date for initiation of the services and their anticipated duration, and finally, the IEP must include evaluation procedures and schedules for determining whether instructional objectives are being achieved. Figure 4.4 is a sample format for an individualized education plan.

Teachers of children with special needs may be expected to participate in one or more of the following activities associated with providing an appropriate education for them:

◆ screening and identification
◆ accurate and objective assessment of student's current levels of performance in the classroom context
◆ referral for further evaluation and diagnosis
◆ participation on a multidisciplinary team (i.e., school psychologist, health care specialist, social work professional, school administrator, other related professionals and parents or parent surrogate, and when appropriate, the child) to determine the student's eligibility for special education services
◆ development of an individualized education plan
◆ student and parent conferences regarding both the development and implementation of the IEP
◆ ongoing assessment of the effectiveness or appropriateness for individual children of the services being provided
◆ participation in due process hearing and negotiations, should the need arise

In working with children with special needs in the regular classroom, the teacher will want to establish collaborative relationships with support personnel within the school, such as those mentioned above, and with the child's parents or guardians in order to provide appropriate and effective learning experiences and instructional strategies, to establish a user-friendly classroom physical environment, to create a psychologically safe psychosocial environment, to use assistive apparatus and technology, and to access a variety of resources available to enhance the child's development and education.

As we stated in Chapter 3, children with special needs reflect a wide range of developmental capabilities. A number of different classification systems are used in schools today to specify the exceptionalities that entitle a child to special education services. Because it is tied to access to funds for special education services, the most commonly used classification system however, is that defined in the Individuals with Disabilities Education Act (IDEA). The following are the IDEA criteria with the definitions (in part), provided in federal guidelines:

Autism

. . . a developmental disability significantly affecting verbal and nonverbal communication and social interactions generally evident before age three, that adversely affects a child's educational performance. Other characteristics often associated with

***INDIVIDUAL EDUCATIONAL PLAN (IEP)**[1,2] Page ____ of ____

☐ *INSTRUCTIONAL SERVICES ☐ DRAFT _____
☐ *RELATED SERVICES DATE
 SPECIFY _____ ☐ ACCEPTED BY ARD COMMITTEE

_____ _____ _____
NAME OF STUDENT SCHOOL GRADE

*Duration of services from: _____ to: _____
 MONTH/DAY/YEAR MONTH/YEAR

*Measurable Annual Goal[3] : _____ Language of delivery _____
 ESL Required ☐ Yes ☐ No

*BENCHMARKS OR SHORT-TERM OBJECTIVES[3] THE STUDENT WILL BE ABLE TO:	*INDICATE LEVEL OF MASTERY CRITERIA	*EVALUATION PROCEDURE	*SCHDULE FOR EVALUATION	EVALUATION CODES				DATE
				DATE	DATE	DATE	DATE	REGRES-SION?
				C,M	C,M	C,M	C,M	
								Y/N
								Y/N
								Y/N
								Y/N
								Y/N
								Y/N
								Y/N
								Y/N
								Y/N
								Y/N
								Y/N
								Y/N
								Y/N

Evaluation Procedure Codes: **Evaluation Codes:**

1. Teacher-made tests 4. Unit Tests 7. Portfolios C – Continue
2. Observations 5. Student Conferences 8. Other: _____ M – Mastered
3. Weekly Tests 6. Work Samples

[1]Goals and objectives for English as a second language and/or primary language development shall be included for limited English proficient students as appropriate.
[2]Criteria and schedule must allow for determining student's eligibility for participation in extracurricular activities.
[3]Must be related to meeting the child's needs resulting from the disability to enable the student to be involved in and progress in the general curriculum and related to meeting each of the student's other educational needs that result from his/her disability.
 *Denotes required items

Figure 4.4
Sample Individualized Educational Plan

autism are engagement in repetitive activities and stereotyped movements, resistance to environmental change or change in daily routines, and unusual responses to sensory experiences.

Mental Retardation

. . . significantly subaverage intellectual functioning existing with concurrent deficits in adaptive behavior, and manifested during the developmental period, that adversely affects a child's educational performance.

Learning Disability

. . . a disorder in one or more of the basic psychological processes involved in understanding or in using language, spoken or written, that may manifest itself in the imperfect ability to listen, think, read, write, spell, or do mathematical calculations. The term includes such conditions as perceptual handicaps, brain injury, minimal brain dysfunction, dyslexia, and developmental aphasia. The term does not apply to children who have learning problems that are primarily the result of visual, hearing, or motor disabilities, or mental retardation, emotional disturbance, or environmental, cultural, or economic disadvantage.

Serious Emotional Disturbance

. . . one or more of the following characteristics [exhibited] over a long period of time and to a marked degree that adversely affects educational performance: (a) an inability to learn which cannot be explained by intellectual, sensory, or health factors; (b) an inability to build or maintain satisfactory interpersonal relationships with peers and teachers; (c) inappropriate types of behavior or feelings under normal circumstances; (d) a general pervasive mood of unhappiness or depression; or (e) a tendency to develop physical symptoms or fears associated with personal or school problems.

Traumatic Brain Injury

. . . an acquired injury to the brain caused by an external physical force resulting in total or partial functional disability or psychological impairment or both that adversely affects a child's educational performance. The term applies to open or closed head injuries resulting in impairments in one or more areas, such as cognition, language, memory, attention, reasoning, abstract thinking, judgment, problem-solving, sensory, perceptual and motor abilities, psychosocial behavior, physical functions, information processing, and speech. The term does not apply to brain injuries that are congenital or degenerative, or brain injuries induced by birth trauma.

Speech and Language Impairment

. . . a communication disorder such as stuttering, impaired articulation, a language impairment, or a voice impairment that adversely affects a child's educational performance.

Visual Impairment

. . . an impairment in vision that, even with correction adversely affects a child's educational development. [Visual impairment] includes both partial sight and blindness.

Deafness and Hearing Impairment

. . . an impairment in hearing that is so severe that the child is impaired in process-ing linguistic information through hearing with or without amplification, [and] that adversely affects the child's educational performance.

Orthopedic Impairment

An impairment that . . . adversely affects a child's educational performance. The term includes impairments caused by congenital anomaly (e.g., clubfoot, absence of some member, etc.), impairments caused by disease (e.g., poliomyelitis, bone tuber-culosis, etc.), and impairments from other causes (e.g., cerebral palsy, amputations, and fractures or burns that cause contractures).

Other Health Impairments

. . . conditions that limit strength, vitality or alertness, [or] chronic or acute health problems, such as a heart condition, tuberculosis, rheumatic fever, nephritis, asthma, sickle cell anemia, hemophilia, epilepsy, lead poisoning, leukemia, or diabetes that adversely affect a child's educational performance.

Assessment of children with disabling conditions is complex and multifaceted. Generally, and as required by law, a multidisciplinary team (MDT) assembles and evaluates information derived from many sources, i.e., medical specialists, par-ents, classroom teachers, school licensed diagnosticians, speech and language specialists, counselors, and others. Using this information, the MDT in consulta-tion with the family and child (as appropriate), determines educational needs, necessary accommodations, and placement. Profound disabilities are usually overt or directly observable and readily diagnosed. As a rule, they have been diagnosed before the child enters kindergarten or first grade. On the other hand, subtle, less profound disabilities can easily be overlooked or mislabeled. Often subtle disabilities are not detected until an astute and observing classroom teacher notices unusual or persistent discrepancies between the behaviors or per-formance of a child and reasonable expectations for age and cultural orientation.

Authentic assessment practices are particularly essential to providing a com-plete and comprehensive profile of children with exceptionalities. Keen and objective observation, a critical element in authentic assessment, alerts one, for example, to speech, language, interaction behaviors, and stereotypical move-ments of children suspected of autism. Observation of a child who appears to be lagging behind others in academic achievement, social and emotional develop-ment, language development, and motor controls may indicate a need for further testing for possible mental retardation. The observant teacher may identify chil-dren who demonstrate intelligence within normal ranges and who have no visual or hearing anomalies, but who are inconsistent in their daily performances, demonstrate unusual strengths and weaknesses with different academic tasks, and are easily frustrated or confused. Such children need to be referred for fur-ther assessment that might focus on visual and auditory perception and other measures for determining learning disabilities. Children with emotional distur-

bances may exhibit serious problems in interpersonal relations (rejection of others, withdrawal and isolation, fighting, name-calling, extreme noncompliance), and they may be unusually and inappropriately emotive (crying for seemingly unexplained reasons, dramatic mood swings, over-reactions, illogical fears). These children may need further psychological evaluations or examination by a board-certified psychiatrist or psychologist. Making these determinations depends on the classroom teacher's ability to recognize behaviors and abilities that fall within normal ranges and those that are seriously discrepant.

While all children from time to time exhibit some of the above or other troubling characteristics, it is the severity, persistence, and non-responsiveness to repeated developmentally appropriate attempts to help that determine a need for evaluation and assessment beyond that which the classroom teacher can provide. We especially want to caution the classroom teacher to be at once, attuned and observant *and* restrained and cautious. Becoming too "problems oriented" causes adults to focus on children's weaknesses (often to excess) which runs the risk of misdiagnoses, labeling, and miseducation. This, of course, imposes a serious and potentially damaging disservice to children. All too often labels remain with them, pre-

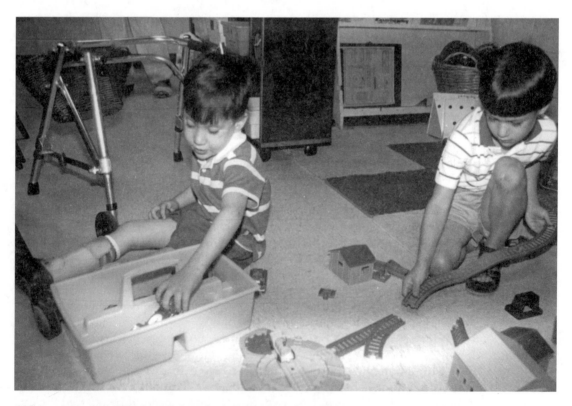

Children with disabilities benefit from inclusion as they benefit from interactions and role models within the class.

empting their opportunities to succeed in their own right. On the other hand, keen observation, studied evaluation, and empathic efforts to help can lead the classroom teacher to potentially "child-saving" early identification and intervention.

Let us add one last word about inclusion. Children with disabilities benefit from inclusion as they enjoy the interactions and modeling of classmates in a heterogeneous group. Children who are not disabled benefit through increased awareness of human diversity and the development of empathy and perspective-taking ability, altruism and helpfulness, and anti-bias dispositions. As children in an inclusive classroom become a cohesive community of learners, each child has opportunities to demonstrate individual strengths and unique talents and to establish successful friendships. Assessment of psychosocial development in children is enhanced through observation of these interactions.

Children with Special Talents

All students exhibit strengths. As with differing rates of development, individual children exhibit special attributes or talents in different ways and at different times. Some children are highly talented in one or more areas and demonstrate this talent through intense and sustained interest in it, an unusually great amount of knowledge and vocabulary associated with it, highly refined skills required for it, and a willingness to take intellectual and skill related risks associated with it. The goal of assessment is to identify the particular strengths of each learner and to identify special talents where they exist. Children with unusual talents need learning experiences that are appropriate in level of difficulty and pace if their proclivities are to be nourished.

Addressing strengths and talents in all children is ethically responsible. Feldhusen (1998) states, "It is immoral to identify a large majority of the nation's young people as 'ungifted' which implies that they are devoid of talent, and it is equally immoral to provide no or inappropriate educational services to precocious youths who are ready for high-level, fast-paced, in-depth instruction" (p. 736). The issue often arises over whether highly talented children receive sufficiently challenging instruction in regular classrooms, or if their needs are best met through special "pull-out" programs. One study found that in spite of federal, state, and local funding for special programs and services for gifted students, few receive the kinds of instruction most suited to their abilities and special talents (Westberg, Archambault, & Brown, 1997). This is due, in part, to the fact that giftedness has been traditionally defined according to scores on standardized IQ and achievement tests. Such definition implies a narrow concept of giftedness that is associated particularly with academic success in language arts, mathematics, and science. To define giftedness in this manner is to exclude or overlook a wide range of potential strengths and talents. For instance, IQ and achievement tests commonly used to identify learners for gifted and talented services are not designed to determine exceptionalities in music, art, drama, dance, or athletic abilities. Nor do such tests identify children who are highly introspective, thoughtful, or empathic, or who have unusual interpersonal talents such as keen and accurate

perspective-taking, tact, diplomacy, conflict resolution, and negotiation skills. Nor do these tests identify children's specific passions for areas of study within the academic fields of mathematics, science, social studies and languages, and so on. These tests, when used without benefit of a variety of other assessment strategies constrict the definition of *gifted and talented* and hence, the opportunities for identification of children who exhibit other exceptionalities.

Contemporary concepts of multiple intelligences (Gardner, 1993a, 1993b) as described in Chapter 3, and of talent development (Bloom, 1985; Feldhusen, 1995; 1998; Renzulli, 1994; Treffinger, 1998) are redirecting assessment and instructional strategies for children with exceptional knowledge, skills, and interests. As educators become more cognizant of the many ways that students exhibit their special strengths, new definitions of talent arise. Treffinger (1998), proposes that *talent* be defined as "the potential for significant, creative contributions or productivity in any domain of inquiry, expression, or action over an extended period of time" (p. 753). He expands his definition beyond one that relies primarily on innate abilities to include the influence of experience, exposure, and encouragement: "Talent emerges from aptitudes and sustained involvement in areas of strong interest or passion. It is not simply a natural endowment or a 'gift'" (p. 753). From this definition, assessment moves from outmoded assumptions about IQ to more encompassing perspectives on student strengths, talents, and interests.

When we change our definition, we also change our approaches to assessment and instruction. While many schools still provide pull-out programs and self-contained classrooms for "gifted" students, it is generally recommended that young children whose proclivities are just emerging and becoming revealed to us, be provided enriched and challenging learning opportunities in their classrooms. The concept of developmentally appropriate practices is quite helpful here. Through the use of learning centers, activities and materials can be strategically selected and provided with a particular child's ableness, interests, talents, and aspirations in mind. The classroom teacher can then observe, interact, scaffold, encourage, and assess talents in individuals. (Of course, this is good practice for *all* children, which is the point of *individual appropriateness* as stated in the definition of developmentally appropriate practices (Bredekamp & Copple, 1998). Such definitions and strategies recognize that strengths and talents exists in all children, including children with disabilities and in all cultural groups.

Responsible Inclusion

Inclusion is as much an attitude as it is a philosophy or mandate. Regardless of talents and strengths, challenges and disabilities, all children have a right to an education that best meets their needs. Responsible inclusion means determining the educational needs of each child, and exploring all options and strategies for advancing development in all of the developmental domains, physical/motor, psychosocial, cognitive, language, and literacy.

The wide range of needs and abilities characteristic of an inclusive classroom population presents a challenging balancing act for educators. On the one hand, the

needs of typically developing children must be considered while making adjust-
ments for children with special needs. On the other hand, children with special
needs who may have individual education plans (IEP) will require focused planning
and implementation. A one-size-fits-all curriculum cannot work in an inclusive
classroom. Acknowledging and responding to diversity can be a challenge, for to do
so requires flexible, creative thinking, and effective child-centered planning. Meet-
ing this challenge need not become an overwhelming task, however.

One such planning strategy is described by Winter (1997) as the "SMART" plan-
ning system for inclusive practices (See Figure 4.5.). The elements of this system
are the following:

1. Collaboratively (with parents and resource professionals) *select* curriculum
 and instructional approaches with the caveat of maintaining the integrity of
 the overall curriculum.

2. Create a *match* between the learning opportunities and children by identify-
 ing individual strengths, learning styles, and the kind an amount of assis-
 tance needed.

3. Determine the types of accommodations needed in the curriculum, the physi-
 cal environment, instructional strategies, and assessment procedures, and
 adapt accordingly.

4. Use a child-centered approach to planning curriculum and instruction, which
 leads to more *relevant* and meaningful learning opportunities for individual
 learners.

5. Incorporate a comprehensive system of *tests* and continuous assessment to
 determine child progress and program effectiveness, and to inform further
 instructional planning. Such multiple assessment measures must focus on
 evaluating whole child outcomes.

The tenets of developmentally appropriate practices (Bredekamp & Copple,
1997) fit well with this planning paradigm. Both the objectives-based approach of
the IEP and the age and individual focus of DAP can be addressed when curricu-
lum and instruction is approached in this manner. This planning model nicely
supports the concept of *activity-based intervention* as described by contemporary
scholars (Bricker & Cripe, 1992; Coling & Garrett, 1995).

Activity-based intervention is derived from the accepted principle that young
children learn through play, and that sensory, motor, language, and cognitive

Figure 4.5
The SMART Planning System for
Responsible Inclusions
Note: From "SMART Planning for
Inclusion," by S. Winter, 1997, *Child-
hood Education, 73*(4), 212–217.
Copyright 1997 by the Association
for Childhood Education Interna-
tional. Reprinted with permission.

S	SELECT
M	MATCH
A	ADAPT
R	RELEVANT
T	TEST

development occur through thoughtfully planned interactions between children and challenging toys, realia, books, and other hands-on, concrete, learning materials. The objectives of the IEP can be embedded effectively in both teacher directed/instruction and self-selected activities and in the daily classroom routines. Activity-based intervention approaches incorporate good practices from the fields of special education and early childhood education, and hence, serve the best interests of all members of the inclusive classroom.

Gender Differences

Interactions between teachers and students often reflect beliefs, expectations and stereotypes about gender categories. Such stereotypes include images of boys as aggressive, independent, adventurous, ambitious, emotionally stoic, and competitive; while girls are viewed as passive, weak, illogical, gentle, emotional, and more amenable to cooperative endeavors. These belief systems cause teachers (and others) to unconsciously and almost automatically categorize individuals on the basis of gender, and to henceforth, expect, even promote, stereotypical gender behaviors (Hamilton & Sherman, 1994). While studies (most notably in the field of mathematics) are emerging that suggest that boys and girls may use different cognitive strategies to solve problems (Fennema, Carpenter, Jacobs, Franke, & Levi, 1998), much is left to learn about how gender affects learning. When teachers treat boys and girls in the class differently, valuing certain gender-associated behaviors over others (e.g., independence, directness, competition), no matter how well meaning and caring the teacher intends to be, a phenomenon often referred to as "hidden gender bias" occurs. Bias in any form interferes with learning and alters the accuracy of assessment findings.

Studies have demonstrated that teachers engage in more frequent and extended interactions with boys than with girls, tolerate more noncompliant behaviors from boys, pose more challenging questions to boys and encourage them to find their own solutions, while reminding girls to comply with the rules, complimenting them on their physical appearance or the tidiness of their work, and assisting rather than challenging the girls to solve complex problems (Sadker & Sadker, 1994). There are other ways in which gender bias occurs in classrooms. Books, stories, fingerplays, songs, visual materials, bulletin boards, and learning center activities and games can unwittingly favor one gender over another or stereotype gender roles. Routines and groupings may perpetuate gender bias: assigning classroom duties according to gender (e.g., boys move tables and chairs out of the way for a musical activity; girls fold the scarves after the musical activity has taken place); dividing children into boy and girl lines to go from the classroom to the playground; failing to use inclusive language (e.g., fireman instead of firefighter); and failing to address children's sexist remarks to one another.

Student achievement and motivation are directly influenced by hidden gender bias (American Association of University Women, 1992; Fennema, 1996; National Research Council, 1989. Sadker & Sadker, 1994). Instructional and assessment practices must be based on an anti-bias paradigm. Anti-bias programs "free chil-

dren from constraining, stereotypic definitions of gender role so that no aspect of development will be closed off simply because of a child's sex" (Derman-Sparks & the ABC Task Force, 1989, p. 49).

IMPLICATIONS FOR INSTRUCTION AND AUTHENTIC ASSESSMENT OF DIVERSE POPULATIONS OF CHILDREN

From the foregoing, it is clear that young children come into our classrooms representing wide variations in prior experiences, knowledge, skills, and dispositions to learn. Their race, culture, first language, socioeconomic situation, gender, and physical, psychosocial, and cognitive capabilities, all influence how they will perceive learning experiences, educators, and society's institutions. Knowledge of their perceptions and those of their families' helps educators to relate appropriately to individual children and their families, and to establish learning environments, curriculums, and assessment strategies that respect and celebrate the unique pathways to development and learning in every child.

Acknowledging the uniqueness of each child means putting into practice instructional and assessment strategies that may differ from traditional classroom practice. These strategies include the following:

Create an Anti-Bias Classroom

The concept of the anti-bias classroom has been advanced by scholar and practitioner Louise Derman-Sparks in collaboration with the ABC Task Force of early childhood educators. The collaborators themselves constituted a diverse group representing a wide range of experience teaching diverse populations of young children. Their book, *Anti-Bias Curriculum: Tools for Empowering Young Children* (Derman-Sparks & the ABC Task Force, 1989), describes eloquently what educators must do to assure that every child is enabled to "achieve the ultimate goal of early childhood education: the development of each child to her or his fullest potential" (p. x). The anti-bias classroom is characterized by the following:

Provides Conditions of Empowerment

Conditions of empowerment are present in a psychosocial climate in which participants have the intellectual and emotional ability to confront bias and oppression and to assume a role as equal stake holder in the creation of a just and fair society (Cummins, 1986; Derman-Sparks & the ABC Task Force, 1989).

As teachers learn more about diversity among children and engage in the work of redefining their relationships with children and families, they gradually become more aware of and acknowledge the strengths and competencies of individuals. Children and adults in inclusive and diverse classrooms can become equal partners and power holders, each making important contributions to

behavioral expectations and group decisions. This perspective leads to a classroom atmosphere that supports and encourages an emerging community of learners each learning to learn from one another. In a community of learners, there is sharing of power and responsibility. Ogbu (1987) asserts that:

> The failure of school personnel to understand and respect minority children's culturally learned behavior often results in conflicts that obstruct children's adjustment and learning. Note, however, that I am not saying that it is only school personnel who have an obligation to understand and accommodate cultural differences: minority children also have an obligation to understand and accommodate school culture. It is a two-way thing. (p. 319)

A synthesis of research (Cummins, 1986, p. 22) reveals that minority students who succeed in school have positive attitudes toward both their own and mainstream culture, that they do not view themselves as inferior to the dominant group. In Figure 4.6, Cummins outlines four structural components within the school experience that determine the degree to which students are empowered or disabled.

A number of strategies have been proposed by Sleeter (1991, p. 6) that educators can consider in creating conditions for empowerment:

Figure 4.6
A Theoretical Framework of Empowerment of Minority Students
Note: From "Empowering Minority Students: A Framework for Intervention," by J. Cummins, 1986, *Harvard Educational* Review, 56(1), pp. 18–36. Copyright © 1986 by the President and Fellows of Harvard College. All rights reserved.

SOCIETAL CONTEXT

Dominant Group

Dominated Group

SCHOOL CONTEXT

Educator Role Definitions

Cultural/Linguistics incorporation	Additive	— Subtractive
Community Participation	Collaborative	— Exclusionary
Pedagogy	Reciprocal Interaction-Oriented	— Transmission Oriented
Assessment	Advocacy-Oriented	— Legitimization-Oriented

EMPOWERED STUDENTS DISABLED STUDENTS

◆ Acknowledge the strengths, experiences, goals, strategies, and needs expressed by oppressed groups.

◆ Create conditions so that people of minority groups can analyze the social structure and act in ways that enable them to achieve their goals.

◆ Create conditions that help minorities succeed in schools and other mainstream institutions.

◆ Create conditions for people from different cultural orientations to succeed academically.

◆ Create conditions so that minorities learn how to advocate for themselves and with others.

◆ Create conditions in which skills and insights can be learned to work with others to achieve social justice.

Creates a Hybrid Culture in the Classroom

A hybrid culture is a concept that is closely aligned with the concept of empowerment. Indeed, empowerment practices lead to a hybrid culture within the group. A hybrid culture is one in which children share the values and behavior standards of their culture with the teacher, and the teacher shares mainstream values and standards of behavior with the children, thereby creating a different culture but one that contains aspects of both groups. The talk–story reading groups used with Hawaiian children (described earlier) is a good example of a hybrid culture in which there is a balance of rights and responsibilities between teacher and children. The teacher retains control over discussion topics in reading groups and by occasionally asking one child to speak at a time. However, the students control the talk by using the talk–story style representative of their cultural backgrounds.

Au and Kawakami (1991) indicate that the hybrid culture does not replicate children's home culture but supports students' achievement of the academic goals of the dominant culture in a manner that is related to the children's cultural backgrounds. Through this process of collaboration and cooperation, a small caring community of learners is created. An example of this strategy is given by Au & Kawakami in the following hybrid of home culture and school literacy expectations. The authors suggest that educators:

◆ encourage children to talk about favorite parts of books read at home the night before.

◆ encourage students to talk about their background of experiences relating to the topic or theme of a text.

◆ encourage students to write on topics of their own choice.

◆ use literature circles where small groups of children can discuss books they are reading or have read.

◆ praise children for their progress in learning.

◆ use peer writing conferences.

◆ publish student books.

◆ use flexible grouping, including teacher-directed large-group instruction, paired instruction, small-group instruction, and independent learning.

◆ communicate seriousness of purpose about learning.

◆ scaffold learning by adults (teachers or aides) or other children.

Strategies such as these are examples of the additive notion and reciprocal interaction pedagogy. Cummins (1986) states that teachers who view their role as adding a "second language and cultural affiliation to the student's repertoire" promote the empowerment of students (p. 25). In contrast, teachers who think their role is to replace or take away children's primary language and culture do not empower students.

Teachers with this latter viewpoint perceive themselves as transmitting knowledge or skills to children. These skills often concentrate exclusively on the surface features of literacy such as handwriting, spelling, decoding, recall of content, drill, and use of workbooks and skill sheets. This approach can convey to minority students that what they have to say is wrong or irrelevant (Cummins, 1986). Constant teacher correction, although well intentioned, can actually have adverse effects on children with diverse background experiences and cultural affiliations. Ramphal (1983) determined that a teacher's frequent correction of students' miscues kept them from attending to what they were reading and encouraged dependent behavior. The students knew that if they stopped reading, the teacher would supply the word for them. Similarly, children diagnosed as having learning disabilities are often given direct instruction. According to Beers and Beers (1980), the nature of direct instruction creates passive behaviors, a form of learned helplessness.

Creates Inclusive and Culturally Responsive Classroom Environments and Pedagogy

Inclusive and culturally responsive classroom environments are characterized by anti-bias elements in the physical environment of the school and classroom. The physical environment is designed to accommodate children with special needs through such considerations as aisles and traffic patterns to accommodate a wheelchair, walker, or other assistive apparatus. Materials are easily accessible, and learning centers and seating arrangements are comfortably accommodating. There is appropriate proximity seating and arrangement of materials for children with vision and hearing impairments, and there are visual and structural cues to help children organize themselves and effectively use all resources in the classroom. Particular attention is given to space arrangements to encourage inclusive and positive social interaction. In addition throughout the school and classroom, posters, bulletin boards, art displays, books, teaching materials, and toys project positive images of race and culture, gender, different ableness and talent, and socioeconomic levels. Images of families are representative of many types of families (single and dual parent families; father-only and mother-only families; grand-

parents and extended families; large and small families; urban, suburban, and rural families, and so on), and props for sociodramatic play are representative and free of bias.

Develops Strategies for Increasing Teachers' Knowledge About Childhood Diversity

The discussions above support the assertion that teachers need to be knowledgeable about many types of diversity. Professional educators seek information that helps them gain understanding of children in their particular classroom. The following are strategies for increasing one's knowledge about diversity:

1. Conduct a needs assessment or form a focus group to determine what information is needed about diversity represented in your classroom or school. What do you need (want) to know about:

◆ learning styles

◆ verbal and nonverbal communication behaviors

◆ language acquisition

◆ parents' goals and expectations

◆ communicating with parents

◆ curriculum extensions and enrichment

◆ celebration of special events

◆ cultural taboos

◆ everyday life

◆ availability and accessibility of support resources and services?

2. Organize study groups that meet during designated planning periods, regularly scheduled inservice time, or at grade-level or cross-grade-level dialogue times.

3. Invite a facilitator who can coordinate the sharing of information about a particular special need or topic associated with childhood diversity. This could be a teacher, curriculum consultant, principal, or parent.

4. Gather materials and resources. This task includes locating, obtaining, and sharing print, multimedia, and electronic materials as well as identifying and using parents and community leaders who can provide first-hand information to school staff.

5. Collaboratively (study group and diverse resource persons) develop guidelines for making classroom learning and assessment more inclusive and culturally responsive.

6. Build positive relationships among teachers, children, and families, and between schools and communities.

Teachers may need to engage individually and collectively in the difficult task of examining their own belief systems as well as those of the school, the commu-

nity, and society at large for misperceptions, bias, prejudice, and practices of institutional bias. Because of long-term stereotyping in every facet of society, including mass media, all people must continually revisit these sensitive issues. Derman-Sparks states:

> No one escapes learning and believing some of the stereotypes and biases that undergird sexism, racism, and handicappism. We all carry scars, whether as initiator or target of unjust acts. Many of us have been both at different times. Few of us have had the opportunity or taken the time to examine deeply and openly the impact on us of these experiences. Instead we keep them hidden and are reluctant to expose our confusions, frustrations, hurt, anger, and guilt. These experiences and feelings daily influence our interactions with children even if we are not aware of it. (Derman-Sparks & ABC Task Force, 1989, p. 112)

7. Collaborate with families. Implementing authentic assessment with diverse populations of children involves increased awareness of parent and community attitudes and perspectives toward schools. In some instances, children will learn new cultural styles even if the school context is very discontinuous with the home. This happens in communities where an atmosphere of trust has been established between teachers and students so that children and parents believe in the legitimacy of goals and curriculum of the school staff (Erickson, 1987). These particular schools seem to have instructional patterns that are easily understood and consistent. The teachers believe that what they do will encourage the children's learning and ability to succeed in the larger society. Consequently, the parents and community support the teachers' sincere beliefs and efforts. Hence, parents and the community perceive the schools as legitimate. Schools gradually earn these perceptions through concerted efforts to communicate with and involve families in mutually setting goals and planning for student progress.

Cummins (1986) believes that the additive orientation (see Figure 4.6) communicates to parents and children that minority culture and language are valued within the school. If the school staff sincerely involves minority parents in their children's education, the parents' trust is communicated to the children, which results in enhanced school performance. Likewise, if children feel comfortable in the school environment, these feelings of well-being and psychological safety are transmitted to the parents.

However, if teachers hold the subtractive perspective, they view teaching as *their* job. They do not perceive parents as a child's first teacher; therefore, collaboration with families is viewed as detrimental to the children's learning. Teachers with this viewpoint usually believe that parent interaction can be a major source of children's problems in school. Lack of parent response, such as failure to attend conferences or parent–teacher organization meetings, is often used by teachers of the subtractive mind-set to maintain the belief that parents of minority children do not care about their children's education.

Cummins (1986) suggests that teachers should view collaboration with parents as part of their role in educating diverse populations of children. Teachers with this perspective:

◆ value and promote parent involvement with their children's learning both
 at home and in the classroom.

◆ work closely with native language teachers, aides, or volunteers to
 communicate effectively and respectfully with the parents of children from
 different linguistic backgrounds.

One final perspective worth noting concerning the involvement of parents
comes from the work of Delpit (1986, 1988). In regard to the promotion of owner-
ship in literacy and the development of voice in the writing process, Delpit
provocatively makes the point that well-intentioned efforts of teachers and their
failure to listen to African–American teachers (and parents) can result in "a certain
paternalism." Delpit (1986) states:

> It is vitally important that non-minority educators realize that there is another view,
> another reality; that many of the teachers (and some parents) whom they seek to
> reach have been able to conquer the educational system *because* they received the
> kind of instruction (skills driven) that their white progressive colleagues are
> denouncing. (p. 384)

Delpit (1988) argues that parents who do not operate within mainstream culture
want such access for their children. Therefore, parents want the school to help
their children acquire "discourse patterns, interactional styles and the spoken and
written language codes that will allow them success in the larger society" (p. 285).
Delpit makes the following recommendations for achieving that goal:

◆ Provide the content minority children need to access the larger society
 through incorporating appropriate strategies for all children within the
 classroom.

◆ Recognize the forms of the language of the culture, then use the children's
 knowledge of these forms to bridge to mainstream culture.

◆ Implement writing for real audiences and purposes.

◆ Use "minilessons" and student-centered conferences with the teacher to
 provide more direct instruction in learning about standard conventions.

◆ Be aware of cultural differences in adult behaviors in oral interactions of
 power and authority, for example, one group may use direct statements
 whereas another may use indirect statements in exercising power.

◆ Be aware of how the parents and children from different cultural groups
 define good teaching.

◆ Help children to value the communication codes of their family and
 culture while assisting them to understand the codes of society at large.
 (Teachers can say to children: "At home and with your family, you talk
 about your cat one way. Now, talk like you are a TV news reporter and tell
 about your cat. Learning to talk like a TV news reporter can help you use
 the language that you'll need to get different kinds of jobs.")

◆ Extend the model and draw parallels in other contexts. (For example, dramatize the difference in behavior in eating in a fast-food restaurant and a more formal restaurant. In the formal context, certain procedures are followed such as when to eat, what utensils to use, what to say, and so on.) This strategy provides an increasing repertoire of behaviors for a wider variety of contexts, including society at large. (pp. 286–297)

8. Advocate for appropriate or authentic assessment. The last suggestion for implementing authentic assessment with diverse populations of children is for teachers to become advocates for more appropriate assessment. As teachers become more knowledgeable and sensitized to childhood diversity, it becomes increasingly clear that, traditional assessment practices (tell and test, lecture and learn, large-scale administration of high stakes standardized tests, and so on) have been a major factor in legitimizing the disabling of "children who do not fit the mold." Children of color, children with learning disabilities and other exceptionalities, children of immigrant families, children living in poverty, children who are subjected to gender stereotypes, and children with special talents bear the brunt of misapplied and misinterpreted traditional assessment strategies. Teachers need to collaborate with other teachers and with all parents to review assessment goals and practices. Concepts that spell failure for students on formal measurement instruments need to be documented in other, more appropriate ways. Teachers must share with policymakers the supporting evidence that, in reality, it is the standardized test that has failed to measure the student's competence, not that the student has failed (Gardner, 1991a, 1991b). Involving psychologists, special educators, and diagnosticians in the assessment process and encouraging them to assume more of an advocacy role is also beneficial.

This chapter has revealed that the authentic assessment of diverse populations of young children is a complex process. Learning about the backgrounds and perspectives of all members of the classroom community of learners, actively listening to one another, and developing a style of working with children and families characterized by openness and respect are behaviors that lead to more focused curriculums and authentic assessments. These strategies require much effort and can be both difficult and rewarding. They are however, an integral part of professionally responsible behavior.

Principles of Assessment

A recent publication of the National Forum on Assessment (1995), a coalition of education and civil rights organizations, sets forth a set of *Principles and Indicators for Student Assessment Systems*. At the heart of this set of principles is the understanding that the primary purpose of assessment is to facilitate learning. The assessments supported by the National Forum's principles are:

grounded in solid knowledge of how people learn;

connected to clear statements of what is important for students to learn;

flexible enough to meet the needs of a diverse student body; and able to provide students with the opportunity to actively produce work and demonstrate their learning. (p. 1)

The seven principles are listed in Figure 4.7. Principle 3 is particularly germane to the discussions in this chapter. The National Forum on Assessment lists the following indicators that accompany this Principle 3:

1. Every student has the opportunity to perform on a variety of high-quality assessments during the school year.
2. Schools prepare all students to perform well on assessments which meet these principles.
3. Assessment practices recognize and incorporate the variety of cultural backgrounds of students who are assessed.
4. Assessment practices incorporate the variety of different student learning styles.
5. Assessments, particularly for young children, are developmentally appropriate.

1. Assessment systems, including classroom and large-scale assessment, are organized around the primary purpose of improving student learning.
2. Assessment systems report on and certify student learning and provide information for school improvement and accountability by using practices that support important learning.
3. Assessment systems, including policies, practices, instruments, and uses, are fair to all students.
4. Knowledgeable and fair educators are essential to high quality assessment systems and practices.
5. Assessment systems draw on the community's knowledge and ensure support by including parents, community members, and students, together with educators and professionals with particular expertise, in the development of the system.
6. Educators, schools, districts, and states clearly and regularly discuss assessment system practices and student and program progress with students, families and the community.
7. Assessment systems are regularly reviewed and improved to ensure that the systems are educationally beneficial to all students.

Figure 4.7
Principles for Student Assessment Systems
Note: From *Principles and Indicators for Student Assessment Systems*, by M. Neill and R. Mitchell, Eds., 1995, Cambridge, MA: National Forum on Assessment. Copyright 1995 by National Forum on Assessment. Reprinted with permission.

6. Assessments are created or adapted to meet the needs of students who are learning English.

7. Assessments are created or adapted and accommodations made to meet the needs of students who have a disability.

8. All students are knowledgeable and experienced in the assessment methods used to evaluate their work.

9. The group which designs or validates an assessment reflects, has experience with, and understands the particular needs and backgrounds of the student population, including race, culture, gender, socio-economic, language, age, and disability status.

10. Committees of persons knowledgeable about the diverse student population review large-scale assessments for bias and are able to modify, remove, or replace items, tasks, rubrics, or other elements of the assessment, if they find them biased or offensive.

11. Teacher education and continuing professional development prepare teachers to assess all students fairly.

12. Technical standards are developed and used to ensure the assessments do not have harmful consequences for student learning or teaching.

13. States and districts report their assessment data by racial, ethnic, gender, linguistic, disability, and socio-economic status groups for analysis of school, district, and state results, provided that doing so does not infringe upon student privacy rights.

14. Schools do not use assessments to track or place students in ways that narrow curriculum options or foreclose educational opportunities (National Forum on Assessment, 1995, p. 11).

Be ever mindful that today's classrooms are rich with diversity, and that first-hand experiences and positive interactions in diversely populated classrooms provide opportunities for the types of learning and experiences that lead children toward attitudes and behaviors requisite to successful participation in a democratic society. If assessment is to truly inform instruction (which of course, is the premise of this text), then the recommendations of the National Forum on Assessment make very good sense.

REVIEW STRATEGIES AND ACTIVITIES

1. Reflect on the ways you think you are currently implementing authentic teaching, learning, and assessment practices with diverse populations of young children.
 a. Identify them.
 b. Describe how you will refine and strengthen your skills in these areas.

 c. Describe how you plan to develop additional skills in the authentic assessment of diverse populations of children.

2. Reflect on the ways your school district may be inappropriately assessing children from varying backgrounds.

 a. Identify them.

 b. Decide what can be done about these inappropriate assessment practices in the short term and long term.

3. Observe children on the playground, in the lunchroom, and during transition times. What competencies do they demonstrate in these contexts? Share these observations with your colleagues during study group or discussion times.

4. Talk with parents and community leaders from various cultural groups. Ask them to share the following:

 a. what they would like the school and teacher to know about their culture

 b. what teachers and the staff can do to make the school more culturally responsive

 c. what teachers can do to promote collaboration with families.

5

Knowledge of Subject Matter Content in the Curriculum

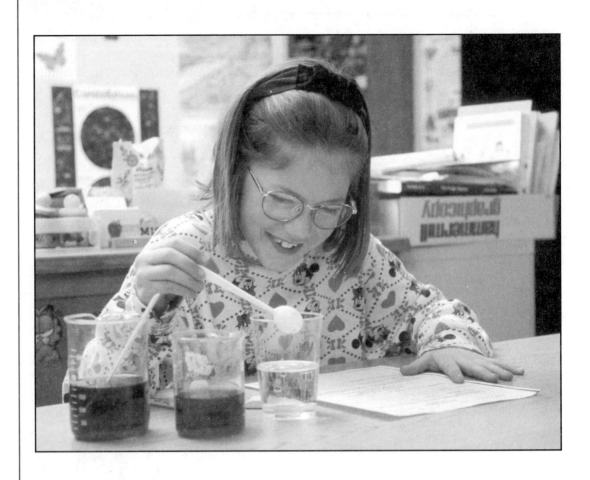

If not pushed two steps ahead of itself, the human mind is a veritable mastery machine.

Stanley Greenspan, 1997, p. 214

If students are to become genuinely more proficient, more capable of dealing with complexity and change, more highly motivated, and more capable of working both autonomously and with others, then we have no choice but to teach for meaningfulness.

Renate N. Caine & Geoffrey Caine, 1994, p. 184

People who do not trust children to learn will always expect a method to do the job.

Frank Smith, 1992, Learning to Read

As early childhood educators look to the disciplines to help guide us about important and rich content to inform curriculum, let us not lose sight of our essential focus on children. Curriculum can be transformed if and only if, we make important knowledge meaningful to individual children by respecting how they learn best and by adapting for their individual strengths, needs, and interests.

Bredekamp & Rosegrant, 1995, p. 175

After reading and studying this chapter you will demonstrate comprehension by being able to:

- identify contemporary forces that determine subject matter content in the curriculum.
- state the goals of education for young children that promote optimal development and learning and competence for the twenty-first century.

- explain the necessity for alignment among appropriate learning goals, curriculum content, and authentic assessment of young children.
- discuss the importance of including the four categories of learning goals—knowledge, skills, dispositions, and feelings—in curriculum and assessment planning.
- describe the relationship of content area standards to early childhood education goals, curriculums, and assessment practices.
- describe pedagogical strategies that facilitate and enhance authentic assessment.
- describe the teacher's role in implementing authentic assessment of subject matter knowledge and skills.

Important background information helpful in successfully implementing authentic assessment with young children includes knowledge of child development and learning (Chapter 3) and knowledge about diversity among children and their families (Chapter 4). A third area of essential knowledge involves subject matter content in the curriculum. This chapter will focus on the nature and content of curriculums in early childhood education and the need for teaching, learning, and assessment to be intertwined and mutually dependent as illustrated in Figure 2.1 in Chapter 2 (p. 38). Full discussion of curriculum content and instructional strategies in early childhood education is beyond the scope of this text. For more expanded information about curriculum and pedagogy, we refer you to the bibliography of resources provided in Chapter 10.

FORCES THAT DETERMINE GOALS OF EARLY CHILDHOOD EDUCATION AND SUBJECT MATTER CONTENT

The school-reform movement of the 1980s and the standards development movement of the 1990s described in Chapter 1 spurred many states to take a more active role in determining and often mandating goals for learning and in implementing assessment processes to determine if these goals were being realized. While the 1980s were characterized by the school-reform movement, the 1990s will go down in education history as the "standards era." Through the development of exemplary standards for K–12 mathematics education, the National Council of Teachers of Mathematics led the way toward more clearly defined standards and outcomes expectations. Other academic disciplines soon followed with the development of discipline-specific standards of what students should know and be able to do. Through various sponsorships, federal and state agencies, scholarly and professional associations, and private foundations, content area standards in virtually every subject taught in public schools were developed during the first half of the decade. Leaders in the standards movement believed that standards would appreciably improve student outcomes. Diane Ravitch, former Assistant Secretary of Education, stated, "Standards can improve achievement by clearly defining what is to be taught and what kind of performance is expected" (Ravitch, 1995, p. 25).

The quality and appropriateness of many of these standards, however, have been a matter of some discussion, garnering both praise and controversy (Marzano & Kendall, 1996). While these national standards were not mandated by federal or state law, they were intended to provide models that states could voluntarily use to determine what students should be learning. The models also were to serve as guideposts for assessing student achievement and school and district accountability. However, the national standards movement aroused concern among professional educators over several issues: the costs and resources necessary to implement them; the potential for disenfranchising students who traditionally do not do well in school; the often limited and static nature and con-

tent of standards; the lack of regional, state, or local perspectives in national standards; and the overwhelming volume of documents needed to communicate the standards. (It has been reported that in 1995, the standards documents taken together weighed fourteen pounds, stood six inches tall and contained more than 2,000 pages, and have continued to grow since 1995 (Marzano & Kendall, 1996). In comparison, Ravitch (1995) notes that the Japanese national curriculum fits into three slender volumes—one each for elementary, lower secondary, and upper secondary levels). The sheer volume of reading material associated with the U. S. standards and their application and assessment has become frightfully overwhelming to practitioners.

In spite of concerns and criticisms, most states have embarked on setting their own standards. Many are modeled after these initial national standards, but with modifications deemed appropriate for individual states. In addition, many local school districts have become involved in standards development. At the same time, many states are aligning assessments and accountability practices with state standards. According to the American Federation of Teachers (AFT) (1996), forty-two states either have or are developing assessment procedures that can be linked to state standards. If such assessments focus narrowly on only certain content areas (e.g., math, reading) to the exclusion of others (e.g., science, social studies, the arts, physical education), the resulting unbalanced curriculum will be a legitimate concern (AFT, 1996). It is most often the case that when classroom time is spent preparing students to do well on a state-mandated assessment, that time is focused on the content areas tested by state-mandated instruments. This of course, deprives learners of a broad education. With state-mandated standards, the widespread use of standardized tests to assess student performance and school accountability increases, and with it, more emphasis on skills and drills to enhance test performance than on student acquisition and construction of knowledge and understanding. Often, the goals of the state and local level are at odds with the contemporary construct of developmentally appropriate practices as defined through scholarly research and professional consensus in the field of early childhood education.

Traditionally, most professional early childhood educators have not had to deal with predetermined, formalized curriculum requirements such as occurs with standards-based curriculums and assessments. Rather they have approached their tasks on the assumption that curriculums most effectively emerge from observing and responding to the needs, capabilities, and interests of the young learner. The term *emergent curriculum* is derived from this perspective (Jones & Nimmo, 1994). Such curriculum development depends on focused observation; ongoing assessment of student achievements and needs; and the teacher's ability to provide rich, varied, mind-engaging content and appropriate materials in response to the observations. Such curriculums are dynamic and child centered. However, with the standards movement the demand for accountability in many states has led to the formulation of learning outcomes for students—including children three, four, and five years of age—which focus on academic indicators that often preclude a child-centered, emergent development curriculum

approach. These stated learning outcomes are variously referred to as *essential elements, essential knowledge and skills, learning objectives,* and so on.

In addition, the expansion of programs for young children has created a shortage of teachers trained in providing appropriate learning experiences for young children commensurate with the growth- and development-focused emergent curriculum paradigm. To respond to state mandates and to provide additional curricular support for teachers who lack appropriate training, written curriculums have become more commonplace in early childhood classrooms. These efforts have often resulted in developmentally inappropriate programs that emphasize whole group, teacher-directed, drill-and-skill, paper-and-pencil learning. Further, these approaches often result in tell-and-test, paper-and-pencil strategies of assessment. As a result, there has been an escalation in the debate over which is more important in curriculum for young children, the process of learning or the acquisition of academic subject matter knowledge and basic skills and the relative effectiveness of teacher-directed instruction versus child-initiated learning. This dilemma was first addressed by the NAEYC and NAECS/SDE (1991):

> The fact remains that the question of which is more important, content or process, is really a moot point. In order to write, think or solve problems, learners must have something to write about, to think about, or some real problem to solve. In short, these important learning processes require content. Similarly, content cannot be learned without learning processes being engaged; the question is more of one of effectiveness or value of the learning processes. (p. 23)

As for the teacher-directed/child-initiated issues, it is important to be guided by our best understanding about how young children learn. Recall the discussion of constructivism in Chapter 1. In reality children construct their learning from both self-initiated activity and interaction with adults who act as facilitators and scaffolders in refining and expanding children's knowledge. Recall also, that the young child's unique ways of making meaning from experiences are supported through pedagogy that draws on psychomotor and psychosocial aspects of development as well as cognitive ones. Further, scholars in early childhood education continue to emphasize the critical role of play in promoting curiosity, concept development, perspective-taking skills, problem-solving strategies and the use of symbols, all of which are precursors to success with later traditional academic instruction.

These perspectives on early learning are undergirded by emerging understandings about brain growth and neurological development. In attempting to translate research from the neurosciences to the classroom, scholars are now advising parents and educators to pay attention to elements in the environment that are conducive to optimal dendrite growth and brain functioning. Such elements include the following:

nutritious diet and adequate amounts of drinking water
positive social and emotional interactions
teaching strategies that enhance self-esteem and a sense of self-efficacy

a variety of experiences that involve the senses and a range of physical, motor skills

learning environments free of undue stress or pressure

curriculums that provide pleasant challenges, elements of novelty, problem solving, and critical thinking, growing out of complex activities and relevant projects

pedagogy in which the students are active participants in a variety of interactions with others and with engaging materials rather than passive recipients of information

learning endeavors and interactions that provide the learner maximum feedback that is supportive, specific, immediate, and respects the learner's capabilities and needs (Caine & Caine, 1994, 1997; Diamond & Hopson, 1998; Jensen, 1998; Sylwester, 1995, 1997; Tomlinson, & Kalbfleisch, 1998).

While the standards movement has the potential to derail developmentally appropriate practices, the development of subject matter/content standards can focus the professional educator's curriculum planning in ways that can enhance learning experiences for young children. For instance, the National Association for the Education of Young Children identified the following potential benefits of standards based planning.

Standards can serve as a frame of reference for the development of curriculum, by providing:

◆ *important content* by helping both content area specialists and early childhood education specialists to identify the "truly important content of each discipline".

◆ *conceptual frameworks* or ways of organizing large amounts of complex information to support communication and understanding among and across professional disciplines.

◆ *coherence,* which is an essential aspect if standards are to be appropriately translated into learning goals for very young children and understood by all users—early childhood educators, parents, students, administrators.

◆ *consistency,* which assures that children and families encounter similar grade level goals, experiences, and expectations when and if they move from one school to another (Bredekamp & Rosegrant, 1995, pp. 8–10).

◆ *high expectations,* which recognize that while children are capable of far more intellectually interesting and challenging study than is often recognized (Katz & Chard, 1989), they do not succeed with watered-down versions of curriculums meant for older children.

Contemporary scholars and professionals in the field of early childhood education continue to offer guidelines for curriculums and programs best suited to long-term positive outcomes for children (Bredekamp & Rosegrant, 1992, 1995; Fraser, 1997; Powell, 1995; Schweinhart & Weikart, 1998), and to document long-term effects of appropriate and inappropriate early childhood education experiences.

(See Dunn & Kontos, 1997, for a review of this research.) In addition, recognizing that early experiences—from birth through about age 10—influence brain cell development in profound ways, early childhood educators are continually called on to interpret emerging child development and early education research for those who mistakenly view early childhood education as a downward extension of elementary school curriculum. Current emphasis on collaboration is encouraging dialogue among teachers; parents; communities; businesses; and coalitions at local, state, and national levels to promote more consensus regarding the framework for curricular goals, content, and assessment in early childhood education (National Association of State Boards of Education, 1988, 1995).

ALIGNMENT AMONG GOALS, CURRICULUM CONTENT, AND ASSESSMENT

As we discussed in Chapter 2, it is important that developmental and education goals, curricular content, and assessment procedures be developed in tandem with one another if the student experience is to be useful and meaningful. Because many schools have yet to make a transition from traditional forms of assessment to more performance-based strategies, incongruence between classroom curricular practices and state or district educational goals and required assessment procedures can be problematic. An example of such a situation is a classroom or school that has moved toward integrated language arts and the writing process but still uses a traditional report card that emphasizes grammar,

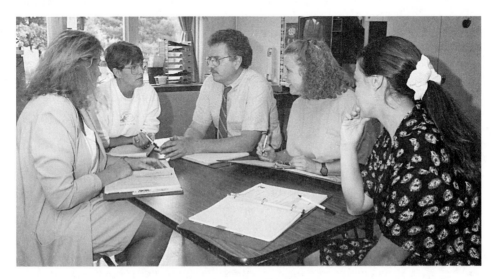

Time expended in efforts to align learning goals, curricular content, and assessment results in more appropriate, efficient, and productive teaching, learning, and assessment.

punctuation, and spelling skills rather than more holistic aspects of language such as writing process competencies. Trying to assess and document achievement using strategies that are not in alignment with classroom curriculum or stated goals can cause teacher frustration. Likewise, parents can be confused when they notice incongruence between children's day-to-day learning experiences and information on report cards. Most troubling however, is that this misalignment can cause confusion and misunderstanding for children when their classroom experiences and accomplishments are not accurately and meaningfully reflected on their report cards.

Of particular concern in this regard is that of accurately reflecting the accomplishments of at-risk students and students with disabilities. Education goals, curriculum content, and assessment procedures that are too rigidly defined, particularly along traditional letter-grade paradigms, may place these students in the position of never fully measuring up, leading these students to feel defeated and incompetent. Indeed, Munk and Bursuck (1998) report that research suggests that 60 percent to 70 percent of students with disabilities in inclusion classrooms receive below-average grades. For this reason many schools are providing alternative grading systems (Bursuck et al., 1996; Munk & Bursuck, 1998). Such systems adapt grading procedures to more accurately reflect individual student progress. Common strategies used with these adaptations include basing grades on student improvement, giving multiple grades, (e.g., a grade for a particular piece of work or a test, and a grade for effort), assigning weighted grades for specific types of work, basing grades on meeting the objectives of an IEP (individual education plan), and assigning separate grades for process and products (Bursuck, et al., 1996). It is important, however, that when these adaptations are used, teachers deem them acceptable and fair and provide positive rationale for their use.

The alignment of learning goals, curriculum content, and assessment could be addressed during regularly scheduled faculty meetings, during in-service training, before and after school, or at grade-level meetings. Time expended in efforts to align these three areas can result in more appropriate, efficient, and productive teaching, learning, and assessment. It is not unusual for teachers to have to adapt and adjust to the incongruences of these three areas while they are working on realigning them. Teachers may have to be creative in adapting or incorporating newer assessment approaches with the old, for example, including new forms of assessment along with the traditional report card or using portfolios during student and parent conferences as well as explaining different assessment techniques to students and parents. In addition, teachers and parents may have to assume an advocacy role and lobby for change and alignment of goals, curricular content, and forms of assessment.

When goals have been clarified, decisions about the development or selection of specific content can be made according to curricular guidelines that reflect current thinking of scholars and practitioners within the field of early childhood education. Early childhood education curricular guidelines serve as standards that professionals can use to judge the appropriateness of including or excluding certain content as part of the early childhood curriculum. Figure 5.1 contains a list of these guidelines that apply to all programs for children ages three through eight. To expedite

this process, it is suggested that curriculum planners analyze the proposed early childhood curriculum according to the questions set forth in Figure 5.2.

In addition to these guidelines, specific goals and curriculum content must be appropriate to the students' age, individuality, and cultural background. Taking into account age range and background of experience, a curriculum for three-

1. The curriculum has an articulated description of its theoretical base that is consistent with prevailing professional opinion and research on how children learn.
2. Curriculum content is designed to achieve long-range goals for children in all domains — social, emotional, cognitive, and physical — and to prepare children to function as fully contributing members of a democratic society.
3. Curriculum addresses the development of knowledge and understanding, processes and skills, dispositions and attitudes.
4. Curriculum addresses a broad range of content that is relevant, engaging, and meaningful to children.
5. Curriculum goals are realistic and attainable for most children in the designated age range for which they were designed.
6. Curriculum content reflects and is generated by the needs and interests of individual children within the group. The curriculum incorporates a wide variety of learning experiences, materials and equipment, and instructional strategies to accommodate a broad range of children's individual differences in prior experience, maturation rates, styles of learning, needs, and interests.
7. Curriculum respects and supports individual, cultural, and linguistic diversity. Curriculum supports and encourages positive relationships with children's families.
8. Curriculum builds upon what children already know and are able to do (activating prior knowledge) to consolidate their learning and to foster their acquisition of new concepts and skills.
9. The curriculum provides conceptual frameworks for children so that their mental constructions based on prior knowledge and experience become more complex over time.
10. Curriculum allows for focus on a particular topic or content, while allowing for integration across traditional subject-matter divisions by planning around themes and/or learning experiences that provide opportunities for rich conceptual development.
11. The curriculum content has intellectual integrity; content meets the recognized standards of the relevant subject-matter disciplines.
12. The content of the curriculum is worth knowing; curriculum respects children's intelligence and does not waste their time.

Figure 5.1
NAEYC Guidelines for Curriculum Content in Early Childhood Programs
Note: From "Guidelines for Appropriate Curriculum and Assessment in Programs Serving Children Ages Three Through Eight" by the National Association for the Education of Young Children and the National Association of Early Childhood Specialists in State Departments of Education, 1991, *Young Children, 46*(3), pp. 29–30. Copyright © 1991 by NAEYC. Adapted with permission.

1. Does it promote interactive learning and encourage the child's construction of knowledge?
2. Does it help achieve social, emotional, physical, and cognitive goals?
3. Does it encourage development of positive feelings and dispositions toward learning while leading to acquisition of knowledge and skills?
4. Is it meaningful for these children? Is it relevant to the children's lives? Can it be made more relevant by relating it to a personal experience children have had or can they easily gain direct experience with it?
5. Are the expectations realistic and attainable at this time or could the children more easily and efficiently acquire the knowledge or skills later on?
6. Is it of interest to children and to the teacher?
7. Is it sensitive to and respectful of cultural and linguistic diversity? Does it expect, allow, and appreciate individual differences? Does it promote positive relationships with families?
8. Does it build on and elaborate children's current knowledge and abilities?
9. Does it lead to conceptual understanding by helping children construct their own understanding in meaningful contexts?
10. Does it facilitate integration of content across traditional subject matter areas?
11. Is the information presented accurate and credible according to the recognized standards of the relevant discipline?
12. Is this content worth knowing? Can it be learned by these children efficiently and effectively now?
13. Does it encourage active learning and allow children to make meaningful choices?
14. Does it foster children's exploration and inquiry, rather than focusing on "right" answers or "right" ways to complete a task?
15. Does it promote the development of higher order abilities such as thinking, reasoning, problem solving, and decision making?
16. Does it promote and encourage social interaction among children and adults?
17. Does it respect children's physiological needs for activity, sensory stimulation, fresh air, rest, and nourishment/elimination?
18. Does it promote feelings of psychological safety, security, and belonging?
19. Does it provide experiences that promote feelings of success, competence, and enjoyment of learning?
20. Does it permit flexibility for children and teachers?

Figure 5.2

Guiding Questions for Determining Appropriate Curriculum for Young Children

Note: From "Guidelines for Appropriate Curriculum and Assessment in Programs Serving Children Ages Three Through Eight" by the National Association for the Education of Young Children and the National Association of Early Childhood Specialists in State Departments of Education, 1991, *Young Children, 46*(3), pp. 31–32. Copyright © 1991 by NAEYC. Adapted with permission.

year-olds will be quite different from curriculum for eight-year-olds. However, the range of development even within a particular age group requires that teachers understand a young child's ways of knowing and the continuum and benchmarks of young children's learning in individual content areas.

The Four Categories of Knowing

A particularly helpful framework for determining learning goals and age-appro-priate curriculum incorporates the process of human learning that proceeds from *awareness* to *exploration* to *inquiry* to *utilization* (Rosegrant & Cooper, 1986; Bre-dekamp & Rosegrant, 1992). Figure 5.3 describes this framework and the accom-panying roles of children and teachers. Consideration of these components of the learning cycle helps prevent inappropriate expectations of mastery while encour-aging teachers to plan for learning beyond the exploration stage.

This framework for authentic teaching and assessment involves asking the fol-lowing questions: "Where did the student start?" "Where is the student going?" "Is the learner at the awareness, exploration, inquiry, or utilization stage?" (See Figure 2.4 in Chapter 2, p. 49). These questions need to be examined in terms of four categories of knowing: (1) the *knowledge* the child is acquiring (ideas, con-cepts, facts), (2) the *skills* the child is developing (physical, social, communicative, cognitive), (3) the *dispositions* the child is acquiring (attitudes, personality traits, curiosity, creativity, resourcefulness, responsibility, initiative, interests, efforts, mastery, challenge seeking), and (4) the *feelings* the child is developing (positive self-esteem, empowerment, autonomy as a learner) (Katz & Chard, 1989). These categories of knowing and learning can be related to the subject matter content of the curriculum and the processes used in teaching and assessing.

If a child is not having success, the teacher must first determine whether the difficulties are associated with health and nutrition, disabilities, or serious psy-chosocial issues. If these possibilities are eliminated, questions regarding the nature and content of the curriculum and the appropriateness of performance expectations must be asked. Such questions include the following:

◆ Does the child need more background information?

◆ Is this the most appropriate time for the child to be learning this information?

◆ Does the child need more challenging information?

◆ Do adjustments in curricular content and instructional strategies need to be made for learning styles, cultural orientations, special needs?

◆ Does instruction reflect age-appropriate standards as stated by the professional organizations representing the subject matter content areas?

Notice that No. 11 of the Guidelines for Curriculum Content in Figure 5.1 addresses the responsibility of early childhood educators to know the knowledge base of the subject matter disciplines. Broad knowledge in the content areas pro-vides teachers with a framework for developing enriched curriculums that are meaningful, relevant, mind-engaging and appropriate for the age and grade for which they are intended. Teachers can juxtapose national, state or local standards with these early childhood education guidelines to help them form the infrastruc-ture for their curriculum development. In so doing, where there are differences in the standards and expected learner outcomes, and the early childhood guide-

What Children Do	What Teachers Do
Awareness	
Experience	Create the environment
Acquire an interest	Provide opportunities by introducing new objects, events, people
Recognize broad parameters	
Attend	Invite interest by posing problem or question
Perceive	Respond to child's interest or shared experience
	Show interest, enthusiasm
Exploration	
Observe	Facilitate
Explore materials	Support and enhance exploration
Collect information	Provide opportunities for active exploration
Discover	Extend play
Create	Describe child's activity
Figure out components	Ask open-ended questions, "What else could you do?"
Construct own understanding	
Apply own rules	Respect child's thinking and rule systems
Create personal meaning	Allow for constructive error
Inquiry	
Examine	Help children refine understanding
Investigate	Guide children, focus attention
Propose explanations	Ask more focused questions, "What else works like this? What happens if?"
Focus	
Compare own thinking with that of others	Provide information when requested, "How do you spell?"
Generalize	
Relate to prior learning	Help children make connections
Adjust to conventional rule systems	
Utilization	
Use the learning in many ways; learning becomes functional	Create vehicles for application in real world
Represent learning in various ways	Help children apply to new situations
Apply to new situations	Provide meaningful situations to use learning
Formulate new hypotheses and repeat cycle	

Figure 5.3

Model of Learning and Teaching

Note: From "Guidelines for Appropriate Curriculum and Assessment in Programs Serving Children Ages Three Through Eight" by the National Association for the Education of Young Children and the National Association of Early Childhood Specialists in State Departments of Education, 1991, *Young Children, 46*(3), p. 36. Copyright © 1991 by NAEYC. Reprinted with permission.

lines, the curriculum can be developed to address these differences assuring that both developmental considerations and content knowledge and skills are addressed in age and individually appropriate ways. This exercise may entail serious choice-making on the part of the curriculum planner. Where standards and developmental issues are at odds, teachers must make decisions about what serves the best interest of the child in the long term. The following discussions address the various content areas taught in elementary school and what children can be expected to know, learn, and be able to do.

Language Arts and Literacy Development

Although a number of educators consider language arts (which includes listening, speaking, writing, reading) as a curricular content area, current perspectives view listening, speaking, reading, and writing as *tools* for learning that are used interchangeably throughout the entire school day These learning tools are used to acquire knowledge and skills in the visual and performing arts, math, science, technology, social studies, and physical education. We discuss language arts first because of its integrative nature and because it encompasses the acquisition of skills essential for academic success in all other content areas.

Contemporary scholarship on language arts and literacy bases curricular approaches on the work of Vygotsky (1962), which emphasizes the relationship between language acquisition and thinking processes. Vygotsky proposed that both cognitive development and language development are mutually dependent, one advancing the development of the other. Because language development is so important to communication and participation in social and cultural contexts, and is integral to literacy development, and because the abilities to listen, speak,

Children use the tools of language arts throughout the day as they engage in activities associated with math, science, social studies, the arts, and physical education.

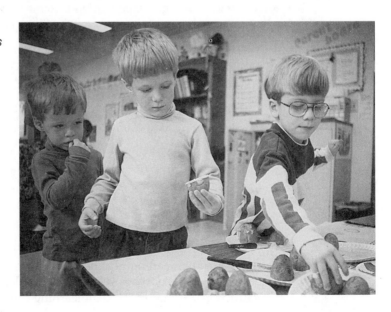

read, and write with facility are essential for achievement in all other content areas, it is critical that young children have many and varied opportunities to hear and use language as prerequisite to later formal content and skills instruction. To this end the language arts and literacy curriculums in early childhood education should provide the following types of essential experiences:

1. Varied opportunities to experience language in many forms and contexts including experiences with more than one language.
 - meaningful and authentic conversations and dialogue with adults
 - social interactions with other children
 - opportunities to engage in conversations with classmates
 - music and dance, songs, fingerplays, raps, rhymes, and poetry
 - enjoyable tales and stories shared in the oral tradition
 - interactive storybook reading
 - exposure to a wide variety of literature genres
 - opportunities to hear, learn, and practice labels, song, stories in additional languages

2. Varied opportunities to develop listening skills through the above activities as well as activities that require the listener to perform tasks such as the following:
 - Orally fill in the blank or complete the sentence or story (e.g., "We watched the _____ at the zoo;" "As I was walking past the picnic tables in the park, I wished that I could _____.")
 - Respond to and participate in predictable refrains in stories and poems.
 - Identify and locate a variety of environmental sounds.
 - Match sounds of objects hidden in small containers.
 - Listen for rhyming words in poetry and stories.
 - Responding to many genres of music, rhythm, and dance.
 - Practice giving full attention to a speaker.
 - Practice staying focused on a topic.
 - Respond to, ask questions, and share ideas.
 - Participate in group discussion and dialogue

3. Varied opportunities to experience print in many forms and contexts, such as the following:
 - noticing and "reading" environmental print
 - access to an array of books on many topics and with a variety of story themes
 - a potpourri of meaningful and inviting print media throughout the classroom on bulletin boards, rebus charts, learning center labels, game instructions, individual student learning contracts, posters and various

decorative (yet relevant and meaningful) media, and student produced writings and art work

4. Varied opportunities to write for many purposes and in many contexts, such as the following:

◆ labeling art work, dictating descriptions and stories

◆ copying environmental print

◆ writing one's own name and that of classmates

◆ keeping journals

◆ writing notes and letters

◆ composing songs, stories, and rhymes

◆ writing lists for class projects

These types of experiences provide essential foundational learning that must precede more formal instruction. All of these activities can take place in conjunction with any of the learning centers or instructional activities because they cross content area or subject matter boundaries.

Contemporary approaches to language arts and literacy instruction are found under many labels—student centered, naturalistic, developmental, organic, integrated, language experience, whole language, literature based and phonics based. Debate about the best ways to begin reading instruction has prevailed for many decades. Regardless of approach, all scholars agree that learning to read and to communicate effectively both orally and in writing, are critical to a child's success in school and in their personal lives. The tendency to stress one method over another, for example phonics instruction over more whole language, contextualized approaches has lead to curriculums that often fall short of their intent.

Ultimately, the learner must want to read, find pleasure in reading, and learn to use print media for both scholarly and entertainment pursuits. Instructional approaches that over-rely on memorization, skill and drill, work sheets, and frequent tests are inappropriate for young children because they too often mitigate against the learner's disposition to use reading for academic and pleasurable purposes, thus ultimately defeating their goals. Such approaches fail to consider the young child's need for hands-on, concrete experiences that relate to and build on the learner's prior knowledge and emerging physical/motor, psychosocial and cognitive skills. On the other hand, simply reading an array of stories and good books with children and placing labels and environmental print about the classroom also fails the learner for such practices do not recognize the child's need to be actively engaged in literacy-related endeavors that include reading and writing for real purposes.

Addressing the critical need for young children to have early literacy experiences that lead to skilled reading and writing for real purposes, the International Reading Association and the National Association for the Education of Young Children published a joint position statement on learning to read and write (see Appendix B). Citing classical and contemporary research on literacy development, the authors of this statement identify the following aspects of learning to read:

Birth Through Preschool

learning and experimenting with language

using visual and physical cues surrounding print to determine that print can represent meaning

experience with a range of writing and reading materials and activities in the home and child care settings

listening to stories read aloud accompanied by predictive and analytic questions, talking about the pictures, retelling the story, discussing favorite parts or actions in the story, having the story reread on request

learning about print—that is, that print has many distinguishing features, that print conveys meaning, that words comprise strings of letters followed by spaces, that reading progresses from left to right and top to bottom of the page, and so on

learning about the shapes of letters

acquiring the alphabetic principle, that is the understanding that there is a relationship between letters and sounds

developing linguistic awareness (the sounds of language) and phonemic awareness (the understanding that spoken words can be segmented into sounds, and syllables)

using invented (or phonemic) spelling to write

Kindergarten

vocabulary development

clarification of the concept of word by learning that talk can be written down (as with experience charts and children's dictations)

developing word awareness, spelling, and conventions of writing

acquiring proficiency in letter recognition including distinctions between upper and lower case letters

developing decoding skills through direct instruction coupled with opportunities to use these skills in meaningful contexts (as in literacy-related play (Neuman & Roskos, 1992), and project approaches (Katz & Chard, 1989)

The Primary Grades

systematic code instruction along with meaningful connected reading

developing fluent and accurate word identification

using knowledge of letter–sound patterns to read (decode) unfamiliar texts

using metacognitive strategies such as making predictions, self-correcting, rereading, questioning, and summarizing

independent practice through reading to others, sharing books in social contexts with other children, opportunities to choose books to be read

instruction that integrates reading and writing

learning about spelling through instruction

becoming an independent and productive reader

From the foregoing, it is clear that for children to become fluent readers who comprehend what they read, there is far more to learning to read than learning letter–sound combinations or simply listening to read aloud stories. Becoming literate is a process that proceeds with some measure of predictable flow from one set of language/literacy related experiences to another.

For purposes of assessment, knowledge of this flow and the experiences essential to its emergence is critical. Goals and expectations, instructional practices and activities, and assessment strategies can be formulated according to this progression. Attention may need to be given to family literacy issues that support or impede literacy development in individual children, since authentic assessment will necessarily take into consideration the learner's prior opportunities and current knowledge and skill repertoire. Observations of progress can be based on attainment of certain developmental benchmarks rather than on the acquisition of specific skill sets. Here again, we must emphasize that measurement instruments (whether standardized or teacher-created) that focus too narrowly on limited skill sets fail to provide a full picture of the learner's progress and emerging abilities. Refer to the Appendix B for a frame of reference for developing assessment benchmarks.

In addition, the assessment of young children's performance in reading and language arts must be *context responsive*. Context-responsive assessment is characterized by the following features:

1. The present and past elements of time are important to context-responsive assessment. Children are constantly observed in the *present*, "talked with in the process of doing—of writing, of exploring language, of telling about their experiences as writers, listeners, creators" (p. 3). The *past* is also important in context-responsive assessment "as children are encouraged to reflect on earlier experiences and how those experiences relate to the present" (p. 3).

2. Context-responsive assessment is collaborative and social in that children, teachers, administrators, and parents "participate in a dialogue" that guides curriculum, instruction, and assessment. Children also share their views of themselves as readers and writers, their work, and their plans for continued learning.

3. Planned and unplanned curricular experiences are valued in context-responsive assessment. The complex nature of human backgrounds and experiences coupled with the dynamics of human interaction create learning contexts that are unpredictable and spontaneous. This dimension of human behavior casts the teacher in the role of "continuous planning while observing, listening to, and talking with students" (p. 4).

4. Context-responsive assessment views teachers and children as both initiators and responders in the teaching and learning process. Both teachers and children are seen as co-learners, as partners and collaborators who work together.

5. Children are viewed as "key participants," "developing beings" possessing knowledge, active contributors in the shaping of their learning, "unique," participants in assessing their progress, "problem finders," and "knowledge seekers" as well as "constructors of knowledge" (pp. 4, 5).

6. Teachers are viewed as *decision makers* because they make judgments and instructional decisions based on "data generated during interactions with children" (p. 5). The quality of these interactions depends on the teacher's listening, observing, and documenting skills. Teachers must decide what learning is worth pursuing and what learning should be "let go of" (p. 3). Teachers are also *creators* of materials and *designers* of procedures, including those for "particular children in particular settings" (p. 5). Teachers intentionally plan for observing children's learning, thinking carefully about what they will listen for as well as their questions and conversations as they talk with children about present or future work (p. 3). Reflecting upon these encounters helps teachers to "envision and create opportunities to create new curriculum" (p. 6). In this process, teachers renew themselves and empower their children as co-learners. Finally, in context-responsive assessment, teachers communicate to those outside the classroom concerning the learning that is occurring in children's lives.

7. Although the context-responsive environment views public knowledge as important, personal knowledge is considered vital to the learning process. Children are encouraged to share the personal knowledge they bring to the classroom and are viewed as "capable of sharing the knowledge they create during their interactions with materials and people" (p. 7). Knowledge is also viewed as "tentative," "in process," and "developing over time." This dynamic perspective of learning cannot be measured by traditional assessment approaches that view knowledge from a static or fixed viewpoint. The aspects of context-responsive assessment described here can also be extended into all other curricular areas (Roderick, 1991, pp. 1–8).

The Arts and Aesthetic Development: Visual Arts, Music, Dance, and Drama

Throughout this text we address the importance of problem solving and higher order thinking skills as essential cognitive attributes. These abilities can be developed and refined through creative and artistic opportunities (Jensen, 1998). In addition, arts education is particularly compatible with the concept of multiple intelligences. Hanna (1992) stated it well: "The arts draw upon multiple intelligences and are conceptually language-like, for humans communicate in multiple ways: visually, aurally, kinesthetically and linguistically" (p. 604). Moreover, research indicates that the arts can encourage "cognitive, aesthetic growth and development of students" (Hanna, 1992, p. 607). The arts provide the forms through which knowledge, insight, and feeling can be represented. In addition to the *expression* of knowledge, the arts can also facilitate the process of *discovery* (Eisner, 1992, p. 595). Eisner explains how these discoveries are made:

As children learn to manipulate, manage and monitor the nuances of voice, movement and visual form, they discover the effects that their fine tuning achieves. As

form is modulated, so too is feeling. As imagination is given permission to rise, children have the opportunity to enter worlds not tied to the literal, to the concrete, to the practical. Discovery emerges in the appreciation of qualities examined and images pursued. (p. 595)

A good arts curriculum can facilitate children's appreciation of the heritage of other cultures and civilizations (U.S. Department of Education & National Endowment for the Arts, 1992). The U.S. Department of Education, the National Endowment for the Arts, and the National Endowment for the Humanities have cooperatively developed standards "that describe the knowledge, skills, and understanding that all students should acquire in the arts" (U.S. Department of Education & National Endowment for the Arts, 1992, p. 2). Also, the Consortium of National Arts Education Associations has developed National Standards for Arts Education which defines what children should know and be able to do in the visual arts (Consortium of National Arts Education Associations, 1994). These frameworks provide the basis for ensuring that all children learn about the arts and for improving teacher education, professional development and assessment.

Aesthetic development depends on opportunities to experience many art forms.

In addition, the National Assessment of Educational Progress has included an art assessment that is aligned with the World Class Standards developed by the collaborative efforts of the U.S. Department of Education, the National Endowment of the Arts, and the National Endowment for the Humanities.

The arts will have an increasingly important role to play in the curriculum of the future. The use of the senses and a variety of modalities to learn as well as to express feeling and knowing has been and will continue to be an important part of early childhood education (Gardner, 1991b; Sylwester, 1998). Because expression is such an integral part of human development, it should be an integral part of not only teaching and learning but assessment as well. Consequently, because there are many ways to express knowledge, students need to be given many ways to express what they know. Thus, drawings, sculptures, crafts, rhymes, poems, and chants, songs, music, movement, and dances are all ways for children to demonstrate their knowing and their abilities. These demonstrations provide rich information for the assessment process. The point is nicely summarized by Hanna (1992),. "Students can learn in the arts, about the arts, and through the arts" (p. 697).

Aesthetic development during the early years depends on opportunities to experience and participate in the visual arts, music, dance, and drama. A major goal of education is that individuals develop an appreciation of various art forms and become personally engaged in the arts in ways that are pleasing and developmentally beneficial. To this end the arts curriculum provides young children with the following essential experiences:

Visual Arts

opportunities to explore, manipulate, and create with a variety of art media with minimum direction on how to use or what to produce

freedom to express feelings and emerging concepts and understandings through art media

opportunities to work alone or with others in creative activities

socially and emotionally satisfying interactions associated with creative activities

opportunities to talk or write about own creations and to have them appreciatively and tastefully displayed

introduction to a variety of artists and genres of visual arts through field trips to museums, pottery and sculpture exhibits, craft shows, statues, and monuments, visiting artists, children's libraries, and book displays

exposure to artistic photography, posters, reproductions of masterpieces and other art

discussions of a variety of art forms that help children focus and respond to what they see

opportunities to learn about selected children's book illustrators and other artists and their works

Music and Dance

many opportunities to participate in enjoyable musical experiences with adults and other children

a variety of experiences with vocal, instrumental, and environmental sounds

opportunities to explore and experiment with sound patterns

opportunities to listen to many genres of music

learning a variety of songs, fingerplays, rhythms and dances

opportunities to respond expressively and rhythmically to many genres of music

freedom to improvise with music through chanting, singing, dancing, and
 interacting with others

exploration and experimentation with a variety of musical instruments.

introduction to age-appropriate music concepts through participatory experi-
 ences: soft, loud, fast, slow, rhythm, melody, names of musical instruments

introduction to song books that illustrate both the lyrics and the musical score

opportunities to observe others in skilled use of musical instruments, singing,
 and dancing

emotionally and socially satisfying experiences with music in many contexts

Drama

freedom to become engaged in sociodramatic play both alone and with others

exposure to a variety of themes for sociodramatic play through age-appropri-
 ate, high-quality children's literature and drama and theater productions

opportunities to participate in pretend and role playing, puppetry, pantomim-
 ing, and a variety of sensory and mood awareness activities that include
 appropriate props and prompts

emotionally and socially satisfying experiences in group dialogue and discus-
 sions, sociodramatic play, spontaneous dramatic presentations, shared
 books and story reading, and exposures to the performing arts through field
 trips to community theaters and age appropriate special performing arts
 events and visiting performing arts professionals

Assessment of the young child's emerging aesthetic appreciation and arts abilities
needs to be in keeping with the following understandings about how such attrib-
utes develop (Andress, 1995; Kolb, 1996; Gardner, 1993; Isenberg & Jalongo, 1996;
McDonald, & Simons, 1989; Sylwester, 1998; Thompson, 1995; Weinberger, 1998):

◆ Sensory experiences enhance all cognitive development. Art, music, and
 drama are natural and enjoyable sources for rich sensory experiences.

◆ Pleasurable art, music, dance, drama and sociodramatic play enhance creativ-
 ity and promote a sense of emotional well-being and personality adjustment,
 social development and a sense of self-efficacy and self-worth.

◆ Art, music and drama provide psychologically safe outlets for expressing and
 understanding feelings.

◆ Both sociodramatic play themes and art work are most often created from chil-
 dren's personal or immediate experiences, and generally reveal topics or
 events that are currently foremost in importance to them.

Fairly predictable stages can be found in drawing, sculpting, block building, singing, creative movement and dance, sociodramatic play, and other creative abilities that proceed from rudimentary and unsophisticated to more skilled and complex, with children progressing through general patterns of development at different and individual rates.

Children benefit from the arts curriculum in the following ways:

◆ Children develop their ability to discriminate sounds, rhythms, and musical forms through experiences in listening, singing, movement, and dance.

◆ Opportunities to hear and experience many genres of music enhance language development and listening ability, which in turn, enhances phonemic awareness and literacy development.

◆ The ability to discriminate rhythm and repetition patterns enhances children's ability to recognize mathematical patterns.

◆ Children develop understanding of story through their sociodramatic play in which there are often beginning, middle and end points as well as characters, themes and plots.

Observation of children's active participation in art, music, dance, drama, and sociodramatic play provides valuable information about each child's interests and capabilities in each of these areas as well as their emerging abilities, concepts, and understandings in other content areas.

Mathematics

The National Council of Teachers of Mathematics (NCTM) (1989) was one of the first professional educator organizations to develop a set of standards for education in its discipline. These standards articulated five general goals for all students: (1) learning to value mathematics, (2) becoming confident in one's own ability, (3) becoming a mathematical problem solver, (4) learning to communicate mathematically, and (5) learning to reason mathematically (pp. 5–6). In presenting its standards, the council stated that new goals were needed in the area of mathematics because of the shift from an industrial- to an information-oriented world society. The standards place heavy emphasis on hands-on experiences to help students better learn and apply mathematical concepts and problem-solving strategies.

Some educators criticized the first publication of the standards for not sufficiently emphasizing the teaching of basic skills. In response to this concern, the NCTM has been working on revised standards which place greater emphasis on teaching basic skills while reaffirming the organization's position that students need to be actively and intimately involved in concrete, firsthand mathematical experiences that can be immediately applied in real-life contexts. It is anticipated that the revised version of the NCTM standards will be formally adopted by the organization at its annual meeting in 2000. For purposes of this discussion, we shall rely on the 1989 standards with the caveat that teaching mathematics to

young children entails an understanding of the manner in which children cognitively construct number concepts and relationships, a process that requires that their experiences be concrete, related to prior understandings, applicable in real-life contexts, and integrated across disciplines in the early childhood curriculum.

Three aspects of mathematics are incorporated in the 1989 NCTM standards. The first is an emphasis on "doing" rather than knowing mathematics. Second, because ways of doing mathematics have changed and because mathematics provides a foundation for other disciplines, students need an awareness of mathematical models, structures, and simulations applicable to a variety of disciplines. Third, because technology has changed mathematics and its uses, NCTM recommends that calculators, as appropriate, and computers be available in classrooms for demonstration purposes, individual and group work, and to allow students to learn to use technology as a tool for processing information and problem solving activities.

Student active engagement is strongly encouraged by these standards. Mathematical activities must grow out of problem situations and involve active participation through appropriate "project work, group and individual assignments, discussion between teacher and students and among students, practice on mathematical methods and exposition by the teacher" (NCTM, 1989, p. 10). In addition, teachers need to consider students' maturity levels, including their current mathematical level and cultural and experiential background. The emphasis in the primary grades is on mathematical language, particularly that relating to whole numbers, common fractions, and descriptive geometry.

Mathematics instruction should evolve from familiar problem situations so that the structure of the situation embedded in each student's memory becomes a foundation for reconstruction at a later time when the problem represents itself. Best stated by Zaslavsky (1998): "The most important and most valid mathematics curriculum is one that resonates to the students' own lives and experiences" (p. 5). The pedagogy of mathematics for young children must include opportunities to use number, measurement, space, and time concepts in meaningful, and relevant contexts. Teachers, then will need to take a student-centered approach to instruction and incorporate a variety of methodologies appropriate for individual, small-group, or large-group instruction.

This is emphasized in the NCTM 1989 curriculum standards for grades K–4 in which traditional and contemporary strategies are contrasted. Instruction traditionally has focused on computation exercises where young students become "passive receivers of rules and procedures rather than active participants in creating knowledge," resulting in a diminution of the student's "belief that learning mathematics is a sense-making experience" (NCTM, 1989, p. 15). Figure 5.4 provides a summary of changes in content and emphasis in K–4 mathematics.

The mathematics curriculum standards for grades K–4 suggests the following criteria:

1. *Address the relationship between young children and mathematics.* Young children's intellectual, social and emotional development should guide their mathematical experiences.

Increased Attention	**Decreased Attention**
Number	*Number*
• Number sense	• Early attention to reading, writing, and ordering numbers symbolically
• Place-value concepts	
• Meaning of fractions and decimals	
• Estimation of quantities	
Operations and Computation	*Operations and Computation*
• Meaning of operations	• Complex paper-and-pencil computations
• Operation sense	• Isolated treatment of paper-and-pencil computations
• Mental computation	
• Estimation and the reasonableness of answers	• Addition and subtraction without renaming
• Selection of an appropriate computational method	• Isolated treatment of division facts
	• Long division
• Use of calculators for complex computation	• Long division without remainders
	• Paper-and-pencil fraction computation
• Thinking strategies for basic facts	• Use of rounding to estimate
Geometry and Measurement	*Geometry and Measurement*
• Properties of geometric figures	• Primary focus on naming geometric figures
• Geometric relationships	• Memorization of equivalencies between units of measurement
• Spatial sense	
• Process of measuring	
• Concepts related to units of measurement	
• Actual measuring	
• Estimation of measurements	
• Use of measurement and geometry ideas throughout the curriculum	
Probability and Statistics	
• Collection and organization of data	
• Exploration of chance	
Patterns and Relationships	
• Pattern recognition and description	
• Use of variables to express relationships	

Figure 5.4
Summary of Changes in Content and Emphasis in K–4 Mathematics

Increased Attention	**Decreased Attention**
Problem Solving	*Problem Solving*
• Word problems with a variety of structures	• Use of clue words to determine which operation to use
• Use of everyday problems	
• Applications	
• Study of patterns and relationships	
• Problem-solving strategies	
Instructional Practices	*Instructional Practices*
• Use of manipulative materials	• Rote practice
• Cooperative work	• Rote memorization of rules
• Discussion of mathematics	• One answer and one method
• Questioning	• Use of worksheets
• Justification of thinking	• Written practice
• Writing about mathematics	• Teaching by telling
• Problem-solving approach to instruction	
• Content integration	
• Use of calculators and computers	

Figure 5.4, *continued*

Note: From *Curriculum and Evaluation Standards for School Mathematics* (pp. 20–21) by the National Council of Teachers of Mathematics, 1989, Reston, VA: Author. Copyright © 1989 by the National Council of Teachers of Mathematics. Reprinted with permission.

2. *Recognize the importance of the qualitative dimensions of children's learning.* Understanding of mathematical ideas is far more important than acquiring a number of skills.

3. *Build beliefs about what mathematics is, about what it means to know and do mathematics, and about children's view of themselves as mathematics learners.* The attitudes young children develop about math influence their attitudes and decisions about math later in life. (NCTM, 1989, pp. 16–17)

A number of basic assumptions influenced the specific K–4 standards. These include the following:

1. *The K–4 curriculum should be conceptually oriented.* Children construct meanings in the context of physical situations.

2. *The K–4 curriculum should actively involve children in doing mathematics.* Children need opportunities to "explore, justify, represent, solve, construct, discuss, use, investigate, develop, and predict" in classrooms that are equipped with "counters; interlocking cubes; connecting links; base-ten attribute and pattern blocks; tiles; geometric models; rulers; spinners; colored rods; geoboards; bal-

ances; fraction pieces; and graph, grid, and dot paper." Household objects such as "buttons, dried beans, shells, egg cartons, and milk cartons" also should be available.

3. *The K–4 curriculum should emphasize the development of children's mathematical thinking and reasoning abilities.* Opportunities for problem solving need to be provided from the beginning of kindergarten.

4. *The K–4 curriculum should emphasize the application of mathematics.* Real-world problems need to be used in K–4 classrooms.

5. *The K–4 curriculum should include a broad range of content.* Young children need to learn about the various branches of mathematics, such as measurement, geometry, statistics, probability, and algebra and their interconnectedness.

6. *The K–4 curriculum should make appropriate and ongoing use of calculators and computers.* While paper-and-pencil computation is appropriate for certain tasks, the use of the calculator helps children to develop awareness of when it is expedient to compute in other ways. Computers can help young children become aware of geometric concepts, renaming of numbers, problem-solving situations, and applications. (NCTM, 1989, pp. 17–19)

The specific K–4 standards include the following topics:

1. Mathematics as problem solving
2. Mathematics as communication
3. Mathematics as reasoning
4. Mathematics as connections
5. Estimation
6. Number sense and numeration
7. Concepts of whole number operations
8. Whole number computation
9. Geometry and spatial sense
10. Measurement
11. Statistics and probability
12. Fractions and decimals
13. Patterns and relationships (NCTM, 1989, p. 15)

Assessment of student mathematical understandings and performance have been addressed by both the National Council of Teachers of Mathematics (NCTM) (1989, 1994) and the Mathematical Sciences Education Board (MSEB) (1994). These assessment standards suggest the following:

◆ student assessment be integral to instruction

◆ multiple means of assessment be used

◆ all aspects of mathematical knowledge and its connections be assessed

◆ instruction and curriculum be considered equally in judging the quality of the program. (NCTM, 1989)

◆ assessment should reflect the mathematics that is most important for students to learn

◆ assessment should enhance mathematics learning

◆ assessment should promote equity by giving each student optimal opportunities to meet expectations and to demonstrate what they know and can do (NCTM, 1994; MSEB, 1994).

This differs from prior methods of assessment in mathematics that generally took a deficit view determining what students do not know, basing grades on number of correct answers, focusing on skill sets, relying mostly on written tests, and excluding calculators, computers, and manipulatives from the assessment process (NCTM, 1989, 1994).

Instead assessment can include techniques that can be used individually, in small groups, or in whole-class settings in a variety of modes: written, oral, manipulatives, or computer oriented. Some examples are dramatizations, class presentations, journals, projects, open-ended or structured interviews, open-ended homework activities, discussion of problems and problem-solving strategies, and exploration of alternative solutions to problems. The assessment should determine the young child's dispositions and abilities to:

◆ explore and use manipulatives to construct, compare, contrast, classify, group, sequence, and measure.

◆ understand and use mathematical concepts and vocabulary (over/under, up/down, around, beside, between, behind/in front, inside/outside, before/after, greater than/less than, large/small, tall/short, long/short, full/empty, yesterday today, tomorrow, much, many, few, part/whole, and so on.)

◆ perceive and discuss size, shape, distance, depth, geometric shapes.

◆ perceive and discuss volume, weight, length, and temperature.

◆ sort and classify objects by more than one attribute (size, shape, color, composition, origin, use, and so on).

◆ perceive and construct patterns using objects and art media.

◆ construct mathematics meaning through both informal and planned problem solving experiences.

◆ count objects using one-to-one correspondence.

◆ use real objects in tandem with pictorial representations (rebus charts, simple recipes, graphs, charts, tables, geometric drawings and illustrations) to construct mathematical meaning.

◆ recognize numerals and other mathematical symbols in print.

◆ use numerals in drawings and writings (at first randomly, then in meaningful contexts).

◆ discuss and solve simple, meaningful mathematical word/story problems.

◆ use both nonstandard and standard units of measure.

◆ form and manipulate sets using addition and subtraction strategies.

◆ write and solve simple addition and subtraction problems (at more experienced levels, multiplication and division).

◆ discuss the use of mathematics in daily lives.

◆ relate to and understand mathematical language and concepts in children's literature and environmental print, social studies, science and health education activities, and other aspects of curriculum and learning.

◆ apply learned mathematics in other activities.

As with other subject matter–content knowledge, there is a continuum of learning that proceeds from the very simple to the complex, though not necessar-

Optimal learning occurs when instructional strategies focus on children's ability to think rather than simply recall or produce correct answers.

ily in an orderly fashion and certainly varied from child to child and among concepts and skills held by each child. Curriculum must integrate mathematics across disciplines and be rich and varied in its invitations to learners to construct mathematical meaning. Constance Kamii, a leading authority on how young children construct or "invent" mathematical understanding encourages instructional strategies that focus more on children's ability to *think* than on their ability to simply recall or learn techniques for producing correct answers to mathematical problems (Kamii, 1985, 1989).

Science

As with mathematics, educators have been guided by science education standards developed through consensus of professionals in the science disciplines. Goals for science processes and content for children have been proposed by the National Center for Improving Science Education (NCISE, 1990). Also, standards are proposed in *Science for All Americans* (American Association for the Advancement of Science, 1990) and *Benchmarks for Science Literacy* (AAAS, 1993). In addition, the National Research Council of the National Academy of Science (1996) has published *National Science Education Standards*. As with mathematics, a common theme running through these sets of goals and standards is an emphasis on instructional practices that focus on logic and thinking abilities rather than simply on the memorization of facts and formulas. The standards are compatible with the tenets of developmentally appropriate practices in that they encourage opportunities for children to construct meaning from their experiences through direct involvement and interactions with materials, classmates, and adults.

Emerging perspectives on science education are shifting the emphasis from discipline specific (biology, chemistry, physics and so on), facts and theory based primarily on inquiry to a social context. In stating a case for a "lived" science curriculum, Paul Hurd, professor emeritus of science education at Stanford University, states the following:

> To reinvent science curricula we must recognize that the nation is moving into a learning society and a knowledge-intensive era. This move has made "learning to learn" a goal for all school subjects. For the sciences this indicates a focus on the new interpretation of what is meant by scientific literacy. The view now seen is one of developing higher-level thinking skills, such as decision making, forming judgments, and resolving problems. Each of these skills depends upon acquiring a variety of cognitive strategies; for example, recognizing risks, ethics, values, and the adequacy of appropriate information. This shift in emphasis is from scientific inquiry to the optimal utilization of science knowledge in human affairs, including social and economic progress. (Hurd, 1997)

Further, Hurd points out that electronic communication now provides access to a huge amount of up-to-date information and ways to access, compare and analyze information on just about any topic. Such access facilitates the development of informed and enriched science curriculums for children. Curriculum

development, however, becomes more complex as children identify topics of particular interest to them and as teachers engage in the important task of discerning and selecting developmentally appropriate topics to explore and to be matched with concrete, hands-on experiences in the classroom. Certainly, the information age is facilitating the development of in-depth study of the topics students and teachers choose.

Early childhood education has an opportune role to play in the development of scientific literacy in young children through its characteristic emphasis on the exploration, discovery, inquiry and utilization paradigm. This paradigm values both the content and the processes by which children come into knowledge and skills associated with various content areas. Such classrooms assure that all children regardless of race, culture, gender, or ableness have varied opportunities to experience all content areas including science and technology in meaningful and authentic ways.

Science curriculums are based on and emanate from the prior and daily experiences and immediate environment of learners. Daily experiences often naturally involve scientific phenomena relating to people, places, time, weather, objects or things, plants, animals, change, and interrelationships. Early childhood educators are keenly aware of the young child's natural curiosity and use that knowledge about children to focus their explorations on topics and events associated with scientific phenomenon. Positive and helpful responses to children's curiosity and special interests facilitate the child's emerging science literacy and continuing disposition to pursue scientific information. Acknowledging the young child's sense of wonder with each new discovery and providing the resources to pursue additional information contribute to the child's maturing interest in science.

Many of the same cognitive processes involved in constructing mathematics understanding are involved in science understanding: observing, comparing, contrasting, classifying, ordering, measuring, estimating, and vocabulary development. Additionally, the scientific process includes controlling variables, demonstrating, describing, forming theories and hypotheses, anticipating cause and effect, generalizing, identifying and describing, interpreting, inferring, predicting outcomes, recording data, and verifying results. Curriculums then, should provide meaningful and relevant science activities that engage these cognitive processes, but it is particularly crucial that content, activities and expectations match the cognitive capabilities of the learner at different stages of development (Brophy, 1983). Assessment strategies focus on these cognitive processes and the particular and sustained interests that individual children demonstrate in their science explorations and discoveries.

The content of the early childhood science curriculum can be quite varied usually focusing on topics in three broad categories: health and the human body (which can include topics relating to personal hygiene, disease prevention, nutrition, dental health, and safety; physical sciences (which can include concepts associated with such phenomena as magnets, levers, wheels, pulleys, vibrations and sounds, and so on, and earth sciences (which includes topics such as air, land, water, plants, animals, weather, and so on). Science concepts and processes inte-

grate easily into all other content areas in the curriculum when the goals for science with young children are kept in mind:

> to develop each child's innate curiosity about the world
> to broaden each child's procedural and thinking skills for investigating the world, solving problems, and making decisions
> to increase each child's knowledge of the natural world. (Kilmer & Hofman, 1995, p. 45)

Valid assessments in science, as in the other curricular areas previously discussed, are blended with learning—"they match instruction, because teaching, learning and assessment are closely interwoven and the teacher should move comfortably from one to the other as purposes change" (Loucks–Horsley, 1989, p. 86). Assessments focus on hands-on performance and process, as well as verbal and written products. Examining the nature and depth of children's understanding through scaffolding is an important aspect of good assessment of science learning. Finally, assessment includes detecting whether children extend and apply their learning into related situations and contexts.

Social Studies

In 1987, the National Commission on Social Studies in the Schools (NCSSS) published "a coherent vision of the role of social studies in the general education of our young people [that] is based upon a wise and studied determination of what it is that students should know and value if they are equipped to be responsible citizens in a society that will be characterized by increasing complexity, diversity and worldwide interdependency." (NCSSS, 1989, p. vii). The National Council for Social Studies (NCSS) (1989) has also developed frameworks for social studies education.

Social studies combines the fields of history, geography, government and civics, economics, anthropology, sociology, psychology, and the humanities "and uses them in a direct way to develop a systematic and interrelated study of people" in past and present societies (NCSSS, 1989, p. ix). The NCSSS rationale for the position statement on the social studies in the twenty-first century states, "Today's social studies curriculum must change because schools themselves are changing—because our society is changing and because our society is changing in relation to the world" (NCSSS, 1989, p. x). To understand the sociological and economic realities of a rapidly changing world, individuals must have an understanding of political and cultural diversity and their own history. Figure 5.5 lists the goals for social studies education.

What application do these goals have for early childhood education? Social studies curriculum for grades K–3:

◆ lays the foundation for social studies education to follow.

◆ excites student interest in social studies and capitalizes on the eagerness of young children to learn.

The Social Studies Curriculum should enable students to develop:
1. Civic responsibility and active civic participation
2. Perspectives on their own life experiences so they see themselves as part of the larger human adventure in time and place
3. A critical understanding of the history, geography, economic, political and social institutions, traditions, and values of the United States as expressed in both their unity and diversity
4. An understanding of other peoples and the unity and diversity of world history, geography, institutions, traditions, and values
5. Critical attitudes and analytical perspectives appropriate to analysis of the human condition

Figure 5.5
The Goals for Social Studies Education
Note: From *Charting a Course: Social Studies for the Twenty-First Century* (p. 6) by the National Commission on Social Studies in the Schools, 1989, Washington, DC: Author. Copyright © 1989 by the National Council for the Social Studies. Reprinted with permission.

- helps students gain a better understanding of themselves and the world within and beyond the classroom.
- is relevant to the needs and interests of young learners.
- is presented in active and engaging ways appropriate to young children's cognitive development.
- maintains a balance of local, national, and global information and concepts.
- helps children recognize how details fit into a larger whole.
- incorporates international perspectives and provides multicultural experiences in an authentic and culturally sensitive manner.
- helps students learn that each individual plays multiple and varied roles and that roles change as circumstances change.
- deals with learning how to make and follow school and community rules.
- nurtures citizenship participation skills.
- introduces basic social science disciplines through concrete applications to particular situations (second and third grades).
- helps children learn about the similarities and differences of families and their own immediate environment through concrete experiences and far away environments through pictures and films (and distance learning).
- facilitates understanding through use of songs, stories, pictures, artifacts, role play, map making and model building.
- helps children comprehend the concept of community, differences in environments and people.

♦ introduces geographic skills.

♦ locates experiences in time and space appropriate to children's cognitive levels.

♦ introduces children to a variety of persons providing models for emulation and adoration.

♦ is integrated with other subject matter areas.

♦ incorporates literature, art, music, and artifacts.

♦ provides opportunities for drawing, building, singing, and acting to make learning fun and stimulate imagination.

♦ uses holidays to acquaint children with social studies concepts and information with the intent to inform, not indoctrinate.

♦ provides coherence and balance from year to year as well as within each grade. (NCSSS, 1987, pp. 7–9)

By the end of third grade, children are expected to have an elementary understanding of world geography (continents, major countries, and climate zones); a familiarity through maps of their immediate environment at neighborhood, city, state, and national levels; knowledge of their community; initial understanding of civic and political traditions of the United States; and a strong sense of human life in different places and times in the past (NCSSS, 1987, p. 9). In addition to the position statement already discussed, the National Council for the Social Studies (NCSS) developed a Global Education Position Statement (NCSS, 1981). This statement recommended the fusion of elements of environmental education and cultural studies with existing curriculum to make children aware of ecological and sociological issues and problems of global concern. Carol Seefeldt, a leading authority on social studies in early childhood education states, " . . . social studies makes us human. The social processes of interacting and negotiating, and the social skills of our society, are practiced, honed, and built through the social studies." (Seefeldt, 1997, p. 194).

As with all other assessment in the content areas, assessment in the social studies relies on the contexts in which children demonstrate their understandings and increasing knowledge. For example, the interweaving of a sense of community and democracy in the classroom through strategies that allow children to participate in rule making, decision making, group consensus building, and voting provide the context for children to demonstrate their increasing social and moral competence. While merely posing questions about the meaning of "democracy" would be inappropriate, calling for abstractions difficult for the young child to conceptualize and articulate. Through curricular themes, project work and "lived" social studies experiences, children can demonstrate their knowledge base and abilities to apply what they know in practical ways in their daily lives. For example, geographical concepts can begin with learning about left and right sides of the body through rhythm and dance followed by demonstrations of ability to follow and give location directions based on immediate and personal experiences, and later expanded to places or objects beyond immediate surroundings. Spatial

perspective-taking is a cognitive process that emerges slowly and is an ability pre-requisite to the ability to provide directional information in response to another's needs. These abilities and others associated with space and distance precede the ability to use maps and other geographic representations. Thus, as with all other content areas, it is important to match social studies with the child's immediate and background experiences and emerging cognitive and social development.

Physical Education

As with other curriculum subject matter/content areas, physical education is guided by national standards published by the National Association for Sport and Physical Education (1995). The document expands on seven national standards for physical education and advances the concept of the "physically educated person."

The seven NASPE standards are the following:

1. Demonstrates competency in many forms and proficiency in a few move-ment forms.
2. Applies movement concepts and principles to the learning and development of motor skills.
3. Exhibits a physically active lifestyle.
4. Achieves and maintains a health-enhancing level of physical fitness.
5. Demonstrates responsible personal and social behavior in physical activity settings.
6. Demonstrates understanding and respect for differences among people in physical activity settings.
7. Understands that physical activity provides opportunities for enjoyment, self-expression, and social interaction.

Some examples of emphases in these standards for children in kindergarten include the following:

◆ Demonstrate progress toward the mature form of selected manipulative, loco-motor, and nonlocomotor skills; and demonstrates mature form in walking and running.

◆ Establish a beginning movement vocabulary (personal space, high/low levels, fast/slow speed, light/heavy weights, balance, twist; and apply appropriate concepts to performance—e.g., change direction while running).

◆ Engage in moderate to vigorous physical activity.

◆ Sustain moderate to vigorous physical activity for short periods of time and identify the physiological signs of moderate physical activity (e.g. fast heart rate, heavy breathing)

◆ Associate positive feelings with participation in physical activity (NASPE, 1995).

Though our national health and well-being "report card" (U.S. Department of Human Services et al., 1996), would suggest otherwise, few of us are unaware of the importance of physical activity in the maintenance of health and the prevention of disease. Health-care professionals continuously remind and urge us to take advantage of the potential positive effects that can accrue from habits of regular moderate to vigorous physical activity. Regular exercise has been shown to reduce the incidence or severity of blood pressure abnormalities, heart disease, diabetes, and some forms of cancer, and can have positive psychological effects by decreasing states of depression and anxiety and increasing a sense of emotional well-being. Regular exercise strengthens bones and muscles and aids in weight control. For young children, whose physical/motor coordinations are just emerging, the need for opportunities to engage in all sorts of movement activities (both guided and spontaneous) is not only beneficial for health and well-being, but also a critical contribution to their overall growth and development.

The physical education curriculum for young children is derived from observation and knowledge of the naturally emerging physical motor coordination and movement capabilities of children. Gallahue and Ozmun (1995) identify the following phases of movement development:

◆ reflexive movement phase from the prenatal period to about 1.4 years
◆ rudimentary movement phase from birth to 2 years
◆ fundamental movement phase from 2 to 7 years
◆ specialized movement phase from 7 to 14 years.

Knowledge of these phases can be instructive for planning developmentally appropriate physical/motor activities and experiences, and for the assessment of individual capabilities. Within these phases and among children of the same age we find that children can be quite dissimilar from one another in their gross and fine motor coordinations and abilities. Some may exhibit movement abilities that seem crude and uncoordinated, while others appear to be quite controlled, smooth, and precise. Most children exhibit large motor controls (walking, running, climbing, and so on) before fine motor coordinations (stringing beads, writing "within the lines," manipulating buttons, zippers, and small objects). Though this may not always be true. Some children may engage quite efficiently in activities requiring fine motor skills, yet still need opportunities to develop large motor controls.

There are also variations in agility, flexibility, balance, strength, and endurance among children, as well as laterality, handedness, prehension, and dexterity. Individual visual, auditory, tactile, and kinesthetic characteristics are intimately related to perceptual motor development, and hence, to coordination and movement capabilities. All of these aspects of development account for variations among children of the same age. These attributes both influence and are influenced by the quality and quantity of physical activity individual children experience.

Variations in physical motor and movement abilities among young children are due to a number of factors including genetic makeup; nutrition and general

health; energy levels and motivation; prior positive or negative experiences with physical activities, games, and sports; adult and peer encouragement and support; physical environments that are safe and conducive to movement and physical activity; self-esteem and self-confidence; cultural values associated with physical activities and games, and others.

Physical education for young children should include both guided and instructed activities and opportunities for spontaneous movement and play. The physical education program for young children should include the following essential experiences:

nutrition, health, and safety instruction
opportunities to run, climb, jump, kick, reach, bend, stretch, twist, swing,
 sway, roll, crawl, dance, slide, hop, skip, march, gallop
opportunities to pull, push and ride wheeled toys (e.g., tricycles, wagons)
opportunities to use a variety of safe sports and playground equipment
throwing and catching balls and bean bags
throwing balls and bean bags to a target
walking low, wide balance beam
responding creatively to music
participating in simple noncompetitive games
kicking balls toward a target
running and stooping or changing direction on cue
learning to use simple sports equipment, balls, bats, racket, and so on
learning safe and appropriate use of playground and sports equipment

Assessment of participation and performance in physical education must consider children's current emerging knowledge level, experience, and physical skills in tandem with the factors we just outlined that influence variations among children. Again, Gallahue and Ozmun (1995) are instructive. They identify three levels of learning new movement skills:

1. *beginning/novice,* which is characterized by exploration and discovery

2. *intermediate practice,* which is characterized by two stages, a *combination* and an *application stage* which include integrating, utilizing, refining, and applying movement skills;

3. *advanced fine-tuning,* which is characterized by a *performance* stage that demonstrates some degree of precision and an *individualized* stage in which the performance is personalized by the individual.

Young children, according to Gallahue and Ozmun seldom are at this latter stage (Gallahue & Ozmun, 1995).

By assessing the current physical motor abilities and status of children, physical education curriculum can be developed to fit individual needs and abilities. This, of course, is superior to attempting to fit children into a predetermined program. A developmental point of view is essential if children are to experience physical activity in ways that encourage and motivate rather than defeat and deflate. The

ultimate goal of physical education is to develop knowledge, attitudes, and dispo-
sitions, that lead to daily habits that enhance physical health and well-being. (U.S.
Department of Health and Human Services, et al, 1996)

Technology

What is the place of technology in early childhood education? The term *technol-
ogy* refers to a variety of resources: computers, interactive video, multimedia,
information databases, applications systems, and telecommunications. As new
technology has become more affordable and accessible, it has become an ever-

*A major goal of physical educa-
tion is the development of knowl-
edge and disposition that lead to
habits of physical activity.*

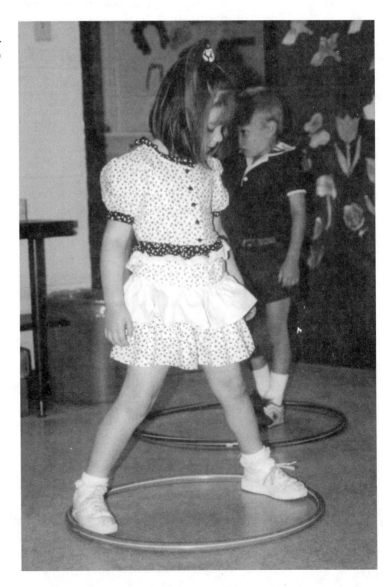

increasing part of all classrooms from preschool through college. Computer technology has been described as "our new chisel and tablet, our new pen and paper, our new chalk and erasers, our new textbook" (Frick, 1991, p. 30).

The explosion of new computer software, digital technologies, and the expanding Internet are reinventing communications systems and transforming education practices and potential. Educators are living with and attempting to respond to ever-present changes in information bases, perspectives, and accessibility of new knowledge brought into the classroom via the information superhighway. For learners, young and old, the possibilities afforded through modern technology are astounding. Today's children are growing up in a world where technologies are making sweeping changes in every imaginable aspect of their lives, education, communication, health care, cultural opportunities, entertainment, preparation for careers and attainment of jobs, and many others.

It is becoming increasingly evident that computer technology is influencing the daily lives of children. It is estimated that at least one million children are online at home, and that number is expected to quadruple by 2000 (Center for Media Education, 1996). Children are exposed to technology in shopping malls where video games and equipment abound, where specialty stores entice consumers with all manner of toys and gadgets driven by computer chip technology. Electronics supermarkets exist in every city where the newest home, office, and entertainment equipment and software are introduced and sold. Children's museums frequently offer science and technology-focused courses and playrooms, libraries make computers available to children, and colleges and universities provide "computer (or technology) camps" for children. In the classroom, today's children are at ease with CDs, VCRs, computer keyboards and monitors, and other equipment, and all sorts of software for drawing, writing, reading, computing, communicating through e-mail, researching topics of interest, and simply playing games and being entertained. It is an interesting truism that "today's children are the first generation of the Digital Age." (CME, p. 2)

The Center for Media Education emphasizes that children's lives will be shaped by new telecommunications systems that will require skills and knowledge essential for navigating a "wired world" (p. 3). Computer literacy and skills will be necessary for later employment and career development. CME notes that computer literacy is now required of more than half of newly created jobs and this will continue to rise. Hence, employees with greater computer skills will be paid more and will be eligible for more desirable jobs. Without basic computer skills, individuals become members of what CME refers to as a "technological underclass" and may have limited opportunities to improve their life circumstances due to inability to meet computer skill needs of employers and to access the computer benefits for their individual and personal needs. In a Digital Age, a danger exists that an electronic caste system will develop in which children can be divided into three categories based on their access to computer technology:

◆ the privileged, who have full access to the Internet at school and at home

◆ the underprivileged, those with limited access at school or home

◆ the excluded, those with no access (CME, 1996, p. 6).

Given the presence and increasing importance of technology in our lives, it falls upon administrators and teachers to assure equity of opportunity to children in their access and use of computers and other technology in schools. Teachers can assess each child's prior experiences with computers and other technologies, and plan for appropriate opportunities and experiences, particularly for individuals who have limited or no access.

The early childhood classroom can provide a variety of opportunities for all children to experience and enjoy new technologies. In discussing strategies for extending science, mathematics, and technology in early childhood curriculum, Patton and Kokosky (1996) define technology in the early childhood classroom as "any tool that extends the senses" (p. 40), and suggests that the classroom physical environment should include a clearly defined library/resource center that includes science, mathematics, and technology information and literature and readily available computers, calculators, and multimedia. Technology can expand and enrich the curriculums in all of the content areas.

Computers are being used to help children problem solve and learn the process of writing, including writing across the curriculum. Talking word processors and voice-activated programs can help children make connections between oral and written language, and programs are available to assist English as Second Language learners. Computer-assisted instruction is particularly helpful to certain at-risk children and children with disabilities. Various software programs are available to streamline recordkeeping for students, teachers, and parents, and to develop digitized portfolios, while videos are often made as a record of children's activities.

With all of these and many more education-enhancing possibilities, there nevertheless are drawbacks and concerns associated with technology in the classroom. Many experts talk of "information overload" and indeed, the information superhighway, television, radio, and the print world do bombard us with more information than we usually want or can mentally process efficiently. Children will need guidance in learning to verify and check the reliability of sources of information and to sort; classify; and use, discard, or ignore information. They will need help—as with sources of information such as storybooks, plays, and sociodramatic interactions—in distinguishing fact and fiction, fantasy and reality. Learning to attend to the most accurate, relevant, and beneficial information is a skill all of us will be developing in an era of information glut.

The Internet, with all its possibilities for expanding intellectual horizons, is also a source of offensive and inappropriate material that is easily accessed by anyone, including children. Burriss (1997) makes the following suggestions for "Safety in the Cybervillage":

1. Teach children that the information superhighway is just like any other public street—you can meet both nice people and people who are not nice and should be avoided; and just like on the street, children should not give their names, addresses or phone number to strangers, nor should they give the name of their school or what they look like.

2. When a "friend" on the Internet engages children in conversations that are questionable, an adult (teacher or parent) should ask to "speak" with the parents at the other end.

3. Instruct children to do the following if e-mail is received that is scary or suspicious:

 ◆ Tell a parent, teacher, or other trusted adult immediately.

 ◆ Do not respond to the message.

 ◆ It may be necessary to report the incident to the online or Internet service provider or to call the police.

4. Both teachers and parents must get acquainted with "kid friendly" locations provided by organizations such as the American Library Association.

5. Adults must remain ever-vigilant, and oversee and supervise Internet activities. One simple way to do this in the classroom is the make sure that the monitors face into the room so that the adult can always see what is on the screen (Burriss, 1997).

As yet, much that is available on the Internet is beyond the experiential and developmental capabilities of young children, and thus must be wisely selected and appropriately complemented and enriched by hands-on, manipulative, concrete, socially interactive experiences. Teachers must help children make meaningful connections between what they experience through technology and the curriculum and activities in the classroom. Integration of technologically derived information with other information and activities in the curriculum is an essential aspect of the use of technology in education. Without it, the learner's experiences and knowledge become an amalgam of data, often in "sound-bite" form, unrelated to a meaningful whole, and often incomplete, disjointed, and difficult to contextualize. Such is a source of misperceptions and misconcepts.

Technology is a reality of the present and certainly of the future. It is a vehicle for learning curricular content, problem solving, and communication, and can be a useful tool with certain populations with special needs. The teacher and children need to evaluate the purpose for using technology and the content created by its use. Teachers also need to make developmentally appropriate decisions regarding the selection and use of technology. Because so much is available today and budgets are limited, educators need to become skilled and discerning in the selection, uses, costs, and benefits of technology. Figure 5.6 suggests a criteria for selecting developmentally appropriate software for young children.

CURRENT THEMES IN TEACHING, LEARNING, AND ASSESSING SUBJECT MATTER CONTENT IN CURRICULUM

Several themes reappear throughout this chapter and are indicative of the emphasis scholars and practitioners are placing on curriculum content, instruc-

1. Are children able to boot up the software program independently?
2. Are children able to understand the initial directions? Are the directions presented using a variety of senses (auditory, visual — both words and graphics)?
3. Is the vocabulary used in the program appropriate to the children's developmental level?
4. Do children know when they are correct and incorrect? Are approximations acknowledged/rewarded at appropriate levels?
5. Are the program keyboard functions too complex for young children? Are the participants required to strike one, two, or three keys at one time?
6. Are the program graphics complementary, appropriate, or distracting?
7. Does the program have an audio component: Are the sound levels appropriate for the learning environment (too loud, too soft)? Is the audio component of the program accurate? (Does a bird sound like a bird in the computer program?)
8. Does the program offer children choices? How many? Are the choices appropriate, too simple, or inappropriately complex?
9. Do the program and your computer system foster independence in children or reliance on teacher direction and assistance?
10. Is the computer program congruent with the content and scope of the classroom curriculum, or is "computing" viewed as isolated learning experiences?

Figure 5.6
Criteria for Developmentally Appropriate Software for Young Children
Note: From *The Young Child: Development from Prebirth through Age Eight* (p. 447), by J. Black and M. B. Puckett, 1996, Upper Saddle River, NJ: Prentice Hall. Copyright 1996 by Prentice Hall. Reprinted with permission.

tional strategies, and assessment practices. Among these themes are application of brain development research to classroom practices, integrated content and instructional strategies that engage problem solving and higher order thinking across the curriculum, the interactive and social nature of learning, and meaningful learning that is applicable in nonschool contexts. We would like to end this chapter with a comment about some of these themes.

Brain Development Research and the Curriculum

Learning is what the human brain does. Each stimulation, experience, and behavior can "wire" (or "rewire" or "misfire") the axon–synapse–dendrite pathways that form the basis for emotions, memory, understanding, behaving, and future learning. Certain essential experiences enhance and support this process, others interrupt, impede, or can even damage it. As we move into a more neurological perspective on teaching and learning, the professional ethics imperative to "do no harm" becomes ever more salient. Authorities in this field urge educators to value process as much as the products and outcomes of learning. Jensen (1998) explains:

Our brain is highly effective and adaptive. What ensures our survival is adapting and creating options. A typical classroom narrows our thinking strategies and answers options. Educators who insist on singular approaches and the "right answer" are ignoring what's kept our species around for centuries. Humans have survived for thousands of years by trying out new things, not by always getting the "right" tried-and-true answer. That's not healthy for growing a smart, adaptive brain. The notion of narrowed standardized tests to get the right answer violates the law of adaptiveness in a developing brain. Good quality education encourages the exploration of alternative thinking, multiple answers, and creative insights. (p. 16)

Jensen further states, "Surprisingly, it doesn't matter to the brain whether it ever comes up with an answer. The neural growth happens because of the process, not the solution." (p. 36).

Contemporary research from the neurosciences has brought new insights into our education profession and reaffirmed long-held beliefs about what types of early experiences and instructional strategies best serve the long-term interests of the developing child. The following are only some of the insights that can guide curriculum and assessment practices. (Because this area of research is expanding so rapidly, the reader is well advised to consult the literature on the following important issues; some resource suggestions are included in Chapter 10):

Motor Skills and Academic Success

Beginning in infancy, motor stimulation is essential for neurological development, and is needed for later school success. Considerable evidence supports the foundational impact of early motor activity on speaking, reading, manual dexterity including drawing and writing, and the ability to direct and sustain attention (Ayers, 1991, Evarts, 1979, Hannaford, 1995, Lyon & Rumsey, 1996, Sylwester, 1995, 1998). Further, brain development research implores us to consider the impact of movement activities throughout the schooling years through both physical education and integration of movement and dance into other content areas. For instance, studies of integrated dance activities with language arts have shown significant gains in attention and reading scores in primary grade students (Gilbert, 1977, Palmer, 1980). Physical activity not only strengthens the muscles, heart, lungs, and bones, but strengthens key areas of the brain (basal ganglia, cerebellum, and corpus callosum) by feeding it essential chemicals that enhance connections between neurons (Jenson, 1998). As such, physical exercise is considered one of the best stimulants to neurological development and learning (Kempermann, Kuhn, and Gage, 1997).

The Arts and the Brain

"Today's biology suggests that it's the arts that lay the foundation for later academic and career success. A strong arts foundation builds creativity, concentration, problem solving, self-efficacy, coordination, and values attention and self-disci-

pline" (Jensen, 1998). This quote represents the thinking of many experts who study neurobiological development of the brain. It is believed that the brain is innately designed to respond to music and art, and as such, early pleasurable experiences with music, art, and movement are critical for later cognitive processes and emotional well-being.

Importantly, both physical education and the arts, particularly vigorous physical activity, movement and dance have been shown to elevate serotonin levels in the brain. Serotonin is a chemical that functions as a neurotransmitter that enhances motor controls through inhibition of quick motor responses and enhancement of feelings of relaxation and calm. When brain serotonin levels are elevated, the individual experiences higher levels of self-esteem and subsequently enhanced social interactions, and when serotonin levels are low, self-esteem is low and social interactions are less positive. In terms of movement and dance, low serotonin levels can result in irritability followed by impulsive, uncontrolled, aggressive and even violent behaviors (Sylwester, 1997, 1998).

Some scholars posit that listening to appropriate forms of background music enhances learning by creating the psychological state of "relaxed alertness" (Caine & Caine, 1994), and that listening to and responding to music engages the entire brain (Shreeve, 1996). These and similar findings compel educators to integrate more and more of the arts—art, music, drama, dance—into their curriculums and instructional practices.

Brain Development Research and Instructional Practices

As we pointed out at the beginning of this chapter, findings from brain research support many of the good practices traditionally associated with quality early childhood education programs: warm and supportive adult/child relationships; psychologically safe interactions and group dynamics; holistic and integrated approaches to curriculum and instruction; challenging and enriched environments and curriculums that engage all of the sensory mechanisms; learning that builds on the learner's past experiences; social interaction and meaningful, immediate feedback; opportunities to talk, question, reflect, and construct meaning; and attention to basic needs for food, water, rest, elimination, and exercise (Caine & Caine, 1994, 1997; Jensen, 1998; Sylwester, 1995, 1997, 1998; Wolfe & Brandt, 1998).

And as suggested earlier, scholars emphasize that neuronal stimulation occurs when learners are engaged in the processes of problem solving, critical thinking, inquiry, talking, and feedback. With such appropriate stimulation, the brain grows new dendritic connections, larger cell bodies and more glial (support) cells (Diamond, 1967; Healy, 1990). The implications of these findings are quite obvious in terms of appropriate and enriched curriculums and pedagogy.

Also emphasized in the brain research literature is the importance of emotions in the educative process. Emotions determine what the learner will enjoy and remember, and what will be found distasteful and avoided. Sylwester (1995) points out, "Far more neural fibers project from our brain's relatively small limbic emotional center into the large logical/rational cortical centers than the reverse, so

emotion is often a more powerful determinant of our behavior than our brain's logical/rational processes (p. 73). This scholar suggests that classroom pedagogy should assist children in accepting and learning to control emotions through non-judgmental dialogue and guidance; encourage children to talk about their emotions, listen to the feelings, intentions, motivations of others; and to think and reflect on a variety of "why" questions related to curriculum content. In addition, activities that promote social interaction such as cooperative learning, project work, group discussions, and so on provide emotional support for learners. Emotion-laden class activities such as role playing assist in recall and memory development. It is especially important to establish a stress-free learning environment in which self-esteem and a sense of self-efficacy can flourish. Further, Sylwester advises that educators should bear in mind the intimate connection between emotions and physical and mental health (pp. 76-77).

Integrated Learning

In addition to brain development research scholars provide other perspectives on integrated learning. Jacobs (1989) suggests several reasons for *curriculum integration*: the growth of knowledge, fragmented schedules, relevance of curriculum (if there are connections between subjects), and society's response to fragmentation (the world of work is multifaceted). Two appropriate design options for using integration in the early childhood classrooms are interdisciplinary units and the integrated day model (Jacobs, 1989, pp. 16–17). In the *interdisciplinary unit*, the full range of disciplines—language arts, math, social studies, science, the visual and performing arts, and physical education—are brought together for a periodic course of study, usually around a topic or theme. The units can last for a few days or up to a week or two. The *integrated day model* is based on themes that arise from children's questions or interests. The notion of integrated curriculum is an important concept in early childhood education because children develop and learn in meaningful contexts. Young children do not segment their learning into separate subject matter areas.

Because multiple learnings can occur simultaneously, authentic assessments can document learning in many of the content areas at once. For example, in graphing a survey on pet behaviors, a child may be learning science, math, problem solving, oral and written language, and motor skills. Thus children are demonstrating the acquisition of knowledge and skills in different developmental and content areas while engaged in a particular activity associated with one of the content areas (as in the example of a mathematical task). Integrative themes need to engage children in thoughtful, purposeful learning. They should not be cute or shallow.

Cooperative Learning

The use of cooperative learning techniques is not new to early childhood education. From the beginning, cooperative experiences have been valued as important to the development of the whole child (Foyle, Lyman, & Thies, 1991). Now this

pedagogical strategy is supported through brain research which suggests that cooperative learning enhances development.

Caine and Caine (1997) elaborate on the "social brain": "It is now clear that throughout our lives, our brain/mind change in response to their engagement with others—so much so that individuals must always be seen to be integral parts of larger social systems. Indeed, part of our identity depends on establishing community and finding ways to belong. Learning, therefore, is profoundly influenced by the nature of the social relationships within which people find themselves" (pp. 104–105). These authors describe our brain-based drive to belong to a group and to have opportunities to relate to others, pointing out that friendship is intrinsically important for its contribution to feelings of safety, security, and relaxed alertness—all of which are conducive to effective and sustained learning (Caine & Caine, 1994). Further group work encourages students to talk, explain, debate, plan, and evaluate—providing important feedback and support for cognitive processes.

To develop effective cooperative learning events, the teacher must construct the methods and framework for group functioning, and provide appropriate experiences and adequate time for full participation. The following questions can be asked to help children assess their understanding of and behavior in cooperative contexts. The children's responses can assist the teacher in evaluating and planning for further cooperative learning experiences.

1. Why is it important for us to work together?
2. In the last activity how did we work together?
3. Why were you glad to have others to help you in the activity we just did?
4. Why was each person important in the activity?
5. What could have happened if you hadn't worked together so well in the activity?
6. How did you have fun working together?
7. How did you help your group?
8. Who did a particularly good job of helping?
9. (After a paired activity) Tell your partner one thing you enjoyed about working with him or her. (Foyle et al., 1991, pp. 38–39)

Problem Solving and Social Decision Making

Opportunities for problem solving and social decision making and thinking within the curriculum are also being given much attention today. The importance of infusing these skills into the subject matter content is reflected in the following quote:

In the twenty-first century, students will be considered "educated" to the extent that they can make informed, responsible decisions to promote their own well-being and contribute to the well-being of others. In preparing the next generation for their roles as responsible adult citizens, educators must strengthen the child's ability to

think clearly, carefully, and sensitively, particularly when under stress. (Elias & Tobias, 1990, p. 13).

Figure 5.7 lists a number of reasons for providing opportunities for problem solving and social decision making within classrooms. These represent comments from teachers and administrators of regular and special education programs, school psychologists, special education aides, substance abuse counselors, learning specialists, social workers, and guidance counselors.

Generally, there are three curricular approaches to providing opportunities for problem solving and social decision making and thinking:

1. To become more successful participants in society
2. To achieve greater success in school
3. To give children the confidence to make positive choices
4. To improve their quality of life by helping students make better decisions and assume greater responsibility in its direction
5. To enable students to have greater self-esteem and a feeling of control over what happens to them
6. To improve basic thinking that will affect all areas of their functioning
7. To make children think through a problem before taking impulsive action
8. To help children behave in a more socially acceptable way to gain peer acceptance
9. To help children gain confidence and knowledge needed to make appropriate social decisions
10. To consider consequences and alternatives
11. To help children to set goals
12. To better prepare children for full participation in the learning process, not just in the classroom but in all aspects of life
13. To enable children to generate solutions to common everyday problems and help them become competent in social circles, situations, and interpersonal relationships
14. To enhance students' abilities to interact socially in a more mature manner
15. To give individuals an approach to handling problems that they can rely on across varying situations
16. To give children more power over their lives, so they are better able to see cause and effect
17. To enhance children's ability to deal with everyday problems in a positive, constructive manner
18. To enhance interpersonal relationships
19. To ensure future success in all the important areas of life—work, loving relationships, etc

Figure 5.7
The Objectives and Relevance of Teaching Social Decision Making to Children
Note: From *Problem Solving/Decision Making for Social and Academic Success*, 1990, National Education Association. Copyright 1990 by the National Education Association. Reprinted with permission.

1. Creation of a classroom environment that fosters thinking without direct teaching of thinking skills (asking thoughtful questions, providing wait time, asking students to explain their reasoning or provide evidence).

2. Infusion of thinking skills into regular classroom instruction (predicting, hypothesizing, remembering, comparing and contrasting, analyzing, inferring, decision making, problem solving, and deductive reasoning).

3. Separate courses for teaching thinking.

The first two approaches are more appropriate for early childhood classrooms.

Assessment of thinking and problem solving needs to be situated in contexts that provide information on how children approach and solve problems. The problem-solving contexts of the present and future require that people know how to cooperate and collaborate. Thus meaningful contexts in which children can work cooperatively to solve problems are important experiences in preparing for a responsible and productive life. Figure 5.8 provides a checklist for assessing student social decision-making and problem-solving strengths.

According to Brophy (1992), analyses of programs that emphasize teaching subject matter content for understanding and higher-order thinking skills have noted the following common principles and practices:

1. The curriculum is designed to equip students with knowledge, skills, values, and dispositions useful both inside and outside of school.

2. The instructional goals underscore developing student expertise within an application of content and with emphasis on conceptual understanding and self-regulated use of skills.

3. The curriculum balances breadth and depth by addressing limited content but developing this content sufficiently to foster understanding.

4. The content is organized around a limited set of powerful ideas (key understandings and principles).

5. The teacher's role is not just to present information but also to scaffold and respond to students' learning.

6. The student's role is not to absorb or copy but to actively make sense and construct meaning.

7. Activities and assignments feature authentic tasks that call for problem solving or critical thinking, not just memory or reproduction.

8. Higher-order thinking skills are not taught as a separate skills curriculum. Instead, they are developed in the process of teaching subject matter knowledge within application contexts that call for students to relate what they are learning to their lives outside of school by thinking critically or creatively about it or by using it to solve problems or make decisions.

9. The teacher creates a social environment in the classroom that could be described as a learning community where dialogue promotes understanding. (p. 6)

Student:_____ **Date:**_____

In what situations is this student able to use the following: Situations*

A. Self-Control Skills
 1. Listen carefully and accurately _____
 2. Remember and follow directions _____
 3. Concentrate and follow through on tasks _____
 4. Calm him/herself down _____
 5. Carry on a conversation without upsetting or provoking others _____

B. Social Awareness and Group Participation Skills
 6. Accept praise or approval _____
 7. Choose praiseworthy and caring friends _____
 8. Know when help is needed _____
 9. Ask for help when needed _____
 10. Work as part of a problem-solving team _____

C. Social Decision-Making and Problem-Solving Skills
 11. Recognize signs of feelings in self _____
 12. Recognize signs of feelings in others _____
 13. Describe accurately a range of feelings _____
 14. Put problems into words clearly _____
 15. State realistic interpersonal goals _____
 16. Think of several ways to solve a problem or reach a goal _____
 17. Think of different types of solutions _____
 18. Do (16) and (17) for different types of problems _____

*Enter the number of those situations in which particular skills appear to be demonstrated, using the following codes:
 1 = with peers in classroom
 2 = with peers in other situations in school
 3 = with teachers
 4 = with other adults in school
 5 = with parent(s)
 6 = with siblings or other relatives
 7 = with peers outside school
 8 = when under academic stress or pressure
 9 = when under social or peer-related stress or pressure
 10 = when under family-related stress or pressure

Figure 5.8
Checklist of Students' Social Decision-Making and Problem-Solving Strengths Across Situations
Note: From *Problem Solving/Decision Making for Social and Academic Success,* 1990, National Education Association. Copyright 1990 by the National Education Association. Reprinted with permission.

The epigraphs at the beginning of this chapter emphasize that curriculum and assessment are ongoing and integrated and lead to curricular development and improvement. Curriculum and assessment are not separate, discrete processes. In addition, the epigraph by Frank Smith serves as a reminder that curricular methodologies are not the central point in the learning process. Rather, an under-

standing of how children learn (Chapters 3 and 4) coupled with knowledge of appropriate subject matter content (Chapter 5) provides the underpinnings for teachers to learn to trust children and themselves, coming to view each other as partners in the instructional, learning, and assessment processes. Creating such a learning community takes time and is an ongoing enterprise.

REVIEW STRATEGIES AND ACTIVITIES

Preservice teachers should use their field experience sites as sources for answering the review strategies and activities. Inservice teachers should use their classrooms as a basis for responding to the following questions.

1. Identify the forces that influence the curriculum in your early childhood classroom. Which seem to be the most influential? Are all forces in agreement?

2. Prepare a presentation for parents describing the learning goals for the young children in your classroom and how these goals will promote competent and productive citizens for the twenty-first century.

3. Respond to the questions in Figure 5.2 regarding your curriculum. Reflect on your responses. What will you continue? Refine? Phase out?

4. Is there alignment among the learning goals in your classroom, subject matter content, and methods of assessment? If not, what can you do to make them more congruent?

5. What knowledge, skills, dispositions, and feelings are children developing in your classroom in each subject matter content area? List them for each curricular area.

6. Does the subject matter content in your classroom represent the standards developed by the state, district, or professional organizations representing particular disciplines or by state-of-the-art thinking about a particular content area? If not, what can you do to make the content more congruent with the standards?

7. Describe how you:
 a. integrate subject matter content in your classroom.
 b. provide opportunities for cooperative learning in your classroom.
 c. promote problem solving and social decision making and higher-order thinking in your classroom.

8. Reflect on the content of this chapter. Make a list outlining the role of the teacher in implementing appropriate and authentic curriculum. What are you already doing? What would you like to refine? What would you like to begin working on?

9. Contact people in your area in leadership positions in the field of early childhood education. Ask them for the names of teachers and schools that are implementing state-of-the-art subject matter and content in their curriculum. Schedule a visit.

Implementing Authentic Assessment

6

Planning for Authentic Assessment

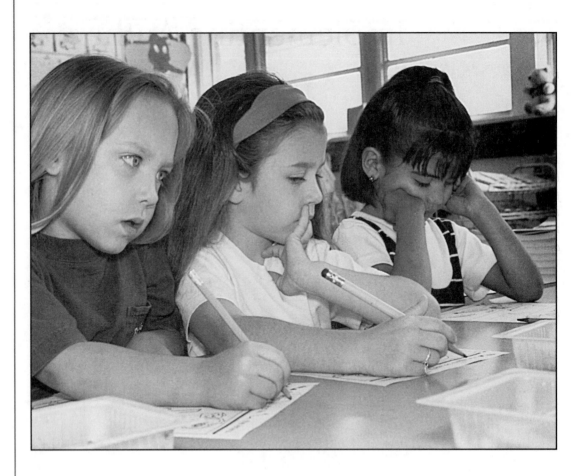

If our goals and objectives are not based on sound, scientific theory about how children learn in depth, demonstrating progress toward them is of little value.

Kamii (1990)

Why do educators believe that intelligence is measurable?

Anonymous

Because such a measurement would be so useful to know! And maybe because educators are idealists at heart—an endearing quality to be found in those so close to our children. Speaking for myself, I think trying to measure intelligence is like trying to measure beauty. Most of us will agree that some people are more attractive than others, but there are many different kinds of wonderful.

Marilyn Vos Savant

After reading and studying this chapter, you will demonstrate comprehension by being able to:

- describe a planning format for the implementation of authentic assessment.
- discuss the goals and purposes of assessment.
- distinguish between formal and informal assessment strategies.
- discuss cautions in the use of standardized tests with young children.
- identify developmental domains in which assessment is focused.
- describe various types of informal assessment strategies.
- define and develop effective rubric systems for assessing student performance, products, and processes.

In the foregoing chapters, we have explored much information vital to authentic assessment:

◆ Authentic assessment must be rooted in knowledge of child development and learning.

◆ Current knowledge of child growth, development, and learning is based on multiple theories and scientific data from many fields, including the biological and neurosciences.

◆ Authentic assessment and developmentally appropriate curriculums are responsive to current research regarding child growth, development, and learning.

◆ Authentic assessment and developmentally appropriate curriculums are mutually supportive and intertwined.

◆ Authentic assessment is responsive to developmental, cultural, socioeconomic, and gender diversity among children.

◆ Broad and in-depth knowledge of subject area content is essential to curriculum enrichment and integration which is designed to meet both the needs of learners and the expectations of standards-based policies.

In this chapter, such information will undergird our discussions of ways to implement authentic assessment in the classroom.

DEVELOPING A PLAN FOR STUDENT ASSESSMENT

Determining what to assess, how to assess it, and what to do with the information obtained may appear to be daunting. Developing a blueprint for assessment is a good way to think through the whole assessment process and what it will entail. Developing a "grand plan" can focus reflection and discussion about expected or targeted student accomplishments over selected periods of time, and the curriculum content and pedagogy that can facilitate and support these accomplishments. Such a plan results in an integrated and meaningful system of assessment that sets realistic and developmentally appropriate goals for learners while effectively informing and giving direction to curriculum and instruction.

The Assessment Blueprint

A planning blueprint will necessarily take into consideration all assessments anticipated during the school year including those mandated by state, district, and school policy. Although there may be differences between state or district needs for student data vis-à-vis large-scale standardized tests and the classroom teacher's need for performance information to inform and guide instruction, mandated standardized tests can be incorporated in the planning scheme. By

including mandated tests in the overall plan, the teacher can address such concerns as arranging for the best time and contexts for their administration, and creating a physical and psychological environment that is nonthreatening and conducive to the students' best efforts.

While large-scale standardized testing is common in today's schools, professional educators guard against their potential to undermine developmentally appropriate curriculums and assessments of individuals. The potential deleterious effects of large-scale testing of young children has been extensively documented (Bredekamp & Shepard, 1989; Charlesworth, 1989; Elkind, 1979, 1986, 1987; Fleege, 1990; Hilliard, 1975; Kamii, 1990; Medina & Neill, 1990; NAECS/SDE, 1987; NAEYC, 1988; Neill & Medina, 1991; SECA, 1990; Shepard & Smith, 1985), and was discussed in Chapter 1. Wiggins (1993) states, " . . . because the *student* is the primary client of all assessment, assessment should be designed to *improve* performance, not just monitor it. Any modern testing (including testing used for accountability) must ensure that the primary client for the information is well served" (p. 6).

Ideally, assessment addresses emerging development in multiple domains, and focuses on the students' emerging capabilities as demonstrated through what they do and how they do it. Such assessment is concerned with student performance, processes, and products and while formative in nature, guiding day-to-day planning, it also over time contributes summative data for cumulative and administrative reports as needed to determine program effectiveness.

Figure 6.1 provides a blueprint for planning for an authentic assessment program. Notice that its parts are arranged in a circular fashion to show that if the process is valid, it fulfills its stated purposes laid out in its initiation (Step 1). In each cell are suggestions for what each step might include.

Recall from discussions in Chapter 2 that authentic assessment should be embarked on slowly and thoughtfully. Reflect on the overall plan and begin with a clear understanding of its goals. Focus on:

1. the purpose the assessment will serve.
2. the domains that will be assessed.
3. the strategies and techniques that will be used.
4. how information will be assembled, stored, and used.

Once the blueprint (or *gestalt*) is drafted, you are ready to look more specifically at these components for day-to-day planning. Figure 6.2 provides a form for this planning process. In this design, each developmental domain section might be treated as a separate planning chart.

The Purposes and Goals of Assessment

In this text, the purpose of authentic assessment is to provide ongoing data on student performance in such a manner as to enhance learning experiences, to ensure student progress and increasing competence for all children, and to

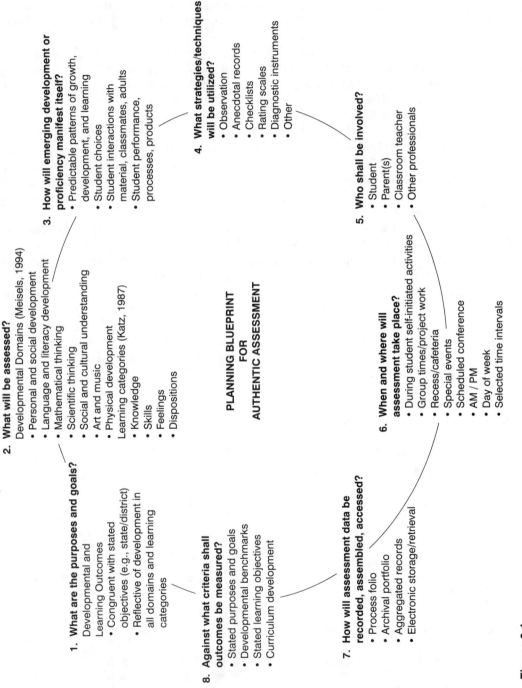

Figure 6.1
Planning Blueprint for Authentic Assessment

Developmental Domain		Knowledge	Skills	Feelings	Dispositions	Possible Portfolio Entries
Mathematical Learning	Performance					
	Products					
	Processes					
Personal/Social Development	Performance					
	Products					
	Processes					

Figure 6.2
Assessment Planning Matrix

inform and enrich both instruction and curriculum. Effective assessments provide information for planning curriculum that is responsive to both curriculum goals and standards and individual developmental needs and capabilities of students. Baseline information obtained through varied assessments helps teachers set goals for curriculum and for individual learners and align both with voluntary professional or state mandated standards.

While our approach to assessment emphasizes performance-based approaches, formal measures can be incorporated into the overall plan when used to identify children with special needs. The planning matrix denotes all of the tests and assessment procedures (including state or district mandated tests) that will be utilized during the school year and should indicate the purposes each test is intended to serve.

What Will Be Assessed?

As discussed in prior chapters, emphasis in early childhood education is on whole child development perspectives. As such, assessment addresses development and learning in physical/motor development; psychosocial development; and cognitive, language, and literacy development. In addition, assessment plans can include the acquisition of knowledge and skills in the content areas of language arts, mathematics, science, social studies, the arts, and physical education. As referenced in Chapter 5, these are among the subject matter areas for which national standards have been published. Such standards provide a frame of reference for establishing goals and benchmarks for each grade. Meisels et al. (1994) suggest the following domains that are compatible with both national standards and developmentally appropriate practices in early childhood and primary education. These domains are used in the Work Sampling System (Meisels, 1993; Meisels et al., 1994), discussed later in this chapter, and follow the typical content areas included in early childhood/primary education. The Work Sampling System is comprehensive in scope and effectively implements an authentic assessment philosophy. We will refer to these domains to guide our discussions and suggest strategies throughout this chapter:

◆ personal and social development

◆ language and literacy

◆ mathematical thinking

◆ scientific thinking

◆ social studies

◆ the arts

◆ physical development

In plotting these or similar domains on your planning matrix, consider the goals that you have for the children in your classroom and the interconnected-

ness of development and learning across developmental domains and curricular areas. Consider also the learning sequence that children follow, from *awareness* to *exploration* to *inquiry* to *utilization* (Bredekamp & Rosegrant, 1992; Rosegrant, 1989). You may also wish to include in your planning the following learning categories as *target behaviors* within each domain (British Columbia Ministry of Education, 1991; Hymes, 1991; Katz, 1987):

◆ *knowledge*—facts, concepts, ideas, vocabulary, stories, and specific subject matter/content areas information

◆ *skills and processes*—physical, social, verbal, mathematical skills, and processes that use thinking, reasoning, problem solving, communicating, decision making, and representational strategies such as constructing, drawing, painting, and writing

◆ *feelings*—security, self-efficacy, self-confidence, belonging, self-respect, and feelings about and toward others, i.e., classmates, teachers, and other school personnel, and toward learning

◆ *dispositions*—curiosity, friendliness, creativity, initiative, cooperation, social responsibility, persistence or inclination to continue to explore, inquire, and use new knowledge and skills.

In an overall plan, a variety of strategies for obtaining significant assessment information about individual learners are considered.

How Will Emerging Development or Proficiency Manifest Itself?

When we explore this topic, we become profoundly aware of the need for the assessor to be well grounded in knowledge of child growth and development. The ability to recognize both expected growth and accomplishments for age as well as behaviors and characteristics suggestive of a need for further evaluation are critical attributes. Setting developmentally appropriate goals and expectations for the class and for individual students within the class depends on this knowledge base. The appendix to Chapter 3, while by no means exhaustive, can be a helpful starting point for learning about developmental trends, and provides a frame of reference for the age ranges from early childhood through the elementary grades. With such a frame of reference, observation of children becomes more focused, and assessment of their "performance, processes, and products" is more accurately related to emerging growth, development, and learning.

Emerging development, knowledge, and skill proficiency are revealed to the astute observer through:

◆ the *choices* children make during self-initiated learning activities

◆ the *nature and content of children's play* and sociodramatic themes

◆ the *language* they use to explore, inquire, and interact with others—classmates, teachers and other school personnel, and family

◆ the *strategies* they use to *solve problems* (e.g., trial and error, asking for help from a classmate or an adult, using varied resources such as books, classroom visuals or other media, and so on)

◆ their *personal accounts* (spoken, written, or depicted in art work) of past experiences and current understandings

◆ their *information-gathering strategies* (e.g., observing others, quizzing peers, adults, parents, searching books, pictures, classroom visuals, or media, experimenting and exploring realia and other objects)

◆ the manner in which they use their *motor controls* for locomotion and play, to self help, explore and manipulate toys and materials

◆ the *interests and hobbies* they enthusiastically pursue

◆ the *social skills* they use to meet their own needs and the needs of others

◆ the *manner in which they participate* as a member of a community of learners

◆ the *cognitive processes* they exhibit (e.g., recalling, reciting, comparing, contrasting, grouping, classifying, ordering, conserving, sequencing, counting, adding, subtracting, and so on)

◆ the *problems they pose,* the *hypotheses they generate,* the *solutions they conceptualize*

◆ their *performance* in the various developmental and content area domains (tasks performed, skills exhibited, levels of mastery in various skill areas)

◆ their *products* or representations of their work (drawings, writings, and constructions)

Clearly, students exhibit emerging development, knowledge, and skills in numerous ways. Skilled observation of active children in purposefully busy classrooms is a reward to education that is difficult to measure, for both the observer and the learner are enriched as a result of it. The opportunities to know each learner well is a valuable by-product of observing and paying authentic attention to what children do, say, and produce. And the enriched curriculums that can emerge from this knowledge challenges the imagination. The task of the assessor is to plan for focused observation while taking advantage of all the incidental observations that occur "on-the-run" during the course of the school day. Of all the skills required of the professional educator, knowing how to observe and respond appropriately to emerging development are among the most critical. We will discuss observation techniques later in this chapter.

What Strategies or Techniques Will Be Used?

Assessment strategies and techniques generally fall into two categories: formal and informal. Formal strategies include professionally developed and published standardized tests, teacher-made true–false and multiple-choice tests, and paper-and-pencil tests that accompany textbooks and are, for the most part, designed to determine student recall of information provided by the lessons. Except for diag-

nostic purposes with individual children, formal tests are of little value in teaching and curriculum development in early childhood education. Results from group-administered standardized tests, however, can provide group profiles from which preliminary planning might evolve. Such test results must be used cautiously with full knowledge of the young child's inconsistent performance on such tests. As discussed in Chapter 2, group scores, when provided in a timely fashion, can signal areas of strength and weakness in the class. This holistic view can guide at least initially, the structure and focus of the curriculum until more specific information about individual developmental and knowledge levels are ascertained through other assessments. Formal group testing may signal the need for more diagnostic evaluation of individual children so that early intervention can take place.

Informal strategies for assessment provide the types of information needed to determine specific developmental characteristics of individual children. This information is then used quite readily to create or modify curriculums to meet individual capabilities, needs, and interests. Informal strategies include skilled observations and the drawing of valid inferences therefrom, anecdotal records, checklists, descriptive inventories, rating scales, time and event sampling, and student interviews. All of these processes lend themselves to the development of student portfolios in which a variety of representations of student products and processes can be assembled and traced for progress over time. As the title of this text suggests, assessment done well celebrates student achievement.

Formal Assessments

Formal assessment usually entails the use of standardized tests. Standardized tests are administered under prescribed conditions that detail time limits; how, when, and by whom the test is to be given; and the manner in which the test is scored. The results of these tests are compared with the scores of a normative group or a predetermined standard. Standardized tests generally fall into the following categories:

◆ *Achievement tests* measure what children have learned or what skills they have acquired from instruction. Examples of standardized achievement tests are the California Achievement Test, Iowa Test of Basic Skills, Stanford Achievement Test, and the Metropolitan Achievement Tests.

◆ *Readiness tests* assess prerequisite skills, knowledge, attitudes, or behaviors believed necessary for the learner to succeed in school. Some examples of readiness tests are the Metropolitan Readiness Test, ABC Inventory, and the Boehm Test of Basic Concepts.

◆ *Developmental screening tests* are procedures designed to identify children who may be at-risk for development or learning problems and might benefit from more extensive diagnostic assessment or specialized instruction. Examples of screening tests include the Denver Developmental Screening Inventory, Developmental

Indicators for the Assessment of Learning-Revised (DIAL-R), McCarthy Screening Test, and the Slingerland Screening Tests for Specific Language Disability.

◆ *Diagnostic tests* and *intelligence tests* are used to identify children with special needs, analyze their problem areas, and prescribe remediation strategies or special services. Examples of diagnostic tests are the Assessment, Evaluation, and Programming System for Infants and Children (AEPS); Kaufman Assessment Battery for Children; Purdue Perceptual–Motor Survey; and the Southern California Sensory Integration Test. Examples of tests of intelligence and cognitive development include the Stanford–Binet Intelligence Scale, Structure of Intelligence, Wechsler Intelligence Scale for Children (revised), and Wechsler Preschool and Primary Scale of Intelligence.

Although many of these tests can be administered by the classroom teacher, others require specialized training and sometimes specific certifications or other professional credentials for individuals who administer and interpret the test. Moreover, it is essential to adhere to strict professional and ethical codes such as *Standards for Educational and Psychological Testing*, published jointly by the American Educational Research Association, the American Psychological Association, and the National Council on Measurement and Education (1985). This code and those of other professional groups in psychology and education emphasize selecting tests that meet the purpose for which they are designed and that are appropriate for the intended test-taking populations. (Unfortunately, standardized tests designed to measure student achievement are frequently used to assess school or district accountability or to evaluate individual school or teacher effectiveness—practices that are clearly at variance with this code.)

In addition to ethics relating to appropriate choice and use of tests, and qualifications of test administrators, use of standardized tests with young children presents another set of issues. At best, widespread use of standardized tests with young children is risky. Because of the dynamic nature of early growth and development, test performance may vary appreciably from one day to the next, yielding interpretations that are less than accurate and potentially misleading. Also, trends in school placement, retention, and extra-year programs for young children have often resulted in labeling, questionable student grouping practices, and inaccurate placement into remedial programs. Such practices inherent in the use of mass standardized testing of young children causes what Meisels (1992) has called *iatrogenic effects*, that is, unintended negative consequences with lifelong harmful outcomes. There are additional compelling reasons to consider alternative approaches to assessing young children:

◆ Young children may not have the auditory perception and auditory memory to follow test instructions, particularly group-administered test instructions.

◆ Young children lack well-developed receptive and expressive verbal skills.

◆ Young children are still struggling with a variety of psychosocial issues, including separation anxiety, group membership and participation, self-concept self-esteem, and a sense of self-efficacy.

- ◆ Young children have short attention spans and are easily distracted.
- ◆ Young children may not have the motor skills to handle test apparatuses, particularly paper-and-pencil tests and those involving "bubble-in" answer pages.
- ◆ Young children form concepts and process information through concrete experiences. (Most standardized tests require the ability to use abstract symbols.)

Moreover, because of the dynamic development occurring during the years from birth to age eight, we must be particularly cognizant of the fact that behaviors and test results that are diagnostic of problems of older children might actually be typical (or "normal") for the young child. For example, awkward use of scissors or writing tools is expected in young children because of typical patterns of gross and fine motor development. Letter reversals are also quite common among young writers but atypical at a later age.

Limitations such as these and concerns over retention, labeling, tracking, and other deleterious decisions based on test results suggest that reliance on standardized measures alone (or, perhaps, at all) should be curtailed. Meisels (1992) states that "standardized, whole-group, objectively scored achievement tests are of little utility for young children. Unless their effectiveness can be demonstrated, they should be curtailed or eliminated at least before third grade" (p. 170).

Addressing the question, "Is standardized testing ever appropriate for young children?" in its position statement on testing young children, NAEYC (1988b) advises:

> When teachers or parents suspect that an individual child may have a learning or developmental problem, the administration of standardized tests by qualified professionals may provide helpful diagnostic information. Under these circumstances, tests should be carefully selected and used only for the purposes for which they were designed and for which there are data demonstrating the accuracy of the measures. If a positive treatment exists, such as the opportunity for individualized instruction or smaller class size, then identifying a child for that treatment is recommended. If a clearly beneficial treatment does not exist, standardized tests do not serve a useful purpose.

Figure 6.3 poses important questions that should be asked when considering the use of standardized measures.

Informal Assessments

Authentic assessment relies heavily on informal strategies. Review the characteristics of authentic assessment as introduced in Chapter 1 and summarized in Figure 6.4. These characteristics suggest that assessment is teacher mediated, child centered, embedded in the curriculum, ongoing and cumulative, and based on multiple theories and knowledge about child growth and development.

Informal strategies emphasize the "Four P's" of authentic assessment: *performance, process, products,* and *portfolios.* (The topic of portfolios will be discussed in Chapter 7.) Although the term *informal* may denote less rigor in design, implementation, and scoring than is usually associated with formal testing, informal assessments nevertheless do not escape rigorous criteria that ensure ethical use

The wise selection of standardized tests is preceded by careful consideration of the following questions:
1. What is the purpose of the test?
2. What reliability and validity data are available?
3. Is the test designed for individual or group administration?
4. For what age person is the test intended?
5. Who will administer and score the test?
6. Are there other tests or assessments that will (or could) be administered in conjunction with this one?
7. How shall the scores be interpreted and by whom?
8. How will test results be used?
9. How much time does the test take to administer? to score?
10. What is the cost per test per pupil?
11. Are there individual benefits to be gained from taking the test?
12. Are there benefits to instruction to be gained?
13. What happens to students who "fail" the test?

Figure 6.3
The Wise Selection of Standardized Tests

and accurate and fair interpretation. Effective use of informal assessment strategies requires careful planning. Given the limitations associated with formal testing of young children, informal assessments provide a viable alternative, but such assessments must:

◆ be embedded in *authentic curriculum* and congruent with its goals and objectives (see Chapter 5).

◆ be guided by knowledge of child growth, development, and learning (Chapter 3), and therefore physically and psychologically safe for the student.

◆ provide representative data about all learning domains and content areas.

◆ be beneficial to the students and the programs that serve them.

◆ be ongoing and cumulative, based on many observations of relevant behaviors and examples of student products.

◆ demonstrate sensitivity to cultural, socioeconomic, and gender diversity, and cognizant of varying learning styles (Chapter 4).

◆ preserve the trust and integrity of all parties who collaborate in the assessment, particularly those of the students and their families.

Reliability and Validity of Informal Assessment Strategies

Concern arises over the *objectivity* and hence, the *reliability* and *validity, of* informal assessment strategies. Recall that reliability refers to the consistency with

Authentic Assessment:
• is performance based
• capitalizes on the strengths of the learner
• is based on real-life events
• emphasizes emerging skills
• focuses on purposeful learning
• relates to instruction
• is ongoing in all contexts — home, school, community
• provides a broad and general picture of student learning and capabilities
• is based on authentic curriculums
• celebrates, supports, and facilitates development and learning.

Figure 6.4
What Is Authentic Assessment?

which various tests or assessment strategies produce the same or similar results for an individual from one administration to the next. Recognizing that child performance on tests is quite variable from day to day and situation to situation, few, if any, formal tests can claim high reliability. To claim the same for performance-based assessment would also be spurious. Grant Wiggins (Brandt, 1992) advises the teacher to know what behavior to look for and to have enough evidence to feel confident that the score given is representative. Further, the teacher must make sure there is enough information collected over time on similar tasks, and must continually observe and compare current observations with previous ones in order to draw accurate and unbiased inferences. In doing so, the teacher is better able to develop and refine a scoring process.

Wiggins also suggests using multiple judges where possible to strive for the highest interrater reliability (i.e., reliability that is derived from similar findings by different raters). Reliability is also enhanced in informal assessments by skillfully monitoring progress from task to task and giving full consideration to the contexts in which the child's performance occurs. The context includes time, setting, situation, extenuating circumstances, relationships or feelings associated with the individuals involved, physical and psychological well-being, distractions, and so on. By providing many opportunities for the student to demonstrate emerging capabilities, and sampling performance in many contexts over time, teachers can ensure reliable and defensible assessment data. The goal in establishing reliability is to ensure that the outcomes of the assessment effort truly reflect lasting characteristics of the student and are not attributable to bias, temporary circumstance, or chance.

Validity, on the other hand, addresses the degree to which a procedure or test measures what it purports to measure. It is determined by comparing or contrasting an outcome with some stated criterion or construct. The goal of valid assessments is to ensure that inferences drawn from assessment outcomes (or test scores) are accurate and meaningful. For this to occur, the teacher must relate student performance, processes, and products to established criteria and to the goals

of the particular learning event or, perhaps, to the broader program or grade-related goals. When student performances, products, and processes are assessed over time, valid assumptions can emerge. It may take as many as six examples of similar types of student work to draw inferences about the student's overall ability or mastery of a particular task (Brandt, 1992). Brandt reminds us of the concept of the *novice*, whose early attempts or performance in any endeavor cannot be judged as indicative of general ability. Such performance will be inconsistent, whether by a novice artist, athlete, or writer, but can improve with further growth and development and additional opportunities to learn and practice. Thus, sampling student performance over time is crucial to ensuring validity.

Objectivity refers to the ability of the assessor to derive data and information about a student that is free of personal feelings or biases. Skilled assessment requires an understanding of the need for objectivity and of observer characteristics that can enhance objectivity or work against it. Bentzen (1993) identifies the following characteristics that can either enhance or mitigate against objective observations and the inferences that are drawn from them:

◆ sensitivity and awareness (about children and emerging development, based on the observer's training and experience)

◆ fatigue, illness, discomfort, environmental distractions (health problems, personal psychological disturbances, such as anxieties, fears, and distractions in the physical surroundings the can distort perceptions, such as lighting, crowding, noise, temperature, [and we might add, reactions of other observers])

◆ influence of self or personality (imposing or projecting one's attitudes, needs, and values onto the child being observed; or liking or disliking a child based on one's personal views of acceptability)

◆ biases (in which behaviors, e.g., aggression, anxiety, dependence, become prevailing characterizations of an individual rather than behavior commensurate with, or provoked by a specific incident or context)

◆ setting or situation (size and arrangement of physical space, equipment, and materials available and in use, characteristic skills and personalities of the children, and the means by which these are evidenced)

An *inference* is an attempt to provide a logical explanation for observed behaviors. Because inferences are based on judgments, the teacher needs to be cognizant of the factors that militate against objectivity. Accurate inference depends on the observer's ability to apply sound principles of growth and development and unbiased perspectives when assessing individual children. Because inferences are constructed by the observer, if they are to be valid the observer must exercise the highest level of objectivity. One question the observer can ask when attempting to draw an inference is: "Would other observers in this same time and context agree with my inference?" For example: Amy throws a block from the block center. All observers can agree that Amy threw a block. Can all observers agree that Amy was angry? Frustrated? Being playful? Trying to get attention? Or

is there another inference to be drawn? Obviously, one would have to have astutely observed and listened to all events (verbal and physical) preceding the throwing of the block and those that followed. Further, more knowledge about Amy is required: patterns of social interaction, typical behaviors associated with fatigue, hunger, boredom, and what types of events provoke excitement, frustration, anger, playfulness, and so on. Inferences then, can not easily be drawn from one event, but must be extrapolated from information derived from observations over time in all developmental domains and in many contexts.

Having discussed reliability, validity, objectivity, and inferences as critical aspects of assessment, we are now ready to describe a number of strategies that can be used in an informal assessment plan. It will take time and some research to identify or create the instruments that best serve individual assessment purposes. The following simply introduces and provides examples of some common practices. The resources provided in Chapter 10 can be helpful in locating appropriate assessment instruments.

Skilled Observation

In Chapter 2, you were introduced to the concept of "kid-watching" (Goodman, 1978). Most teachers agree that observing children is an integral part of their teaching. Through kid-watching, a conscious effort is made to focus on specific behaviors of individual students or on the interactions among small groups of students to expose and reflect on their emerging capabilities—their knowledge, skills, feelings, and dispositions, if you will. Understanding children begins with observing them. Indeed, much of what is known about child growth and development has been derived from observational studies and the inferences that have been drawn from them.

Classroom teachers engage in both incidental and focused observations. *Incidental* observations occur quite frequently as the teacher circulates among students who are engaged in classroom tasks and activities. During story time, for example, the teacher scans the listeners for facial expressions and body language and listens for verbal responses indicative of enjoyment, language development, and comprehension. The teacher observes children as they move about, attending to their posture, gait, coordination, agility, endurance, persistence, use of materials and equipment, and the choices they make. The children are also observed as they interact with one another and with adults. There are innumerable incidental observations inherent in day-to-day interactions with children. These incidental observations provide valuable information about what individual students *are feeling, thinking, understand, and can do* and guide the responsive teacher in setting appropriate expectations and experiences for them.

In discussing the difference between "looking" and "seeing," Leonard (1997) cautions observers about the "visibility trap" in which the observer's attention easily gravitates toward certain highly visible children or children whose behaviors, looks, activity preferences, level of dependency, and social skills to mention a few are valued by the observer, while other children in the group become rela-

tively "invisible." Keeping organized records on all children helps to prevent this type of selective observation from occurring. Skill in observing and recognizing significant behaviors and emerging capabilities is necessary for both teaching and assessing, and as discussed above, skilled observation enhances the reliability and validity of inferences that are drawn. Consider the following example and each teacher's observations and inferences:

Event	Teacher A	Teacher B
Christi arrives at kindergarten late. The class is assembled around the teacher who is previewing the day's schedule.	Christi is "always" late.	Christi's eyes are red and she looks tired, sad, or mad; I can't tell for sure.
Christi shoves her lunch box into her cubby. Rather than joining the group, she goes to a table to sit, leans forward, and buries her face in her arms.	Christi is in a bad mood.	Christi is obviously disturbed about something. I noticed she "shoved" her lunch box into her cubby and practically "fell" into the chair before burying her face in her arms.
Christi remains in this posture throughout the group time and well into center time.	Obviously, Christi does not wish to participate this morning.	Christi's behavior may be a call for help. I will ask.
After the teacher questions her, Christi reveals a very upsetting argument her parents had the evening before and some of the words that were exchanged. The most disturbing to her was the idiom her mother used in reprimanding her father for throwing a book across the room: "You are going to kill somebody." Christi thus repeated to the teacher, "My daddy is going to kill somebody."	It is sad when parents don't get along; no wonder Christi is in a bad mood. Christi gets frightened when her parents argue.	Christi does not yet separate fantasy and reality, and does not understand idioms, so she is frightened by what she heard. Most likely her sleep was disturbed, explaining the red eyes and disinterest in joining the group.

Although each teacher's observations are "correct," Teacher B has exercised more skilled observation based on her knowledge of child development. Because Teacher B's observations are more detailed, she is able to explore three possible avenues for enabling Christi to learn and to cope: (1) provide opportunities to experience in positive ways the differences between fantasy and reality; (2) introduce the concept of idioms through stories, games, or by explaining many other such expressions, focusing on the more comforting ones; and (3) provide some unencumbered time for Christi to collect herself and perhaps to rest from a sleepless night. In addition, Teacher B is able to infer from her observations and thus derive a plan for future observations of Christi, being alert to other behaviors indicative of continuing discord in the family. She may determine that a parent conference could help.

Teacher A established that Christi was in a "bad mood," but did not observe her physical appearance, posture, body language, or facial expression. She inferred that Christi did not wish to participate without having adequate data to verify the inference or explain the behavior. Her inference that Christi had been frightened was correct, but she failed to connect Christi's fears with her levels of cognitive and psychosocial development. There is also evidence of teacher bias. Teacher A has observed little to be of much help to Christi or to supply any information of consequence about Christi that might inform teacher–child interactions and instructional planning.

Skilled observation enables a teacher to attend to a variety of cues or signals that children exhibit. (See Figure 6.5.) Teacher B responded to Christi's refusal to join the group as a signal for attention—a cry for help. Wisely, she allowed Christi to verbalize her experience and thus reveal her level of understanding that, in turn, provided Teacher B with valuable insights into Christi's current (and possibly future) behaviors. From this example, we can extrapolate the following characteristics of a skilled observer:

◆ Is informed by knowledge of child growth and development.

◆ Avoids jumping to conclusions.

◆ Is empathic and devoid of bias and preconceived ideas.

◆ Attends to details.

◆ Forms hypotheses and observes further for verification.

◆ Facilitates drawing valid inferences.

◆ Generates a plan for further observation.

◆ Informs instruction and adult/child interactions.

Focused observation entails using a preplanned format such as a checklist, rating strategy, anecdotal record, or other instrument for systematically recording observational data. Incidental observations may find their way into these formats as well, for there is a need to record and assemble significant information gained from all observations. Focused observations are usually predetermined with ele-

talking	playing	listening	interacting
singing	pretending	rapping	building
reading	writing	drawing	painting
sorting	classifying	graphing	seriating
computing	mapping	constructing	debating
problem solving	dramatizing	empathizing	persisting
role playing	questioning	bragging	explaining
manipulating	balancing	lifting	helping
disassembling	sculpturing	climbing	running
organizing	sharing	making choices	negotiating

Figure 6.5
Behaviors to Observe in Children

ments of time, place, and activity controlled in some manner. Focused observations may be carried out by the classroom teacher during the course of the school day, or may involve one or more other persons, e.g., another teacher, a parent, classroom aide, diagnostician, school principal, or other appropriate observer depending on the purpose and goals of the observation. When two or more individuals observe the same children and event, observations can be compared to determine areas of agreement and disagreement. Interrater reliability evolves from this type of process rendering the inferences drawn toward higher levels of reliability. When in doubt about a particular observation, this strategy can be helpful. Good focused observations have these qualities:

◆ clearly stated purpose and goals for the observation

◆ clearly defined target behaviors to be observed

◆ well-designed instruments to focus observations specifically on the identified target behaviors

◆ observer familiarity with the purpose and goals, target behaviors, expected behaviors (or a developmental frame of reference), the assessment instrument and how it will be used and scored

◆ adequate time to conduct the observation(s)

◆ clearly elaborated and developmentally sensitive scoring procedures

◆ professionalism and ethics in evaluating and interpreting the observations

In addition, observers must be fully aware of the context in which observing is taking place, and events preceding and following the observation, and should be as unobtrusive and inconspicuous as possible during observations. Children's behaviors change when they are aware that they are being observed. The techniques that follow can strengthen observation skills and, over time, increase the teacher's knowledge base about child development and learning. Let's examine

the features and uses of some of the more practical methods for recording and assembling observation data.

Anecdotal Records

An *anecdote* is a short account of some significant event or incident in a child's day. The record of this event can be quite detailed or very brief. Usually written after the event, these short reports (or vignettes) describe, in a factual way, the incident, its context, and what was said or done by the participant(s). Skilled observation and accurate recording provide an opportunity to capture the essence of an event. The less time that elapses between the incident and the recording of it, the more detailed and accurate the anecdotal record can be.

Ideally, the anecdotal record should be recorded as it unfolds or immediately thereafter. However, this is not always possible in a busy classroom with few adult helping hands. Anecdotal records usually have to be written later, perhaps during a planning period or at the end of the school day. Because it is sometimes difficult to rescue and remember all of the aspects of an event for later recording, keeping brief notes on index cards carried in your pocket or placed about the room for ready accessibility can be helpful. Jotting one-word reminders or short phrases on the cards as the event unfolds (or immediately following it) can provide a set of handy reminders for recording later in the day, when the anecdotal record is written. You can record information such as the child's initials; time; place (playground, writing center, music activity, and so on); other participants; any words, phrases, or quotations that will help you remember what was said; antecedents to the episode; and the outcomes or other items germane to the event. The index card might look like the example in Figure 6.6.

These short notes can be extended into full descriptions later, using a form designed for anecdotal records. The completed form should be placed in the student's portfolio. The anecdotal record might look like the form in Figure 6.7.

Figure 6.6
Anecdotal Record Note Card

CEP	*11/16/00*
	9:15 AM
block center	
w/ MH, DP, JB	
crowded dispute over truck	
"...we are friends..."	
prosocial solution	

<div style="border:1px solid black;">

Child's Name: _Catherine E. P._

Date and Time: _11 / 16 / 00 9:15 am_

Observer: _J. Nowell_

Place or Learning Center: _block center_

Observed Event and Behaviors:

While working together in the block center, Maria, Darrell, Jamie, and Catherine began to argue over who would be the driver of the dump truck. Maria allowed that none of the others could be her friend if she was not the driver. Catherine suggested that there were two other trucks and an airplane—she could be the pilot and everyone else could drive a truck. They were each satisfied and soon settled back into their roadbuilding play theme. Catherine soothed feelings by saying "I like it when we are friends."

Comments / Summary

Catherine, while meeting her own needs to "be the pilot," nevertheless revealed unusual facility in negotiation and compromise. Her prosocial skills were evident in this incident. Observe for further evidence of this skill with other classmates.

Reminder: Reduce number of children allowed in the block center at one time to alleviate crowding.

</div>

Figure 6.7
Anecdotal Record

Records such as these and more detailed ones take some time to do well. However, their ability to capture the richness and complexity of the moment as children interact with one another and with materials provides a valuable source of information. Meisels (1992) suggests that at least one anecdotal record per child per week be completed, but more are recommended when feasible. These records of child behavior and learning accumulated over time enhance the teacher's understanding of the individual child as patterns or profiles begin to emerge. Behavior change can be tracked and documented, and suggestions for future observations, curriculum adjustments, and student or parent conferences can be included in teacher planning.

Checklists

More expeditious than anecdotal records, the *checklist* helps to focus the observer's attention on the presence or absence of selected behaviors or learning. Checklists may focus on growth and development indicators or on learning objectives and curriculum components. They may contain lists of traits, skills, behaviors, interests, concepts, or developmental or curricular benchmarks.

Checklists can be used to assess student performance, student products, and student processes. Checklists may be teacher designed or developed by authorities in particular development or skill areas. Some learning systems and textbooks come with their own objectives checklists.

Regardless of origin, checklists should be designed to portray well-defined criteria. Criterion-referenced checklists may be based on local or state mandated learning objectives or perhaps on school site-based goals and objectives for specific curriculum areas or grade levels. Further, checklists must reflect current knowledge in child growth, development, and learning and be sensitive to diversity and special needs. You may wish to take the time to read through the variety of checklists to develop a sense of content and sequence.

A developmental checklist assists the teacher in monitoring the growth and development of each child. A good developmental checklist provides a sequential overview of expected patterns of development from which an emerging profile of the student becomes evident and from which decisions can be made about the types of classroom experiences that will be most beneficial. Figure 6.8 is an example of a sequential checklist for observing emerging fine motor development. Checklists may also alert the teacher to the need for additional, more in-depth assessment for a particular child. A practical way to use checklists is to focus on a small group of four to five children per day. Attempting to complete whole group checklists in one day increases the risk of mistakes, oversights, and overgeneralizations, and simply is not practical.

For focused observation across developmental domains, a criterion-referenced checklist such as that developed by Marsden, Meisels, Steele, and Jablon (1993) is a good example (see Figures 6.9 and 6.10). Other exemplary checklists have been developed by Beaty (1998), Frost and Wortham (1984), Wortham (1984), and others (see "Resources" in Chapter 10). Using developmental checklists to date the emergence of each developmental indicator provides a criterion against which to compare other data—performance, processes, and products. Other checklists may address curriculum-related areas and the developmental progression toward expected learning or skill outcomes.

For summative reports used for grade or school progress reporting, assessing class progress in selected curriculum areas, and for planning for curriculum modification or enrichment, whole group checklists may be useful. Such lists can be assembled into a class summative portfolio for periodic assessment and summary data. Such a report includes identical information collected on each student in the class and depicted on a matrix such as the one in Figure 6.11.

A major disadvantage of the checklist is that it provides no context cues surrounding the observed behavior or learning. A checklist tells little or nothing about the frequency with which the behavior or event occurs or the duration of the behavior or episode being observed. The checklist does not describe or elaborate. It is necessary to complement checklists with other, more detailed observations of student performance and with actual samples or representations (e.g., photographs, audio or video recordings, or computer disc storage) of student products.

	Date	Date	Date	Comments
Picks up objects easily with pincer movement				
Releases grasp with ease				
Builds stable vertical structures with unit blocks				
Handles feeding utensils efficiently				
Manages clothing (buttons, zippers, ties, snaps, belt buckles, etc.)				
Demonstrates hand preference				
Pours from small pitcher				
Turns knobs, handles, etc.				
Manipulates bead stringing, peg board activities, puzzles, and other small manipulatives				
Turns pages of book, one at a time				
Holds crayon in fist				
Holds crayon with fingers				
Manipulates clay and sculpting material				
Molds discernable shapes or objects with clay				
Draws using wide circular marks				
Draw discernable shapes or pictures				
Folds paper				
Traces shapes and figures with finger				
Traces shapes and figures with crayon or pencil				
Copies shapes and figures				
Cuts with scissors—straight lines				
Cuts with scissors—curved lines				
Cuts with scissors—outlined shapes				
Grasp pencil correctly				
Uses pencil to make letters, numerals				
Copies letters, shapes, designs				
Writes in a horizontal line				
Writes within guidelines				

Figure 6.8
Fine Motor Development Checklist

I. Personal and Social Development

A. Self concept

1. **Has a positive sense of self and shows confidence that others will like her/him;** See Guidelines p. 3

 FALL ☐ ☐ ☐
 WINTER ☐ ☐ ☐
 SPRING ☐ ☐ ☐

2. **Shows eagerness and curiosity as a learner.** See Guidelines p. 3

 FALL ☐ ☐ ☐
 WINTER ☐ ☐ ☐
 SPRING ☐ ☐ ☐

I. Personal and Social Development

A. Self concept

1. **Has a positive sense of self and shows confidence that others will like her/him;**

Children acquire increasing self-awareness and positive self image through their interactions with others and experiences of being effective. Some examples include:

• becoming absorbed in "work," e.g., an art project, doing a puzzle, building with blocks, etc., and not seeking constant adult support and approval;

• entering an established group with confidence that s/he will be accepted, and suggesting a role for her/himself in the group.

2. **Shows eagerness and curiosity as a learner.**

Five year olds are active learners, and are curious and excited about their environment. Examples include:

• being excited and curious about new things in the classroom, e.g., a collection of fall leaves, or shells from the sea shore;

• asking questions that are meaningful and appropriate;

• showing interest in stories and events related by other children.

Figure 6.9
The Work Sampling System Developmental Checklist

COMMENTS
Fall Observation Period

Winter Observation Period

Spring Observation Period

CHILD _____

DATE OF BIRTH _____

TEACHER _____ SCHOOL _____

FEMALE ☐ MALE ☐

OBSERVATION PERIODS: FALL _____ WINTER _____ SPRING _____

K

Figure 6.10
Comments Section of the Work Sampling System Developmental Checklist

Figure 6.11
Class Summary Report

Target Behaviors

Student's name

Inventories

The checklist's "cousin," the *inventory*, can also be useful. The inventory has more meaning in terms of the overall picture. Inventories are generally more comprehensive and detailed than checklists and provide a way to keep track of what is currently happening or, in developmental terms, what observed development is emerging. This differs from checklists in that no single item on the inventory represents a necessary achievement. Checklists generally suggest the direction that growth, development, and learning should be following. Inventories, on the other hand, highlight growth, development, and learning as they occur. As Engel (1990) points out, the difference between the two is the difference between *prescription* and *description*. For example, Figure 6.12 illustrates a descriptive inventory of "observable" cognitive processes. Note that in this particular inventory, while the items are arranged from less to more complex and sophisticated levels of cognitive abilities, they do not necessarily represent an invariant step-by-step stage sequence. The descriptor, "observed," is surrounded by quotation marks to convey the obvious, that the classroom observer cannot actually get into the mind of the learner and know with certainty the cognitive processes that are taking place, but can attend to the outward manifestations (i.e., language, behaviors, and activities) emanating from the learner's thinking processes. We must also note that this OCP inventory is by no means a complete list of cognitive processes. The observer can use this inventory to profile the types of processes a learner uses in different contexts and with different tasks.

Rating Scales

Another device for recording observations is the *rating scale*. The rating scale requires that the observer make judgments about knowledge, skills, feelings, and

Check (✓) observed behaviors **Comments**

_____ Observes actions of objects and people

_____ Intentionally repeats behaviors or pleasurable actions

_____ Employs imitative behaviors

_____ Demonstrates the concept of object permanence

_____ Motorically explores physical surroundings

_____ Listens intently and curiously

_____ Visually focuses on speaker or source of sound

_____ Auditorily focuses on speaker or source of sound without visually searching

_____ Engages in tactile exploration of objects

_____ Engages in taste exploration of edibles

_____ Uses sense of smell to identify objects, places, or events

_____ Uses objects to represent ideas, events, play themes, or experiences

_____ Connects sounds and rhythms with bodily movement

_____ Expresses thought, ideas, and mood through movement, music, and/or art production

_____ Verbally labels objects and events

_____ Uses trial and error strategies to solve problems

_____ Verbalizes previously learned concepts

_____ Repeats previously learned behaviors

_____ Applies previously learned concepts or behaviors in new situations and different contexts

_____ Uses prior experiences and knowledge to verbally explain current event or dilemma

_____ Demonstrates concept of cause and effect

_____ Applies concept of cause and effect in play with objects

_____ Applies concept of cause and effect in problem solving

_____ Applies concept of cause and effect in social interactions

_____ Experiments with new or novel uses for familiar objects

Figure 6.12
"Observed" Cognitive Processes Inventory

_____ Solves concrete problems using physical objects

_____ Manipulates and explores objects and classroom materials

_____ Uses classroom materials in traditional ways

_____ Uses classroom materials in creative, imaginative ways as a means to convey meaning or to further understanding

_____ Contrasts and compares objects, events, and ideas

_____ Formulates hypotheses

_____ Tests predictions

_____ Seeks verification through dialogue

_____ Seeks verification through experimentation with objects

_____ Attempts to explain or interpret new information

_____ Generates and verbally suggests procedures for problem solving

_____ Works independently to solve problems

_____ Interacts with classmates to solve problems

_____ Enlists adult interaction to solve problems

_____ Asks meaningful questions

_____ Responds thoughtfully to answers

_____ Challenges answers when necessary

_____ Applies answers in subsequent situations

_____ Engages in meaningful dialogue using questions to expand understanding

_____ Uses a variety of speech forms to sustain conversation/ dialogue

_____ Demonstrates observant behaviors by calling attention to less obvious objects, events or situations

_____ Relates objects and/or events to one another

_____ Demonstrates functional relationships (objects, events, or ideas that are mutually dependent)

_____ Classifies by one attribute

Figure 6.12, *continued*

dispositions in the domains being observed by assigning them a numerical or descriptive rating. Rating scales can be difficult to construct because it is necessary to keep descriptors and numerical ratings within the common understanding of each person who will use the scale. There is also a heightened possibility for bias to creep into rating scales. Although such scales help teachers to record observations quickly and efficiently, they must be used prudently and must fairly

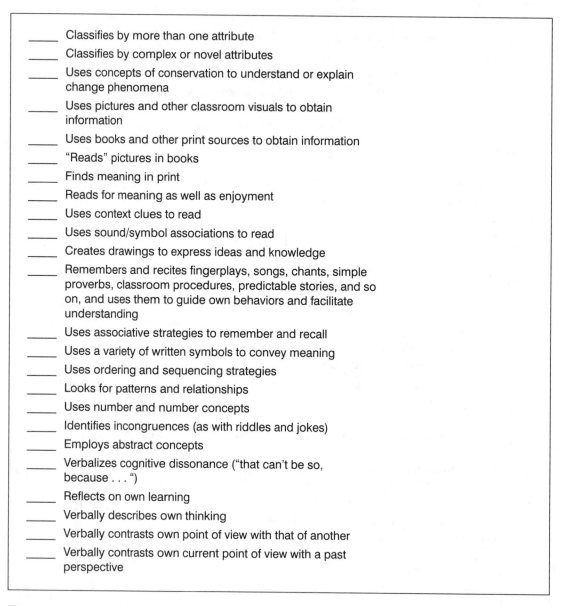

_____ Classifies by more than one attribute

_____ Classifies by complex or novel attributes

_____ Uses concepts of conservation to understand or explain change phenomena

_____ Uses pictures and other classroom visuals to obtain information

_____ Uses books and other print sources to obtain information

_____ "Reads" pictures in books

_____ Finds meaning in print

_____ Reads for meaning as well as enjoyment

_____ Uses context clues to read

_____ Uses sound/symbol associations to read

_____ Creates drawings to express ideas and knowledge

_____ Remembers and recites fingerplays, songs, chants, simple proverbs, classroom procedures, predictable stories, and so on, and uses them to guide own behaviors and facilitate understanding

_____ Uses associative strategies to remember and recall

_____ Uses a variety of written symbols to convey meaning

_____ Uses ordering and sequencing strategies

_____ Looks for patterns and relationships

_____ Uses number and number concepts

_____ Identifies incongruences (as with riddles and jokes)

_____ Employs abstract concepts

_____ Verbalizes cognitive dissonance ("that can't be so, because . . . ")

_____ Reflects on own learning

_____ Verbally describes own thinking

_____ Verbally contrasts own point of view with that of another

_____ Verbally contrasts own current point of view with a past perspective

Figure 6.12, *continued*

(without bias) represent the observed behavior. Figure 6.13 illustrates rating scales in which descriptive categories are assigned frequency ratings.

Time Sampling

Using the *time sampling* techniques, an observer or teacher attempts to record the occurrence or nonoccurrence of selected behavior(s) within certain time frames. For

Level	Problem Solving	Rating			Comments / Notes
		Frequently	Sometimes	Never	
EXPLORATION	1. Exhibits curiosity/ interest in the problem				
	2. Asks questions about the problem				
	3. Draws on past experience to understand the problem				
DISCOVERY	4. Verbally or graphically represents the problem				
	5. Draws on past experience to plan a solution				
INQUIRY	6. Engages others in the solution				
	7. Accepts assistance				
UTILIZATION	8. Initiates a plan				
	9. Evaluates the solution				
	10. Applies solution in other contexts				

Figure 6.13
Problem-Solving Rating Scale

instance, a teacher may want to ascertain how many times a child moves from one learning center to another during periods when students are encouraged to self-select and initiate their own learning activities. A time sampling chart might look like the example in Figure 6.14. Time sampling is helpful in determining the frequency with which certain behaviors occur and can be designed to include context clues such as time of day, place of event, other individuals involved in the event and so on.

Activity Changes	Time Unit										Comments
	9:00		9:15		10:00		10:15		10:30		
(child's name)	U	F	U	F	U	F	U	F	U	F	

U = unfocused/undecided about what to do next
F = focused/next activity pursued with obvious intent

Figure 6.14
Frequency of Activity Changes

Event Sampling

Using the *event sampling* technique, observers can record events or categories of events as they occur. For example, teachers may wish to observe creative effort with art media. They must first identify the behaviors to be observed and then record each event when it is observed. This record can be designed several ways; Figure 6.15 illustrates one such method. Event sampling can be as brief or as detailed as time and need dictate. Always, the more information provided by an observation record, the more useful it can be later when interpretation or summarization is required.

Interviews

Student *interviews* are particularly helpful in deepening one's understanding of each child. Through interviews teachers can gain insight into students' prior knowledge and experience, current understandings, learning styles, interests, motivations, anxieties, and so on. Teachers can observe students' responses and reactions to questions and dialogue without looking for the "correct" answer or

Creative Endeavor							
(child's name)	Draw	Paint	Clay	Paste	Multi-media	Other	Comments
10-12-92	l l		l	l			
10-15-92	l l l	l					

Figure 6.15
Event Sampling: Creative Activity

"good" or "right" behaviors. The interview provides a special opportunity to help students reflect upon their own products, processes, performance, and portfolio development. It also sets the stage for determining each student's zone of proximal development (discussed in Chapter 4) and provides the essential opportunity for the teacher to engage in scaffolding activities that enhance student learning and understanding. This and other topics relating to collaborating with students are covered in greater detail in Chapter 8.

How Will Student Performance, Processes, and Products Be Judged?

Fair, valid, and reliable assessment depends on having clearly defined the developmental domains and the specific behaviors, skills, or knowledge expected to emerge within each. Having done so, assessment instruments can be designed to reflect the degree to which the student exhibits the identified behaviors or is progressing toward specific learning outcomes. The term *rubrics* is commonly used to refer to the descriptions of the criteria in each level or gradation of a performance, product, or process. Rubrics are useful because they establish what is important; they define target outcomes and clarify expectations. The development of rubrics helps to focus observations and assessments on the essentials and assists both learners and teachers in defining progress and quality. Well-framed rubrics, while time-consuming to develop, ultimately reduce assessing and grading time and render more accurate, complete, context specific information.

Rubrics provide immediate feedback to learners, thus giving them positive support and encouragement while helping them to identify and correct their mistakes, or practice an emerging skill. Further, rubrics provide a clear frame of reference for articulating student progress and performance to various stakeholders: learners, their parents or guardians, appropriate school personnel and policy-makers. Well-framed rubrics have the following characteristics:

◆ They are tied to clearly stated learning objectives or developmental outcomes.
◆ They articulate a sequence that moves logically from emergent to proficient.
◆ They are stated in positive ("can do") terms.
◆ They are free of bias relating to age, gender, socioeconomic status, ethnicity, and ableness.
◆ The terminology is understandable and meaningful to the learner.
◆ The terminology is universally understood by all professionals who are involved in the use of the particular assessment instrument.
◆ Rating scales or codes are fair and easily interpreted.
◆ The rubrics as stated and the scores thus derived facilitate decision making.

Scoring rubrics can be described several ways. Stiggins (1997a) classifies scoring rubrics into two categories: analytic and holistic. An *analytic* scale sets forth a series of statements describing characteristics associated with each score in a range of scores. The statements describe the progression the learner should go through to get more proficient. The scale provides a precise picture and is more "diagnostic" than other scoring systems, though it takes considerably more time to develop. Analytic scales are frequently used to describe levels of acceptable performance in academic achievements and are keyed to content area standards. The learner's performance or products are judged according to how close they come to the standard at the time of the assessment. Figure 6.16 shows a sample rubrics paradigm for early childhood mathematics assessment.

In line with this paradigm, one could construct a rubric that indicated where in the recursive learning cycle (Bredekamp & Rosegrant, 1992, Rosegrant, 1989) a student might be with regard to particular concepts or content. The four-part rubric would denote how a learner is relating to various aspects of the current curriculum and progressing toward new awarenesses. Such a rubric would help focus observation on learner processes while providing guidance to the teacher seeking to facilitate the learner's pursuit of understanding. The descriptors would be those described by Bredekamp and Rosegrant (1992): awareness, exploration, inquiry, utilization. (The reader is advised to study about this learning cycle described fully in Bredekamp & Rosegrant (1992). The rubrics for such an instrument might look like those in Figure 6.17.

A *holistic* approach entails assigning a single score based on the overall quality of the student performance or product. Quick and simple, this approach yields little specific information to guide instruction, though it may be used to flag indi-

Not observed yet	Emerging	Gaining competence	Proficient
Counts by rote 1 to 10	Counts by rote beyond 10	Counts by rote to 30	Counts by rote to 100
Uses one-to-one correspondence to count up to 5 objects	Uses one-to-one correspondence to count 10 objects	Uses one-to-one correspondence to count 10 to 30 objects	Uses one-to-one correspondence to count more than 30 objects
Attempts to count objects for a purpose, e.g., a napkin for each of 6 members of the group	Counts objects for a purpose with no more than one or two miscalculations	Counts objects for a purpose with no miscalculations	Helps others count objects for a purpose with no miscalculations
Identifies objects as being a member of a set	Identifies objects as being a member of a set that is verbally described	Creates sets of objects	Creates sets of objects and describes the sets' attributes
Attempts to group objects by one attribute	Groups objects by one attribute	Attempts to group objects by more than one attribute	Groups objects by two or more attributes
Responds appropriately to most positional language, e.g., up, down, over, under, behind, in front, etc.	Responds appropriately to all positional language	Uses positional language to describe own behaviors	Uses positional language to describe and explain own and others' behaviors and to direct problem-solving activities

Figure 6.16
Mathematics

vidual students who may need more focused assessment. An example of holistic scoring might be to assign a score of 1, 2, 3, or 4 (1 representing the lowest score and 4 representing the highest), to a student's participation in a cooperative group endeavor. A set of general guides would describe what each numerical score means. For instance, in the cooperative group endeavor the following might describe the types of behaviors typically exhibited:

1 reticent, timid, reluctant, or interfering behaviors
2 minimal participation with some constructive suggestions and some counterproductive or interfering behaviors
3 participation with constructive contributions

Awareness	Exploration	Inquiry	Utilization
Experiences new concept or phenomenon	Observes materials, events, interactions	Extended exploration of the materials or information associated with the concept or event	Applies new learning to new situations or in other contexts
Shows interest	Explores the materials, attends to components or attributes		Demonstrates new learning through a variety of representations, drawing, writing, construction, interactions with others
Attends to its characteristics or elements		Engages in focused information gathering activities	
	Engages in play associated with new concept or phenomenon		
		Proposes own explanations	
	Attempts to apply labels, descriptions, attributes to new concept or event	Compares own perceptions with that of others	Uses language associated with new learning
		Relates new information to prior experiences or learning	New awarenesses are created, new hypotheses formulated
	Attempts to represent new concept through drawing, writing, constructions, and sociodramatic play		
		Generalizes to other concepts, events or phenomena	

Figure 6.17
Recursive Learning Cycle Observation

4 focused participation with goal-oriented suggestions and meaningful contributions

Gredler (1996) refers to a "key features" approach that determines to what degree certain characteristics or features occur—for example, the extent to which a child's retelling of a story contains the following features: title; author; beginning; middle; and end; or perhaps more detail such as setting, characters, story problem (plot, climax); and story solution/conclusion. The evaluative code might include a three-part scale such as:

Not yet Sometimes Most of the time

Emerging Developing Proficient

An assessment of a child's emergent drawing ability is an example of a key features approach and might look like that in Figure 6.18.

Emergent	Beginning	Developing	Proficient
Controlled fine motor strokes	Hand-eye coordination	Controlled eye-hand movements	Drawings represent familiar objects or experiences
Controlled use of implements, e.g., paint brush, crayons, markers, etc.	Curved line drawings	Drawings, sculptures, and so on are goal oriented	Demonstrates own unique ways of drawing certain pictures or symbols
Random line or shape drawings	Creates recognizable forms	Drawings include symbols	Uses some stereotypes observed in other art
Focus is primarily on sensory enjoyment and exploration of the media	Draws specific shapes, e.g., squares, rectangles, circles	Names symbols in drawings	Person drawing is elaborate with numerous details
	Curious about art media, e.g., clay, glue, finger paint, etc.	Stick figure person showing greater detail (eyes, hair, finger, toes, clothing, etc.)	Size of individual objects in drawings represent their importance to the child
	Repetition in drawings of same or similar pictures	Dictates labels or a one or two sentence story for art	Pictures contain a base line
	Draws stick figure person	Requests name be printed on art work	Dictates or writes labels or extended story on art work
		Distinguishes own art work from that of others	Most objects in drawings are recognizable to others
		Enjoys and takes pride in art work	Interested in the end product
			Saves art to share with others

Figure 6.18
Drawing: Key Developmental Features

As you can see, this paradigm is detailed and follows an expected developmental sequence. It can be used to assess many drawings over time. Information derived from this approach can be used to assess levels of development from very specific indicators and inform and complement other assessments. For example, drawing assessment in Figure 6.18 can provide information about emerging symbol awareness, use, and meaning; writing and reading; concept development associated with the content of drawings; spatial awareness reflected

in drawings (e.g., left/right, top/bottom); story construction capabilities; and so on. The drawing assessments then, can be triangulated (or merged) with assessments in other developmental or content areas to cross-reference and verify initial inferences. Thus the key features approach provides a very useful and meaningful set of data that can integrate across developmental and curriculum areas.

Each scale value or dimension must be chosen for the message to be conveyed and to whom. For instance some scales are designed to assist nonreaders and beginning readers in evaluating their own performance and therefore use pictures or symbols (e.g., a series of "smiley" faces or geometric shapes); others are intended to provide general developmental information to adults and use descriptive terminology. Whether intended for the adult or student user, the scales must be tied to and relate meaningfully to the criteria, standard, or developmental sequence being assessed. In addition to simply documenting the presence or absence of an attribute, scale values can be labeled in numerous ways. When using a range of values, each level must be clearly described and defined, so that all raters and ratings use the same criteria. The following are some examples of scale values:

Cannot do Can do with assistance Can do independently

Not yet Developing Achieving Extending

Not yet In process Proficient

Never Sometimes Always (or Consistently)

Not very much A little bit Much of the time Always

Working on Demonstrated some of the time Effectively demonstrated

Not assessed Not yet demonstrated In progress Consistently demonstrate mastery

Novice Apprentice Proficient Distinguished

Emerging Beginning Developing Proficient (or for reading: Fluent)

Initiated In progress Completed

| Early Emergent | Advanced Emergent | Early Beginning | Advanced Beginning | Early Independent | Advanced Independent |

Scales can range from two point (yes/no) to up to six or even nine points. While we would not suggest limiting yourself to one particular type of point value, we like a four-point scale for several reasons. Using four levels or dimensions prevents the tendency to pull the score to the middle when undecided; it

forces the assessor to be explicit about whether a ranking represents upper or lower level expectations or performance. Recognizing that systems for reporting student progress still include report cards, many of which continue to use A, B, C, D grades, an additional reason for favoring a four-point paradigm is that it facilitates translation into letter or numerical grades when such is required. As discussed earlier, many student attributes measured through authentic assessment processes cannot and should not be translated into letter grades or numerical scores. Nevertheless, school policy may dictate letter grades for certain attainments in behavioral or content areas, and meaningful instruments can be developed that provide descriptive information that can be scored in such a way that the scores can be translated. When numbers are attached to the grades in a four-point scale, 4=A, 3=B, 2=C, 1=D, averaging is quick and easy.

When and Where Will Assessment Take Place?

A skilled observer is alert to behaviors and performances in all contexts: the classroom, playground, with individuals, in groups, with parents and other adults, on a field trip, in the cafeteria, and all other places where children and teachers are together. For most teachers, observing children is a natural part of their work, they do so without conscious effort. However, becoming skilled at drawing valid inferences, selecting and using a variety of assessment instruments, and assessing student products from an emergent development perspective rather than a deficit identification approach, and finally, recording and showcasing student progress takes conscientious planning, focused observation, and practice.

A frequent concern associated with authentic assessment is the time involved in doing a good job. This is a legitimate concern, but need not discourage the effort. The rewards in terms of professional development as teachers become more knowledgeable about their individual students and about child growth, development, and learning, and the opportunities to effectively enrich curriculums to meet needs, the possibilities of better performance and sustained learning on the part of students are all valid reasons to make the time for a better system. Again, as stated in Chapter 2, begin slowly with areas in which one has the greatest confidence, and gradually increase the domains and the methods used to assess. Do not try to assess the whole class at once. Work with small groups, week by week, rotating and observing and assessing different groups until all children are involved in an authentic assessment process. As with any new skill, the more you practice, and modify and refine the process, the easier it will become. Indeed, integrating authentic assessment into your teaching/educating repertoire can lead to more efficient and purposeful use of time—both yours and the students'—as priorities change and former less essential practices are discarded.

Who Shall Be Involved in the Assessment Process?

As we shall see in the ensuing chapters, authentic assessment is a collaborative endeavor. The classroom teacher does not sit in a "judge's seat" seeking to note what children do not know or cannot do. Rather, the teacher becomes a partner

with all learners, helping them set realistic and obtainable goals, showcase their accomplishments, and celebrate their progress. Collaborating with parents to meet each child's unique needs and interests brings the home and school into shared responsibility for student outcomes. Working collaboratively with students, parents, and other professionals within the school, assessments become more authentic, and therefore more useful. As you will see in Chapters 7, 8, and 9, students and parents can play an active role in the authentic assessment process. In the next chapter we will describe a major part of this process, the design, development, evaluation, maintenance, and uses of the portfolio.

REVIEW STRATEGIES AND ACTIVITIES

1. With a partner, observe the same child for thirty minutes. Decide in advance what recording form or forms you will use. Write separate summary reports from your observations, but do not reveal your observations to one another. Draw inferences where possible and make some suggestions regarding the education of the child you both observed. Later, in class, compare your observations.

 a. What did one of you notice that the other did not?

 b. What did you notice but not record?

 c. Why did you choose not to record that incident?

 d. How objective were your observations?

 e. Do you think your inferences were valid, based on what you were able to observe?

2. Conduct your own survey of the literature for developmental and curricular checklists. Compare the items and sequences with principles of development and learning described in your child development textbook.

3. Select a standardized test used extensively in your state or school district. (Consult current volumes of Buros's *Tests in Print*.) Discuss the test with a classroom teacher or principal who is well acquainted with it. Determine the following:

 a. description and purpose of test

 b. how the test was developed and by whom

 c. validity and reliability of the test

 d. under what circumstances the test should be used

 e. how difficult or easy the test is to administer

 f. cost of administering and scoring

 g. legal considerations in the use of the test (e.g., test security, score reporting, student privacy, and who should administer)

4. Compare the essential characteristics of the type of test you have reviewed and the essential characteristics of authentic assessment. Discuss the purpose(s) each strategy serves in the educative process.

7

Portfolio Development and Assessment

If, in everyday contexts, most caretakers do not impose unobtainable goals or unrealistic behavioral standards on young children, and if they praise achievement efforts more than they criticize failures, then in naturalistic contexts positive reactions to success would be expected to be more prominent in young children than negative reactions to failure.

 Stipek, Recchia, & McClintic (1992, p. 79)

The most appropriate use of assessment is in the service of instruction: Assessment information should be used to make school experiences and life better for children.

 Bredekamp & Rosegrant, (1992, p. 29)

Just as high-quality assessments give meaning to report card grades, so too do they permit portfolios to tell rich and compelling stories about student academic growth and development. But, they can help us to communicate more effectively and thus improve schools only if they tell an accurate story.

 Stiggins (1997, p. 453)

After reading and studying this chapter you will demonstrate comprehension by being able to:

- define and describe the portfolio process for student assessment and curriculum planning.

- identify student products and processes that provide authentic assessment information.

- describe the different types of portfolios according to their purposes.

- articulate guidelines for the appropriate uses of the assessment portfolio.

HOW WILL ASSESSMENT INFORMATION BE ASSEMBLED AND USED?

In the preceding chapter, we began our development of a "grand plan" or blue-print for implementing authentic assessment in early childhood education. Such a plan entails making decisions about who and what will be assessed, what strategies or techniques will be employed, what measures need to be taken to ensure reliability and validity, and where and when assessment can (should) occur. In this chapter, we will extend the discussion of the overall plan to include how assessment information will be assembled and accessed to benefit learners and curriculums, and amalgamated into a dynamic and meaningful portfolio system.

Performance, Processes, and Products

Recall from Chapter 6 the ways in which students reveal to us their feelings and knowing, their capabilities and interests. Authentic assessment derives its information and inferences from astute attention to students' performance on both required and self-selected tasks, on the products of their work and play, and on the processes they employ when they are engaged in meaningful, purposeful work and play.

Until now we have focused mostly on assessments that address observed student performance and processes. What about the products of student learning? Appreciative parents and grandparents over the years have saved the products of their children's learning, collecting them in drawers and boxes and proudly displaying them on refrigerator doors. Cameras and video cameras are eagerly engaged when special events showcase what their children are doing and learning at school. In authentic assessment schools, student products are not only showcased at special events, but are an integral part of each child's day-to-day schooling and are considered to be an essential ingredient in an ongoing assessment process. Student products provide a medium through which teachers gain insight into a student's learning processes, uncovering important information about characteristics such as how individuals explore, discover, invent, and solve problems. Figure 7.1 lists examples of products available across curriculum areas through which children demonstrate their knowledge, skills, feelings, and dispositions.

When we broaden assessment to include this eclectic array of student products, we expand and deepen our knowledge about children. Gardner's multiple intelligences, for example, are dramatically made real for us through student writings, art productions, musical activities, social interactions and unique interests and academic skills. Piaget's cognitive theory comes to life when we observe the ways in which children use real objects to explain a phenomenon or new understanding. Erikson's psychosocial theory is played out in the satisfying interactions in which children become engaged and that culminate in rich sociodramatic play with cleverly improvised props and coherent themes. Learning styles and cultural and linguistic strengths come into clearer focus and are valued for the individuality they represent. Looking at the products of student learning heightens

author lists	silly sayings	signs
activity choices	songs	tales and stories
audiotapes	collages	dialogues
block constructions	conversations	dictations
book titles	computer productions	dictionaries
book illustrations	counting objects	dioramas
charts and graphs	creative movement	drawings and paintings
child-authored books	coordinated gross motor	dreams and secrets
clay and dough	movement	exhibits
manipulations	demonstrations	experiments
fact files	diaries	lists
finger plays	instrutive discourse	love notes, greetings, thank-
flannel board depictions	innovations	you notes and other written
game and game rules	jokes and riddles	messages
group projects	jump rope rhymes	news
manipulative constructions	humor	opinions
maps	labels	pantomime
math journals	math games and	picture journals
plans and journals	manipulatives	props
plans and projects	monologues	photographs
posters	models and replicas	theater arts projects
puppets	murals	tunes and melodies
puzzles	sortings and classifications	verse manipulations
questionnaires	special interest collections	vocabulary cards
raps	sticker designs	videotapes
rebus stories	socio-dramatic themes	word banks
recipes and menus	surveys	writing journals
rhythms	story illustrations	word play
rhymes	sculptures	wood-working projects
role play	skits	

Figure 7.1
Student Products

our empathy and sharpens our insights. Instruction and curriculums benefit from broader, more learner-centered perspectives and content that is driven by diverse student interests and capabilities.

Because authentic assessment employs a variety of methods to assess all of these aspects of learning, finding meaningful and functional ways to assemble and use information about student performance, products, and processes is a critical task. Combining all of the assessment instruments, observation notes, and student products into some kind of meaningful whole is one of the challenges of authentic assessment. One methodology proving to be quite effective for assembling and organizing student products and assessment data is the portfolio. The portfolio encourages continual assessment across developmental domains and subject matter content areas and provides for more flexibility in curriculum plan-

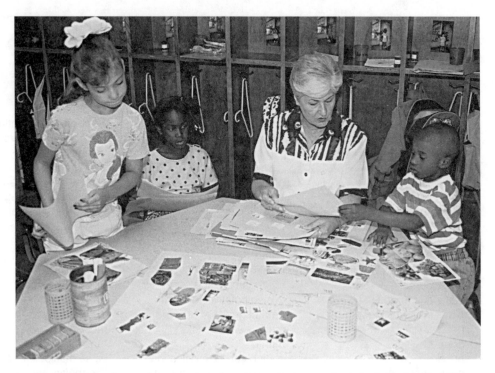

Looking at the products of student learning sharpens the teacher's insights and heightens empathy, thus enhancing the authentic assessment process.

ning (Grace & Shores, 1991). According to the Northwest Evaluation Association (Meyer, Schumann, & Angello, 1990):

> [A portfolio is] a purposeful collection of student work that exhibits to the student (and/or others) the student's efforts, progress or achievement in (a) given area(s). The collection must include:
>
> ◆ student participation in selection of portfolio content
> ◆ the criteria for selection
> ◆ the criteria for judging merit
> ◆ evidence of student self-reflection.

A portfolio can portray student accomplishments at selected time intervals and provide data for permanent or long-term records of student progress, but it differs from the traditional cumulative folder in the following ways.

◆ A portfolio is created primarily by the student
◆ provides an opportunity for the student to select and examine work in progress, reflect upon their efforts and accomplishments, and revisit and review past performance and products

◆ includes only that ongoing information that is meaningful to the learner and use-
ful in planning current and future instructional needs

◆ is assembled to convey student strengths and progress toward developmental or
instructional goals.

Teachers must be clear about what types of student products and assessment
information will be included in the portfolio. All information and contents in the
student's portfolio should be designed to assist in positive and supportive ways
the student's efforts to learn and develop skills. Remember, authentic assessment
is focused on what the learner *can do*, not on identifying deficits or comparing
performance and products with that of other students in the class. The selection
of materials for the portfolio must meet the following criteria:

◆ The student products are primarily selected by and are personally meaningful
to the learner.

◆ The products and assessment instruments reflect development and/or learning
in all domains, in varying contexts, and on an ongoing basis throughout the
school year.

◆ The contents of the portfolio are related to instructional objectives.

◆ The contents provide a medium for shared meaning between the student and
their teachers, parents, and when appropriate, their peers.

Keep in mind that reliability of data and inferences drawn from portfolio infor-
mation depend on the consistency with which the same or similar results are
found with similar tasks, and show coherent trends when observations or prod-
ucts are compared with previous ones. To establish reliable information and to be
able to accurately prescribe subsequent learning experiences for individual learn-
ers, portfolio contents must contain examples of similar work in the same domain
or content area that can be contrasted and compared with previous items or
observational data on an ongoing basis. For reporting purposes or for parent con-
ferences, this comparative data tells a more complete story about the learner's
developmental and educational journey. To do this, materials in the portfolio
must always be dated and sequenced to reflect the most recent work. Categoriz-
ing student products according to specific developmental and content area
domains such as those suggested in Chapter 6 will also help to organize the mate-
rials and focus subsequent analysis and interpretation. Color coded portfolios can
be created for the assembly of items in specific content areas: mathematics, lan-
guage arts, writing, art, and so on.

At the early childhood level (prekindergarten through grade three), contents
should be representative of emerging development keeping in mind that there is
a developmental continuum associated with the content areas as illustrated in the
Appendices to Chapter 3 and Figure 7.2. It is this continuum of emerging devel-
opment that early childhood assessment must address and often confuses the
scoring system. Traditional grades for the most part score a final product—or

whether a student grasps certain information or performs a certain skill at a predetermined level representing mastery. When development and learning are viewed as *emergent*, placing a letter grade or numerical score on it is of little use. Most early childhood portfolio entries are examples of emerging development as opposed to academic achievements per se. One can neither excel in nor flunk "*emerging* development"! Therefore, the portfolio and its contents become a "picture story" of whole child development and its segue into acquisition of academic content knowledge and skills. As such, portfolios in early childhood education should be evaluated on the basis of whether the design and contents satisfy the following conditions:

◆ exemplify *progress toward* target behaviors or achievements, or toward district, school, or individual learning goals or outcomes

◆ reflect all contexts in which learning occurs: developmental, cultural, home, school, group, and individual

◆ reflect and facilitate individual intelligences and learning styles

Sharing the products of their work helps children to reflect and plan future endeavors.

What Goes into Portfolios?

Portfolios are as unique as the children they represent. They consist of materials that reflect and describe the child's development. Here are some typical contents:

Infant Portfolios

Anecdotal records - objective observations written by a caregiver that describe something the baby did or how the baby reacted in a situation—how Maria laughed out loud when the sparrow jumped on the windowsill, for example.

Science process skills - a caregiver's assessment of the child's thinking process, such as how Michael uses his eyes, hands, and mouth to observe a new rattle.

Learning cycle - a caregiver's assessment of the child's learning process, such as how LaKeesha finds an object hidden under a blanket.

Language sample - an audiotape of a baby cooing and babbling, with dated sections showing the child's progress.

Daily schedule - description of a day's events written by the caregiver, noting the baby's activities by hour such as sleeping, eating, and playing.

Target skills - listing of physical, cognitive, social-emotional, and self-help skills that an infant is practicing or has achieved.

Toddler Portfolios

Anecdotal records - objective observations written by a caregiver. Example: After Joseph puts on his shorts, he discovers that both legs are in one pant leg. He refuses help, saying, "Me do it."

Scribbling or drawing - sample of the child's drawing with the teachers' assessment of the child's verbal comments, attention span, and level of scribbling.

Social play record - teachers' observation and written assessment of the child's stage of social play such as onlooker, parallel, or associative.

Attention span mapping - a floor plan of the classroom with the teacher's notes about how and where the child spent 30 minutes, such as stacked blocks for 5 minutes, climbed steps for 4 minutes, pushed the wagon for 7 minutes, and scribbled at the art table for 14 minutes.

Language development checklist - a checklist of typical language skills that the teacher has used to assess the child's development at a given date.

Preschool Portfolios

Anecdotal Records - objective observations written by a teacher. Example: When a light rain begins to fall in drought-ridden South Texas, Charlene jumps up and says, "Look, it's spitting."

Logic interview - the results of a series of five Piagetian tests to determine whether a child has reached the pre-operational level of thinking.

Use of scissors - samples of materials the child has cut with scissors and the teacher's written assessment of the child's skills.

Physical checklist - a checklist used by the teacher to assess the child's small-motor and large-motor skills.

Draw-a-person picture - a sample of a child's drawing in response to the teacher's request to "draw a person" and the teacher's written assessment.

Dictated story - a story told by a child to a teacher who writes as the child dictates. The teacher may ask the child to describe something that has happened, to re-tell a storybook tale "in your own words," or to make up a story.

Math assessment - the teacher's written assessment of a child's performance during a series of math activities such as counting objects, following a pattern with beads, or identifying coins by name.

School-Age Portfolios

Work samples - a collection of homework or group assignments, often chosen by the child.

Handwriting - dated samples of the child's handwriting skills.

Journal entries - photocopied samples of journal entries written and selected by a child.

Taped reading - an audiotape of a child reading a section from a book. A tape may contain several reading segments over time that document the child's progress.

Block construction - drawings or photographs of the structures the child has built with blocks.

Jokes - photocopies of the child's favorite jokes with a written assessment by the teacher. Jokes often reflect a child's level of thinking and language development such as knowing that similar sounding words do not have the same meaning.

Figure 7.2
What Goes into Portfolios

Note: From Texas Association for the Education of Young Children (1997). *Appropriate Early Childhood Assessment: A Position Statement* (D. Diffily, Ed.), Austin, TX: TAEYC. By permission.

◆ reflect individual capabilities and interests

◆ invite student dialogue and self-reflection

◆ provide a basis for meaningful mind-engaging communication between teacher and student

◆ provide a basis for meaningful and helpful collaboration between the teacher and the student's parents or guardians

◆ can be used to inform instruction and curricular decisions.

Using these criteria, the portfolio can be a rich source of data on student performance and learning processes and a meaningful guide for the development of learner-centered curriculums. In early childhood education the portfolio is ongoing; it is never a "completed" product intended to culminate in a final "portfolio grade" or ranking as is associated with some upper grade academic, vocational, and graduation requirements, special placement or college entrance applications, or visual or performing arts auditions. The contents of the early childhood education portfolio are forever changing, reflecting dynamic human growth and development as it is occurring in individual children while providing information that leads to alignment of academic expectations with child development realities.

Is There More Than One Type of Portfolio?

How can a portfolio enhance student understanding and performance, communicate student and class progress, inform curriculum, and assure accountability? That is a lot to ask of one pedagogical process. To get at how this is possible we need to return to our discussion of formative and summative data. Recall that formative data are collected on an ongoing basis and can reflect the student's day-to-day efforts or accomplishments. Summative data, on the other hand, are collected from information and products gathered over time and periodically evaluated and compared with earlier data to reveal developmental and learning trends (including indications of progress, plateaus, or regressions) in student performance, products, or processes. Each set of data is essential for both short- and long-term planning for individual student needs.

In addition to formative and summative data on individual students, summative data can be derived from the class as a whole by collecting random samples of products and assessment information to be assembled to form a class profile. This collected data is then used to determine group needs and interests, curricular content and direction, and any need for pedagogical modification. Class summative information also helps to establish progress toward stated class, grade, school, or district goals. In time, program effectiveness, when measured against stated grade or content area objectives or standards can be documented to assure accountability.

So what we have here, is a three-tier system in which portfolios are assembled according to how they are to be used and what information they are designed to convey. Each tier represents a work in progress that fulfills different purposes at different times:

◆ the individual formative assessment process, or the *process portfolio*
◆ the individual summative assessment process, or the *archival portfolio*
◆ the whole class summative assessment process, or the *aggregated portfolio*

Let's elaborate on each of these types of portfolios.

Process portfolios

To follow a student's growth, development, and day-to-day learning; address short-term goals; and evaluate current performance, processes, and products, a *process portfolio* is established. This portfolio assembles work *in progress*, and is organized so that the student's most recently completed pieces are a place mark. Included in this portfolio are teacher comments and observation notes, student self-evaluations, jointly prepared progress notes, and planning notes for continued work, and perhaps, dialogue journals, in which certain types of work are entered and students and teacher communicate in writing about the work. The process portfolio may include photographs of three-dimensional work such as block or clay constructions; or of large items such as a mural, panoramic display; or of a sorting or classifying activity in which manipulatives are used. A tape recording of the student retelling a familiar story or explaining a mathematical or scientific phenomenon might also be included. The student places work in progress in the portfolio as needed or required to meet short term goals and revisits incomplete work as needed to revise, refine, or finish.

Sometimes the process portfolio contains a daily or weekly "contract" between the teacher and the learner that gives focus and direction for daily activities and anticipated accomplishments. Contracts can be designed with picture or graphics to be "read" by nonreaders or with rebus or word-only formats for emergent readers (see figures 7.3 and 7.4). Such a contract might suggest the learning centers that should be visited during the day (or week), or a particular storybook to be shared with a reading buddy, a concept game to be played with a classmate, a special writing project, or art activity to pursue. During a specific time each day, the teacher can review the day's activities with the learner, checking off the contract items completed and activities that remain to be done on another day or eliminated for lack of need or interest. Where classes are large, the teacher may review the contracts with for example, one-third of the total number of students in the class each day, making certain that each learner is given an opportunity to share their work and receive important feedback and support at regularly anticipated times.

While contracts are not essential, simple ones help children organize themselves and focus on selected activities during the school day. At the beginning of the school day, students can take a look at their contracts and proceed to the activities they suggest. Certainly, the contract would not preclude self-selected and self-initiated activity, for these choices are important aspects of development, learning, and assessment as well. Three important points need to be made:

Figure 7.3
Individual Student Contract (for Nonreaders)

1. The suggested activities on the contract are developmentally appropriate, taking full advantage of the classroom learning centers through which meaningful, hands-on, interactive learning can take place.

2. Contracts should be designed to include numerous opportunities for learners to make choices and initiate much of their own learning.

3. Classroom design and learning center content must be rich, meaningful, challenging, and connected in relevant and developmentally sensitive ways to the goals and outcomes established for content areas and grade.

The accumulation of dated contracts helps the teacher assess, over time, student interests, learning modalities, and capabilities and in on-going planning for subsequent learning. The contract system also serves as a powerful communicator with parents who often mistakenly measure what happens at school by the

Figure 7.4
Individual Student Contract (for Beginning Readers)

Name _____ Week _____
Monday AM
Art Center
 Choose Activity _____
Books
 Choose one to
 share with Partner _____
Science
 Sort Seeds _____
PM
Meet with Teacher _____
Portfolio _____
Blocks _____
Math Journal _____

Name _____ Week _____
Tuesday AM
Pretend Center _____
Puzzles _____
Writing Center
 Journal Activity _____
PM
Math Center
 Weigh Rocks Activity _____
 Math Journal _____
Art Center
 Mural _____
Music Center
 Sing-along _____

types of worksheets, arts, or crafts that the student brings home. The contract portrays all other types of tasks and learning that can take place at school and helps adults in the home to understand school curriculums and expectations and to find ways to support school learning through sensitive and supportive interactions and developmentally appropriate projects at home.

The archival portfolio

Students regularly review the contents of the daily process portfolio to make selections for their individual *archival* portfolios or the portfolios from which summative data might be derived. The teacher works with students on their process portfolios, reviewing and revising the work, planning for work to follow, and deciding on products from the process portfolio to be transferred to archival portfolios. When skillfully handled, this process provides a developmental view of accomplishments, informing the learner, teacher, and parent about areas of accomplishment or need, and building a sense of shared schooling experiences among child, parent, and teacher.

The student's archival portfolio might include both novice and "accomplished" products, notes about how and why each piece was selected, what meaning the products or process had for the learner, student-dictated notes about the choices, and a table of contents. At regular intervals (three or four times during the year), the archival portfolio contents can be assessed for progress toward school, district, or other established outcome goals or professional standards for specific content areas. At the end of the school year, the archival portfolio can be either taken home by the student for continued visitations or forwarded to the student's

When children take the lead in selecting the contents for their portfolios, their interests become vested and their motivation to learn more intrinsic.

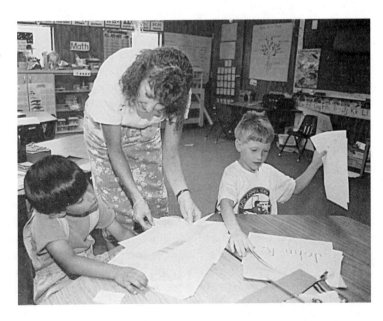

next grade teacher as a "portrait" of the student's emerging capabilities. (Or selected products from the process portfolio can be divided between an archival portfolio that goes home at the end of the year and another that remains at school to be forwarded to the next teacher.) The end-of-the-year archival portfolio provides a summative report of the year's accomplishments for each student.

The aggregated portfolio

There are two levels of summative data. In one, individual student effort, progress, and performance are aggregated and analyzed as suggested in the preceding paragraph. The other, which brings us to the third type of portfolio in our assessment system, contains a sampling of exemplary student products representative of the whole class. Representative samples of student assessment items collected over time throughout the school year are assembled in an *aggregated portfolio* for use by teachers and school administrators in evaluating program effectiveness.

The class aggregated portfolio includes representative work samples (spanning the school year) from each student's portfolio, along with class summaries, analyses, and interpretations of beginning, middle, and end-of-year individual or group checklists, rating scales, anecdotal records, and summary notes from time or event studies. Also included are reports of special or formal evaluations, home visits, case studies as appropriate, and student and parent conference reports. This information can be analyzed and contrasted with expected developmental trends, grade level goals, content area standards, and expected learner outcomes to determine how the class as a whole is doing. Periodic summary analysis of the aggregated portfolio can guide plans for follow-up, for meeting individual or group needs, and goals for ongoing curriculum development.

These reports, then, should well serve the need for administrative accountability data, and when combined with required group-administered standardized tests, can place such test scores in a more holistic and meaningful context. At the end of the school year, the aggregated portfolio can be measured against national, state or district standards, providing additional verification of student outcomes. Figure 7.5 illustrates this three tier system of portfolio development.

Portfolio Storage and Retrieval Systems

There is no one way to assemble, store, and retrieve portfolio contents. Methods will depend on the types of portfolio products chosen. Deciding what type of container or containers to use and how to store them to be readily accessible to the student for "visitations" is a first step. File folders, expandable folders, hanging files, pocket folders, oversize sheets of construction paper folded in half and stapled, stacking baskets, corrugated cubbyhole units, wall filing units, and uniform-size boxes are some possibilities. If permanent or stationery units are used, students will still need a folder or container to transport their portfolio and its contents to their work station, home, or other places where it is to be used.

I
Student projects and
products in-progress

II
Student selected
archival items:
 "best"
 "most difficult"
 "most enjoyable"
 "just want to keep"
 etc.

III
Sampling of student archival
items selected by student in
collaboration with teacher
and representative of each
of the assessment domains

Student Process
Portfolio

Student's Archival
Portfolio

Class Profile
Aggregated Portfolio

Figure 7.5
A Three-Tiered System of Portfolio Development

While there will always be a desire and a need for children to create, manipulate, and interact with the concrete tools of learning and to have "hard copy" representations of the products of their learning, the use of technology in portfolio development holds some promise for simplifying and organizing the many-faceted portfolio process and can serve to complement other assessment strategies.

Electronic Portfolios

As technology has expanded beyond the computer literacy level and the use of computers for skill-and-drill practices, sophisticated hardware and software are providing innovative electronic tools for children and teachers to pursue an ever expanding knowledge universe, and to store, retrieve, and assess all sorts of student products and performance indicators. Sophisticated electronic linkages have expanded the curriculum borders well beyond the school or classroom walls through distance learning networks and well beyond the curriculum "tool subjects" of reading, writing, and arithmetic into subject and content areas heretofore inaccessible. Telecommunications networks have made it possible for students to:

◆ send and receive electronic mail from people around the world.

◆ access thousands of databases containing information on almost every topic imaginable.

◆ access libraries around the world.

◆ participate in discussions with other students in faraway places.

◆ obtain current, up-to-the-minute information by accessing weather reports, news events, and late-breaking scientific discoveries.

- ◆ "visit" their family members' work sites or perhaps their siblings' classrooms in other parts of the building or in other schools.
- ◆ engage in multimedia projects of all sorts.
- ◆ store pictures, photographs, and video and audio recordings of students and their work.

Multimedia systems made up of computers, video cameras, and laser disks are providing new possibilities for assembling, recording, and storing individual student and group assessment data. These new systems allow for permanent storage of optical data, written, drawn, and photographed images, and audio data. Computerized portfolio assessment systems are commercially available. (See the resources section in Chapter 10.) Report cards are frequently being replaced by software programs designed to collect and organize detailed histories of student progress—information that can be made available to the student, parents, and teachers. Data banks of districtwide assessment data provide storage and retrieval systems for selected information on individual students, and modem linkages connect home and schools through electronic mail and creative web sites. Through these linkages, schools now have the capabilities to conference with parents, share the contents of electronic portfolios, and access needed resources for individual learners.

The wise use of technology can enhance both learning and the assessment process.

As teachers are expected to manage increasingly more information, both for curriculum enrichment and student assessment, the use of such technology holds promise. The need continues to find ways to economically and effectively incorporate emerging technologies into schools and to continuously maintain upgraded systems. Further, continuing teacher training and in-school technicians are required to keep pace with new and expanding technological capabilities. With technology however, we must keep in mind that its use should never be allowed to curtail or preclude the critical human dimension in education—that warm, friendly, mutually supportive relationship that builds between teacher, student, and family when communications are less mechanical.

Assessment Practices and Rights to Privacy

Individual state laws require schools to maintain various cumulative records on each student. In addition to basic demographic information such as name, address, birth date, parent or guardian's name, ethnicity, current grade, schools attended, and so on, cumulative files often include a range of information to which access must be restricted. Student cumulative files may contain any of the following: previous and current report cards; results of standardized tests and other assessments; attendance records; reports from other professionals, such as the school psychologists and speech, hearing, and language professionals; and physician's health care reports; records of parent conferences. Where special needs are concerned, student files also may contain individual education plans (IEP) and individual family service plans (IFSP) and other state or district required reports associated with eligibility for certain federal or state funds such as the free lunch program or Chapter 1. These records are accessed legally by school personnel (such as school nurse, psychologist, counselor, teacher) who have a *legitimate* need for the information and those individual professionals outside of the school whom the parents have authorized to receive or provide information about their child, such as their family physician.

Obviously, a considerable amount of personal and private information can be contained in these records. Therefore, both the law and professional ethics dictate that information about students and their families be held in strict confidentiality. This same level of professionalism applies to files and portfolios maintained by individual teachers within their individual classrooms. Pupil performance, processes, and products, are a matter of individual learner concern, and therefore are protected from perusal by anyone other than the learner, the learner's parents or guardians, the classroom teacher, and individuals who have a legitimate reason or have been authorized by the parent or guardian.

Teachers therefore, must use sound judgment in determining the contents of portfolios and how, when, and under what circumstances they are to be displayed and shared with others. Given that teachers have always displayed student work on bulletin boards and in hallways, a good rule of thumb is to consult with the learner about items to publicly discuss or display, and to expose no student efforts that would embarrass or demean an individual or preclude their

chances for fair and unbiased relationships with classmates or others. A young child's "cute" rendition of a song, story, or drawing may make charming conversation with a colleague or other adult, but might be embarrassing to the child, and would be considered inappropriate, unprofessional, and potentially litigious.

By the same token, portfolios themselves, when not in use, should be stored in a private place, inaccessible to others. If they include sensitive information, such as family issues that have been shared with the assessor, the manner in which this information is recorded (if at all) must be kept confidential to protect the privacy of the child and the family. Information about individual students and their families is never appropriate for conversation outside the context of professional assessment for current instructional decisions. A first-grade teacher, curious about how kindergartner Jamie is going to perform in first grade next year, might wish to ask the kindergarten teacher, "How's Jamie doing in your class?" But such a conversation would be a violation of Jamie's privacy, and therefore inappropriate and unethical. The first-grade teacher will have to wait until the appropriate records are forwarded to her.

With regard to video, audio, and photographic representations of children and their work, teachers must obtain parent permission to record and use these images for assessment and instructional purposes, and must assure parents that these images will be used only for assessment and instructional decisions. The use of electronics, for all its fascinating possibilities, must never infringe on the individual privacy rights of the students and families and should be designed to prevent access by unauthorized individuals.

INITIATING A PORTFOLIO SYSTEM

In recent years the use of portfolios in classrooms has become quite popular. Many tend to view the portfolio as an assessment process in and of itself. This is a misnomer. The portfolio is a way of assembling relevant information about a learner, much of which has been assessed prior to entry into the portfolio. In the case of the process portfolio, we are talking about a work in progress with in-progress assessment feedback to guide the student's immediate and continuing accomplishments. Hence, the portfolio should be viewed as a process, not an end product, until it can be used to inform summary reports and be released to the student, the parents, or the student's next teacher. However, even then, the process can continue. The portfolio's contents—varied and representing multiple forms of assessment—do not lend themselves to a "final portfolio grade." In the context of early childhood education, the portfolio contents are used on an ongoing basis to collaborate with individual students, to collaborate with a student's parents, and to inform instruction. As Stiggins states, the portfolio is a "communication system rather than an assessment system" (Stiggins, 1997a, p. 452). The following are some guidelines for initiating and developing a dynamic and worthwhile portfolio system:

1. Analyze district, school, or grade outcomes and standards requirements. Establish preliminary short- and long-range goals for the class.

2. Collaborate with other teachers to explore what to assess and how. Think through the developmental domains, the school or district learning goals and expectations, and professional content area standards. Then refine and align short- and long-range goals with them.

3. Some schools have developed their own or adopted commercial systems for portfolio development. Become thoroughly acquainted with this system, analyze its elements to determine how well it aligns with your developmental and curriculum goals, mandated and professional standards, and expected outcomes. Determine if this program needs to be supplemented with additional information. If your school does not have in place an assessment system, explore a variety of assessment forms and instruments and put them through the same scrutiny. Explore available electronic systems.

4. Make preliminary decisions about how and when to use individual assessment items, aligning each with your curriculum plans. The assessment instruments may change over time, as you become more acquainted with individual students, as curriculums emerge, and as you become more comfortable with the process.

5. Get organized. Assemble all of the necessary materials needed to begin a portfolio system: Storage units, folders, spiral notebooks, carpenter's apron, sticky pads of various colors, index cards of various colors, clip boards, assessment forms and instruments, curriculum and assessment planning book with calendar, camera, film, audio and visual equipment, blank computer discs, and other computer related software and materials.

6. Collect baseline information on each student as a starting point. Parents or guardians should be engaged to provide initial information about the child's early growth and development, child care and preschool experiences, current interests, capabilities, and needs.

7. Begin informal and holistic observations of students in the class. Observe behaviors in a selected developmental domain (e.g., large motor characteristics, social interactions, literacy behaviors), observing small groups of five or six children at a time as described in Chapter 2. Then move to other domains one at a time until you have additional baseline information sufficient to determine your starting place(s) for more individualized, focused observation. Use developmental checklists and take notes.

8. List and analyze your findings from these holistic observations.

9. Identify the "target" behaviors in your short- and long-range goals, and begin integrating formal assessments and student interviews into your daily plans.

10. Develop initial assessment plans for each student. Explain the portfolio process to each student during individual interviews. Begin with a general process portfolio or, for very young children who are new to the idea, begin with a "quasi-archival" portfolio of "favorite" products that can be taken home and

shared. Because very young children do not always part with their products willingly, learning to maintain an in-school collection will be a gradual process. You may need to make photocopies of items deemed particularly significant and worth noting. Eventually, the young child will learn to maintain the portfolio at school. Begin with one portfolio folder (or other storage unit) adding color coded content specific portfolios as the need arises. Keep it simple.

11. Continue to peruse, critique, select, or develop observation and assessment instruments that align with curriculum and efficiently and accurately portray student processes, products, and performance.

12. Analyze your scoring systems (Herman, Aschbacher, & Winters, 1992):

 ◆ Are all important goals, standards, or outcomes being addressed?

 ◆ Are your rating strategies appropriate for their intended purposes (key features, holistic, analytic)?

 ◆ Do rating scales provide adequate, accurate, and objective information that is easily interpreted?

 ◆ Are the scoring rubrics stated in clear and understandable language so that students, parents, and other professionals can understand?

 ◆ Do your expectations and assessment processes reflect current best practice in early childhood education?

 ◆ Are your expectation and assessment practices free of bias and fair to all students regardless of their age and development, socioeconomic status, gender, ethnicity, or ableness?

 ◆ Is your overall assessment plan manageable with appropriate domains and a limited, yet sufficient number of items or dimensions in each domain to provide meaningful information?

 ◆ Can the information obtained from your assessment instruments and their scoring rubrics inform assessment in other domains (as with the drawing assessment in Figure 6.18, p. 237), or perhaps, suggest additional areas for assessment?

13. Determine how assessment scores and evaluations will be used to inform curriculum planning.

14. Make necessary adjustments in curriculum content and pedagogy, as indicated by assessment data.

15. Collaborate and celebrate with students and parents in both predictably scheduled and informal interviews and dialogue. We will elaborate on these student and parent collaborations in Chapters 8 and 9.

The development of a portfolio system is not easy; it takes time and commitment. However, the rewards are immeasurable, as we come to value more fully *all* of the processes of learning, focus more clearly on emergent development, and share the joy of each student's accomplishments. Valencia (1990) says it well:

The real value of a portfolio does not lie in its physical appearance, location, or organization; rather, it is in the mind-set that it instills in students and teachers. Portfolios represent a philosophy that demands that we view assessment as an integral part of our instruction, providing a process for teacher and students to use to guide learning. It is an expanded definition of assessment in which a wide variety of indicators of learning are gathered across many situations before, during, and after instruction. It is a philosophy that honors both the process and the products of learning as well as the active participation of the teacher and the students in their own evaluation and growth." (Valencia, 1990, p. 340)

In Chapter 8 we will explore how portfolios can be used to focus teacher student collaborations and lead to informed assessments. In Chapter 9, we will explore how the portfolio can be used to engage students with their parents in collaborative assessments.

REVIEW STRATEGIES AND ACTIVITIES

1. Work with a classroom teacher who is implementing authentic assessment strategies. Use the planning format illustrated in Figures 6.1 and 6.2 to plan a portfolio system for one of the students in the class. This should be a collaborative exercise among you, the teacher, and the student. Consider the developmental domains to be assessed and also the following questions:

 a. What kinds of performance, products, and processes will you assess?

 b. Against what criteria will you measure these elements?

 c. What types of rubrics and scoring devices will you use?

 d. How will you use the assessment information?

2. What do you consider to be the strengths and the limitations of a portfolio process? Brainstorm with your classmates and the instructor, ways to address the limitations you have identified.

3. Visit a classroom in which portfolios are prominent. How does the teacher schedule assessment activities? What uses do the students make of their portfolios? Can you identify connections between the contents of the portfolios and the goals of the grade or content area?

8 Collaborating with Young Children to Promote Their Self-Assessment and Learning

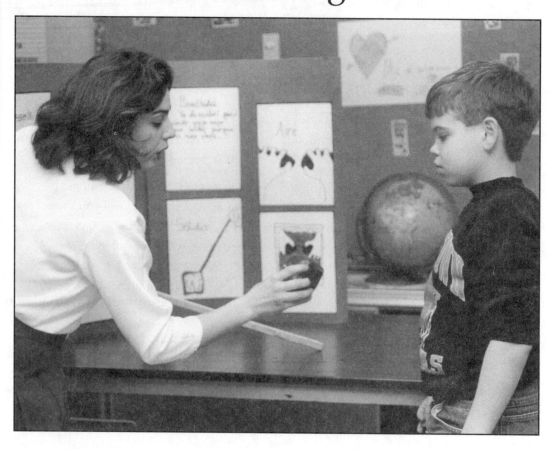

Observations and interviews have revealed that most kindergarten and first grade students rank themselves at the top of the class regardless of actual teacher-ranking. Young children consider themselves "smart" because for them, intelligence occurs any time something is learned.
 Thomas, 1989, p. 235

A child's success is not accurately measured by how quickly she learns, or whether her method resembles that of others, but by how well she learns when taught in a manner suited to her needs.
 Greenspan, 1997, p. 213

Learning is a consequence of thinking. (Perkins, 1992). We should remind every child of this statement each day.
 Abbott, 1997

The very process of helping kids prepare to be intelligent reflectors upon their own performance may be one of the most powerful instructional interventions that it's possible to conceive.
 Stiggins, 1997b

After reading and studying this chapter, you will demonstrate comprehension by being able to:

- discuss the value and critical elements of effective student-teacher collaborations.
- describe the various processes and strategies that can be used to help students reflect on their own products, processes, and performance.
- identify practices that facilitate teacher–child collaborations and dialogue.
- describe how curriculum and instruction modifications can evolve from teacher–child collaborations.

SETTING THE STAGE FOR COLLABORATION WITH YOUNG CHILDREN

As the first epigraph in this chapter suggests, young children generally view themselves as "smart." They arrive at school eager to learn and to interact with one another. Learner-centered classrooms based on the principles of developmentally appropriate practices provide numerous opportunities for interactions that sustain and support this early sense of self as a competent learner. In classrooms in which children are engaged in hands-on activities, working in small groups or independently, and using the spaces and contents of learning centers to focus their learning, this view of themselves as "smart" is allowed to flourish. Opportunities to self-select and self-direct makes way for autonomy, initiative, and industry to emerge, further enhancing this sense of self as capable. In such classrooms, both guided and self-initiated learning opportunities expand the student's awareness and insights, and interactions with classmates encourage social development and perspective-taking abilities. Where skillfully carried out, developmentally appropriate classroom practices nourish each child's enthusiasm for learning and their unembarrassed personal "sense of smart." Settings where young children are personally and actively involved in varied and challenging pursuits provide the context for an insightful multi-dimensional assessment system—a system that can broadly and effectively focus on development and learning in several developmental and content area domains.

A key ingredient in the developmentally appropriate classroom and its assessment system is the interaction between the adult and the child (teacher and student). Building carefully and genuinely, a relationship of mutual trust and rapport entails a certain amount of "quality time" in which student and teacher can interact in meaningful ways around relevant topics and issues of mutual import. Building time for these important interactions and structuring them in such a way as to benefit both the learner and the assessment process is what this chapter explores.

What It Means to Collaborate with Students

Collaboration with students is a positive and supportive way to engage individual children in meaningful and developmentally appropriate ways in thinking about and planning for their own learning. Within the context of stated goals and standards for grades and content areas, student and teacher explore together individualized goals, expectations, and learning plans. The student's products, performance, and processes are assessed on an ongoing basis through a collaborative conference in which dialogue and feedback provide focus and direction to the student's efforts. Collaborations need not be lengthy, but do need to occur fairly often. Student–teacher collaborations often occur spontaneously, and are regularly and predictably scheduled for the more focused portfolio visitations.

Collaboration Encourages Students' Love of Learning

There is no question that the individual, focused, empathic interactions between adult and child play a profound role in supporting and sustaining young children's typical eagerness to learn and "prove" how smart they can be. Collaboration in assessment and planning can shift the emphasis in instructional practices from teacher as authority and primary source of ideas and information, to students as idea-generators, choice-makers, co-planners, and contributors to a community of learners. Student–teacher collaborations provide students important and contextualized feedback, while the personalized dialogue between student and teacher provides the teacher insights unobtainable in larger group contexts or paper-and-pencil tasks and tests. When young students and teachers collaborate, students:

◆ get to know their teachers and their teachers' expectations.
◆ develop a sense of trust in their teachers.
◆ can talk about topics or concerns of importance to them.
◆ can showcase their work.
◆ receive timely and specific feedback.
◆ can receive necessary clarifications and scaffolding to support their learning.
◆ learn to think about and reflect on their products and performance.
◆ learn to make choices and organize their efforts.
◆ begin to learn about learning and to talk about their learning.
◆ learn about the sequences of daily activities and gain a sense of time needed for task completion.
◆ receive guidance for directing their behaviors.

When young students and teachers collaborate, teachers:

◆ get to know each student and appreciate the individuality of each person.
◆ have an opportunity to dialogue with students about topics and issues of mutual import.
◆ observe and assess development in many domains and determine special needs, talents, and intelligences.
◆ observe, assess, and discuss student processes, products, and performance.
◆ answer questions and correct misperceptions.
◆ give specific directions and clarify expectations.
◆ provide scaffolding for new and emerging knowledge and skills.
◆ help children make connections between prior learning and new content.
◆ discuss and provide guidance to help individuals self-direct their behaviors.
◆ set challenging, yet attainable, goals for individual learners.

◆ help children compensate for skills they cannot master.

◆ plan together ways to work toward learner goals.

◆ obtain meaningful information to guide ongoing assessment.

◆ obtain important information to guide curriculum development toward individual interests and capabilities.

◆ obtain relevant and meaningful assessment information to share with parents or guardians.

◆ can more effectively collaborate with parents in planning educational opportunities for children.

◆ help children view themselves as competent learners.

Role of the Teacher in Collaborating with Students

In authentic assessment classrooms the teacher does not separate curriculum and assessment, but intertwines them into a meaningful, ongoing process. Through this process, assessment entails continuous observation and reflection on child-

An essential component of authentic assessment and of higher order thinking is the teacher who creates a cooperative learning community where dialogue and interaction promote understanding.

hood behaviors and learning. These observations and assessments depend on close and individualized interactions with students. The goals of collaboration are (1) to promote in students self-esteem, self-respect, and satisfaction in work and learning, (2) to guide students toward autonomous and divergent thinking, and (3) to provide challenging, meaningful, developmentally appropriate experiences for learners. Moreover, in authentic assessment classrooms, curriculums become more customized to meet the needs of the particular class and individuals within the class. Collaboration with students is a key element in this whole process. For collaboration to be successful, the teacher must:

◆ assume an apprenticeship role in which the child is the novice and the teacher is the mentor.

◆ be committed to shared experiences and shared responsibility for learning.

◆ view the classroom as a community of learners, each variously exploring, discovering, inquiring, and using new knowledge and skills.

◆ appreciate and incorporate children's ideas and interests into the curriculum.

◆ be willing to follow the student's lead.

◆ trust children to learn from self-initiated explorations as well as teacher-directed ones.

◆ act as resource and facilitator.

◆ recognize and respect the fact that learning is not simply a matter of intellectual pursuit, but has deeply personal emotional and social elements as well.

◆ recognize that many ways exist for children to demonstrate what they know and can do, and that different intelligences are manifested through different cognitive processes, products, and performance.

Pedagogical Features that Support Collaboration

The following are a few of the important aspects of early childhood education that support the collaborative process:

Communicating Goals and Expectations

Children need to know what is expected of them and how they are to proceed. The collaborative process begins with making certain that assessment goals and strategies are directly and intimately related to developmental and curriculum goals. So one most important pedagogical feature that supports collaboration between teachers and students is that students and teachers are equally clear about expectations. As Stiggins writes, " . . . students can hit any target that they can see and that holds still for them." Stiggins (1997a, p. 458).

Classroom Design

Another pedagogical feature that supports collaboration is that of classroom design. The typical early childhood classroom arrangement of spaces into learning centers to focus on specific content and skills provides the most feasible setting for authentic assessment. This setting and its encouragement of student choice and self-initiated activities exposes a wider and more diverse range of student behaviors and abilities. This setting also allows the teacher to move about and among learners, observing, listening to and interacting with students as they work. The teacher can join a group or partner with an individual to instruct, coach, model, and in various other ways facilitate their learning. In this context, scaffolding can naturally occur as students seek help and teachers observe and assess their efforts.

Daily Schedules

Because authentic assessment is an ongoing process in which students are observed and assessed in many contexts, one must determine how to integrate assessment activities into the daily schedule. Again, practices typical of early childhood education work best. Daily schedules are divided into reasonable blocks of time determined by the activities that need to occur. At least two large blocks of time are scheduled each day for learning center instruction and activities. Smaller blocks are used for whole group instruction and activities, and for routines of rest, snack, lunch, recess, and so on. Collaborations with individual students can occur briefly and informally during these large blocks of times. Some schedules include a "meet with the teacher" period in which a few students each day are invited to go over their portfolios, contracts, and engage in other assessment procedures. Regardless of how the day is scheduled, it is important

Providing opportunities for children to learn in groups can trigger learning that might not occur individually.

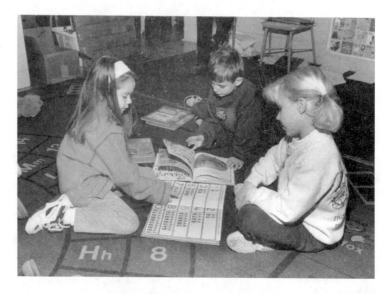

that students be able to predict and anticipate these collaborative moments. When appropriate, students can be asked to organize their portfolios in pre-scribed ways (sometimes with a table of contents) in preparation for their inter-view with the teacher.

Scaffolding Student Learning

The concept of scaffolding children's learning is an integral aspect of authentic assessment. According to Vygotskian theory, learning and development are inter-dependent. This theory suggests that while maturation influences whether a child can perform certain tasks or engage certain cognitive processes at given points in time, it is the interdependence in which development influences learning and learning influences development that is important. One causes the other to occur. So it is in authentic assessment that we employ aspects of Vygotsky's theory when we engage in collaboration with children to support and enhance both learning and development. The concept of scaffolding is particularly important here. Help-ing children to become self-directing learners means understanding and using the concept of *scaffolding*—a metaphoric term that attempts to describe adult participa-tion in joint activities with students. Scaffolding occurs when teachers (or in some instances, classmates) initially provide and execute the major parts of a task or learning event, then gradually decrease their help, allowing the student to assume more and more of the task until the student begins to feel competent to pursue the task independently, and the "scaffold" can be withdrawn (Bruner, 1978). Collabo-rating with students helps the teacher to determine if the student has sufficient background ability or knowledge to proceed to each new level of learning. This means becoming sensitive to the child's zone of proximal development (ZPD) (Vygotsky, 1978). The ZPD is the point at which a skill is "on the edge of emer-gence" (Bodrova & Leong, 1996, p. 38). This concept is important to the assessment process because it expands assessment beyond simply what a child knows and can do independently at a given point in time, to what a child can do with different levels of assistance. Bodrova and Leong encourage assessors to note how children use the teacher's help, and what types of hints are the most useful to them. By using the ZPD in assessment, these authors believe that estimates of children's abilities are more accurate and less likely to be viewed as dichotomous, that is, viewing the ability or attribute as either present or not present.

Campione (Cazden, 1988), describes three components of scaffolding:

1. The teacher instructs, models, demonstrates, and explains.
2. The teacher and student engage in guided practice in which the teacher grad-ually relinquishes responsibility for the task, transferring it to the student.
3. The student engages in practice and application.

Through scaffolding interactions, the teacher becomes intimately aware of the processes by which children come to know and do. Through collaboration with individual students teachers converse with them to determine the extent of their

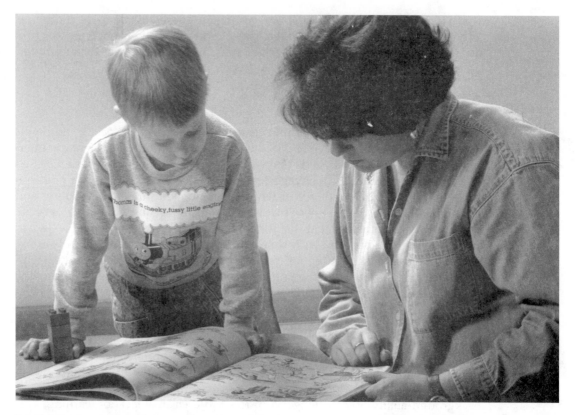

Scaffolding involves guided practice with a gradual release and transfer of responsibility for the task from the teacher to the student.

understanding and the amount of help they are needing. Teachers become engaged in scaffolding spontaneously during the day's activities as children interact with materials and with one another. Scaffolding also occurs when student and teacher are engaged in planning and evaluating portfolio contents and assessment data.

Classmates can also provide scaffolding for one another as they work in pairs or small groups. In small cooperative groups, children quite naturally scaffold one another as one who has grasped a concept or mastered a skill assists others who need help. Sometimes, the teacher may purposely place together students who can assist others, thus setting the stage for scaffolding to occur among students. Observing these scaffolding events reveals information about the levels of understanding of both the students—the one who provides the scaffold and the one who is being assisted.

Cooperative Group Work and Problem Solving

Much has been written about cooperative learning and cooperative problem-solving activities with young children (Bayer, 1990; Foyle, Lyman, & Thies, 1991; Katz

& Chard, 1989; Slavin, 1983, 1991). In cooperative learning groups, students work together on a particular task or project. Studies indicate that work in cooperative groups leads to positive student achievement outcomes when (1) group goals are established and (2) each member of the group is held accountable for the success of the whole group (Slavin, 1991). Further, positive outcomes have been found in the areas of self-esteem, intergroup relations, acceptance of students with special needs, attitudes to school, and the ability to work cooperatively (Slavin, 1991).

When children engage in cooperative learning and group problem-solving activities, they learn to recognize and define a problem and plan or negotiate a solution. Problem-solving events emerge from both academic pursuits and social interactions, and hence are a naturally occurring part of a student's day-to-day experiences. Recording the strategies children use and the outcomes of those strategies helps teachers to assess cognitive, language, and social development appropriate for group work and to identify individual skills and dispositions. As children gain experience in cooperative group efforts, they learn to negotiate and collaborate with others, to consider other points of view, and to assert their own point of view appropriately. As children are skillfully guided during teacher–student collaborations, they learn to reflect on their participation and contributions to group endeavors.

Foyle et al. (1991) explain cooperative learning in early childhood education:

The relationship between Cooperative Learning and early childhood education is this: the process of peer interaction within a group-interdependent structure pro-

When children engage in coop-erative learning and problem-solving activities, they learn to recognize and define a problem and plan or negotiate a solution.

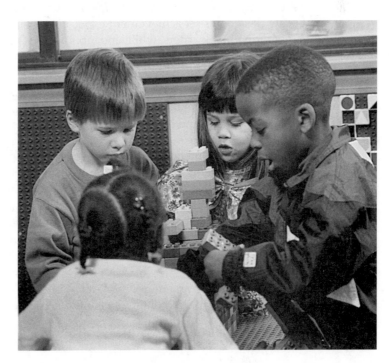

vides several of the components critical for effective learning in young children (early childhood education). Cooperative Learning includes several basic principles. *Positive interdependence* in a *heterogeneous group* promotes acceptance, inclusion, and caring for others. Children with diverse ideas collaborate on a task that no one member could achieve alone. *Group interaction* develops communication skills (speaking and listening) and social skills, which become the primary tools for task accomplishment and success as a group. Active involvement within a small group or pair offers opportunities for self-direction, problem solving, and conflict resolution. *Individual accountability* requires personal investment and builds individual responsibility for learning. Each child's contribution to *group success* is acknowledged through *group rewards,* processing and evaluating group performance on the task, and in cooperative behaviors. (p. 17)

Psychologically Safe Classroom Dynamics

In learner-centered classrooms the focus is on helping individuals succeed. To this end, every effort is made to assure a psychologically safe learning environment. Such a classroom environment is as sensitive to the emotional and social dimensions of learning as it is to the cognitive or academic aspects. Psychological safety in the classroom is best described as the comfort level children feel in the classroom context—with expectations and tasks, their relationship with the teacher or other adults, and as a member of a social group (Eggen & Kauchak, 1992; Good & Brophy, 1987). Psychologically safe classrooms are characterized by:

◆ *Challenging, yet reasonable and achievable expectations.* Developmentally appropriate classrooms set achievement expectations within the developmental reach of individual learners, while encouraging best efforts and high standards.

◆ *Empowerment.* By allowing students to make choices and participate in group decision making, teachers transfer some of their "power" to the students. Thus, ownership of what goes on in the class, and among its members is shared by each participant. The growth of the psychosocial dimensions of trust, autonomy, initiative, and industry are encouraged in such a context. In a community of learners where there is group sharing of responsibility for what happens in the classroom, where class meetings provide opportunities to group problem-solve, and where solutions are derived from group consensus, students experience the tenets of a democratic society (Developmental Studies Center, 1996).

◆ *Mutual respect.* In psychologically safe classroom environments, the teacher strives to create a group dynamic that is characterized by mutual respect between teacher and students, and among all students. In such a classroom, every contribution is valued, group problem-solving and consensus building is practiced, and learning to accept individual differences and take the perspectives of others is an integral part of the interpersonal dynamics modeled by the teacher and expected of members of the class.

◆ *Free of impositions of embarrassment, guilt, ridicule, or negative or hurtful feedback.* A major aspect of mutual respect is setting a climate of intolerance of mistreat-

ment of others. Neither teacher nor classmates may embarrass, humiliate, or demean in any way another classmate. All students are treated equitably and where limits must be set, they are fair, reasonable, clearly stated, and consistently applied.

◆ *Encouragement of risk-taking and freedom to make mistakes.* In a psychologically safe classroom environment, mistakes are valued on several fronts: They provide insight into the learner's thinking processes and their willingness to put forth effort, to take a risk, to try. Students' mistakes also provide an opportunity to define their zone of proximal development and to coach or scaffold emerging understanding or skills. When skillfully addressed, students' mistakes can serve as intrinsic motivators to exploring possibilities and finding solutions. Students need not be embarrassed by their mistakes; indeed, fear of mistakes can lead to down-shifting, the psychophysiological phenomenon mentioned earlier in this text.

◆ *Reasonably stress-free.* Research has effectively demonstrated that children in programs in which they are confronted with developmentally inappropriate practices exhibit nearly twice the levels of stress behaviors as children in more developmentally appropriate situations (Burts, Hart, Charlesworth, Fleege, Mosley, & Thomasson 1992), and have been found to do less well in academic achievement (Bryant, Burchinal, Lau, Sparling, 1994; Stipek, Feiler, Daniels, & Milburn 1995). See Figure 8.1. When expectations are developmentally appropriate, understood by the learner, provided for with appropriate and challenging materials and activities, and supportive feedback from adults who matter to the child is consistently provided, the issue of stress need not arise.

INITIATING ASSESSMENT COLLABORATIONS

Most teachers collaborate with children in many contexts every day, and frequently go over grades and expectations with individual students and with the class. In an authentic assessment system, effort is made to structure these important instructional practices to fit specific goals and outcomes outlined in a class (or grade level) assessment plan. Assessment in this context systematically focuses on particular domains as identified in the over-all assessment plan, and utilizes criteria-based scoring and rating systems to develop an emerging profile of individual students. To begin this process, it is helpful to know something about each child's early development and background experiences.

Obtaining Baseline Information

Obtaining baseline information about each child is one of the first steps in authentic assessment and individualized planning. Such information helps teachers get acquainted with children and their families and to plan more appropri-

Figure 8.1

Signs of Stress in Young Children

Regressions from more to less mature forms of behaving, e.g., toileting accidents, thumbsucking, clinging to adults, temper tantrums, etc.

Daydreaming

Difficulty concentrating and staying with a task to completion

Little tolerance for change or frustration, easily overwhelmed

Moods may be depressed, or inauthentically happy with silly, acting-out behaviors

Psychosomatic symptoms: eating and sleep disorders, aches and pains, upset stomach, diarrhea, headaches

Restlessness

"Nervous habits", e.g., nailbiting, hair twitching or pulling, scratching or picking at sores or scabs, overeating or loss of appetite

Irritability

Cries easily

Difficulty making friends and enjoying social interactions

Increased need for reassurance

Increase in fears and preoccupation with frightening things

Speech and language difficulties, e.g., stuttering, speaking too softly or too loudly, too fast, or whining

Withdrawing behaviors

Muscular tensions revealed in taut facial muscles, poor motor controls, trembling hands, facial twitches, frequent accidents, and less coordinated use of pencils, crayons, scissors, computer keyboard, etc.

Impatience with others

Aggressive behaviors toward others

ately for the experiences they will have at school. Baseline information is derived from parent conferences, home visits, previous records, and initial observations and interactions with the student. From this information a preliminary plan for each student can be developed—a plan that uses information about developmental characteristics to provide appropriate initial learning and assessment activities. Baseline information may include the following:

Important Developmental Information Associated with Physical Growth and Health History

general health
eating habits

sleeping habits
disease, allergies, accidents, traumas

Information Derived from Early Screening Tests

special needs
current treatment and service plans

Special or Unique Early Experiences

favorite toys
special interests or proclivities
special friends
memorable events

Child Care and Preschool Experiences

at what age enrolled
type of child care or early education
types of experiences
relationship with caregivers
relationship with other children

Family Life Experiences

family members/siblings
traditions
memorable events
types of discipline or guidance
educationally enriching experiences
chores and responsibilities

Feelings About School, Classmates, and Learning

prior knowledge about school
prior experiences with books, writing,
 reading, numbers, and so on
stress, fears, or anxieties
familiarity with classmates
enjoyment of learning

Parents' Goals, Expectations, and Concerns

parents' prior experience with their child's school
congruency between parent goals and expectations and the schools' need for
 special or atypical support services

Using the Portfolio as a Tool for Effective Collaborations

Perhaps the most important aspect of portfolio development is the opportunity it provides for student–teacher collaboration. These focused interactions have enormous potential for enhancing learning through the opportunities they provide for students to discuss and reflect on their work in positive and self-affirming ways. The portfolio process begins with encouraging children to collect samples of their work and helping them devise ways to organize their collections. Once students have been introduced to the concept of collecting and storing their work (both in-progress and completed items), the teacher begins to think about helpful ways to communicate progress and expectations to students and engage them in thoughtful reflection and purposeful planning.

As has been encouraged in previous chapters, introducing students to the concept of the portfolio should begin simply and on a small scale. For example, a strategy used by a kindergarten teacher to collect children's writing activities (both regularly scheduled and child initiated) is illustrated in Figure 8.2. Each child was given a legal-size folder with the student's name printed in large letters on the outside. Stapled to the inside was a sheet of paper blocked into six sections. As the teacher reviewed the writing with each child, she wrote a brief comment in one of the squares, dated it, and shared the comments with the student. When all the squares were filled, the teacher and student revisited the portfolio, reread together the teacher's notes and talked about each item in the folder. The student was asked to choose one or two writing samples to be placed in the student's archival portfolio and perhaps an item for the class aggregated portfolio for later summative reports. The student also selected items to take home, along with a copy of the teacher's dated comment sheet for the child's parents to read. The teacher's comment sheet (or a photocopy of it) was placed in the student's archival folder for later summary review and a soon-to-be-scheduled collaborative conference with the parents. Writing projects in-progress were left in the folder to be completed later. This plan can be expanded to cover other content or subject areas.

The contents of a portfolio are for the most part controlled by the student, but guidance is needed to assure that the contents of the portfolio eventually accomplish the following:

◆ provide evidence of growth and development across all domains
◆ are related to instructional goals and objectives

Figure 8.2
Beginner's Writing Portfolio

◆ reflect events or learnings that are personally meaningful to the student

◆ reveal performance and processes as well as products

◆ assist the student in clarifying performance expectations

◆ provide a medium for shared meaning between the student and teacher, between the student and parents, and, when appropriate, among the student and classmates.

When students take the lead in selecting the contents for their portfolios, their interests become vested and their motivation to learn becomes more intrinsic. Students may choose items on the following bases:

> most meaningful
> best work
> favorite piece
> most difficult to do
> sentimentality or serendipity—reminiscent of home, family, or significant personal events
> just to save

During the ongoing collaborative assessment process, the contents may grow to include additional items, such as:

> process samples and final products
> student reflections and self-evaluations (see Figure 8.3)
> teacher's observation notes
> dialogue notes in which the teacher and student communicate back and forth
> dialogue journals
> progress notes jointly prepared by the student and teacher
> miscue analysis records
> copies of text students are now able to read
> audiotapes and videotapes
> a variety of products such as those listed in Chapter 7
> summary report (compiled and shared at least three times during the school year).

Student Reflection

When collaborating with students at both scheduled and informal times, the teacher should engage them in thoughtful reflection about their work. The goal of collaborative assessment is to help students become cognitively engaged in their own work and to be able to talk about and reflect on their choices, procedures for doing things or figuring things out, and the products of their efforts. During collaborative interactions the teacher focuses on student strengths and interests, feelings and dispositions, demonstrated knowledge and skills, and the cognitive processes that appear to characterize their learning. Seeking "right" or

Name _____ Date _____

○ Today I discovered

 It is important to know

 I'm glad I learned about

○ I still want to know more about

 I need to do more work on

○ Tomorrow, I would like to

Figure 8.3
Student Self-Evaluation Form

"correct" answers to the teacher's questions is not the focus of these collaborations. What is important is determining how students think and perceive their assignments, and what strategies they use to pursue them. For example, through properly executed questions, the teacher may discover that the student's wrong answers reflect right thinking! A student may answer, "White," when asked, "What color is an apple?" Questions should be used to open dialogue and foster discussion between the student and the teacher. They should be open-ended for the most part and should lead to supportive and helpful interactions between the student and the teacher. Questions should be genuinely posed, well-timed, challenging, relevant, and focused on the student's work.

If students are to be able to think clearly and talk frankly about their work and their efforts, dialogue with them must put them at ease and convey that the teacher is interested in how and what they think. As well, collaborations with students should be nonthreatening and nonjudgmental. According to Sigel and Saunders (1979), questions that promote cognitive development and inquiry should solicit the following types of responses:

◆ labeling (What is this called?)
◆ reconstructing previous experience (Tell me about your visit with your cousin.)
◆ proposing alternatives (Is there another way to do that?)
◆ resolving conflict (There are only two trucks; how will the three of you share them?)
◆ classifying (How did you decide what to put in each group?)
◆ estimating (How many pieces of wood will you need to build that airplane?)
◆ enumerating (How can we tell how many beads you have on your string?)
◆ synthesizing (What kinds of ideas have we shared, and how can we decide which to try?)
◆ evaluating (What is it about this writing example that you feel makes it your best?)
◆ generalizing (We watched ice melt on the windowsill in the sun; what will happen to the snow when the sun shines?)
◆ transforming (If we mix these ingredients together, what will we have?)

Dialogue should flow naturally from the student's answers and be allowed to evoke additional questions. As part of ongoing assessment, the teacher may later record the types of questions posed during such dialogue and the types of answers they elicited. Inferences are more carefully drawn when questions and dialogue are framed to allow students to fully reveal their knowing. Anecdotal records (Figure 8.3) or simple self-reflecting questionnaires—what I knew; what I know now—(Figure 8.4) are helpful ways to record the richness of these interactions and should be included in the student's portfolio to be revisited in subsequent collaborative sessions.

What I Knew Before the Field Trip About How Candy is Made	What I Know Now About How Candy Is Made
1.	1.
2.	2.
3.	3.
4.	4.
5.	5.
6.	6.

Figure 8.4
Reflecting On What Has Been Learned

Just as questions must be relevant and meaningful, so must the dialogue that accompanies them. Students need authentic dialogue with adults that responds specifically and helpfully to their responses, inquiries, and comments. Authentic dialogue involves actively listening to what the student is saying and providing useful feedback and suggestions. While positive and supportive, this approach uses praise judiciously. Inauthentic praise does little to instill intrinsic motivation, and undermines the student's trust and respect for the adult's point of view. The following types of responses get beyond the perfunctory and encourage mutually engaged participation in the collaborative process.

This idea interests me. How will you. . . .
Another way to look at this is. . . .
Another way to think about this is. . . .
Perhaps this item tells a better story.
Perhaps this item shows what you do best.
Perhaps this item answers that question about. . . .
My feelings about this are. . . .
You seem very pleased with what you just did; tell me about it.
I would like to hear more about that.
You seem to be very interested in. . . . (curious about . . . , puzzled about. . . .)
These are the strong points that I see.
The reason I think so is. . . .
If you change this part, then you may need to think about. . . .
Another way to do this would be. . . .
That is a really good question. How can we find the answer?

This is a difficult task and hard to figure out. You might try _____ to help
 you get started. If that doesn't work, we could explore other possibilities.
Have you tried . . . ?
Did you think about . . . ?
Yes, that makes good sense to me because. . . .

Dialogue Journals and Notes

As the student becomes more involved with portfolio development, a diary or
journal can be initiated that may or may not relate to the contents of the portfolio.
A simple diary or log of meaningful activities might start this process and can
begin with headings such as "What I Do at School" or "What I Am Learning
Today." Depending on the developmental level of the students the journal entries
may be drawings, cut and glued pictures, copied letters or other representations,
dictations, or beginning writing.

These dialogue journals invite students to record their thinking, planning, and
learning and to exchange ideas and information with others. Through dialogue
that supports, reacts, questions, and challenges, students can be guided into deeper
understandings and broadened perspectives. Journals can be used to enhance just
about any activity. Journal writing is particularly helpful in the areas of language
development, writing, spelling, and reading. Writing in journals emphasizes writ-
ing as a way of communicating, and develops in the writer a sense of audience. In
non-English speaking children, journals can reveal their progress toward acquiring
English, and the teacher's written responses can provide models for conventional
forms of English. Math journals (Figure 8.5) provide an opportunity to illustrate the
many uses of mathematics in everyday life, an awareness found to be limited in
early childhood and primary grades (Perlmutter, Bloom, Rose, Rogers, 1997). Dia-
logue journals may be created for science, social studies, and other content areas as
well, and for special curriculum activities. For example:

A *research journal* through which students are taught the concept of "research"
 and its components including strategies for framing questions, looking for
 answers, summarizing findings, and telling where you got your informa-
 tion. Figure 8.6 illustrates a set of questions one second grade student posed
 relative to his chosen research topic.
A *current events journal* in which students may draw, dictate, write about (or cut
 and glue from newspaper, magazine, fliers, event programs, and so on) sig-
 nificant happenings at school, in the community, or elsewhere.
A *thematic project journal* in which each student keeps a diary of the class pro-
 ject, its progress, and their individual contributions to the endeavor.
A *learner's book of lists* in which students collect all sorts of informational or
 "hobby" lists: books I have read; places I have visited; people I know; names
 I can spell; flowers I can name; street names in my neighborhood; friends
 and what I like about them, and things I want to know more about; "I wish I
 had . . . ," I wish I could . . . ," and so on.

MADELEINE

Numerals in My House

MADELEINE (student's handwritten title)

TV
PHONE 851-8760
HOUSE 858

4 RAMRYRT-SOSIS54
COMPUTER 1555

RDO 66.3 FM

CLOU 10:01
OVNNO 808-55

SUGARS TE

	TV
	telephone
	house number
	address book
	computer
	radio
	clock
	oven
	cereal box

Figure 8.5
A Kindergarten Math Journal (Teacher's translation is noted to the right of the student's list entries.)

KATie

My Own Numbers

age 7

birthday January the 12

number of people in my family four

telephone 924-f02ð

address 2ðlð BoydꞋ Ave

mother at work

 address/phone number

daddy at work 33f-9l53

 address/phone number

grandmother's phone number 292-1254

grandfather's phone number 292-1254

emergency phone number 911

time I go to bed 8:00

time I get up in the morning 7:30

minutes to travel from my house to school 5

blocks or miles to school from my house 2 miles

how many cups of water I drink each day 2

how many cups of milk I drink each day 1

how many ounces of juice I drink each day 24

number of trees in my yard 5

number of windows in my house 18 windows

number of stuffed toys in my room 14

Figure 8.6
Second-Grade Student's Research Questions

Over time, journal activities develop into more sophisticated processes and complex topics and activities. Throughout, dialogues need to be meaningful and focused on extensions such as those suggested in the questions and comments listed above.

Dialogue notes placed in the student portfolio can include such things as:

◆ comments on personal experiences similar to the student's

◆ questions designed to stretch the student's thinking

◆ comments about parts, sections, and characteristics of the product that the teacher found interesting, enlightening, helpful, and so on

◆ an invitation to talk about the project or share it with classmates

◆ encouraging notes about student progress

◆ offers to help with revising, expanding, or completing the project

◆ reassurance of the value of trying, of taking risks, and of making mistakes.

Students may respond to dialogue notes with their own drawings, dictations, or writings. They may wish to respond to the teacher's notes or place short reminders to themselves of things to do or say. Dialogue such as this leads to additional discussion, debate, and, perhaps, further inquiry, and should expand the student's range of experience and expose further interests and challenges.

Students' responses to questions and dialogue reflect their level of understanding of (1) the requirements, expectations, or reasons for the work being assessed and (2) the reflective, self-evaluation process itself. It is important to ascertain if students are clear about the task at hand and what their responsibilities are. Teachers will want to be sensitive to the students' ability to work within this collaborative structure and ensure that the structure provides a psychological context in which it is safe to express themselves, perhaps challenge the teacher, pose questions, take risks, and make mistakes. Evidence of student self-reflection is found in answers to questions such as these:

◆ How does the student choose portfolio or journal contents?

◆ What meaning does the student attach to the choice?

◆ How does the student communicate this meaning?

◆ What observations, connections, generalizations does the student make?

◆ Does the collaboration generate expanded or new goals for learning?

A summary of student portfolio entries and their evaluations should be completed at least three times a year. Figure 8.7 shows a form for this process. From a summary report the teacher can identify strengths, analyze attempts and processes, decide what next step(s) to encourage, determine instructional and scaffolding needs, and plan curriculum modifications and logical progressions.

Name _____ **Teacher** _____

Grade _____

Date _____ *Exemplary items (list)*

Fall Report

Developmental domains
or learning objectives:

Comments:

Date _____ *Exemplary items (list)*

Mid-Year Report

Developmental domains
or learning objectives:

Comments:

Date _____ *Exemplary items (list)*

End-of-Year Report

Developmental domains
or learning objectives:

Comments:

Figure 8.7
Portfolio Summary

Portfolio Collaborations

Providing predictable times for student-teacher collaborations helps children to organize themselves and their work. As students learn to anticipate these special interactions with their teacher, they can begin to collect and select portfolio items and think about what they want to say or do during the conference. Recall the suggestion in Chapter 2 that children be assigned to a day-of-the-week conference group (four or five children on Monday, three or four on Tuesday, etc.). If this procedure is followed predictably each week, both teacher and children can organize and plan for it. It is during these revisits that timely and meaningful dialogues take place and when students have opportunities to reconstitute or reorganize their collections. Some pieces may be withdrawn to take home, others assigned to the archival or aggregated (class) portfolio, still others brought out for display, demonstration, or group work. Predictable scheduling of conferences with students should not, however, preclude what Graves (1983) refers to as the "roving conference," in which the teacher captures special teachable moments to collaborate with individuals or with small work groups on their progress and plans.

Setting Goals and Plotting New Directions

Young children can learn to "think ahead" and to plan for things to come; they can set realistic goals for learning (White, Hohn, & Tollefson, 1997). When teachers engage in collaborative dialogue such as has been described in this chapter, they begin to develop skills in organizing and planning their work and anticipating what comes next. These processes help young children learn to set goals and anticipate next steps. Young children should be involved in this type of planning. Children engaged in setting goals and planning next steps are assuming more and more responsibility for their own learning. A beginning step for this process is to have children dictate or write lists with headings such as the following:

When I finish this (task, assignment, job, activity), I am going to do. . . .
When I come to school tomorrow, I want to. . . .
I want to learn about (read about, write about, draw about, talk about). . . .
I plan to build (construct, make). . . .
Today, I will start a project in the science center (art center). . . .
Next week I would like to. . . .
I don't know how to _____. I will ask _____ to help me.

These lists help children to think ahead, plan, organize, collect materials, seek advance information, and initiate personally relevant activities. As the year progresses, these lists can evolve into more elaborate lists of complex plans involving two or more levels ("First I will do A; then I will need to do B."), and goals can become more complex and multifaceted ("Caitlin and I are going to draw a spaceship and then make one out of wood."). With guidance, the time frames for goals can become more extended as children engage in increasingly more complex, long-term projects. Their goal statements might look something like the following:

By the end of this week, I want to have finished. . . .
When I complete A, then I will start on B. To get started, I need. . . .
This next step is going to take a long time. I think I will need three days to do it.
By the next holiday, our group project will be ready to share with the class.
I want to finish _____ before my next portfolio conference.

This type of planning and goal setting guides and motivates learners. The clarity of purpose and sense of accomplishment when goals are completed contributes to the child's sense of self as a learner and competent person. Guided goal setting and choice-making help children to become wise choice-makers. As these goals inspire both teaching and learning, the collaborative process becomes even more dynamic and generative and we learn that children's ideas and interests can extend and enrich the curriculum.

Taking cues from student's portfolios, journals, dialogue, and goal statements, the teacher can match curriculums to children's interests and emerging capabilities. For example, Chad, a second grader, initiated a research journal and selected his own topic. His interesting research was shared with the class and subsequently extended into a thematic unit. Chad's research journal includes both his own and dictated writings. Yes, students' own ideas can enrich the curriculum for everyone, and collaborative assessments open the windows for that to happen.

Reflecting on Collaborations and Student Reflections

In Chapter 2, we suggested that teachers should set aside scheduled times for reflection. Several tools can assist you in doing this.

The Teacher's Reflective Journal

Prepare a loose-leaf notebook with tabbed sections for each student in your class. Let this be your running log of on-the-run notes—a place to put stickies you have jotted notes or ideas on, a place to write notes that can jog your memory prior to a student or parent collaborative interview, a place to record notes that would be inappropriate for dialogue journals or portfolios, but can assist in framing the questions for interviews and conferences and remind you of behaviors to observe further. In this log, you can record the dates and topics of each dialogue session, both planned and extemporaneous. Be reminded that this, like other information regarding children, is private information and should be kept in a secure place available only to those who have a legitimate reason to access it. As with all records, the contents of this document must be professionally worded, accurate, and unbiased. Beware: Anything written can be read by others, including students who can read.

Create a section in which you jot down thoughts from your own experiences with authentic assessment. After each interview or conference consider reflective questions such as the following to get you started thinking about schooling processes and the effects on children and their behaviors and learning.

What behaviors did you observe?

What do these behaviors tell you about child development? Learning? A child's immediate physical or psychosocial needs?

Are you detecting any signs of undue stress? What do you think might be causing stress behaviors?

What can you do to minimize stress at school?

How does context (time, place, people, physiological or emotional needs) influence a child's behavior?

What is the social and emotional climate in this class?

Are the tasks that children pursue sufficiently challenging, meaningful, relevant, mind engaging, and developmentally and culturally sensitive.?

Are the children in this class developing a sense of community?

Are individuals growing into a sense of self-efficacy, autonomy, initiative, industry, social and moral competence?

Reflect on the assessment process itself:

What glitches have you run into?

Have any of your colleagues run into these or similar problems?

What resources do you need to enhance or streamline the process?

What ideas have been generated for working with and meeting parents or guardians' needs for assessment information?

What curriculum ideas have emerged from the collaborations and assessments with children?

In what ways have authentic assessment strategies enhanced learning? Curriculums?

What resources are needed to improve the process?

How are parents responding to portfolios, journals, and conferences?

REVIEW STRATEGIES AND ACTIVITIES

1. Visit an early childhood classroom in which children are engaged in portfolio development. With the permission of a child and the teacher, invite the child to share a portfolio. Use some of the questioning and dialogue strategies mentioned in this chapter and those that flow naturally from the interaction to practice collaborative assessment.

2. Make a list of your observations of the child's development or capabilities in any of the developmental domains (personal and social development, language and literacy, mathematical thinking, scientific thinking, social and cultural understanding, art and music, physical development).

 a. Discuss your observations and notes in class. What have you learned about child development in general? Learning styles, diversity and special needs, the connection between child development and curriculum development?

 b. From this brief encounter, can you draw any initial inferences about the child's knowledge, skills, feelings, or dispositions?

 c. How would you plan to collaborate with the child on projects, processes, and performance?

9 Collaborating with Families to Promote Authentic Assessment

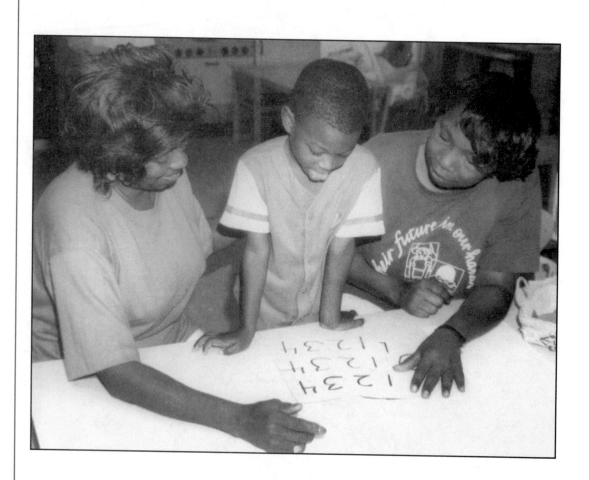

We begin, where we must, with parents. When all is said and done, mothers and fathers are the first and most essential teachers. It's in the home that children must be clothed, fed, and loved. This is the place where life's most basic lessons will be learned. And no outside program—no surrogate or substitute arrangement—however well planned or well intended, can replace a supportive family that gives the child emotional security and a rich environment for learning.

Boyer (1991)

Open communication between parents and the school staff is basic to the success of an early childhood program, and must be two-way—not a situation in which educators talk and parents passively listen.

National Association of Elementary School Principals (1990)

After reading and studying this chapter, you will demonstrate comprehension by being able to:

- discuss factors that influence the abilities and inclinations of parents to work with schools.
- identify strategies for involvement of families in the authentic assessment process.
- list the types of information needed from families to conduct authentic assessment.
- describe strategies for informing and engaging families in the ongoing assessment of their children.
- describe the elements of an effective collaborative parent conference.
- identify strategies for informing families of school and community resources.

Early childhood educators have historically valued and promoted parent involvement as an important contributor to children's success in school. Most federally funded programs for young children require parent involvement components to the programs as a requisite for funding. The belief that parent involvement has positive influences on academic achievement and school adjustment is widely held and continues to be supported by research (Reynolds, 1992).

Traditional school models of parent involvement have been characterized by parents' (mainly mothers) attendance at meetings such as PTA and at programs in which their children participated. The success of these models depended on the extent to which parents volunteered in the classroom, assisted on field trips, planned school parties and special events, and assisted children at home with school assignments. This model of parent involvement is still helpful to teachers and may strengthen (at least for some parents) the home–school relationship. However, the changing economic and family life contexts in which parents are raising their children today and the changing view of education of children as a joint home–school effort presupposes another parent involvement model—a model that emphasizes family participation through home–school *collaboration*.

FORMULATING A COLLABORATIVE MODEL

A collaborative model links home and school in unique and nontraditional ways. The goal of the collaborative model of home–school relationships is to engage parents, students, teachers, and appropriate school personnel in meaningful and relevant interactions and shared responsibilities. The Task Force on Early Childhood Education of the National Association of State Boards of Education (NASBE) (1988) has described school partnerships with parents as *multilateral*, in which parents and professionals exchange information through a reciprocal process. It is a relationship characterized by mutual respect, in which schools and teachers are open to the expertise and insights that parents can provide about their children. Parents are purposefully invited into a partnership of shared visions characterized by programs that:

◆ promote an environment in which parents are valued as primary influences in their children's lives and are essential partners in the education of their children.

◆ recognize that the self-esteem of parents is integral to the development of the child and should be enhanced through positive interactions with the school.

◆ include parents in decision making about their own child and the overall early childhood program.

◆ facilitate opportunities for parents to observe and volunteer in classrooms.

◆ promote exchange of information and ideas between parents and teachers which will benefit the child.

◆ provide a gradual and supportive transition process from home to school for those young children entering school for the first time. (p. 19)

These broad goals provide a framework for the conceptualization of innovative strategies to link homes and schools in meaningful and relevant ways. A collaborative model addresses the following six principles:

1. Shared goals for a child's success in school are overt—they are discussed and acted on. Parents and teachers explore together their mutual concerns for the child's success, listing specific developmental and learning goals and planning collaboratively strategies for reaching these goals. In a collaborative model, the student is often a contributing member of this collaboration. As goals are identified, *all* participants identify and commit to their individual and collective roles and responsibilities.

2. Teachers are knowledgeable about child growth and development and share this knowledge with parents in appropriate and affirming ways. Teachers have a unique opportunity to enhance parenting experiences through shared understandings of how children grow, develop, and learn. But teachers have a concurrent and profound responsibility to provide correct and sound child development information to parents. This information must be based on current and best understandings, drawing on research-based knowledge in the field and the educator's own practical experiences. Well-designed developmental checklists and other strategies discussed in earlier chapters provide a medium for meaningful dialogue about developmentally appropriate expectations and goals for individual children.

3. Teachers are knowledgeable about and sensitive to human diversity in culture, language, capabilities, and circumstances within and among families. Families

Home visits strengthen collaborative relationships.

differ in skills, feelings, prior experiences, and attitudes toward school and school personnel. They also differ in the availability and use of resources through which to broker the schooling experience for their children. Let us return to Lareau's (1989) most provocative study of social class and school relationships mentioned in Chapter 4. Lareau uncovered a litany of differences between lower-income working-class and higher-income middle-class family relationships and attitudes toward schooling experiences. These two groups of parents had common hopes that their children would be successful in school, but pursued these hopes in different ways.

Working-class parents were found to separate family life from educational institutions. Although they helped to prepare their children for school by teaching manners and perhaps some rudimentary skills, they did not attempt to intervene in their children's schooling, expecting and assuming that the school would take charge of their children's education needs. In so doing, these parents depended on teachers to ensure equitable and suitable educations for their children.

In contrast, upper middle-class families were found to be "connected" to educational institutions and to devote more time and energy to preparing their children both academically and socially for school. Further, these parents were more likely to supervise, supplement, and intervene in their children's schooling: hiring tutors, requesting certain teachers, challenging appropriateness of curriculums or grades, and sometimes even circumventing school policy. They formed and participated in friendship networks with other parents and teachers, thus obtaining more detailed information about the schools (teachers, administrators, policies, and so on) and what schools wanted from them. As such, their roles more closely matched teachers' expectations and wishes than did those of the working-class parents. There was some evidence, however, of increased stress for children whose parents became heavily involved.

Lareau's research found that middle-class parents were more likely to hold college degrees and, therefore, felt competent to communicate about education issues even when they didn't always understand the educator's professional jargon. Working-class parents, on the other hand, most of whom were, at most, high school graduates, tended to leave parent–teacher conferences confused and felt incapable of engaging in routine interactions with the teacher. In terms of social interactions, middle-class parents viewed teachers as social equals, often thinking that they, too, could have been a teacher had they so chosen. On the other hand, the working-class parents looked up to teachers and felt the social difference between themselves and "educated" people, often holding teachers in awe.

Income influenced the quantity and quality of clothing, toys, and books for children, and constraints of child care and transportation influenced the parents' ability or willingness to provide at-home school preparation or enrichment and to attend school events. Occupations also placed different demands on workers. Lareau (1989) refers to the work–family connections of middle-class families as paralleling the family–school connection.

Work–family connections of many upper middle-class jobs give employees a vision of work as a diffuse, round-the-clock experience taking place at home *and* at the work place—which is similar to the vision held by teachers. Parents, partic-

ularly fathers, provide role models for children, as they labor at home in the evening and on weekends. Parents also embrace a notion of children's school work as legitimately taking place in the home on a regular basis.

Working-class jobs give the employees a different vision of work—as discrete, time-limited, and taking place only at the work site. Workers holding these positions have less experience and less enthusiasm for work taking place at home on a sustained and regular basis. This conflicts with the teachers' vision of children's school work as well as teachers' own diffuse work experience. Conceivably, this perspective influences the support and help that children receive on homework assignments and, hence, the teachers' misperception of the parents' level of concern for their children's education.

As for student progress in school, Lareau (1989) found that working-class parents take grades very seriously, superordinating them to other indicators of school success such as comprehension or understanding certain content. They often fail to understand what grades mean in terms of what their children have learned or their rate of progress, and can be confused by or disinterested in psychometric measures that are communicated in percentile rankings or grade equivalents. In many of the families studied, there was often little understanding of broad curricular goals. Moreover, their awareness and understandings of changing methodologies lag behind their middle-class counterparts; therefore, they are less equipped to communicate about or to help their children with school work or career choices.

A more recent study has found that different racial and ethnic groups have different beliefs about child rearing and what they expect from their children in school (Okagaki & Frensch, 1998). In a study of the relationships between parenting and school performance of fourth- and fifth-grade children in three groups—Latino, Asian-American and European-American—it was found that Asian-American parents held the highest educational aspirations of the groups studied, expecting their children to have more years of education than did other parents in the study; they were least satisfied with grades of B or C. This suggests that they place at least as much, if not more, emphasis on effort as they do on their child's possible innate ability. Latino parents placed considerable importance on the development of children's autonomy and on monitoring their children's behaviors, and tended to perceive grades as more related to innate ability. Although parent reports of the frequency with which they made efforts to help children with school work were similar among the groups, the study found that European-American parents felt more confidence about their ability to help their children succeed in school. These and other studies underscore the need for educators to be aware of varying parental perspectives on schooling and their roles in helping their children succeed in school. Sensitivity to the unique needs and perceptions of parents leads to more promising and helpful practices in parent involvement. Keep these studies in mind as we discuss specific strategies for parent collaborations later in this chapter.

4. Communications about curriculums and assessments are regular and ongoing throughout the school year, with predictable times for summary reports and

conferences. When parents are participants in curriculum and assessment decisions involving their children, their investment in the educative process becomes more sustained (Swick, 1991). Their efforts to work with their own children are guided by mutually established goals and mutually understood curriculums. Teachers must develop skills in explaining developmentally appropriate practices and curriculums and assessment procedures that may differ from those experienced by the parent, and strategies for communicating with parents must get beyond the traditional report card to employ a variety of ways to communicate about curriculums and assessment. Also, by establishing predictable times for summary reports and conferences with parents and their children, the teacher gives parents a sense of inclusion in the curriculum and assessment process and reinforces the spirit of collaboration.

5. Parental input is actively pursued on issues relating to policies, programs, curriculums, and assessments and is treated with respect and thoughtful response. Not unrelated to this discussion is Berger's (1995) description of parental levels of participation to which teachers must learn to respond in positive and supportive ways. According to Berger, parent participation falls on a continuum as follows:

- Parents who avoid schools like the plague
- Parents who need encouragement to come to school
- Parents who readily respond when invited to school
- Parents who are comfortable and enjoy involvement in school
- Parents who enjoy power and are overly active. (p. 124)

A study from the U. S. Department of Education's Office of Educational Research and Improvement (1998) has found that children whose fathers are highly involved in their schools have better success rates in academic achievements. This finding held true regardless of whether fathers live with their children and whether mothers are also involved. Given that fathers tend not to be as active in home–school activities (Minnesota Fathering Alliance, 1992), this study suggests a need for more focused effort to plan for and involve fathers. This study reinforces the findings of numerous previous studies that strong links between parents and their children's schools enhances students' school success.

As teachers and parents enter into regular collaborations, opportunities arise to elicit interests and concerns about school programs and policies, as individual student needs and progress are discussed. A sense of trust and mutual respect that can emerge from these supportive interactions helps to build and solidify the home–school partnership. For this to happen, teachers must develop skill in listening to parental concerns and conveying an open and flexible mind. They must assure parents that their interests and concerns will be thoughtfully considered and appropriately addressed.

6. Both in-school and community resources are made available to families to support their efforts to ensure their children's success in school. As student and

For collaborative relationships to flourish, schools and classrooms must adopt an open-door policy with parents.

family needs become apparent, teachers and other school personnel can identify and inform parents of additional resources, materials for learning, enrichment opportunities, tutoring, support groups and neighborhood parent networks, social services, health-care sources, transportation help, and so on. Some parents may need help accessing appropriate resources for their children. Through this holistic approach, families are assisted in meeting the needs of their children and in finding ways to participate in and support the education process for them.

CREATING OPPORTUNITIES FOR HOME SCHOOL COLLABORATIONS

In Chapter 8, we discussed the need for baseline information about each child to initiate teacher–child collaboration. A similar and companion principle is that of sharing information and gaining input from parents at the beginning of the school year. Teachers will want to discuss with parents their shared goals for the child; the idiosyncrasies, interests, and needs of the student; the parents' expectations, hopes, and concerns; the child's prior experiences in other programs and at home; the child's general health and well-being; and other issues of importance to the teacher and parents. The teacher will also want to ascertain the parents' comfort level with school and school personnel and help them forge a positive and mutually supportive relationship. A variety of strategies are possible for these purposes.

Home Visits

Visits to students' homes before the beginning of the school year prove to be quite rewarding for teachers who can arrange for them. Through the home visit, the child and the parent can become acquainted with the teacher in the comfort of their own surroundings. For some, this reduces the stress of meeting for the first time at the school, with its seemingly impersonal atmosphere and frequent interruptions. The home visit provides an opportunity for the teacher to experience the child's home context firsthand. It also demonstrates for parents the teacher's genuine interest in the child. The child, of course, has a unique opportunity to become acquainted with the teacher in a personal way and in the secure surroundings of home, belongings, and parents. There may be some parents however, who are quite uncomfortable with a teacher's visit, fearing the teacher will judge their family, lifestyle, or home. In such a case, the teacher may wish to postpone the visit until the parents feel more at ease in the relationship and view the teacher as their child's advocate and friend, not as a professional who has come to judge the family and its surroundings. Teachers should follow certain procedures in planning for and carrying through with home visits:

◆ Ascertain the parents' desire or willingness to have the teacher visit in their home.

◆ Prearrange the date and time of the visit by telephone, e-mail, or a written note.

◆ Assure the parent(s) of the purpose of your visit.

◆ Encourage the parents to include their child in the visit.

◆ Plan the agenda—what you wish to discuss or accomplish.

◆ Take every precaution to avoid causing the parents to feel uneasy.

◆ Bring along a photograph of the child's new school and/or your classroom.

◆ Provide succinct materials for the parents to read about the school and things they can do to prepare their child for the first days of school.

◆ As a guest in the home, follow the host or hostess' lead.

◆ Dress in a conservative manner, neither "threateningly professional" nor too casual.

◆ Arrive on time and end the home visit within a reasonable length of time—no longer than 45 minutes to one hour.

◆ Be friendly, relaxed, and assuring.

◆ If the parents are willing, take a photograph of them and the child together for a school bulletin board.

◆ Invite the parents, if they wish, to share family photos, memorabilia, or other significant items or events that have been special in their lives.

◆ Write a thank-you note as a follow-up and include some positive statements about some aspect of the visit, such as meeting the family pet, holding baby sister, accepting tomatoes from their garden, and so on.

♦ Continue follow-up communications about specific goals, issues, or concerns discussed during the home visit through notes, conferences, and in-school visits.

♦ Evaluate the conference and record pertinent information needed to plan curriculums and assessment for the child.

♦ When feasible and appropriate, schedule another home visit later in the year to strengthen and continue the collaborative relationship.

School-Based Activities

When home visits are not feasible, a telephone call to each home can set the stage for positive communications between the teacher and families. These calls should take place throughout the year as needed and should not occur only when their is a concern or problem to be discussed. In some situations, a particular evening or time during the school day when the teacher can be available to receive telephone calls may be necessary to make telephone communications manageable. With home computer use increasing, and the availability of computers expanding to libraries, community centers, and places easily accessible to families, the possibilities for home–school collaborations to occur via computer technology is emerging. In addition to home visits, telephone conversations, and computer communications, a number of school-based events can support a collaborative model. Such events might include some of the following.

Open-Door Policy

Parents must be made to feel that the doors to their child's school and classrooms are open to them. Teaching with visitors in the room may be a bit uncomfortable for some teachers. However, it is the teacher who can set the stage for these visitations. Set purpose and goals for the visit in advance with the parent(s) so that they arrive with a sense of what to do and what their focus will be. Provide a place for parents to hang their coats or store their personal belongings and a comfortable, yet unobtrusive place for the parent to sit to observe; or provide some materials for the parent to peruse while visiting. One teacher we know has a hand-out for the parent's visit that describes a "scavenger hunt" in which parents can scan the room or quietly move about the classroom identifying the items on the list (see Figure 9.1)

Another teacher encourages parents to peruse the classroom parents' center that provides displays of children's work, information of use to parents, and sign-up rosters to assist with various class or school activities. When parents volunteer in the classroom, give them something specific to do with simple instructions, if necessary (read to a particular child or group of children, supervise the woodworking center, sort school supplies for storage, assist in the mathematics center, assist children with milk cartons at lunchtime, and so on). Provide parents with guidelines about expected classroom behaviors and how to respond to off-task or inappropriate behaviors. Be certain parent volunteers know the schedule and

Instructions:

With your child or another member of our class, explore the classroom and locate as many items on this list as you can. Give yourself five points for each correct find. Perfect score is 60 points.

1. How many learning centers can you count in this classroom?
2. Can you name them?
3. How many examples of student's creative works can you find?
4. Can you locate and read a "predictable" book?
5. Can you locate the parent information corner? Find something you would like to read.
6. Find two examples of learning materials that help children learn concepts of time.
7. Identify two ways children are encouraged to develop self-help skills.
8. Locate four mathematics activities. Have your child tell you about them.
9. Locate two activities that help children develop awareness of letters and letter sounds.
10. Find two ways large motor development is encouraged.
11. Find two ways small motor development is encouraged.
12. Ask your child if he or she would like to read their dialogue journal with you.

Answers:
1. 12, not counting the Parents' Corner.
2. Centers: Science, Sociodramatic, Writing, Listening, Mathematics, Creativity, Music, Blocks, Woodworking, Current Events, Library, Retreat/Relax Area
3. If you counted at least five, give yourself 5 points
4. How do you know what you read is a "predictable book"? If you are certain, give yourself 5 points.
5. What did you find there?
6. Clock, calendar, seasons chart, hour glass, timer, clock game, daily schedule, daily planning form, student daily contracts and so on.
7. Individual cubbies for personal belongings, water fountain, hand washing sink, dress-up clothes, self-help board games, low shelves for easy access and return of classroom materials, daily individual work contracts, and so on.
8. You will find numerous items and activities for developing math concepts in the Math Center.
9. Both letters and written words and messages can be found in every learning center.
10. Balance beam, bean bag toss, large balls, ladder to reading loft, rhythm and dance activities, and of course, outdoor climbing equipment and space to run.
11. Puppetry, beads/strings, peg boards, art work, puzzles, manipulatives, counting objects, and so on.
12. Did your child enjoy sharing his or her dialogue journal with you? What did you learn about your child's developing knowledge and skills?

Figure 9.1
A Parent's "Scavenger" Hunt

help children complete their activities and make transitions in a timely fashion. If conferencing with the parent is to occur during these volunteer visits, be certain the parent knows when and where it will take place. The more opportunities parents can have to observe and participate in the classroom and to be helpful in other areas of the school, the greater is their understanding of curriculums and assessment processes and their commitment to a collaborative model of home school relationships.

Breakfasts

These morning events, planned for those who cannot come at other times, allow parents to visit with the teacher briefly on their way to work. It is probably better to hold several breakfasts for a few parents at a time rather than try to accommodate all in one class at the same time. These breakfast meetings will be brief by necessity, so supplying parents with succinct written or pictorial materials, and perhaps questionnaires they can take with them to complete and return through the mail or by their child the next day, can expedite the purposes of the meeting. A short video showing the children's classroom "in action" or illustrating the curriculum and assessment practices can be shown, followed perhaps by a few minutes for questions and answers. Parents should be invited to visit the classroom following the breakfast or at some other time convenient for them.

The disadvantages of this procedure as an initial contact with parents are its group nature and brief time allotment. Obviously, there is less opportunity for parents and teachers to get to know one another on a more personal basis. These breakfasts, however, do provide parents a chance to meet other parents and school personnel and begin to find their place in the school community.

Open Houses, Saturday Family Days, Supper Specials

Special events, scheduled early in the school year, can encourage parents to participate and provide them opportunities to become acquainted with the teacher, school personnel, other parents and children, school policies, and the curriculums and assessment practices that will be employed. Again, because these events involve large groups of parents, their purpose will be to communicate general information. Small groups of parents can be formed to discuss with a teacher topics relating to the school and its curriculums and assessment practices. These groups often evolve into school committees, parent support groups, and other networks. Later in the year as assessment strategies get underway, a portfolio open house, when students can showcase their archival portfolio with others, is an effective way to help advance understanding of alternative methods of assessment.

Classroom Parent Center

To support and encourage parents to visit and become knowledgeable about the school and its programs, space within the classroom or the school building can be

provided where parents have the opportunity to peruse selected journal articles, curriculum materials, parenting books, and class-authored books, science and art displays, and other items of particular interest to parents. Space in the classroom allows the parents to visit, observe, and become better acquainted with their children's teacher and his or her method of teaching. They also have a chance to explore the various materials the teacher has made available to inform parents about the classroom and its activities. (Some of these materials might be information on how to help in the classroom and a schedule for classroom volunteers; information on the current thematic unit, its progress, and materials needed to carry it out; classroom discipline and guidance strategies; a photo album of recent classroom events; weekly assignment logs; suggested books to read to children; a small bulletin board of school or classroom announcements; and ways parents can help their children at home.

Information-gathering items might also be included, such as parent questionnaires, opinion polls, and checklists for selected topics. The parents can also observe their own child's activities, behaviors, and choices during the school day and assess the child's capabilities and relationships within the school context. Providing checklists, rating scales, observation guidelines, and so on, helps parents to become engaged in the ongoing assessment process and invites them to provide additional helpful information. This information combined with classroom observations and portfolios are used to guide and inform the child–parent–teacher collaborative conferences. When parents can visit or volunteer in the classroom, teachers and parents have an opportunity to become better acquainted. Every child benefits from a parent visit as the presence of a parent in the classroom helping and interacting with the students affirms the importance of the school experience.

Parent Resource Room

Sometimes schools provide a parent resource room in which a variety of activities can take place. Such a room can provide space for small group meetings (support groups, committees, informal gatherings) and, if space can be so configured, for private collaborative conferences. The resource room can display and make available various types of information to parents: grade-level curriculum materials; school handbooks and policy manuals; audio and visual materials of school events and topics of importance to parents and equipment for listening to and viewing them; video access to individual classrooms for observation; computer linkages to the classrooms; bulletin boards with calendars, school announcements, volunteer schedules, small-group meeting dates; book and toy lending library and exchange programs; recyclables programs, opportunities to donate materials for arts and crafts projects and for thematic units and other long-term projects. This room can provide a place where materials to assist parents in locating and using community resources are displayed and fliers, brochures, and other materials about local community health and human services agencies are made available. Resource people from these various community programs can be

scheduled for small-group discussions in the parent resource room from time to time. Information about before- and after-school child care, summer programs, transportation and car pools, and nannies and baby-sitters can also be exchanged. When scheduling the hours of availability of the parent resource room, consideration will need to be given to the many parents who have limited opportunities to visit the school during regular school hours. Again, innovative and creative thinking will assure that no parent is disadvantaged by their family circumstances or employment obligations. These types of activities and events bring families into the community of parents and teachers, help them grow in a sense of belonging and "ownership" within the school, and open communication and collaboration between and among families and school personnel.

OBTAINING INITIAL INFORMATION FROM FAMILIES ABOUT THEIR CHILDREN

As mentioned in the previous chapter, initial information about individual children is helpful in planning an effective assessment system. An initial parent conference should be scheduled with each parent as early in the school year as possible. During this conference, goals, curriculums, and expectations can be shared, concerns addressed, and plans developed for sharing assessment related information. The teacher may invite the parent to describe or discuss their child's early and current development, characteristics, and experiences centering on some of the following important topics:

◆ The child's general health and well-being; eating, sleeping, and daily routines and habits; prior illnesses or accidents; special or unusual needs

◆ The child's prior experiences within the family, with siblings, and with playmates in various contexts, for example, birthday parties, neighborhood play groups, day-care and preschool groups, homes of relatives

◆ The child's play and work preferences—toys, books, stories, television, "best" friends; and the amount of time spent with these activities

◆ The manner in which parents share with and teach their own children

◆ The manner in which parents handle misbehavior

◆ The child's fears, anxieties, joys, emotional attachments

◆ The child's strengths—abilities, talents, skills, hobbies, special interests

◆ In what types of contexts and with what types of toys or materials the child seems to do the most focused work

◆ Hopes, aspirations, expectations, and goals parents hold for the child

◆ The parents' desires or comfort level in communicating with and working with the teacher in planning for the child's experiences at school

Teachers may wish to devise checklists, a brief questionnaire or other forms to be completed by the parent and used during collaborative conferencing. Figure 9.2 illustrates a goal statement that can be completed by the child, the child's parent(s), or the child and parent(s) together.

Child's name: _____ **Parent's name(s):** _____

School: _____

Our/my goals for the school year are as follows:

I will get started by:

1.

2.

3.

I will need help from:

I will need these materials, supplies, books, etc.:

I will know I have accomplished my/our goals when:

Date:_____ _____
 Child's signature

 Parent's signature

Figure 9.2
Goal Statement Form

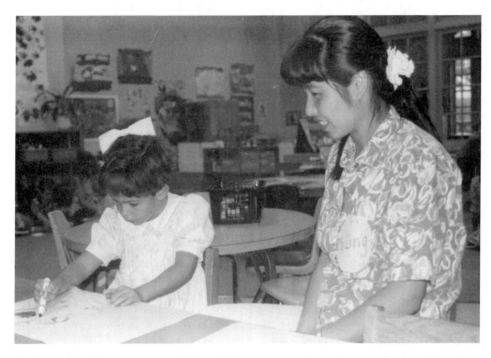

Students need time to prepare their portfolios for the collaborative parent–student–teacher conference.

Collaborative Assessment

In Chapter 8, we discussed collaborating with students to provide authentic assessment and curriculum planning. Collaborating with parents is an essential part of this process. Parents are a rich source of information about their children, and they provide insights not obtainable through other sources or strategies. Early in the school year, an initial collaborative conference should be scheduled to discuss the baseline information previously described, and to talk about the authentic assessment strategies that will be used during the school year. It will be necessary to convey to parents the importance of their role in collaborative assessment and the opportunities they will have to influence the types of experiences and learnings that their child will have and to participate in them throughout the school year. Parent participation in this process can answer questions before they arise and helps to preclude any anxieties, misconceptions, or misinterpretations that might arise in parents regarding how their children will be taught and how they will be graded and tested. As partners in planning, reviewing, and assessing student progress, both teachers and parents develop a healthy and positive regard for the individual learner's emerging development and capabilities.

It will take time and perhaps training to assist parents in becoming effective collaborators in the assessment process. They should not be expected to know

how to assess and monitor their child's progress along authentic assessment lines; nor should they be expected to know principles of child growth and development. Getting parents involved in the process early in the year; providing them with lots of opportunities to observe, experience, read about, and understand the process; and sharing student products and discussing processes and performances with them on an ongoing basis will help parents to grow in their understanding of and support for a method of assessment quite different from the traditional report cards and standardized tests which most likely characterized their own schooling experiences.

Documenting Child Development and Learning at Home

There are a number of ways that parents can begin documenting their child's development and learning in out-of-school contexts. They can learn to keep dated samples of their child's at-home products, constructions, writings, drawings, and so on. They can keep photo collections and albums depicting their child's growth and development, activities, and friends. Parents can be provided with anecdotal record forms or observation guides and checklists and can keep logs or diaries themselves in spiral notebooks to be brought to collaborative conferences and shared. They can make lists of shared reading, writing, and math activities: favorite books read at bedtime; books recently checked out from the library; books or stories read or told by the parent; notes, letters, and lists shared with one another; mathematics-related experiences such as counting out spoons and forks for the family picnic; measuring the distance from the back of the house or apartment to the front door; calculating the time it takes to drive to school at 20 miles an hour; planning a savings account to buy Mom or Dad a birthday present; and an infinite number of other activities occurring in the regular course of the day and created for shared learning experiences. The richness of these activities and the enthusiasm they generate in parents and children enhances and informs the overall authentic assessment process, not to mention the parent–child relationship.

Contemporary studies of parent–child communications have focused attention on the conditions and contexts in which children and parents communicate and on developing strategies for enhancing this communication. Bradbard, Endsley, and Mize (1992) developed a checklist to examine and describe if, when, where, and to what extent parent–child conversations about preschool or day care occur and the topics and triggers of these conversations. Their findings suggest the role of the teacher in enhancing these communications as we learn more about them. For instance, from their study of well-educated parents whose children attended high-quality preschools, they found that parents communicated with their children about preschool nearly every weekday, but significantly less often on weekends. Their topics centered more often on people at school or their particular child. They talked about schoolmates and teachers nearly every day, and, similarly, they talked daily about programmatic themes such as outside play, learning activities, and special events. They talked very little about health-related topics

such as toileting and napping. Children communicated most frequently by describing what they did at school, asking questions, or performing (singing, dancing, and role playing, as opposed to emotional expressions, imitating, imaginary talking, or complaining).

Daily routines triggered parent–child conversations, as did parental classroom observations. Often conversations were motivated by conversations with the teacher, information in school newsletters, and subtle signals such as dirty hands or wet clothing. Mothers started conversations most frequently, although fathers and other children were also frequent initiators. Siblings and grandparents only sometimes (i.e., once a week or less) initiated conversations.

Studies such as these can help teachers and researchers begin to think about intervention strategies for low-communicating parents and children, helping them to learn to communicate more effectively. For instance, it is helpful to know that parent observations in the classroom enhance communications between the child and parent; it stands to reason that these observations provide topics about which parents and child can become engaged. Intervention strategies can be developed to help parents use the most likely times when they and their children can communicate and enjoy quality interactions with one another, (i.e., en route to and from school, at mealtimes, just before bedtime, and those parent–child moments that simply occur spontaneously from time to time throughout the day). Bradbard, Endsley, and Mize (1992) suggest that teachers can help parents use topics of interest with their children and help them understand that young children communicate through describing, asking questions, and performing. Parents can be guided toward framing conversations that elicit these ways of communicating. The parent may begin the conversation with, "Tell me about the science project you and Jeremy started today," and proceed to talk with the child in a positive, nonjudgmental conversation. There is much to be learned in this area, but we do know that if parent–child communications can be improved, they can enhance the parents' understanding of their children and how they are responding to their classroom experiences. In turn, the parent–teacher communications can be richly enhanced as the parent's interest, knowledge and insights become more focused. Collaborations among parents, children, and teachers is also a beneficiary.

The Collaborative Conference

The collaborative conference is one in which parent(s), teacher, and student examine and reflect on summary reports and portfolio contents together. They examine the goals they had established earlier, look at criteria in each of the developmental domains for determining progress, and explore areas of strength, areas needing more time and practice or enrichment, and directions for new learnings.

In planning conferences, teachers must be sensitive to demands on parents' time and resources. Schools may wish to include conference schedules in the master calendar so parents can begin to plan in advance to schedule for them. When the school has established three scheduled summary conferences with parents

(fall, mid-year, and spring), parents know what to expect during the year and can attempt to plan their work, baby-sitting, and transportation needs around these dates. For some parents, advance planning may not be that easy, so it is important that schedules be flexible in date, day of week, and time of day. There may be a need to plan before-school or Saturday conferences. There may be a need for the school to assist with transportation, perhaps by arranging car pools. Baby-sitting arrangements may need to be coordinated through the school PTA or other group to assist parents in keeping their conference appointments. Invitations (or reminder notes) to a collaborative conference should be warm and friendly, upbeat, and inviting. They should be written in language the parents understand. Sometimes other school personnel can be enlisted to translate the invitation into the language of the home. By the same token, where low literacy skills exist in the home, written communications must incorporate familiar words, i.e., "Do you need a ride?" vs. "Please request transportation." (Bohler, Eichenlaub, Litteken, & Wallis, 1996) Formal letters can be off-putting and for some, confusing or threatening. The invitation should tell parents what the conference will entail and specifically how they might prepare for it. Facilitating parental participation is a major factor in the success of collaboration and child-centered assessments.

Before the conference, the teacher should send a copy of the summary report home so that parents will have a few days to read over it, think about its contents, discuss it with their child, anticipate questions, and be prepared before the conference occurs. It is unfair to surprise parents with information about their child's schooling and then expect them to respond in helpful and cooperative ways. Again, planning and communication are the key to the success of collaboration with parents.

The collaborative conference should not be rushed, neither should it drag on and detain a parent unnecessarily. Thirty to forty-five minutes should suffice; however, some may take a little longer. If the teacher has prepared an agenda that lists the topics to cover and in what order to discuss them; includes time for the child to review and describe portfolio contents; and allows time for the parents to express observations, pleasure, and concerns and to pose questions that will arise, the meeting can flow with some sense of focus and purpose. The agenda, however, should serve to focus the conference and should not be so binding as to interfere with meaningful and in-depth dialogue among teacher, parents, and student which naturally issues forth from the examination of the summary report, the portfolio contents, and the child's comments and contributions.

Teachers will want to employ a variety of strategies for collaboratively assessing the child's performance, products, processes, and portfolio. The components of the collaborative conference portfolio are illustrated in Figure 9.3. Teachers may wish to include graphic material such as that illustrated in Figure 9.4 to help parents visualize the progress their child is making. If standardized tests have been used, these instruments and how they relate to other assessments must be explained.

When reviewing the products and contents of the portfolio, the teacher may pose questions to help the child and parent focus and reflect on the material. For instance, the following questions might be helpful:

Figure 9.3
Portfolio Conference Components

Reading, Writing, Math, Science, Journal Samples

Teacher's Notes & Comments

Self Assessment & Goals

Criterion Referenced Scores

Collaborative Conference Notes & Goal Setting Forms

Appropriate Norm-Referenced Scores & Test Data

Portfolio Components

Which item in the portfolio tells you the most about your child's ability in art? Math? Writing? Reading?

What strengths do you see in your child's school work?

Have you observed similar performance (similar process, similar products) at home? Tell me about them.

What growth and progress do you see in these materials?

How is your child feeling about her or his work at school?

What areas do you think we should explore further?

Do you have concerns about any of the materials we have examined?

What suggestions do you have for helping your child to continue to improve?

Are additional resources needed?

How can I help?

How would you like to be involved in (the next project, the field trip, planning our open house, setting up the parent center, and so on)?

The teacher might address questions such as the following to the child:

Did you enjoy having your parent(s) share your portfolio with you?

What do you think your parent(s) learned about your work in school?

What did you learn about your own knowledge or skills?

Where (when, how) do you think you do your best work?

How do you feel about your work in math? In reading? In art? In physical education?

Is there anything else you want to share with us about your portfolio or how you feel about school?

What else do you want to learn about? Learn to do?

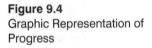

Figure 9.4
Graphic Representation of
Progress

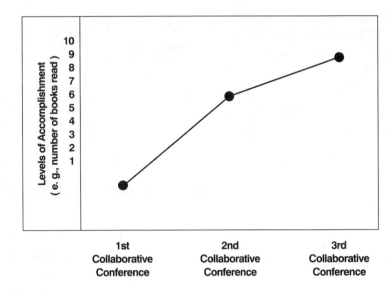

How can your parent(s) help?
How can the teacher help?

To each of the collaborators, these questions may be helpful:

What did we all learn from this process?
Where do we want to go from here?
Are there subjects, skills, feelings, dispositions, and so on that we should revisit
 and make plans for their improvement?
Are additional assessments necessary?
Can we now set some additional goals for learning?
What curricular or pedagogical modifications need to take place now?

A summary report of the collaborative conference should be completed together
and placed in the student's archival portfolio. This report can include the Goals
Statement Form (see Figure 9.2) along with other forms that were used and a narra-
tive account. This summary will serve as a starting point for the next collaborative
conference to assess what progress was made and if goals are being achieved.

The collaborative conference is designed to identify student strengths, to cele-
brate learning. Throughout the conference, the emphasis must be on evidence of
progress, not on deficits or mistakes. Any weaknesses or mistakes that show up
should be used to illustrate how learning emerges—through some trial and error;
through making mistakes and discovering ways to correct them; through taking
risks; and through exploration, inquiry, and use of newfound skills and knowl-
edge. From this context, the students can come to view themselves as learners,
capable of finding out, and to view supportive adults as resources and advocates.

When setting goals, it seems appropriate to return to Gardner's theory of multiple intelligences. Quite clearly, not all children are mathematicians or linguistically skilled, the two intellegences most frequently emphasized in traditional curriculums and on standardized tests. In a new era of curriculums and assessment, it is imperative that we reconstruct our goals for children around their strengths and learning styles as revealed to us through these more comprehensive and holistic assessments. Summarizing the benefits of collaborative goal setting around varied intelligences, Ellison (1992) advises:

> Individual goal setting helps us honor student differences and plan for the wide range of diverse needs. And by using Gardner's multiple intelligences, all areas of growth become the domain for school learning and all kinds of excellence are celebrated. (p. 72)

This chapter has attempted to convey the profound importance of establishing partnerships with parents. As educators become skilled in the art of collaboration with parents and with parents and children, assessment and curriculum planning become more focused on strengths of individuals and, ultimately, more humane and constructive. Meaningful communications and supportive relationships among students, parents, and teachers are the foundation upon which authentic curriculums and assessments are built and antecede excellence and equity in education.

The following poem perhaps best summarizes the effect of parent–teacher collaboration:

Unity

I dreamed I stood in a studio
And watched two sculptors there.
The clay they used was a young child's mind,
And they fashioned it with care.
One was a teacher; the tools he used
Were books, and music, and art;
One, a parent with a guiding hand,
And a gentle, loving heart.
Day after day the teacher toiled,
With touch that deft and sure
While the parents labored by his side
And polished and smoothed it o'er.
And when at last their task was done,
They were proud of what they had wrought.
And each agreed he would have failed
If he had worked alone,
For behind the parent stood the school
And behind the teacher, the home.

Author Unknown

REVIEW STRATEGIES AND ACTIVITIES

1. Interview a number of parents (10 to 15 or more) whose young children are in school. Ask each the following questions, then share and compare your findings with your colleagues. From this information, develop a plan for establishing a collaborative model for home–school interactions.

 a. What elements or features of your child's school (or classroom) solicit, encourage, or motivate you as a parent to take an active role in your child's schooling experience?

 b. What elements or features, if any, tend to impede your participation?

 c. What would you recommend to make your child's school more "user friendly" for parents?

2. Accompany a skilled teacher on a home visit as long as it is appropriate and you are welcome in the home. Discuss the goals and purposes of the visit in advance. Observe the teacher's techniques and strategies for ensuring a successful visit. Observe the parents' role and comfort level. Reflect on the success of the visit and discuss your observations with the teacher. Given the different parent-school interaction patterns described by Lareau (1989), discuss the teacher's professional responsibility to be sensitive, flexible, and willing to adapt school procedures and curriculums to individual differences and needs of parents.

3. List and analyze the various resources available to parents in your school and community. Do parents use these resources? How are these resources made known to parents? Do these resources enhance the educative process for their children? Are there other resources needed by parents that the school or classroom might provide to enhance the collaborative process between home and school?

4. Prepare a welcome booklet for parents that explains the collaborative assessment process; defines the roles of children, teachers, and parents; and creates a calendar for collaborative assessment opportunities.

5. For a parent visit or school open house, create a scavenger hunt in which parents explore the school or classroom for evidence of developmentally appropriate practices and authentic assessment strategies. Use their finds to celebrate together the development and learning that can take place in such a setting.

10 Advocating for Quality Authentic Assessment Practices

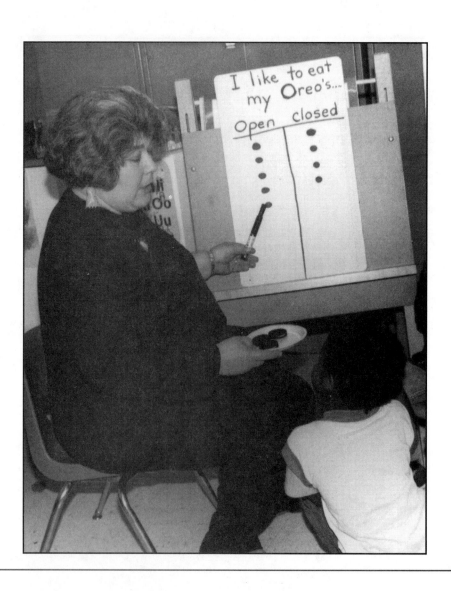

*A capacity for autonomous learning and a thirst for unending educa-
tion are more important than accurate recall or simplistic application of
the particular knowledge taught. The implications for assessment are
fundamental: We need to be assessing primarily for mature habits of
mind and a thoughtful and effective use of knowledge.*

Wiggins (1993, p. 34)

*To help promote greater development of the talents of all our people,
alternative forms of assessment must be developed and more critically
judged and used, so that testing and assessment open gates of opportu-
nity rather than close them off.*

*As the global economy becomes more competitive and interdepen-
dent, we will more than ever need the talents of all our people. Our
challenge will be to create social institutions that value and benefit
from racial, cultural, and linguistic diversity, while at the same time
guaranteeing opportunities for all.*

National Commission on Testing and Public Policy (1990)

*Our profession pays lip service to educating the whole student, but
school activities tend to focus on the development of measurable, ratio-
nal qualities. We measure students' spelling accuracy, not their emo-
tional well-being. And when the budget gets tight, we cut the difficult-
to-measure curricular areas, such as the arts, that tilt toward emotion.*

Sylwester (1995, p. 72)

After reading and studying this chapter you will demonstrate
comprehension by being able to:

- articulate concerns and controversies surrounding testing of
 young children.
- discuss the need for alternative forms of assessment.
- use available professional resources to become personally
 informed on issues surrounding assessment of young children.
- use available professional resources to inform parents, col-
 leagues, school board members, community leaders, and
 other policymakers about the importance of sound curricu-
 lums and assessment for young children.

We began this text with a projection of the types of knowledge and skills the successful citizen of the twenty-first century will need: skills in communication, cooperation, negotiation, problem solving, and critical thinking, and a global perspective. The epigraphs at the beginning of this chapter call these characteristics back to mind and motivate us to promote better, more meaningful strategies for educating and assessing today's children.

THE NEED FOR ADVOCACY

It is both timely and appropriate—indeed, some believe it is a "moral imperative" (Hastings, 1992)—to move away from testing, labeling, grouping, and tracking systems that sort and classify human beings, often relegating to them labels they can never shed. Mounting concerns over the uses and abuses of large-scale testing in schools are compelling. Concerns about widespread use of standardized tests center on the following themes:

1. narrowed curriculums that focus on smaller and smaller bits of knowledge and isolated academic skills
2. lowered expectations for students as test scores are used to group or classify individuals into sometimes belittling categories
3. escalating academic demands in preschools, kindergarten, and first grade as preparation—or "readiness"—for academically oriented, developmentally *in*appropriate curriculums become widespread in early education
4. decision making based on test score results that affect all levels, from placement and retention of young learners to allocation of resources to school districts, causing "high stakes" value to be placed on tests and test results
5. failure of widespread testing to show concomitant widespread improvement in student learning and performance
6. inability to predict how well students will do later
7. misuses of tests designed for one purpose but used for another (e.g., a standardized test designed to ascertain student achievement scores used to rank teachers, school, or school districts)
8. inappropriateness of use with young children third grade and below because development is seen as emergent and uneven in these early years
9. failure to take into account the full range of cultural and social backgrounds of students who take the tests, resulting in racial, cultural, and social biases
10. misappropriation of limited resources required to develop, purchase, implement, score, and publish the results of millions of tests yearly
11. failure to provide timely information about individual students in order to inform curriculum and pedagogical practices

12. obtuse scoring information (e.g., stanine, percentile, grade equivalent) that is confusing to parents and to students

Because many practitioners in early childhood education share these concerns, the need exists to identify the most meaningful and useful ways to assess student progress and outcomes. In schools where standardized tests are imposed on young children (ages 8 and younger) it is imperative that they are wisely selected (see criteria in Chapter 6) and used only for the purposes for which they were written. As with Keith's teacher (Figure 10.1), school testing mandates need not undermine personal professional perspectives on student performance and developmental needs. Early childhood educators often have to find an ethical compromise between conflicting school policies and developmentally appropriate practices, while becoming active in efforts to inform and bring about constructive change.

We can become advocates for change, assuming a proactive role that informs others that alternatives do exist and that such alternatives hold promise. While the research on the long-term effects of alternative forms of assessment is limited,

Professional early childhood educators often have to find an ethical compromise between conflicting school policies and developmentally appropriate practices.

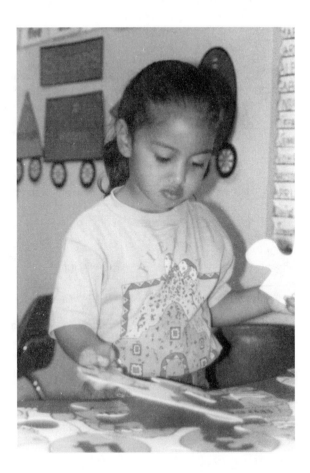

The school building was getting new air conditioning units that were being installed on the roof above the kindergarten classroom. It was late spring and the week during which readiness testing for first-grade placement was taking place. As a safety precaution, the school principal arranged for the children to be given the test in the school cafeteria. It was 9:30 A.M, and both cleanup from breakfast and preparations for lunch for the 500+ students in the school were underway. The kitchen was teaming with food service personnel greeting delivery persons, visiting with one another, and talking loudly over the clang and bang of large pots and pans and the shrill of the giant bread dough mixer. Teachers on break wandered in and out to pour themselves a cup of tea or sample a warm cookie fresh from the oven and chatted loudly, if briefly, with cafeteria friends.

Twenty-nine kindergartners seated precariously in chairs too large for them, at tables too tall for them were straining to maintain their physical balance, handle test booklets and pencils, and hear and follow the teacher's test directions. After several pages of the test, Keith, one of the brightest in my class, tensed, his body rigid to the point of shaking, his face buried in his fists that were attempting to rub away the tears he didn't want others to see. I drew near, as unobtrusively as possible. Without looking up, Keith sobbed, "I can't do this." I looked around at all the little intense faces, eager to please and show what they could do, but unsure and uneasy: signs of stress emerging throughout the class.

That marked the beginning of my distaste for mass standardized testing of young children. Inquiring of my colleagues and school leaders, I asked a number of questions:

Q: Given the construction work taking place on the roof of our building and outside our windows, did we have to administer the test on this particular day?

A: Yes. The district has so decreed and all kindergartens in the district will be testing on this day and for the next two days.

Q: Was there no other place in the building to give this test?

A: No. All other classrooms are in use; the library is in use by another grade (not for testing, by the way), and the auditorium would be less suitable than the cafeteria.

Q: Was it necessary to administer this test to Keith and others like him whose "readiness" for first grade was already apparent to me?

A: Yes. All kindergarten children must be so tested.

Q: Given the unbearable distractions — physical/motor, visual, auditory, and, yes, olfactory — how representative or valid can these test scores actually be?

A: It doesn't seem to matter, since children in this school usually do well on this particular test anyway.

Q: Who selected this test?

A: Not sure; it is the one we have used for years.

The answers to my questions left me perplexed and wanting. My concern for Keith and others who were brought to tears (and, sometimes, nausea) by an insensitive bureaucracy surrounding standardized testing in our schools was, and continues to be, profound. I ask myself often: Why do we do this? If I must, how can I make the experience as benign as possible? On a personal/professional level, of what value is professional training and a teacher's intimate knowledge of the capabilities of children in their classroom? Is there anything I, as a professional trained in early childhood education, can do about policies that, in my view, are not in the best interests of young children?

Figure 10.1
A Teacher's Story

the initial studies favor portfolio assessments (Herman & Winters, 1994). However, the alternative assessment field awaits more data that is based on more finely tuned assessments than now exists. We want to be able to assure quality and equity in the instruments and procedures used, but we do not want to lose the learner-centered focus that builds on "what is" rather than what "should have been", and systematically reaches for "what might be." While psychometricians are uncomfortable with data that is difficult to quantify, classroom teachers are faced with individuals, each representing varied and unique sets of characteristics and background experiences. Because human variability is a reality lived out in day-to-day interactions with children, whole-class cookie-cutter assessments are neither practical, useful, nor economical. Assessments that bypass student individuality assure that someone will always fail.

Yes, there is much yet to be learned, and a definition of "state-of-the-art best practice" in authentic assessment has yet to evolve. The state of our knowledge is cutting edge, however, and many scholars and leading professional organizations are engaged in research on this most timely alternative. Research on alternative and more authentic forms of assessment will need to address the following questions (Herman & Winters, 1994):

> To what extent can users of assessment results be assured that the results provide accurate information for the decisions that are made?
>
> How can we demonstrate that results of portfolio assessments are reliable, consistent, and meaningful estimates of what students know and are able to do?

WHAT TEACHERS CAN DO TO PROMOTE QUALITY, AUTHENTIC ASSESSMENTS AND CURRICULUMS

Helping colleagues, parents, and policymakers to accept new paradigms is often a challenge for professional educators. It will always be our responsibility to interpret new knowledge and new perspectives to others. Following are some suggestions:

1. Become knowledgeable and articulate about authentic assessment practices.
2. Use a variety of resources to expand and balance your perspectives on topics and concerns associated with authentic assessment practices.
3. Share information with your colleagues and school administrators through the following:
 - ◆ informed discussion
 - ◆ sharing of professional and scholarly organization position statements and timely journal articles
 - ◆ invitations to attend meetings or join professional groups concerned with this issue

4. Share information with parents through parent organizations, by:
 ◆ inviting speakers who are knowledgeable and enthusiastic about the topic
 ◆ devoting short segments of the school newsletter to articles or excerpts of books or articles about this topic
 ◆ making available professional literature of interest to parents on the topic
 ◆ demonstrating through classroom practice the positive effects of authentic assessments and curriculums
 ◆ providing parents with audiotapes or videotapes of their children engaged in developmentally appropriate activities
5. Provide similar information for members of your local and state school boards.
6. Compose a letter to the editor of your local newspaper supporting developmentally appropriate practices with young children including alternative forms of assessment.
7. Attend local and state school board meetings. Prepare and present statements supporting developmentally appropriate practices and authentic assessments.
8. Get to know your early childhood specialists in the state department of education and support their efforts to communicate appropriate practices.
9. Join local, state, regional, and national professional organizations in early childhood education.
10. Organize a group of interested colleagues and parents to study ways authentic assessment can be implemented in your school or district and prepare a position statement to share with administrators and other policymakers.

Teachers and parents can do much to help others understand and support authentic assessment and developmentally appropriate practices. Sometimes effecting change seems painfully slow, but it may be helpful to keep in mind the following statement:

> We often forget in the quick-fix mentality of today that the most important goals of education are to contribute to children's intellectual, social, and moral development in the long run. The story of the tortoise and the hare has never had much appeal in America, but we must remember that the tortoise won the race. As Eleanor Duckworth (1987) has wisely suggested, the important thing is not how fast we go but, how far we go. (Murphy & Baker, 1990, p. 109)

SELECTED RESOURCES ON DEVELOPMENTALLY APPROPRIATE CURRICULUMS AND ASSESSMENT

The following resources are divided into topical categories to assist the reader in locating specific references or materials. The categories are Child Development; Curriculum; Diversity; Home/School Collaboration; Portfolios; and Professionalism and Advocacy

Child Development

Allen, K. E. (1999). *Developmental Profiles: Prebirth through eight* (3rd ed.). Albany, NY: Delmar.

Beaty, J. J. (1998). *Observing development of the young child* (5th ed.). Upper Saddle River, NJ: Merrill/Prentice Hall.

Black, J., & Puckett, M. (in press). *The young child: Development from prebirth through age eight* (3rd ed.). Upper Saddle River, NJ: Merrill/Prentice Hall.

Bodrova, E., & Leong, D. J. (1996). *Tools of the mind: The Vygotskian Approach to early childhood education.* Upper Saddle River, NJ: Merrill/Prentice Hall.

Caine, R. N., & Caine, G. (1997). *Education on the edge of possibility.* Alexandria, VA: Association for Supervision and Curriculum Development.

Charlesworth, R. (1996). *Understanding child development* (4th ed.). Albany, NY: Delmar.

Gardner, H. (1993). *Multiple intelligences: The theory in practice: A reader.* New York: Basic Books.

Hyson, M. C. (1994). *The emotional development of young children: Building an emotion-centered curriculum.* New York: Teachers College Press.

Shore, R. (1997). *Rethinking the brain: New insights into early development.* New York: Families and Work Institute.

Sylwester, R. (1995). *A celebration of neurons: An educator's guide to the human brain.* Alexandria, VA: Association for Supervision and Curriculum Development.

Talay-Ongan, A (1998). *Typical and atypical development in early childhood.* New York: Teachers College Press.

Taylor, J. B. (Ed.). (1996). Piagetian perspectives on understanding children's understanding. (Annual Theme Issue). *Journal of Childhood Education, 72*(5).

Curriculum: The Arts

de la Roche, E. (1996). Snowflakes: Developing meaningful art experiences for young children. *Young Children, 51*(2), 82–83.

Gallas, K. (1994). *The languages of learning: How children talk, write, dance, draw, and sing their understanding of the world.* New York: Teachers College Press.

Greer, W. D. (1997). *Art as a basic.* Bloomington, IN: Phi Delta Kappa, International.

Jalongo, M. R., & Stamp, L. S. (1997). *The arts in children's lives.* Needham Heights, MA: Allyn & Bacon.

Smith, N. R., & the Drawing Study Group (1998). *Observation drawing with children.* New York: Teachers College Press.

Curriculum: Cooperative Learning

Developmental Studies Center (1996). *Ways we want our class to be: Class meetings that build commitment to kindness and learning.* Oakland, CA: Author.

DeVries, R., & Zan, B. S. (1994). *Moral classrooms, moral children: Creating a constructivist atmosphere in early education.* New York: Teachers College Press.

Slavin, R. E. (1991). *Student team learning: A practical guide to cooperative learning* (3rd ed.). Washington, DC: National Education Association.

Curriculum: Language Arts and Literacy

Adams, M. J., Foorman, B. R., Lindberg, I., & Beeler, T. D. (1998). *Phonemic awareness, in young children: A classroom curriculum.* Baltimore MD: Brookes Publishing Co.

Bunce, B. H. (1996). *Building a language-focused curriculum for the preschool classroom, Volume II: A planning guide.* Baltimore, MD: Brookes.

Calkins, L., Montgomery, K., & Santman, D. (1998). *A teacher's guide to standardized reading tests.* Westport, CT: Heinemann.

Dyson, A. H. (1997). *Writing superheroes: Contemporary childhood popular culture, and classroom literacy.* New York: Teachers College Press.

Hall, N., & Robinson, A. (1995). *Exploring writing and play in the early years.* Bristol, PA: David Fulton Publishers.

Morrow, L. M., & Smith, J. K. (Eds.). (1990). *Assessment for instruction in early literacy.* Upper Saddle River, NJ: Merrill/Prentice Hall.

Rice, M. L., & Wilcox, K. (1996). *Building a language-focused curriculum for the preschool classroom, Volume I: A foundation for lifelong communication*. Baltimore, MD: Brookes.

Strickland, D. S. (1998). *Teaching phonics today: A primer for educators*. Newark, DE: International Reading Association.

Texas Association for the Education of Young Children (1997). *Early childhood literacy development: A position statement*. Puckett, M. (Ed.). Austin, TX: Author.

Curriculum: Mathematics

Adams, T. L. (1998). Alternative assessment in elementary school mathematics. *Childhood Education 74(4)*, 220–224.

Association for Childhood Education International (1996). *Math/Science: Readings from Childhood Education*. Olney, MD: Author.

Charlesworth, R., & Lind, K. (1999). *Math and science for young children* (3rd ed.). Albany, NY: Delmar.

Kamii, C., with Livingston, S. J. (1993). *Young children continue to reinvent arithmetic—3rd Grade*. New York: Teachers College Press.

Kamii, C. (1989). *Young children continue to invent arithmetic: 2nd grade*. New York: Teachers College Press.

Kamii, C. (1983). *Young children reinvent arithmetic*. New York: Teachers College Press.

Curriculum: Problem Solving

Brooks, J. G., & Brooks, M. G. (1993). *In search of understanding: The case for the constructivist classroom*. Alexandria, VA: Association for Supervision and Curriculum Development.

Waite–Stupiansky, S. (1997). *Building understanding together: A constructivist approach to early childhood education*. Albany, NY: Delmar Publishers.

Torp, L., & Sage, S. (1998). *Problems as possibilities: Problem-based learning for K–12 education*. Alexandria, VA: Association for Supervision and Curriculum Development

Curriculum: Physical, Health and Safety, Education

Beneli, C., & Yongue, B. (1995). Supporting young children's motor skill development. *Childhood Education, 71(4)*, 217–220.

Gallahue, D., & Ozmun, J. C. (1995). *Understanding motor development: Infants, children, adolescents, adults*. Dubuque, IA: Brown & Benchmark.

Curriculum: Science

Gallas, K. (1995). *Talking their way into science*. New York: Teachers College Press.

Rivkin, H. (1996). *Science experiences for the early childhood years* (6th ed.). Upper Saddle River, NJ: Merrill/Prentice Hall.

Curriculum: Social Studies

Seefeldt, C. (1997). *Social studies for the preschool-primary child* (5th ed.). Upper Saddle River, N:: Merrill/Prentice Hall.

Curriculum: Technology

Dede, C. (1998). *Learning with technology*. Alexandria, VA: Association for Supervision and Curriculum Development.

Haughland, S. W., & Wright, J. L. (1997). *Young children and technology: A world of discovery*. Des Moines, IA: Allyn & Bacon.

National Association for the Education of Young Children (1996). NAEYC position statement: Technology and young children—ages three through eight. *Young Children 51(6)*, 11–16.

Curriculum: General and Assessment

Armstrong, T. (1998). *Awakening genius in the classroom*. Alexandria, VA: Association for Supervision and Curriculum Development.

Bredekamp, S., & Rosegrant, T. (Eds.). (1992). *Reaching potentials: Appropriate curriculums and*

assessment for young children (Vol. 1). Washington, DC: NAEYC.

Bredekamp, S., & Rosegrant, T. (Eds.). (1995). *Reaching potentials*: *Transforming early childhood curriculum and assessment* (Vol. 2). Washington, DC: National Association for the Education of Young Children.

Powell, D. R. (1995). *Enabling young children to succeed in school*. Washington, DC: American Educational Research Association.

Puckett, M. B., & Diffily, D. (1998). *Teaching young children: An introduction to the early childhood profession*. Fort Worth, TX: Harcourt Brace

Tomlinson, C. A. (1995). *How to differentiate instruction in mixed ability classrooms*. Alexandria, VA: Association for Supervision and Curriculum Development.

Curriculum: Inclusion Practices

Accardo, P., & Whitman, B. (1996). *Dictionary of developmental disabilities terminology*. Baltimore, MD: Paul Brookes Publishing.

Alper, S., Schloss, P. J., Etscheidt, S. K., & Macfarlanem, C. A. (1995). *Inclusion: Are we abandoning or helping students?*. Thousand Oaks, CA: Corwin Press, Inc.

Brown W. H., & Conroy, M. A. (1997). *Including and supporting preschool children with developmental delays in early childhood classroom*. Little Rock, AR: Southern Early Childhood Association.

McCormick, L., & Feeney, S. (1995). Modifying and expanding activities for children with disabilities. *Young Children, 50*(4), 10–17.

Tertell, E., Klein, S., & Jewett, J. (Eds.). (1998). *When teachers reflect: Journeys toward effective inclusive practices*. Washington, DC: National Association for the Education of Young Children.

Wodrich, D. L. (1997). *Children's psychological testing: A guide for nonpsychologists* (3rd ed.). Baltimore, MD: Brookes.

Curriculum: Integrated

Association for Childhood Education International. (1996). *Integrated Curriculum: Readings from Childhood Education*. Olney, MD: Author.

Bredekamp, S., & Copple, S. (Eds.). (1997). *Developmentally appropriate practice in early childhood programs serving children birth through age eight* (Rev. ed.). Washington, DC: National Association for the Education of Young Children.

Campbell, B. (1991). Multiple intelligences in the classroom. *Cooperative Learning, 12*(1), 24–25.

Hart, C. H., Burts, D. C., & Charlesworth, R. (1997). *Integrated curriculum and developmentally appropriate practice birth to age eight*. Albany: State University of New York.

Jones, E., & Nimmo, J. (1994). *The Emergent Curriculum*. Washington, DC: National Association for the Education of Young Children.

Katz, L., & Chard, S. (1989). *Engaging children's minds: The project approach*. Norwood, NJ: Ablex.

Katz, S. A. & Thomas, J. A. (1996). *Teaching creativity by working the word: Language music, and movement*. Norwood, NJ: Ablex.

Wishon, P. M., & Crabtree, K. (1998). *Curriculum for the primary years: An integrative approach*. Upper Saddle River, NJ: Merrill/Prentice Hall.

Wood, E., & Attfield, J. (1996). *Play, learning, and the early childhood curriculum*. Bristol, PA: Paul Chapman Publishing, Ltd.

Cultural Diversity

Delpit, L. D. (1995). *Other people's children: Cultural conflict in the classroom*. New York: The New Press.

Derman-Sparks, L., & Phillips, C. B. (1997). *Teaching/learning anti-racism*. New York: Teachers College Press.

Gallas, K. (1998). *Sometimes I can be anything: Power, gender, and identity in a primary classroom*. New York: Teachers College Press.

Gregory, E. (1997). *One child, many worlds: Early learning in multicultural communities*. New York: Teachers College Press.

Kuball, Y. E. (1995). Goodbye dittos: A journey from skill-based teaching to developmentally appropriate language education in a bilingual kindergarten. *Young Children, 50*(2), 6–14.

Lynch, E. W., & Hanson, M. J. (1998). *Developing cross-cultural competence: A guide for working with*

children and their families (2nd ed.). Baltimore, MD: Brookes.

Maeroff, G. I. (1998). *Altered destinies: Making life better for school children in need.* New York: St. Martin's Press.

Meir, D. (1997). *Learning in small moments: Life in an urban classroom.* New York: Teachers College Press.

National Association for the Education of Young Children. (1996). NAEYC Position Statement: Responding to linguistic and cultural diversity—Recommendations for effective early childhood education. *Young Children, 51*(2), 4–16.

Nieto, W. (1996). *Affirming diversity: The sociopolitical context of multicultural education.* New York: Longman.

Ramsey, P. B. (1998). *Teaching and learning in a diverse world*: Multicultural *education for young children.* New York: Teachers College Press.

Rangel, R., & Bansberg, B. (1997). *Snapshot assessment system for migrant, language minority, and mobile students Grades 1–3.* Alexandria, VA: Association for Supervision And Curriculum Development/McREL.

Stefanakis, E. H. (1998). *Whose judgment counts?: Assessing bilingual children K–3.* Westport, CT: Heinemann.

Tabors, P. O. (1997). *One child, two languages: A guide for preschool educators of children learning English as a second language.* Baltimore, MD: Brookes.

Home/School Collaboration

Berger, E. H. (1995). *Parents as partners in education: Families and schools* working together (4th ed.). Upper Saddle River, NJ: Merrill/Prentice Hall.

Davis, B. M. (1995). *How to involve parents in a multicultural school.* Alexandria, VA: Association for Supervision and Curriculum Development.

Diffily, D., & Morrison, K. (Eds.). (1996). *Family-friendly communication for early childhood programs.* Washington, DC: National Association for the Education of Young Children.

Harding, N. (1996). Family Journals: The bridge from school to home and back again. *Young Children, 51*(2), 27–30.

Portfolios

Helm, J. H., Beneke, S., & Steinheimer, K. (1998). *Windows on learning: Documenting young children's work.* New York: Teachers College Press.

Leonard, A. M. (1997). *I spy something: A practical guide to classroom observations of young children.* Little Rock, AR: Southern Early Childhood Association.

Martin-Kniep, G., Cunningham, D., Feige, D. M., & teachers from the Hudson Valley Portfolio Assessment Project (1998). *Why am I doing this?: Purposeful teaching through portfolio assessment.* Westport, CT: Heinemann.

McDonald, S. (1996). *The portfolio and its use: A road map for assessment.* Little Rock: Southern Early Childhood Association.

Meisels, S. J., & Fenichel, E. (Eds.). (1996). *New visions for the developmental assessment of infants and young children.* Washington, DC: Zero to Three.

Meisels, S. J., Jablon, J. R., Marsden, D. B., Dichtelmiller, M. L., Dorfman, A. G., Steele, D. M. (1994). *The Work Sampling System* (3rd ed.). Ann Arbor, MI: Rebus Planning Associates, Inc.

Stone, S. J. (n.d.). *ACEI Speaks: Understanding Portfolio Assessment (an alternative to traditional testing), A Guide for Parents.* Olney, MD: Association for Childhood Education International.

Taggart, G. L., Phifer, S. J., Nixon, J. A. Wood, M. (1998). *Rubrics: A handbook for construction and use.* Lancaster, PA: Technomic Publishing Co., Inc.

Electronic Portfolios

Classroom Manager
CTB Macmillan/McGraw-Hill
Monterey, CA

Electronic Portfolio
Learning Quest
Corvallis, OR

Electronic Portfolio
Scholastic
Jefferson, MO

On Track
Addison-Wesley Longman
Reading, MA

Professionalism and Advocacy

Bredekamp, S. (1996). What do early childhood professionals need to know and be able to do? *Young Children, 50*(2), 67–69.

Clarridge, P. B., & Whitaker, E. M. (1997). *Rolling the elephant over: How to effect large-scale change in the reporting process.* Westport CT: Heinemann.

Cummings, C. (1995). *Creating good schools for young children: Right from the start: A study of eleven developmentally appropriate primary school programs.* Alexandria, VA: National Association of State Boards of Education.

National Education Goals Panel. (1997). *The National Education Goals report: Building a nation of learners, 1997.* Washington, DC: U. S. Government Printing Office.

National Forum on Assessment. (1995). *Principles and indicators for student assessment systems.* Cambridge, MA: National Center for Fair & Open Testing.

National Governor's Association (1995). *Governor's Campaign for Children: An action agenda for states.* Washington, DC: Author.

Southern Early Childhood Association. (1999). *Developmentally appropriate assessment (A position statement).* Little Rock, AR: Author.

U. S. Department of Education. (1990, July). *National goals for education.* Washington, DC: U. S. Government Printing Office.

U. S. Department of Education. (1991, August). *Preparing young children for success: Guideposts for achieving our first national goal.* Washington, DC: U. S. Government Printing Office.

Professional and Advocacy Organizations

American Academy of Pediatrics
141 Northwest Point Boulevard
P.O. Box 927
Elk Grove Village, IL 60009-0927
(312) 228-5005
Web site: http://www.aap.org/

American Association of School Administrators
 (AASA)
1801 North Moore Street
Arlington, VA 22209-9988
(703) 528-0700

Association for Childhood Education
 International (ACEI)
The Olney Professional Building
17904 Geogia Avenue, Suite 215
Olney, MD 20832
(301) 570-2111 or (800) 423-3563
e-mail: ACEIED@aol.com
Web site: http://www.udel.edu/bateman/acei

Association for Supervision and Curriculum
 Development (ASCD)
1250 N. Pitt Street
Alexandria, VA 22314-1403
(703) 549-9110
e-mail: member@ascd.org
Web site: http://www.asdc.org/

Clearinghouse on Disability Information
U.S. Department of Education
Room 3132 Switzer Bldg.
Washington, DC 20202-2524
Web site:
 www.ninds.nih.gov/healinfo/feds/codi.htm

Council for Exceptional Children
1920 Association Drive
Reston, VA 22091
(703) 620-3660
e-mail: cec@cec.sped.org
Web site: http://www.cec.sped.org

ERIC Clearinghouse on Elementary and Early
 Childhood Education (ERIC/ECE)
University of Illinois at Urbana
805 W. Pennsylvania Avenue
Urbana, IL 61801

(217) 333-1386
e-mail: ericeece@uiuc.edu
Web site: http://ericps.crc.uiuc.edu/ericeece.html

High/Scope Educational Research Foundation
600 N. River Street
Ypsilanti, MI 48198-2898
(313) 485-2000
e-mail: info@highscope.org
Web site: www.highscope.org/

International Reading Association
800 Barksdale Road
P.O. Box 8139
Newark, DE 19714-8139
(302) 731-1600
e-mail: pubinfo@reading.org
Web site: http://www.reading.org/

National Association for the Education of Young
 Children (NAEYC)
1509 16th Street, NW
Washington, DC 20036-1426
(800) 424-2460
e-mail: membership@naeyc.org
Web site: http/www.naeyc.org/naeyc

National Association of Elementary School
 Principals
1615 Duke Street
Alexandria, VA 22314
(800) 38-NAESP
e-mail: naesp@naesp.org
Web site: http://www.naesp.org/

National Black Child Development Institute
1023 Fifteenth Street, NW, Suite 600
Washington, DC 20005
(202) 387-1281
e-mail: moreinfo@nbcdi.org
Web site: http://cpmcnet.columbia.edu/dept/nccp

National Center for Fair and Open Testing
342 Broadway
Cambridge, MA 02139-1802
(617) 864-4810
e-mail: FairTest@AOL.com

National Assessment of Educational Progress
 (NAEP)
555 New Jersey Avenue NW, Room 512B
Washington, DC 20208

National Congress of Parents and Teachers
330 North Wabash Avenue, Suite 2100
Chicago, IL 60611-2571
(312) 670-6782
e-mail: info@pta.org
Web site: http://www.pta.org/

National Council for Excellence in Critical
 Thinking
4655 Sonoma Mountain Road
Santa Rosa, CA 95404
(707) 546-0629

National Education Association (NEA)
1201 Sixteenth Street NW
Washington, DC 20036
(202) 822-7200

Northwest Regional Educational Laboratory
The Test Center
101 SW Main Street, Suite 500
Portland, OR 97204
(503) 275-9500

Southern Early Childhood Association (SECA)
Box 5403
Brady Station
Little Rock, AR 72215
(501) 227-6404
Web site: http://www.usakids.org/sites/seca.html

REVIEW STRATEGIES AND ACTIVITIES

1. With a partner, reread Figure 10.1, "A Teacher's Story". You and your partner should each make a list of the elements in the story that are incongruent with the principles of authentic assessment that you have been learning about in this text.

 a. Is your list the same as your partner's?

 b. What elements did each of you find most troubling?

 c. How would you have responded to Keith and others who were similarly disturbed during the test?

 d. What strategies would you advise the teacher to use for advocating change?

2. With the rest of your classmates, acquire several items from the resource list in this chapter. Review them carefully. Plan a "show-and-tell" day in which these materials are displayed, reviewed, and discussed. Determine how you personally might use any of the items to advocate for appropriate curriculums and assessments for young children.

3. Invite a local or state school board member to talk to the class. Determine this policymaker's views on early childhood education; share what you are learning and talk about promising programs for young children in school.

4. Volunteer to work with the public policy committee of your local or state early childhood professional organization. Keep a log of its concerns, issues being addressed, and advocacy strategies. Use a variety of the resources available through professional organizations to assist the committee.

Appendix A

Checklist for Diversity in Early Childhood Education and Care

How do we support diversity in early childhood classrooms? Genuine diversity begins with respect for each and every individual and grows with adults' understanding that culture is a powerful part of children's development. In early childhood settings, this means that every child and family feels respected and valued.

This checklist includes features of the culturally diverse, developmentally appropriate early childhood classroom. It can help you think through the fundamental issues of diversity in early childhood education and care. Remember that some of these features may be appropriate for very young children but not for primary-grade children, and vice versa. Few programs have all of these features, but all early childhood programs can and should have some of these features and demonstrate that they are working toward the others.

Physical Environment

Does the classroom seem to be the children's place or the teacher's place?
- Are children's creative artworks displayed throughout the room?
- Is a bulletin board available to the children as a work space for notes and plans and for works in progress?
- Are there "mailboxes" where children can leave private messages for each other and for teachers?

- Is there a show-and-tell display area? Are photographs and artifacts of the children's families evident?
- Does the teacher continually replace or rearrange materials in classroom centers to support children's changing interests? For example, does the dramatic play center lend itself to a fishing pier as well as the traditional "housekeeping"?

Do materials in the room reflect the cultural diversity of the children and of the world?
- Do dolls and other toys reflect different ethnic backgrounds and physical abilities?
- Is there a large quantity and wide variety of classic and contemporary picture and story books?
- Are high-quality, culturally diverse children's periodicals, such as *Cricket, Spider,* and *Ladybug,* available?

Does the teacher demonstrate the world's variety of languages in her classroom?
- Do labels in the classroom reflect children's home languages? Are some labels in Braille?

Curriculum

Does the curriculum incorporate each child's personal experiences?
- Does the curriculum reflect that different individuals view and interpret the world differently?

- Are children able to suggest topics for exploration?
- Does the teacher suggest that children pursue interesting ideas through different forms and media? For example, would the teacher suggest that a child experiment with creating a self-portrait in crayon, pencil, and then collage? Would he invite a preschooler to expand a block construction, or a second-grader to write a second draft of a story, adding more details?

Does the teacher recognize and support children's different learning styles?
- Does the school honor all children's efforts instead of focusing on academic "stars"?

Does the teacher pay attention to individual children's interests and provide opportunities for them to pursue those interests?
- Does the teacher frequently group children according to their interests, instead of grouping them by ability?

Does the teacher discourage bias? For example, does he support a girl's interest in science or math?

Do the children have many opportunities to express themselves and explore ideas through art, music, and plays?

Do children have many opportunities to write notes, letters, lists, diaries, stories, and songs?
- Does the teacher treat children's writings seriously by "publishing" some and sharing it with other classes, families, etc.?

Does the program measure each child's accomplishments in comparison to the child's earlier work through the use of portfolios?

Interactions in the Classroom

Are children encouraged to talk with each other?
- Are there times when children can tell imaginative and true stories of their own experiences?
- Are children encouraged to listen to everyone's ideas as they work on projects in groups?
- Do they have opportunities throughout the day to work and play in pairs and small groups as well as in mixed-age groups and alone?
- Does the teacher help children who do not speak English to participate in conversations?

Does the teacher really listen to the children?
- Does she respond to children's specific ideas and questions instead of making general comments like "good idea" or "we'll get to that later"?
- Does the teacher pay attention to and use different communication styles?
- Does she sit at the children's eye level?

Does the teacher intervene when children hurt each other's feelings?
- Does she help children figure out reasons for conflicts and support their problem-solving, rather than simply discourage insults?

Does the teacher observe rather than lead the activity in the room much of the time?

Family Involvement

Does the teacher see family members as resources?
- Are family members encouraged to visit classrooms at any time?
- Does the teacher solicit family participation?

- Does she make arrangements as necessary to accommodate all family members, including persons with disabilities and extended family members?

Does the teacher consider children's home cultures in planning center or school events?
- Do working parents receive enough notice of assignments and special activities to allow them to fully participate?
- Are announcements, newsletters, etc., spoken and written in families' home languages?
- Are activities inexpensive enough for all to participate?

Are activities, materials, and resources in the classroom open-ended about the nature of families, instead of suggesting, for instance, that every family has "a mommy and a daddy"?

Community Involvement

Do children have many informal opportunities to meet parents and other community members who work in various capacities? For example, do they meet the father who is a blind executive, or the merchant who is Vietnamese?

Do teachers encourage visitors to talk with individual children and with small groups as well as with whole classes?

Do centers and schools recognize that all people are important, instead of occasionally celebrating a few well-known persons such as Martin Luther King, Jr.? Do they recognize persons in children's own families who contribute to the community?

Does the center or school use senior citizens as resources? What about high school students?

Are children able to take field trips to various nearby locations so that they can learn about their own community?

Resources

Derman-Sparks, L., & A.B.C. Task Force. (1989). *Anti-bias curriculum: Tools for empowering young children.* Washington, DC: National Association for the Education of Young Children.

Grace, C., & Shores, E. G. (1991). *The portfolio and its use: Developmentally appropriate assessment of young children.* Little Rock, AR: Southern Early Childhood Association.

Katz, L. G., Evangelou, D., & Hartman, J. A. (1990). *The case for mixed-age groupings in early education.* Washington, DC: National Association for the Education of Young Children.

McCracken, J. B. (1993). *Valuing diversity: The primary years.* Washington, DC: National Association for the Education of Young Children.

Credits

Authors: Nelle Peck, M.Ed., and Elizabeth F. Shores

Advisors: Carol Brunson Phillips, Ph.D., and Louise Derman-Sparks

Appendix B

Learning to Read and Write:

Developmentally Appropriate Practices for Young Children

Note: Reprinted by permission of the National Association for the Education of Young Children from "Learning to Read and Write: Developmentally Appropriate Practices for Young Children: A Joint Position Statement by the National Association for the Education of Young Children and the International Reading Association." In *Young Children, 53*(4), pp. 30–46.

Learning to Read and Write:
Developmentally Appropriate Practices for Young Children

A joint position statement of the
International Reading Association (IRA)
and the **National Association for the Education of Young Children (NAEYC)**

Adopted 1998

Learning to read and write is critical to a child's success in school and later in life. One of the best predictors of whether a child will function competently in school and go on to contribute actively in our increasingly literate society is the level to which the child progresses in reading and writing. Although reading and writing abilities continue to develop throughout the life span, the early childhood years—from birth through age eight—are the most important period for literacy development. It is for this reason that the International Reading Association (IRA) and the National Association for the Education of Young Children (NAEYC) joined together to formulate a position statement regarding early literacy development. The statement consists of a set of principles and recommendations for teaching practices and public policy.

The primary purpose of this position statement is to provide guidance to teachers of young children in schools and early childhood programs (including child care centers, preschools, and family child care homes) serving children from birth through age eight. By and large, the principles and practices suggested here also will be of interest to any adults who are in a position to influence a young child's learning and development—parents, grandparents, older siblings, tutors, and other community members.

Teachers work in schools or programs regulated by administrative policies as well as available resources. Therefore secondary audiences for this position statement are school principals and program administrators whose roles are critical in establishing a supportive climate for sound, developmentally appropriate teaching practices; and policymakers whose decisions determine whether adequate resources are available for high-quality early childhood education.

A great deal is known about how young children learn to read and write and how they can be helped toward literacy during the first five years of life. A great deal is known also about how to help children once compulsory schooling begins, whether in kindergarten or the primary grades. Based on a thorough review of the research, this document reflects the commitment of two major professional organizations to the goal of helping children learn to read well enough by the end of third grade so that they can read to learn in all curriculum areas. IRA and NAEYC are committed not only to helping young children learn to read and write but also to fostering and sustaining their interest and disposition to read and write for their own enjoyment, information, and communication.

First, the statement summarizes the current issues that are the impetus for this position; then it reviews what is known from research on young children's literacy development. This review of research as well as the collective wisdom and experience of IRA and NAEYC members provides the basis for a position statement about what constitutes developmentally appropriate practice in early literacy over the period of birth through age eight. The position concludes with recommendations for teaching practices and policies.

Statement of the issues

Why take a position on something as obviously important as children's learning to read and write? The IRA and NAEYC believe that this position statement will contribute significantly to an improvement in practice and the development of supportive educational policies. The two associations saw that a clear, concise position statement was needed at this time for several reasons.

• **It is essential and urgent to teach children to read and write competently, enabling them to achieve today's high standards of literacy.**

Although this country enjoys the highest literacy rate in its history, society now expects virtually everyone in the population to function beyond the minimum standards of literacy. Today the definition of *basic proficiency* in literacy calls for a fairly high standard of reading comprehension and analysis. The main reason is that literacy requirements of most jobs have increased significantly and are expected to increase further in the future. Communications that in the past were verbal (by phone or in person) now demand reading and writing—messages sent by electronic mail, Internet, or facsimile as well as print documents.

• **With the increasing variation among young children in our programs and schools, teaching today has become more challenging.**

Experienced teachers throughout the country report that the children they teach today are more diverse in their backgrounds, experiences, and abilities than were those they taught in the past. Kindergarten classes now include children who have been in group settings for three or four years as well as children who are participating for the first time in an organized early childhood program. Classes include both children with identified disabilities and children with exceptional abilities, children who are already independent readers and children who are just beginning to acquire some basic literacy knowledge and skills. Children in the group may speak different languages at varying levels of proficiency. Because of these individual and experiential variations, it is common to find within a kindergarten classroom a five-year range in children's literacy-related skills and functioning (Riley 1996). What this means is that some kindergartners may have skills characteristic of the typical three-year-old, while others might be functioning at the level of the typical eight-year-old. Diversity is to be expected and embraced, but it can be overwhelming when teachers are expected to produce uniform outcomes for all, with no account taken of the initial range in abilities, experiences, interests, and personalities of individual children.

• **Among many early childhood teachers, a maturationist view of young children's development persists despite much evidence to the contrary.**

A readiness view of reading development assumes that there is a specific time in the early childhood years when the teaching of reading should begin. It also assumes that physical and neurological maturation alone prepare the child to take advantage of instruction in reading and writing. The readiness perspective implies that until children reach a certain stage of maturity all exposure to reading and writing, except perhaps being read stories, is a waste of time or even potentially harmful. Experiences throughout the early childhood years, birth through age eight, affect the development of literacy. These experiences constantly interact with characteristics of individual children to determine the level of literacy skills a child ultimately achieves. Failing to give children literacy experiences until they are school-age can severely limit the reading and writing levels they ultimately attain.

• **Recognizing the early beginnings of literacy acquisition too often has resulted in use of inappropriate teaching practices suited to older children or adults perhaps but ineffective with children in preschool, kindergarten, and the early grades.**

Teaching practices associated with outdated views of literacy development and/or learning theories are still prevalent in many classrooms. Such practices include extensive whole-group instruction and intensive drill and practice on isolated skills for groups or individuals. These practices, not particularly effective for primary-grade children, are even less suitable and effective with preschool and kindergarten children. Young children especially need to be engaged in experiences that make academic content meaningful and build on prior learning. It is vital for all children to have literacy experiences in schools and early childhood programs. Such access is even more critical for children with limited home experiences in literacy. However, these school experiences must teach the broad range of language and literacy knowledge and skills to provide the solid

IRA and NAEYC believe that goals and expectations for young children's achievement in reading and writing should be developmentally appropriate, that is, *challenging but achievable*, with sufficient adult support.

foundation on which high levels of reading and writing ultimately depend.

• **Current policies and resources are inadequate in ensuring that preschool and primary teachers are qualified to support the literacy development of all children, a task requiring strong preservice preparation and ongoing professional development.**

For teachers of children younger than kindergarten age in the United States, no uniform preparation requirements or licensure standards exist. In fact, a high-school diploma is the highest level of education required to be a child care teacher in most states. Moreover, salaries in child care and preschool programs are too low to attract or retain better qualified staff. Even in the primary grades, for which certified teachers are required, many states do not offer specialized early childhood certification, which means many teachers are not adequately prepared to teach reading and writing to young children. All teachers of young children need good, foundational knowledge in language acquisition, including second-language learning, the processes of reading and writing, early literacy development, and experiences and teaching practices contributing to optimal development. Resources also are insufficient to ensure teachers continuing access to professional education so they can remain current in the field or can prepare to teach a different age group if they are reassigned.

What research reveals: Rationale for the position statement

Children take their first critical steps toward learning to read and write very early in life. Long before they can exhibit reading and writing production skills, they begin to acquire some basic understandings of the concepts about literacy and its functions. Children learn to use symbols, combining their oral language, pictures, print, and play into a coherent mixed medium and creating and communicating meanings in a variety of ways. From their initial experiences and interactions with adults, children begin to read words, processing letter-sound relations and acquiring substantial knowledge of the alphabetic system. As they continue to learn, children increasingly consolidate this information into patterns that allow for automaticity and fluency in reading and writing. Consequently reading and writing acquisition is conceptualized better as a developmental continuum than as an all-or-nothing phenomenon (see pp. 40–41 for an illustration of a developmental continuum).

But the ability to read and write does not develop naturally, without careful planning and instruction. Children need regular and active interactions with print. Specific abilities required for reading and writing come from immediate experiences with oral **and** written language. Experiences in these early years begin to define the assumptions and expectations about becoming literate and give children the motivation to work toward learning to read and write. From these experiences children learn that reading and writing are valuable tools that will help them do many things in life.

The beginning years (birth through preschool)

Even in the first few months of life, children begin to experiment with language. Young babies make sounds that imitate the tones and rhythms of adult talk; they "read" gestures and facial expressions, and they begin to associate sound sequences frequently heard—words—with their referents (Berk 1996). They delight in listening to familiar jingles and rhymes, play along in games such as peek-a-boo and pat-a-cake, and manipulate objects such as board books and alphabet blocks in their play. From these remarkable beginnings children learn to use a variety of symbols.

In the midst of gaining facility with these symbol systems, children acquire through interactions with others the insights that specific kinds of marks—print—also can represent meanings. At first children will use the physical and visual cues surrounding print to determine what something says. But as they develop an understanding of the alphabetic principle, children begin to process letters, translate them into sounds, and connect this information with a known meaning. Although it may seem as though some children acquire these understandings magically or on their own, studies suggest that they are the beneficiaries of considerable, though playful and informal, adult guidance and instruction (Durkin 1966; Anbar 1986).

Considerable diversity in children's oral and written language experiences occurs in these years (Hart & Risley 1995). In home and child care situations, children encounter many different resources and types and degrees of support for early reading and writing (McGill-Franzen & Lanford 1994). Some children may have ready access to a range of writing and reading materials, while others may not; some children will observe their parents writing and reading frequently, others only occasionally; some children receive direct instruction, while others receive much more casual, informal assistance.

What this means is that no one teaching method or approach is likely to be the most effective for all

We should strengthen our resolve to ensure that every child has the benefit of positive early childhood experiences that support literacy development. At the same time, regardless of children's prior learning, schools have the responsibility to educate every child and to never give up even if later interventions must be more intensive and costly.

children (Strickland 1994). Rather, good teachers bring into play a variety of teaching strategies that can encompass the great diversity of children in schools. Excellent instruction builds on what children already know, and can do, and provides knowledge, skills, and dispositions for lifelong learning. Children need to learn not only the technical skills of reading and writing but also how to use these tools to better their thinking and reasoning (Neuman in press).

The single most important activity for building these understandings and skills essential for reading success appears to be **reading aloud to children** (Wells 1985; Bus, Van Ijzendoorn, & Pellegrini 1995). High-quality book reading occurs when children feel emotionally secure (Bus & Van Ijzendoorn 1995; Bus et al. 1997) and are active participants in reading (Whitehurst et al. 1994). Asking predictive and analytic questions in small-group settings appears to affect children's vocabulary and comprehension of stories (Karweit & Wasik 1996). Children may talk about the pictures, retell the story, discuss their favorite actions, and request multiple rereadings. It is the talk that surrounds the storybook reading that gives it power, helping children to bridge what is in the story and their own lives (Dickinson & Smith 1994; Snow et al. 1995). Snow (1991) has described these types of conversations as "decontextualized language" in which teachers may induce higher-level thinking by moving experiences in stories from what the children may see in front of them to what they can imagine.

A central goal during these preschool years is to enhance children's **exposure to and concepts about print** (Clay 1979, 1991; Holdaway 1979; Teale 1984; Stanovich & West 1989). Some teachers use Big Books to help children distinguish many print features, including the fact that print (rather than pictures) carries the meaning of the story that the strings of letters between spaces are words and in print correspond to an oral version, and that reading progresses from left to right and top to bottom. In the course of reading stories, teachers may demonstrate these features by pointing to individual words, directing children's attention to where to begin reading, and helping children to recognize let-

ter shapes and sounds. Some researchers (Adams 1990; Roberts in press) have suggested that the key to these critical concepts, such as developing word awareness, may lie in these demonstrations of how print works.

Children also need opportunity to practice what they've learned about print with their peers and on their own. Studies suggest that the physical arrangement of the classroom can promote time with books (Morrow & Weinstein 1986; Neuman & Roskos 1997). A key area is the classroom library—a collection of attractive stories and informational books—that provides children with immediate access to books. Regular visits to the school or public library and library card registration ensure that children's collections remain continually updated and may help children develop the habit of reading as lifelong learning. In comfortable library settings children often will pretend to read, using visual cues to remember the words of their favorite stories. Although studies have shown that these pretend readings are just that (Ehri & Sweet 1991), such visual readings may demonstrate substantial knowledge about the global features of reading and its purposes.

Storybooks are not the only means of providing children with exposure to written language. Children learn a lot about reading from the labels, signs, and other kinds of print they see around them (McGee, Lomax, & Head 1988; Neuman & Roskos 1993). Highly visible print labels on objects, signs, and bulletin boards in classrooms demonstrate the practical uses of written language. In environments rich with print, children incorporate literacy into their dramatic play (Morrow 1990; Vukelich 1994; Neuman & Roskos 1997), using these communication tools to enhance the drama and realism of the pretend situation. These everyday, playful experiences by themselves do not make most children readers. Rather they expose children to a variety of print experiences and the processes of reading for real purposes.

For children whose primary language is other than English, studies have shown that a strong basis in a first language promotes school achievement in a second language (Cummins 1979). Children who are **learning English as a second language** are more

likely to become readers and writers of English when they are already familiar with the vocabulary and concepts in their primary language. In this respect, oral and written language experiences should be regarded as an additive process, ensuring that children are able to maintain their home language while also learning to speak and read English (Wong Fillmore, 1991). Including non-English materials and resources to the extent possible can help to support children's first language while children acquire oral proficiency in English.

A fundamental insight developed in children's early years through instruction is the **alphabetic principle,** the understanding that there is a systematic relationship between letters and sounds (Adams 1990). The research of Gibson and Levin (1975) indicates that the shapes of letters are learned by distinguishing one character from another by its type of spatial features. Teachers will often involve children in comparing letter shapes, helping them to differentiate a number of letters visually. Alphabet books and alphabet puzzles in which children can see and compare letters may be a key to efficient and easy learning.

At the same time children learn about the sounds of language through exposure to **linguistic awareness** games, nursery rhymes, and rhythmic activities. Some research suggests that the roots of phonemic awareness, a powerful predictor of later reading success, are found in traditional rhyming, skipping, and word games (Bryant et al. 1990). In one study, for example (Maclean, Bryant, & Bradley 1987), researchers found that three-year-old children's knowledge of nursery rhymes specifically related to their more abstract phonological knowledge later on. Engaging children in choral readings of rhymes and rhythms allows them to associate the symbols with the sounds they hear in these words.

Although children's facility in **phonemic awareness** has been shown to be strongly related to later reading achievement, the precise role it plays in these early years is not fully understood. Phonemic awareness refers to a child's understanding and conscious awareness that speech is composed of identifiable units, such as spoken words, syllables, and sounds. Training studies have demonstrated that

phonemic awareness can be taught to children as young as age five (Bradley & Bryant 1983; Lundberg, Frost, & Petersen 1988; Cunningham 1990; Bryne & Fielding-Barnsley 1991). These studies used tiles (boxes) (Elkonin 1973) and linguistic games to engage children in explicitly manipulating speech segments at the phoneme level. Yet, whether such training is appropriate for younger-age children is highly suspect. Other scholars find that children benefit most from such training only after they have learned some letter names, shapes, and sounds and can apply what they learn to real reading in meaningful contexts (Cunningham 1990; Foorman et al. 1991). Even at this later age, however, many children acquire phonemic awareness skills without specific training but as a consequence of learning to read (Wagner & Torgesen 1987; Ehri 1994). In the preschool years sensitizing children to sound similarities does not seem to be strongly dependent on formal training but rather from listening to patterned, predictable texts while enjoying the feel of reading and language.

Children acquire a working knowledge of the alphabetic system not only through reading but also through writing. A classic study by Read (1971) found that even without formal spelling instruction, preschoolers use their tacit knowledge of phonological relations to spell words. **Invented spelling** (or phonic spelling) refers to beginners' use of the symbols they associate with the sounds they hear in the words they wish to write. For example, a child may initially write *b* or *bk* for the word *bike,* to be followed by more conventionalized forms later on.

Some educators may wonder whether invented spelling promotes poor spelling habits. To the contrary, studies suggest that *temporary* invented spelling may contribute to beginning reading (Chomsky 1979; Clarke 1988). One study, for example, found that children benefited from using invented spelling compared to having the teacher provide correct spellings in writing (Clarke 1988). Although children's invented spellings did not comply with correct spellings, the process encouraged them to think actively about letter-sound relations. As children engage in writing, they are learning to segment the words they wish to spell into constituent sounds.

Classrooms that provide children with regular opportunities to express themselves on paper, without feeling too constrained for correct spelling and proper handwriting, also help children understand that writing has real purpose (Graves 1983; Sulzby 1985; Dyson 1988). Teachers can organize situations that both demonstrate the writing process and get children actively involved in it. Some teachers serve as scribes and help children write down their ideas, keeping in mind the balance between children do-

Reading and writing acquisition is conceptualized better as a developmental continuum than as an all-or-nothing phenomenon.

ing it themselves and asking for help. In the beginning these products likely emphasize pictures with few attempts at writing letters or words. With encouragement, children begin to label their pictures, tell stories, and attempt to write stories about the pictures they have drawn. Such novice writing activity sends the important message that writing is not just handwriting practice—children are using their own words to compose a message to communicate with others.

Thus the picture that emerges from research in these first years of children's reading and writing is one that emphasizes wide exposure to print and to developing concepts about it and its forms and functions. Classrooms filled with print, language and literacy play, storybook reading, and writing allow children to experience the joy and power associated with reading and writing while mastering basic concepts about print that research has shown are strong predictors of achievement.

In kindergarten

Knowledge of the forms and functions of print serves as a foundation from which children become increasingly sensitive to letter shapes, names, sounds, and words. However, not all children typically come to kindergarten with similar levels of knowledge about printed language. Estimating where each child is developmentally and building on that base, a key feature of all good teaching, is particularly important for the kindergarten teacher. Instruction will need to be adapted to account for children's differences. For those children with lots of print experiences, instruction will extend their knowledge as they learn more about the formal features of letters and their sound correspondences. For other children with fewer prior experiences, initiating them to the alphabetic principle, that a limited set of letters comprises the alphabet and that these letters stand for the sounds that make up spoken words, will require more focused and direct instruction. In all cases, however, children need to interact with a rich variety of print (Morrow, Strickland, & Woo 1998).

In this critical year kindergarten teachers need to capitalize on every opportunity for enhancing children's **vocabulary development.** One approach is through listening to stories (Feitelson, Kita, & Goldstein 1986; Elley 1989). Children need to be exposed to vocabulary from a wide variety of genres, including informational texts as well as narratives. The learning of vocabulary, however, is not necessarily simply a byproduct of reading stories (Leung & Pikulski 1990). Some explanation of vocabulary words prior to listening to a story is related significantly to children's learning of new words (Elley 1989). Dickinson and Smith (1994), for example, found that asking predictive and analytic questions before and after the readings produced positive effects on vocabulary and comprehension.

Repeated readings appear to further reinforce the language of the text as well as to familiarize children with the way different genres are structured (Eller, Pappas, & Brown 1988; Morrow 1988). Understanding the forms of informational and narrative texts seems to distinguish those children who have been well read to from those who have not (Pappas 1991). In one study, for example, Pappas found that with multiple exposures to a story (three readings), children's retelling became increasingly rich, integrating what they knew about the world, the language of the book, and the message of the author. Thus, considering the benefits for vocabulary development and comprehension, the case is strong for interactive storybook reading (Anderson 1995). Increasing the volume of children's playful, stimulating experiences with good books is associated with accelerated growth in reading competence.

Activities that help children clarify the **concept of word** are also worthy of time and attention in the kindergarten curriculum (Juel 1991). Language experience charts that let teachers demonstrate how talk can be written down provide a natural medium for children's developing word awareness in meaningful contexts. Transposing children's spoken words into written symbols through dictation provides a concrete demonstration that strings of letters between spaces are words and that not all words are the same length. Studies by Clay (1979) and Bissex (1980) confirm the value of what many teachers have known and done for years: Teacher dictations of children's stories help develop word awareness, spelling, and the conventions of written language.

Many children enter kindergarten with at least some perfunctory knowledge of the alphabet letters. An important goal for the kindergarten teacher is to reinforce this skill by ensuring that children can recognize and discriminate these letter shapes with increasing ease and fluency (Mason 1980; Snow, Burns, & Griffin 1998). Children's proficiency in **letter naming** is a well-established predictor of their end-of-year achievement (Bond & Dykstra 1967; Riley 1996), probably because it mediates the ability to remember sounds. Generally a good rule according to current learning theory (Adams 1990) is to start with the more easily visualized uppercase letters, to be followed by identifying lowercase letters. In each case, introducing just a few letters at a time, rather than many, enhances mastery.

At about the time children are readily able to identify letter names, they begin to connect the letters with the sounds they hear. A fundamental insight in this phase of learning is that a letter and letter sequences map onto phonological forms. Phonemic awareness, however, is not merely a solitary insight or an instant ability (Juel 1991). It takes time and practice.

Children who are phonemically aware can think about and manipulate sounds in words. They know when words rhyme or do not; they know when words begin or end with the same sound; and they know that a word like *bat* is composed of three sounds /b/ /a/ /t/ and that these sounds can be blended into a spoken word. Popular rhyming books, for example, may draw children's attention to rhyming patterns, serving as a basis for extending vocabulary (Ehri & Robbins 1992). Using initial letter cues, children can learn many new words through analogy, taking the familiar word *bake* as a strategy for figuring out a new word, *lake*.

Further, as teachers engage children in shared writing, they can pause before writing a word, say it slowly, and stretch out the sounds as they write it. Such activities in the context of real reading and writing help children attend to the features of print and the alphabetic nature of English.

There is accumulated evidence that instructing children in phonemic awareness activities in kindergarten (and first grade) enhances reading achievement (Stanovich 1986; Lundberg, Frost, & Petersen 1988; Bryne & Fielding-Barnsley 1991, 1993, 1995). Although a large number of children will acquire phonemic awareness skills as they learn to read, an estimated 20% will not without additional training. A statement by the IRA (1998) indicates that "the likelihood of these students becoming successful as readers is slim to none This figure [20%], however, can be substantially reduced through more systematic attention to engagement with language early on in the child's home, preschool and kindergarten classes." A study by Hanson and Farrell (1995), for example, examined the long-term benefits of a carefully developed kindergarten curriculum that focused on word study and decoding skills, along with sets of stories so that children would be able to practice these skills in meaningful contexts. High school seniors who early on had received this type of instruction outperformed their counterparts on reading achievement, attitude toward schooling, grades, and attendance.

In kindergarten many children will begin to read some words through recognition or by processing letter-sound relations. Studies by Domico (1993) and Richgels (1995) suggest that children's ability to read words is tied to their ability to write words in a somewhat reciprocal relationship. The more opportunities children have to write, the greater the likelihood that they will reproduce spellings of words they have seen and heard. Though not conventional, these spellings likely show greater letter-sound correspondences and partial encoding of some parts of words, like *SWM* for *swim,* than do the inventions of preschoolers (Clay 1975).

To provide more intensive and extensive practice, some teachers try to integrate writing in other areas of the curriculum like literacy-related play (Neuman & Roskos 1992), and other project activities (Katz & Chard 1989). These types of projects engage children in using reading and writing for multiple purposes while they are learning about topics meaningful to them.

Early literacy activities teach children a great deal about writing and reading but often in ways that do not look much like traditional elementary school instruction. Capitalizing on the active and social nature of children's learning, early instruction must provide rich demonstrations, interactions, and models of literacy in the course of activities that make sense to young children. Children must also learn about the relation between oral and written language and the relation between letters, sounds, and words. In classrooms built around a wide variety of print activities, then in talking, reading, writing, playing, and listening to one another, children will want to read and write and feel capable that they can do so.

The primary grades

Instruction takes on a more formal nature as children move into the elementary grades. Here it is virtually certain that children will receive at least some instruction from a commercially published product, like a basal or literature anthology series.

Although research has clearly established that no one method is superior for all children (Bond & Dykstra 1967; Snow, Burns, & Griffin 1998), approaches that favor some type of **systematic code instruction along with meaningful connected reading** report children's superior progress in reading. Instruction should aim to teach the important letter-sound relationships, which once learned are practiced through having many opportunities to read. Most likely these research findings are a positive result of the Matthew Effect, the rich-get-richer effects that are embedded in such instruction; that is, children who acquire alphabetic coding skills begin to recognize many words (Stanovich 1986). As word recognition processes become more automatic, children are likely to allocate more attention to higher-level processes of comprehension. Since these reading experi-

Throughout these critical years, *accurate assessment* of children's knowledge, skills, and dispositions in reading and writing will help teachers better match instruction with how and what children are learning.

ences tend to be rewarding for children, they may read more often; thus reading achievement may be a by-product of reading enjoyment.

One of the hallmarks of skilled reading is **fluent, accurate word identification** (Juel, Griffith, & Gough 1986). Yet instruction in simply word calling with flashcards is not reading. Real reading is comprehension. Children need to read a wide variety of interesting, comprehensible materials, which they can read orally with about 90 to 95% accuracy (Durrell & Catterson 1980). In the beginning children are likely to read slowly and deliberately as they focus on exactly what's on the page. In fact they may seem "glued to print" (Chall 1983), figuring out the fine points of form at the word level. However, children's reading expression, fluency, and comprehension generally improve when they read familiar texts. Some authorities have found the practice of repeated rereadings in which children reread short selections significantly enhances their confidence, fluency, and comprehension in reading (Samuels 1979; Moyer 1982).

Children not only use their increasing knowledge of letter-sound patterns to read unfamiliar texts. They also use a variety of strategies. Studies reveal that early readers are capable of being intentional in their use of **metacognitive strategies** (Brown, & DeLoache 1978; Rowe 1994) Even in these early grades, children make predictions about what they are to read, self-correct, reread, and question if necessary, giving evidence that they are able to adjust their reading when understanding breaks down. Teacher practices, such as the Directed Reading-Thinking Activity (DRTA), effectively model these strategies by helping children set purposes for reading, ask questions, and summarize ideas through the text (Stauffer 1970).

But children also need time for **independent practice.** These activities may take on numerous forms. Some research, for example, has demonstrated the powerful effects that children's reading to their caregivers has on promoting confidence as well as reading proficiency (Hannon 1995). Visiting the library and scheduling independent reading and writing periods in literacy-rich classrooms also provide children with opportunities to select books of their own choosing. They may engage in the social activities of reading with their peers, asking questions, and writing stories (Morrow & Weinstein 1986), all of which may nurture interest and appreciation for reading and writing.

Supportive relationships between these communication processes leads many teachers to **integrate reading and writing** in classroom instruction (Tierney & Shanahan 1991). After all, writing challenges children to actively think about print. As young authors struggle to express themselves, they come to grips with different written forms, syntactic patterns, and themes. They use writing for multiple purposes: to write descriptions, lists, and stories to communicate with others. It is important for teachers to expose children to a range of text forms, including stories, reports, and informational texts, and to help children select vocabulary and punctuate simple sentences that meet the demands of audience and purpose. Since handwriting instruction helps children communicate effectively, it should also be part of the writing process (McGee & Richgels 1996). Short lessons demonstrating certain letter formations tied to the publication of writing provide an ideal time for instruction. Reading and writing workshops, in which teachers provide small-group and individual instruction, may help children to develop the skills they need for communicating with others.

Although children's initial writing drafts will contain invented spellings, learning about spelling will take on increasing importance in these years (Henderson & Beers 1980; Richgels 1986). **Spelling instruction** should be an important component of the reading and writing program since it directly affects reading ability. Some teachers create their own spelling lists, focusing on words with common patterns, high-frequency words, as well as some personally meaningful words from the children's writing. Research indicates that seeing a word in print, imagining how it is spelled, and copying new words is an effective way of acquiring spellings (Barron 1980). Nevertheless, even though the teacher's goal is to foster more conventionalized forms, it is important to recognize that there is more to writing than just spelling and grammatically correct sentences. Rather, writing has been characterized by Applebee (1977) as "thinking with a pencil." It is true that children will need adult help to master the complexities of the writing process. But they also will need to learn that the power of writing is expressing one's own ideas in ways that can be understood by others.

As children's capabilities develop and become more fluent, instruction will turn from a central focus on

helping children learn to read and write to helping them read and write to learn. Increasingly the emphasis for teachers will be on encouraging children to become **independent and productive readers,** helping them to extend their reasoning and comprehension abilities in learning about their world. Teachers will need to provide challenging materials that require children to analyze and think creatively and from different points of view. They also will need to ensure that children have practice in reading and writing (both in and out of school) and many opportunities to analyze topics, generate questions, and organize written responses for different purposes in meaningful activities.

Throughout these critical years **accurate assessment** of children's knowledge, skills, and dispositions in reading and writing will help teachers better match instruction with how and what children are learning. However, early reading and writing cannot simply be measured as a set of narrowly-defined skills on standardized tests. These measures often are not reliable or valid indicators of what children can do in typical practice, nor are they sensitive to language variation, culture, or the experiences of young children (Shepard & Smith 1988; Shepard 1994; Johnston 1997). Rather, a sound assessment should be anchored in real-life writing and reading tasks and continuously chronicle a wide range of children's literacy activities in different situations. Good assessment is essential to help teachers tailor appropriate instruction to young children and to know when and how much intensive instruction on any particular skill or strategy might be needed.

By the end of the third grade, children will still have much to learn about literacy. Clearly some will be further along the path to independent reading and writing than others. Yet with high-quality instruction, the majority of children will be able to decode words with a fair degree of facility, use a variety of strategies to adapt to different types of text, and be able to communicate effectively for multiple purposes using conventionalized spelling and punctuation. Most of all they will have come to see themselves as capable readers and writers, having mastered the complex set of attitudes, expectations, behaviors, and skills related to written language.

Statement of position

IRA and NAEYC believe that achieving high standards of literacy for every child in America is a shared responsibility of schools, early childhood programs, families, and communities. But teachers of young children, whether employed in preschools, child care programs, or elementary schools, have a unique responsibility to promote children's literacy development, based on the most current professional knowledge and research.

A review of research along with the collective wisdom and experience of members has led IRA and NAEYC to conclude that learning to read and write is a complex, multifaceted process that requires a wide variety of instructional approaches, a conclusion similar to that reached by an esteemed panel of experts for the National Academy of Sciences (Snow, Burns, & Griffin 1998).

Similarly, this review of research leads to a theoretical model of literacy learning and development as an interactive process. Research supports the view of the child as an active constructor of his or her own learning, while at the same time studies emphasize the critical role of the supportive, interested, engaged adult (e.g., teacher, parent, or tutor) who provides scaffolding for the child's development of greater skill and understanding (Mason & Sinha 1993; Riley 1996). The principle of learning is that "children are active learners, drawing on direct social and physical experience as well as culturally transmitted knowledge to construct their own understandings of the world around them" (Bredekamp & Copple 1997, 13).

IRA and NAEYC believe that goals and expectations for young children's achievement in reading and writing should be developmentally appropriate, that is, *challenging but achievable,* with sufficient adult support. A continuum of reading and writing development is generally accepted and useful for teachers in understanding the goals of literacy instruction and in assessing children's progress toward those goals. (An abbreviated continuum of reading and writing development appears on pp. 40–41; for more detailed examples, see Chall 1983; Education Department of Western Australia 1994; Whitmore & Goodman 1995; Snow, Burns, & Griffin

No one teaching method or approach is likely to be the most effective for all children. Rather, good teachers bring into play a variety of teaching strategies that can encompass the great diversity of children in schools.

1998). Good teachers understand that children do not progress along this developmental continuum in rigid sequence. Rather, each child exhibits a unique pattern and timing in acquiring skills and understanding related to reading and writing.

Like other complex skills, reading and writing are outcomes that result from the continual interplay of development and learning, and therefore a range of individual variation is to be expected in the rate and pace at which children gain literacy skills. Given exposure to appropriate literacy experiences and good teaching during early childhood, most children learn to read at age six or seven, a few learn at four, some learn at five, and others need intensive individualized support to learn to read at eight or nine. Some children who do not explore books and other print during their early years are likely to need more focused support for literacy development when they enter an educational program, whether at preschool, kindergarten, or first grade (since preschool and even kindergarten attendance is not universal). Other children who enter school speaking little or no English are likely to need instructional strategies in their home language (Snow, Burns, & Griffin 1998).

Given the range within which children typically master reading, even with exposure to print-rich environments and good teaching, a developmentally appropriate expectation is for most children to achieve beginning conventional reading (also called early reading) by age seven. For children with disabilities or special learning needs, achievable but challenging goals for their individual reading and writing development in an inclusive environment are established by teachers, families, and specialists working in collaboration (DEC Task Force 1993; DEC/CEC 1994).

IRA and NAEYC believe that early childhood teachers need to understand the developmental continuum of reading and writing and be skilled in a variety of strategies to assess and support individual children's development and learning across the continuum. At the same time teachers must set developmentally appropriate literacy goals for young children and then adapt instructional strategies for children whose learning and development are advanced or lag behind those goals. Good teachers make instructional decisions based on their knowledge of reading and writing, current research, appropriate expectations, and their knowledge of individual children's strengths and needs.

A continuum of reading and writing development is useful for identifying challenging but achievable goals or benchmarks for children's literacy learning, remembering that individual variation is to be expected and supported. Using a developmental continuum enables teachers to assess individual children's progress against realistic goals and then adapt instruction to ensure that children continue to progress. During the preschool years most children can be expected to function in phase 1 of the developmental continuum, Awareness and Exploration. In kindergarten an appropriate expectation is that most children will be at phase 2, Experimental Reading and Writing. By the end of first grade, most children will function in phase 3, Early Reading and Writing. An appropriate expectation for second grade is Transitional Reading and Writing (phase 4), while the goal for third grade is Independent and Productive Reading and Writing (phase 5). Advanced Reading is the goal for fourth grade and above.

As fundamental as the principle of individual variation is the principle that human development and learning occur in and are influenced by social and cultural contexts. Language, reading, and writing are strongly shaped by culture. Children enter early childhood programs or schools having learned to communicate and make sense of their experiences at home and in their communities. When the ways of making and communicating meaning are similar at home and in school, children's transitions are eased. However, when the language and culture of the home and school are not congruent, teachers and parents must work together to help children strengthen and preserve their home language and culture while acquiring skills needed to participate in the shared culture of the school (NAEYC 1996a).

Most important, teachers must understand how children learn a second language and how this process applies to young children's literacy development. Teachers need to respect the child's home language and culture and use it as a base on which to build and extend children's language and literacy experiences. Unfortunately teachers too often react negatively to children's linguistic and cultural diversity, equating difference with deficit. Such situations hurt children whose abilities within their own cultural context are not recognized because they do not match the cultural expectations of the school. Failing to recognize children's strengths or capabilities, teachers may underestimate their competence. Competence is not tied to any particular language, dialect, or culture. Teachers should never use a child's dialect, language, or culture as a basis for making judgments about the child's intellect or capability. Linguistically and culturally diverse children bring multiple perspectives and impressive skills, such as code-switching (the ability to go back and forth between two languages to deepen conceptual understanding), to the tasks of learning to speak, read, and write a second language. These self-motivated, self-initiating, constructive thinking processes should

Continuum of Children's Development in Early Reading and Writing

Note: This list is intended to be illustrative, not exhaustive. Children at any grade level will function at a variety of phases along the reading/writing continuum.

Phase 1: Awareness and exploration (goals for preschool)

Children explore their environment and build the foundations for learning to read and write.

Children can

• enjoy listening to and discussing storybooks
• understand that print carries a message
• engage in reading and writing attempts
• identify labels and signs in their environment
• participate in rhyming games
• identify some letters and make some letter-sound matches
• use known letters or approximations of letters to represent written language (especially meaningful words like their name and phrases such as "I love you")

What teachers do

• share books with children, including Big Books, and model reading behaviors
• talk about letters by name and sounds
• establish a literacy-rich environment
• reread favorite stories
• engage children in language games
• promote literacy-related play activities
• encourage children to experiment with writing

What parents and family members can do

• talk with children, engage them in conversation, give names of things, show interest in what a child says
• read and reread stories with predictable text to children
• encourage children to recount experiences and describe ideas and events that are important to them
• visit the library regularly
• provide opportunities for children to draw and print, using markers, crayons, and pencils

Phase 2: Experimental reading and writing (goals for kindergarten)

Children develop basic concepts of print and begin to engage in and experiment with reading and writing.

Kindergartners can

• enjoy being read to and themselves retell simple narrative stories or informational texts
• use descriptive language to explain and explore
• recognize letters and letter-sound matches
• show familiarity with rhyming and beginning sounds
• understand left-to-right and top-to-bottom orientation and familiar concepts of print
• match spoken words with written ones
• begin to write letters of the alphabet and some high-frequency words

What teachers do

• encourage children to talk about reading and writing experiences
• provide many opportunities for children to explore and identify sound-symbol relationships in meaningful contexts
• help children to segment spoken words into individual sounds and blend the sounds into whole words (for example, by slowly writing a word and saying its sound)
• frequently read interesting and conceptually rich stories to children
• provide daily opportunities for children to write
• help children build a sight vocabulary
• create a literacy-rich environment for children to engage independently in reading and writing

What parents and family members can do

• daily read and reread narrative and informational stories to children
• encourage children's attempts at reading and writing
• allow children to participate in activities that involve writing and reading (for example, cooking, making grocery lists)
• play games that involve specific directions (such as "Simon Says")
• have conversations with children during mealtimes and throughout the day

Phase 3: Early reading and writing (goals for first grade)

Children begin to read simple stories and can write about a topic that is meaningful to them.

First-graders can

• read and retell familiar stories
• use strategies (rereading, predicting, questioning, contextualizing) when comprehension breaks down
• use reading and writing for various purposes on their own initiative
• orally read with reasonable fluency
• use letter-sound associations, word parts, and context to identify new words
• identify an increasing number of words by sight
• sound out and represent all substantial sounds in spelling a word
• write about topics that are personally meaningful
• attempt to use some punctuation and capitalization

What teachers do

• support the development of vocabulary by reading daily to the children, transcribing their language, and selecting materials that expand children's knowledge and language development

- model strategies and provide practice for identifying unknown words
- give children opportunities for independent reading and writing practice
- read, write, and discuss a range of different text types (poems, informational books)
- introduce new words and teach strategies for learning to spell new words
- demonstrate and model strategies to use when comprehension breaks down
- help children build lists of commonly used words from their writing and reading

What parents and family members can do

- talk about favorite storybooks
- read to children and encourage them to read to you
- suggest that children write to friends and relatives
- bring to a parent-teacher's conference evidence of what your child can do in writing and reading
- encourage children to share what they have learned about their writing and reading

Phase 4: Transitional reading and writing (goals for second grade)

Children begin to read more fluently and write various text forms using simple and more complex sentences.

Second-graders can

- read with greater fluency
- use strategies more efficiently (rereading, questioning, and so on) when comprehension breaks down
- use word identification strategies with greater facility to unlock unknown words
- identify an increasing number of words by sight
- write about a range of topics to suit different audiences
- use common letter patterns and critical features to spell words
- punctuate simple sentences correctly and proofread their own work
- spend time reading daily and use reading to research topics

What teachers do

- create a climate that fosters analytic, evaluative, and reflective thinking
- teach children to write in multiple forms (stories, information, poems)
- ensure that children read a range of texts for a variety of purposes
- teach revising, editing, and proofreading skills
- teach strategies for spelling new and difficult words
- model enjoyment of reading

What parents and family members can do

- continue to read to children and encourage them to read to you
- engage children in activities that require reading and writing

- become involved in school activities
- show children your interest in their learning by displaying their written work
- visit the library regularly
- support your child's specific hobby or interest with reading materials and references

Phase 5: Independent and productive reading and writing (goals for third grade)

Children continue to extend and refine their reading and writing to suit varying purposes and audiences.

Third-graders can

- read fluently and enjoy reading
- use a range of strategies when drawing meaning from the text
- use word identification strategies appropriately and automatically when encountering unknown words
- recognize and discuss elements of different text structures
- make critical connections between texts
- write expressively in many different forms (stories, poems, reports)
- use a rich variety of vocabulary and sentences appropriate to text forms
- revise and edit their own writing during and after composing
- spell words correctly in final writing drafts

What teachers do

- provide opportunities daily for children to read, examine, and critically evaluate narrative and expository texts
- continue to create a climate that fosters critical reading and personal response
- teach children to examine ideas in texts
- encourage children to use writing as a tool for thinking and learning
- extend children's knowledge of the correct use of writing conventions
- emphasize the importance of correct spelling in finished written products
- create a climate that engages all children as a community of literacy learners

What parents and family members can do

- continue to support children's learning and interest by visiting the library and bookstores with them
- find ways to highlight children's progress in reading and writing
- stay in regular contact with your child's teachers about activities and progress in reading and writing
- encourage children to use and enjoy print for many purposes (such as recipes, directions, games, and sports)
- build a love of language in all its forms and engage children in conversation

be celebrated and used as rich teaching and learning resources for all children.

Recommended teaching practices

During the infant and toddler years. Children need relationships with caring adults who engage in many one-on-one, face-to-face interactions with them to support their oral language development and lay the foundation for later literacy learning. Important experiences and teaching behaviors include but are not limited to

• talking to babies and toddlers with simple language, frequent eye contact, and responsiveness to children's cues and language attempts;

• frequently playing with, talking to, singing to, and doing fingerplays with very young children;

• sharing cardboard books with babies and frequently reading to toddlers on the adult's lap or together with one or two other children; and

• providing simple art materials such as crayons, markers, and large paper for toddlers to explore and manipulate.

During the preschool years. Young children need developmentally appropriate experiences and teaching to support literacy learning. These include but are not limited to

• positive, nurturing relationships with adults who engage in responsive conversations with individual children, model reading and writing behavior, and foster children's interest in and enjoyment of reading and writing;

• print-rich environments that provide opportunities and tools for children to see and use written language for a variety of purposes, with teachers' drawing children's attention to specific letters and words;

• adults' daily reading of high-quality books to individual children or small groups, including books that positively reflect children's identity, home language, and culture;

• opportunities for children to talk about what is read and to focus on the sounds and parts of language as well as the meaning;

• teaching strategies and experiences that develop phonemic awareness, such as songs, fingerplays, games, poems, and stories in which phonemic patterns such as rhyme and alliteration are salient;

• opportunities to engage in play that incorporates literacy tools, such as writing grocery lists in dramatic play, making signs in block building, and using icons and words in exploring a computer game; and

• firsthand experiences that expand children's vocabulary, such as trips in the community and exposure to various tools, objects and materials.

In kindergarten and primary grades. Teachers should continue many of these same good practices with the goal of continually advancing children's learning and development (see the continuum of reading and writing development on pp. 40–41 for appropriate grade-level expectations). In addition every child is entitled to excellent instruction in reading and writing that includes but is not limited to

• daily experiences of being read to and independently reading meaningful and engaging stories and informational texts;

• a balanced instructional program that includes systematic code instruction along with meaningful reading and writing activities;

• daily opportunities and teacher support to write many kinds of texts for different purposes, including stories, lists, messages to others, poems, reports, and responses to literature;

• writing experiences that allow the flexibility to use nonconventional forms of writing at first (invented or phonic spelling) and over time move to conventional forms;

• opportunities to work in small groups for focused instruction and collaboration with other children;

• an intellectually engaging and challenging curriculum that expands knowledge of the world and vocabulary; and

• adaptation of instructional strategies or more individualized instruction if the child fails to make expected progress in reading or when literacy skills are advanced.

Although experiences during the earliest years of life can have powerful long-term consequences, hu-

A continuum of reading and writing development is useful for identifying challenging but achievable goals or benchmarks for children's literacy learning, remembering that individual variation is to be expected and supported.

man beings are amazingly resilient and incredibly capable of learning throughout life. We should strengthen our resolve to ensure that every child has the benefit of positive early childhood experiences that support literacy development. At the same time, regardless of children's prior learning, schools have the responsibility to educate every child and to never give up even if later interventions must be more intensive and costly.

Recommended policies essential for achieving developmentally appropriate literacy experiences

Early childhood programs and elementary schools in America operate in widely differing contexts with varying levels of funding and resources. Regardless of the resources available, professionals have an ethical responsibility to teach, to the best of their ability, according to the standards of the profession. Nevertheless the kinds of practices advocated here are more likely to be implemented within an infrastructure of supportive policies and resources. IRA and NAEYC strongly recommend that the following policies be developed and adequately funded at the appropriate state or local levels:

1. *A comprehensive, consistent system of early childhood professional preparation and ongoing professional development* (see Darling-Hammond 1997; Kagan & Cohen 1997).

Such a professional preparation system is badly needed in every state to ensure that staff in early childhood programs and teachers in primary schools obtain specialized, college-level education that informs them about developmental patterns in early literacy learning and about research-based ways of teaching reading and writing during the early childhood years. On-going professional development is essential for teachers to stay current in an ever-expanding research base and to continually improve their teaching skills and the learning outcomes for children.

2. *Sufficient resources to ensure adequate ratios of qualified teachers to children and small groups for individualizing instruction.*

For four- and five-year-olds, adult-child ratios should be no more than 1 adult for 8 to 10 children, with a maximum group size of 20 (Howes, Phillips, & Whitebook 1992; Cost, Quality, and Child Outcomes Study Team 1995). Optimum class size in the early grades is 15 to 18 with one teacher (Nye et al. 1992; Nye, Boyd-Zaharias, & Fulton 1994). Young children benefit most from being taught in small groups or as individuals. There will always be a wide range of individual differences among children. Small class size increases the likelihood that teachers will be able to accommodate children's diverse abilities and interests, strengths and needs.

3. *Sufficient resources to ensure classroom, school, and public libraries that include a wide range of high-quality children's books, computer software, and multimedia resources at various levels of difficulty and reflecting various cultural and family backgrounds.*

Studies have found that a minimum of five books per child is necessary to provide even the most basic print-rich environment (Morrow & Weinstein 1986; Neuman & Roskos 1997). Computers and developmentally appropriate software should also be available to provide alternative, engaging, enriching literacy experiences (NAEYC 1996b).

4. *Policies that promote children's continuous learning progress.*

When individual children do not make expected progress in literacy development, resources should be available to provide more individualized instruction, focused time, tutoring by trained and qualified tutors, or other individualized intervention strategies. These instructional strategies are used to accelerate children's learning instead of either grade retention or social promotion, neither of which has been proven effective in improving children's achievement (Shepard & Smith 1988).

5. *Appropriate assessment strategies that promote children's learning and development.*

Teachers need to regularly and systematically use multiple indicators—observation of children's oral language, evaluation of children's work, and performance at authentic reading and writing tasks—to assess and monitor children's progress in reading and writing development, plan and adapt instruction, and communicate with parents (Shepard, Kagan, & Wurtz 1998). Group-administered, multiple-choice standardized achievement tests in reading and writing skills should not be used before third grade or preferably even before fourth grade. The younger the child, the more difficult it is to obtain valid and reliable indices of his or her development and learning using one-time test administrations. Standardized testing has a legitimate function, but on its own it tends to lead to standardized teaching—one approach fits all—the opposite of the kind of individualized diagnosis and teaching that is needed to help young children continue to progress in reading and writing.

Competence is not tied to any particular language, dialect, or culture. Teachers should never use a child's dialect, language, or culture as a basis for making judgments about the child's intellect or capability.

6. Access to regular, ongoing health care for every child.

Every young child needs to have a regular health care provider as well as screening for early diagnosis and treatment of vision and hearing problems. Chronic untreated middle-ear infections in the earliest years of life may delay language development, which in turn may delay reading development (Vernon-Feagans, Emanuel, & Blood 1992). Similarly, vision problems should never be allowed to go uncorrected, causing a child difficulty with reading and writing.

7. Increased public investment to ensure access to high-quality preschool and child care programs for all children who need them.

The National Academy of Sciences (Snow, Burns, & Griffin 1998) and decades of longitudinal research (see for example, Barnett 1995) demonstrate the benefits of preschool education for literacy learning. Unfortunately, there is no system to ensure accessible, affordable, high-quality early childhood education programs for all families who choose to use them (Kagan & Cohen 1997). As a result, preschool attendance varies considerably by family income; for example, 80% of four-year-olds whose families earn more than $50,000 per year attend preschool compared to approximately 50% of four-year-olds attending preschool from families earning less than $20,000 (NCES 1996). In addition, due primarily to inadequate funding, the quality of preschool and child care programs varies considerably, with studies finding that the majority of programs provide only mediocre quality and that only about 15% rate as good quality (Layzer, Goodson, & Moss 1993; Galinsky et al. 1994; Cost, Quality, & Child Outcomes Study Team 1995).

Conclusion

Collaboration between IRA and NAEYC is symbolic of the coming together of the two essential bodies of knowledge necessary to support literacy development of young children: knowledge about the processes of reading and writing and knowledge of child development and learning. Developmentally appropriate practices (Bredekamp & Copple 1997) in reading and writing are ways of teaching that consider

1. what is generally known about children's development and learning to set achievable but challenging goals for literacy learning and to plan learning experiences and teaching strategies that vary with the age and experience of the learners;

2. results of ongoing assessment of individual children's progress in reading and writing to plan next steps or to adapt instruction when children fail to make expected progress or are at advanced levels; and

3. social and cultural contexts in which children live so as to help them make sense of their learning experiences in relation to what they already know and are able to do.

To teach in developmentally appropriate ways, teachers must understand *both* the continuum of reading and writing development *and* children's individual and cultural variations. Teachers must recognize when variation is within the typical range and when intervention is necessary, because early intervention is more effective and less costly than later remediation.

Learning to read and write is one of the most important and powerful achievements in life. Its value is clearly seen in the faces of young children—the proud, confident smile of the capable reader contrasts sharply with the furrowed brow and sullen frown of the discouraged nonreader. Ensuring that all young children reach their potentials as readers and writers is the shared responsibility of teachers, administrators, families, and communities. Educators have a special responsibility to teach every child and not to blame children, families, or each other when the task is difficult. All responsible adults need to work together to help children become competent readers and writers.

References

Adams, M. 1990. *Beginning to read.* Cambridge, MA: MIT Press.

Anbar, A. 1986. Reading acquisition of preschool children without systematic instruction. *Early Childhood Research Quarterly* 1: 69–83.

Anderson, R.C. 1995. *Research foundations for wide reading.* Paper presented at invitational conference on The Impact of Wide Reading at Center for the Study of Reading, Urbana, IL.

Applebee, A.N. 1977. Writing and reading. *Language Arts* 20: 534–37.

Barnett, W.S. 1995. Long-term effects of early childhood programs on cognitive and school outcomes. *The Future of Children* 5: 25–50.

Barron, R.W. 1980. Visual and phonological strategies in reading and spelling. In *Cognitive processes in spelling*, ed. U. Frith, 339–53. New York: Academic.

Berk, L. 1996. *Infants and children: Prenatal through middle childhood.* 2d ed. Boston: Allyn & Bacon.

Bissex, G. 1980. *GNYS at work: A child learns to write and read.* Cambridge, MA: Harvard University Press.

Bond, G., & R. Dykstra. 1967. The cooperative research program in first-grade reading instruction. *Reading Research Quarterly* 2: 5–142.

Bradley, L., & P.E. Bryant. 1983. Categorizing sounds and learning to read—A causal connection. *Nature* 301: 419–21.

Bredekamp, S., & C. Copple, eds. 1997. *Developmentally appropriate practice in early childhood programs.* Rev. ed. Washington, DC: NAEYC.

Brown, A.L., & J.S. DeLoache. 1978. Skills, plans and self-regulation. In *Children's thinking: What develops?* ed. R. Siegler, 3–36. Hillsdale, NJ: Erlbaum.

Bryant, P.E., M. MacLean, L. Bradley, & J. Crossland. 1990. Rhyme and alliteration, phoneme detection, and learning to read. *Developmental Psychology* 26: 429–38.

Bryne, B., & R. Fielding-Barnsley. 1991. Evaluation of a program to teach phonemic awareness to young children. *Journal of Educational Psychology* 83: 451–55.

Bryne, B., & R. Fielding-Barnsley. 1993. Evaluation of a program to teach phonemic awareness to young children: A 1-year follow-up. *Journal of Educational Psychology* 85: 104–11.

Bryne, B., & R. Fielding-Barnsley. 1995. Evaluation of a program to teach phonemic awareness to young children: A 2- and 3-year follow-up and a new preschool trial. *Journal of Educational Psychology* 87: 488–503.

Bus, A., J. Belsky, M.H. van IJzendoorn, & K. Crnic. 1997. Attachment and book-reading patterns: A study of mothers, fathers, and their toddlers. *Early Childhood Research Quarterly* 12: 81–98.

Bus, A., & M. Van IJzendoorn. 1995. Mothers reading to their 3-year-olds: The role of mother-child attachment security in becoming literate. *Reading Research Quarterly* 30: 998–1015.

Bus, A., M. Van IJzendoorn, & A. Pellegrini. 1995. Joint book reading makes for success in learning to read: A meta-analysis on intergenerational transmission of literacy. *Review of Educational Research* 65: 1–21.

Chomsky, C. 1979. Approaching reading through invented spelling. In *Theory and practice of early reading,* vol. 2, eds. L.B. Resnick & P.A. Weaver, 43–65. Hillsdale, NJ: Erlbaum.

Clarke, L. 1988. Invented versus traditional spelling in first graders' writings: Effects on learning to spell and read. *Research in the Teaching of English* 22: 281–309.

Clay, M. 1975. *What did I write?* Portsmouth, NH: Heinemann.

Clay, M. 1979. *The early detection of reading difficulties.* Portsmouth, NH: Heinemann.

Clay, M. 1991. *Becoming literate.* Portsmouth, NH: Heinemann.

Cost, Quality, and Child Outcomes Study Team. 1995. *Cost, quality, and child outcomes in child care centers, public report.* 2d ed. Denver: Economics Department, University of Colorado, Denver.

Cummins, J. 1979. Linguistic interdependence and the educational development of bilingual children. *Review of Educational Research* 49: 222–51.

Cunningham, A. 1990. Explicit versus implicit instruction in phonemic awareness. *Journal of Experimental Child Psychology* 50: 429–44.

Darling-Hammond, L. 1997. *Doing what matters most: Investing in quality teaching.* New York: National Commission on Teaching and America's Future.

DEC/CEC (Division for Early Childhood of the Council for Exceptional Children). 1994. Position on inclusion. *Young Children* 49 (5): 78.

DEC (Division for Early Childhood) Task Force on Recommended Practices. 1993. *DEC recommended practices: Indicators of quality in programs for infants and young children with special needs and their families.* Reston, VA: Council for Exceptional Children.

Dickinson, D., & M. Smith. 1994. Long-term effects of preschool teachers' book readings on low-income children's vocabulary and story comprehension. *Reading Research Quarterly* 29: 104–22.

Domico, M.A. 1993. Patterns of development in narrative stories of emergent writers. In *Examining central issues in literacy research, theory, and practice,* eds. C. Kinzer & D. Leu, 391–404. Chicago: National Reading Conference.

Durkin, D. 1966. *Children who read early.* New York: Teachers College Press.

Durrell, D.D., & J.H. Catterson. 1980. *Durrell analysis of reading difficulty.* Rev. ed. New York: Psychological Corp.

Dyson, A.H. 1988. Appreciate the drawing and dictating of young children. *Young Children* 43 (3): 25–32.

Education Department of Western Australia. 1994. *Reading, writing, spelling, verbal language developmental continuum.* Portsmouth, NH: Heinemann.

Ehri, L. 1994. Development of the ability to read words: Update. In *Theoretical models and processes of reading,* eds. R. Ruddell, M.R. Ruddell, & H. Singer, 323–58. Newark, DE: International Reading Association.

Ehri, L.C., & C. Robbins. 1992. Beginners need some decoding skill to read words by analogy. *Reading Research Quarterly* 27: 13–26.

Ehri, L., & J. Sweet. 1991. Finger-point reading of memorized text: What enables beginners to process the print? *Reading Research Quarterly* 26: 442–61.

Elkonin, D.B. 1973. USSR. In *Comparative Reading,* ed. J. Downing, 551–80. New York: Macmillian.

Eller, R., C. Pappas, & E. Brown. 1988. The lexical development of kindergartners: Learning from written context. *Journal of Reading Behavior* 20: 5–24.

Elley, W. 1989. Vocabulary acquisition from listening to stories. *Reading Research Quarterly* 24: 174–87.

Feitelson, D., B. Kita, & Z. Goldstein. 1986. Effects of listening to series stories on first graders' comprehension and use of language. *Research in the Teaching of English* 20: 339–55.

Foorman, B., D. Novy, D. Francis, & D. Liberman. 1991. How letter-sound instruction mediates progress in first-grade reading and spelling. *Journal of Educational Psychology* 83: 456–69.

Galinsky, E., C. Howes, S. Kontos, & M. Shinn. 1994. *The study of children in family child care and relative care: Highlights of findings.* New York: Families and Work Institute.

Gibson, E., & E. Levin. 1975. *The psychology of reading.* Cambridge, MA: MIT Press.

Graves, D. 1983. *Writing: Teachers and children at work.* Portsmouth, NH: Heinemann.

Hakuta, K., & E. Garcia. 1989. Bilingualism and education. *American Psychologist* 44: 374–79.

Hannon, P. 1995. *Literacy, home and school.* London: Falmer.

Hanson, R., & D. Farrell. 1995. The long-term effects on high school seniors of learning to read in kindergarten. *Reading Research Quarterly* 30: 908–33.

Hart, B., & T. Risley. 1995. *Meaningful differences.* Baltimore: Paul Brookes.

Henderson, E.H., & J.W. Beers. 1980. *Developmental and cognitive aspects of learning to spell.* Newark, DE: International Reading Association,

Holdaway, D. 1979. *The foundations of literacy .* Portsmouth, NH: Heinemann.

Howes, C., D.A. Phillips, & M. Whitebook. 1992. Thresholds of quality: Implications for the social development of children in center-based child care. *Child Development* 63: 449–60.

IRA (International Reading Association). 1998. *Phonics in the early reading program: A position statement.* Newark, DE: Author.

Johnston, P. 1997. *Knowing literacy: Constructive literacy assessment.* York, ME: Stenhouse.

Juel, C. 1991. Beginning reading. In *Handbook of reading research,* vol. 2, eds. R. Barr, M. Kamil, P. Mosenthal, & P.D. Pearson, 759–88. New York: Longman.

Juel, C., P.L. Griffith, & P. Gough. 1986. Acquisition of literacy: A longitudinal study of children in first and second grade. *Journal of Educational Psychology* 78: 243–55.

Kagan, S.L., & N. Cohen. 1997. *Not by chance: Creating an early care and education system for America's children.* New Haven, CT: Bush Center in Child Development and Social Policy, Yale University.

Karweit, N., & B. Wasik. 1996. The effects of story reading programs on literacy and language development of disadvantaged pre-schoolers. *Journal of Education for Students Placed At-Risk* 4: 319–48.

Katz, L., & C. Chard. 1989. *Engaging children's minds.* Norwood, NJ: Ablex.

Layzer, J., B. Goodson, & M. Moss. 1993. *Life in preschool: Volume one of an observational study of early childhood programs for disadvantaged four-year-olds.* Cambridge, MA: Abt Associates.

Leung, C.B., & J.J. Pikulski. 1990. Incidental learning of word meanings by kindergarten and first grade children thorough repeated read aloud events. In *Literacy theory and research: Analyses from multiple paradigms*, eds. J. Zutell & S. McCormick, 231–40. Chicago: National Reading Conference.

Lundberg, I., J. Frost, & O.P. Petersen. 1988. Effects of an extensive program for stimulating phonological awareness in preschool children. *Reading Research Quarterly* 23: 263–84.

Maclean, M., P. Bryant, & L. Bradley. 1987. Rhymes, nursery rhymes, and reading in early childhood. *Merrill-Palmer Quarterly* 33: 255–81.

Mason, J. 1980. When do children begin to read: An exploration of four-year-old children's word reading competencies. *Reading Research Quarterly* 15: 203–27.

Mason, J., & S. Sinha. 1993. Emerging literacy in the early childhood years: Applying a Vygotskian model of learning and development. In *Handbook of research on the education of young children*, ed. B. Spodek, 137–50. New York: Macmillian.

McGee, L., R. Lomax, & M. Head. 1988. Young children's written language knowledge: What environmental and functional print reading reveals. *Journal of Reading Behavior* 20: 99–118.

McGee, L., & D. Richgels. 1996. *Literacy's beginnings*. Boston: Allyn & Bacon.

McGill-Franzen, A., & C. Lanford. 1994. Exposing the edge of the preschool curriculum: Teachers' talk about text and children's literary understandings. *Language Arts* 71: 264–73.

Morrow, L.M. 1988. Young children's responses to one-to-one readings in school settings. *Reading Research Quarterly* 23: 89–107.

Morrow, L.M. 1990. Preparing the classroom environment to promote literacy during play. *Early Childhood Research Quarterly* 5: 537–54.

Morrow, L.M., D. Strickland, & D.G. Woo. 1998. *Literacy instruction in half- and whole-day kindergarten*. Newark, DE: International Reading Association.

Morrow, L.M., & C. Weinstein. 1986. Encouraging voluntary reading: The impact of a literature program on children's use of library centers. *Reading Research Quarterly* 21: 330–46.

Moyer, S.B. 1982. Repeated reading. *Journal of Learning Disabilities* 15: 619–23.

NAEYC. 1996a. NAEYC position statement: Responding to linguistic and cultural diversity—Recommendations for effective early childhood education. *Young Children* 51 (2): 4–12.

NAEYC. 1996b. NAEYC position statement: Technology and young children—Ages three through eight. *Young Children* 51 (6): 11–16.

NCES (National Center for Education Statistics). 1996. *The condition of education*. Washington, DC: U.S. Department of Education.

Neuman, S.B., & K. Roskos. 1992. Literacy objects as cultural tools: Effects on children's literacy behaviors in play. *Reading Research Quarterly* 27: 202–25.

Neuman, S.B., & K. Roskos. 1993. Access to print for children of poverty: Differential effects of adult mediation and literacy-enriched play settings on environmental and functional print tasks. *American Educational Research Journal* 30: 95–122.

Neuman, S.B., & K. Roskos. 1997. Literacy knowledge in practice: Contexts of participation for young writers and readers. *Reading Research Quarterly* 32: 10–32.

Nye, B.A., J. Boyd-Zaharias, & B.D. Fulton. 1994. *The lasting benefits study: A continuing analysis of the effect of small class size in kindergarten through third grade on student achievement test scores in subsequent grade levels—seventh grade (1992–93), technical report*. Nashville: Center of Excellence for Research in Basic Skills, Tennessee State University.

Nye, B.A., J. Boyd-Zaharias, B.D. Fulton, & M.P. Wallenhorst. 1992. Smaller classes really are better. *The American School Board Journal* 179 (5): 31–33.

Pappas, C. 1991. Young children's strategies in learning the "book language" of information books. *Discourse Processes* 14: 203–25.

Read, C. 1971. Pre-school children's knowledge of English phonology. *Harvard Educational Review* 41: 1–34.

Richgels, D.J. 1986. Beginning first graders' "invented spelling" ability and their performance in functional classroom writing activities. *Early Childhood Research Quarterly* 1: 85–97.

Richgels, D.J. 1995. Invented spelling ability and printed word learning in kindergarten. *Reading Research Quarterly* 30: 96–109.

Riley, J. 1996. *The teaching of reading*. London: Paul Chapman.

Roberts, B. In press. "I No EverethENGe": What skills are essential in early literacy? In *Children achieving: Best practices in early literacy*, eds. S.B. Neuman & K. Roskos. Newark, DE: International Reading Association.

Rowe, D.W. 1994. *Preschoolers as authors*. Cresskill, NJ: Hampton.

Samuels, S.J. 1979. The method of repeated readings. *The Reading Teacher* 32: 403–08.

Shepard, L. 1994. The challenges of assessing young children appropriately. *Phi Delta Kappan* 76: 206–13.

Shepard, L., S.L. Kagan, & E. Wurtz, eds. 1998. *Principles and recommendations for early childhood assessments*. Washington, DC: National Education Goals Panel.

Shepard, L., & M.L. Smith. 1988. Escalating academic demand in kindergarten: Some nonsolutions. *Elementary School Journal* 89: 135–46.

Shepard, L., & M.L. Smith. 1989. *Flunking grades: Research and policies on retention*. Bristol, PA: Taylor & Francis.

Smilansky, S., & L. Shefatya. 1990. *Facilitating play: A medium for promoting cognitive, socio-emotional and academi : development in young children*. Gaithersburg, MD: Psycholsocial & Educational Publications.

Snow, C. 1991. The theoretical basis for relationships between language and literacy in development. *Journal of Research in Childhood Education* 6: 5–10.

Snow, C., M.S. Burns, & P. Griffin. 1998. *Preventing reading difficulties in young children*. Washington, DC: National Academy Press.

Snow, C., P. Tabors, P. Nicholson, & B. Kurland. 1995. SHELL: Oral language and early literacy skills in kindergarten and first-grade children. *Journal of Research in Childhood Education* 10: 37–48.

Stanovich, K.E. 1986. Matthew effects in reading: Some consequences of individual differences in the acquisition of literacy. *Reading Research Quarterly* 21: 360–406.

Stanovich, K.E., & R.F. West. 1989. Exposure to print and orthographic processing. *Reading Research Quarterly* 24: 402–33.

Stauffer, R. 1970. *The language experience approach to the teaching of reading*. New York: Harper & Row.

Strickland, D. 1994. Educating African American learners at risk: Finding a better way. *Language Arts* 71: 328–36.

Sulzby, E. 1985. Kindergartners as writers and readers. In *Advances in writing research*, ed. M.Farr, 127–99. Norwood, NJ: Ablex.

Teale, W. 1984. Reading to young children: Its significance for literacy development. In *Awakening to literacy*, eds. H. Goelman, A. Oberg, & F. Smith, 110–21. Portsmouth, NH: Heinemann.

Tierney, R., & T. Shanahan. 1991. Research on the reading-writing relationship: Interactions, transactions, and outcomes. In *Handbook on reading research*, vol. 2, eds. R. Barr, M. Kamil, P. Mosenthal, & P.D. Pearson, 246–80. New York: Longman.

Vernon-Feagans, L., D. Emanuel, & I. Blood. 1992. About middle ear problems: The effect of otitis media and quality of day care on children's language development. *Journal of Applied Developmental Psychology* 18: 395–409.

Vukelich, C. 1994. Effects of play interventions on young children's reading of environmental print. *Early Childhood Research Quarterly* 9: 153–70.

Wagner, R., & J. Torgesen. 1987. The nature of phonological processing and its causal role in the acquisition of reading skills. *Psychological Bulletin* 101: 192–212.

Wells, G. 1985. *The meaning makers*. Portsmouth, NH: Heinemann.

Whitehurst, G., D. Arnold, J. Epstein, A. Angell, M. Smith, & J. Fischel. 1994. A picture book reading intervention in day care and home for children from low-income families. *Developmental Psychology* 30: 679–89.

Whitmore, K., & Y. Goodman. 1995. Transforming curriculum in language and literacy. In *Reaching potentials: Transforming early childhood curriculum and assessment*, vol. 2, eds. S. Bredekamp & T. Rosegrant. Washington, DC: NAEYC.

Wong Fillmore, L. 1991. When learning a second language means losing the first. *Early Childhood Research Quarterly* 6: 323–46.

Glossary

accountability

Holding teachers, schools, and school districts responsible for student outcomes through various accounting systems, including the use of standardized tests.

aggregated data

An assemblage of student (or class) products and other ongoing assessment information brought together to establish a holistic view of student progress toward stated goals.

analysis paralysis

Attending to excessive detail, which results in the inability to function effectively or to attend to the more important aspects of a situation.

anti-bias curricula and pedagogy

Curricula, materials, and teaching strategies that challenge prejudice and stereotyping biases and help all children regardless of race, gender, or ableness to construct positive identities and a sense of personal efficacy.

archival portfolio

A portfolio in which representative selections from and information about the student is maintained over time.

assessment

The use of multiple measures and techniques to obtain evidence of student development and learning.

at-risk

Children whose prenatal or early environments, experiences, or health conditions presuppose less than optimal physical/motor, psychosocial, cognitive, language development, or academic success.

audiometric assessment

Hearing assessment using an audiometer, a machine that produces sounds of varying frequencies and volumes emitted through headphones worn by the child, who is instructed to indicate when sounds are heard or not heard.

authentic assessment

Assessment derived from learning processes, and student products emerging from meaningful, relevant, and developmentally appropriate curriculums.

autonomy

A sense of self-government and independence.

axon

The core of a nerve fiber through which impulses are conducted.

benchmark

A standard based on research evidence by which changes in children's development and learning are noted or marked, thereby providing teachers with direction in facilitating the next step in children's learning.

bias

A particular preference, inclination, point of view, or philosophy that impedes impartial perspectives and judgment; a lack of objectivity.

bilingualism

Proficiency in two languages.

cognitive-interactionist theory

A theory that emphasizes the interaction of heredity and environment in the cognitive development of the individual.

cognitive processes
The mental activities involved in thinking and making meaning.

communicative congruence
The degree to which communication between individuals is consistently understood.

context
The circumstances of time, place, people, activity, philosophical, physical, and psychological characteristics and conditions that surround an event.

context-responsive assessment
Assessment that takes into account the various influencing elements in a situation or event and responds appropriately based on this information.

criterion-referenced assessment
Determining where a learner stands in relation to a criterion or standard rather than to a comparative group of other learners.

critical (or sensitive) period
A period of time when there is increased potential for development, learning, or consolidation of previously learned skills and knowledge.

culture group
A socially constructed group in which members recognize and share attitudes and value systems relating to knowledge, norms of behavior, learning styles, social roles, and so on and through which a sense of identity emerges.

culturally responsive pedagogy
Instruction adapted to take into account various cultural values, behaviors, and ways of learning.

curriculum integration
The incorporation of more than one subject matter, content, or skill area into thematic units, project work, or other academic experiences.

dendrite
A branching part of a nerve cell that carries impulses toward the cell body.

developmentally appropriate
Expectations and practices based on what is known about child growth and development.

developmental diversity
Refers to the possible range of growth and ability characteristics among individuals within the same chronological age range.

developmental screening
A process of large-scale assessment using standardized procedures to identify individuals who might benefit from further more specific assessment.

diagnostic testing
A process that usually involves several tests and assessment procedures to compile and categorize physical/motor, psychological, social, and/or academic symptoms and characteristics for the purpose of identifying specific conditions and prescribing appropriate intervention or remediation. Diagnostic testing is usually performed by a medical doctor or licensed diagnostician.

dialects
Ways of speaking associated with region, ethnic or cultural groups, gender, age, and social class that have distinctive linguistic features (syntactic, semantic, and phonetic).

dispositions
Various attitudes and personality traits such as curiosity, creativity, resourcefulness, responsibility, initiative, interests, effort, challenge seeking, and so on considered important for effective thinking and learning; sometimes referred to as *habits of mind*.

downshifting
A psychophysiological response to perceived threat which is accompanied by a sense of helplessness or lack of self-efficacy.

emergent development
The concept that growth, development, and learning are continually changing and progressing toward more mature or sophisticated forms.

English as a Second Language (ESL)
Refers to individuals whose first language is other than English.

ethnicity
Refers to a particular group's shared heritage, which generally includes a common history with distinctive traditions and celebrations. Ethnic groups generally speak a common language and often share common religious beliefs.

5-to-7 shift
The age range when most children begin to move into new areas of cognitive processing.

formative evaluation
Assessment of student learning that takes place as learning occurs, and is used to inform current instructional practices.

gifted and talented
Individuals who show exceptional ability or functioning in intellectual, creative, artistic, leadership, or specific academic fields.

glial cells
Cells found in the nervous system that support and insulate neurons.

high-stakes tests
Tests for which significant (life-influencing) decisions, such as group or grade placement, assignment to special programs, promotion, and retention are made based on an individual's score. Sometimes scores on high stakes tests are used to rank schools, teachers, and school districts, and allocation of public funds are tied to rankings.

inclusion
Providing education for students with disabilities in general education settings.

individualized education plan (IEP)
A written plan for the education of a student with disabilities that follows procedures for development and implementation that have been set forth by federal legislation.

individual family service plan (IFSP)
A written plan of child and family needs, outcomes to be achieved, and the specific services that will be provided. Its development usually involves the family and must meet criteria established by federal law.

industry
The developing sense of mastery of physical, social, and academic skills that leads to feelings of self-reliance and self-assurance.

inference
A conclusion based on logic that suggests explanations, reasons, or causes for behaviors or events.

initiative
The use of a sense of autonomy to initiate and pursue ideas, interests, activities, and interactions.

inquiry
The process of understanding the common attributes across events, concepts, objects, and people

and adapting personal knowledge to more adult-like approaches to thinking and behaving.

integrated day model
The use of children's questions, interests, and social interaction to develop themes or projects that promote cognitive, language, aesthetic, and psychomotor growth and attainment of basic skills.

integrated language arts
Integration of the various components of the language arts—reading, writing, speaking, and listening—as well as integration of these language arts processes across the curriculum.

interdisciplinary unit
Periodic course of study about a topic or theme incorporating the disciplines of language arts, math, social studies, sciences, theater arts, and physical education.

interrater reliability
The degree to which two or more observers are in agreement with what was observed. The higher the agreement between observers' accounts, judgments, and inferences, the higher the interrater reliability.

intervention
Strategies or activities, (such as medical or psychological treatment, speech–language therapy, providing adaptive equipment, modifying the physical environment, accessing and advocating for appropriate resources and policies) designed to facilitate optimal development in children with special needs.

kid-watching
Informal, ongoing teacher observation of children in a variety of situations within the classroom and school, including the lunchroom, outdoor learning center, and transition times.

learning styles
Individual variations in preferred, or most efficient modalities and contexts of learning.

least restrictive environment
A learning environment in which children with disabilities are allowed to participate to the extent possible while still having their special needs met.

limited English proficiency
Lack of facility with the English language.

mediator
An adult or more astute child who facilitates broader understandings and helps establish concepts important in children's learning.

microcultural group
Groups to which all individuals belong such as gender, social class, race, ethnicity, ableness, religion, and region.

multiple intelligences
The theory that there are many more kinds of intelligences than typically emphasized in traditional school curriculums and measures of performance.

neuron
A nerve cell and its connections; the basic functional unit of the nervous system.

neurotransmitters
Chemicals that carry messages from one cell to another across the synapse.

nonverbal behavior
Communicative style (both intentional and nonintentional) that include gestures, facial expressions, physical distance, and posture.

normative group
The sample of test-takers whose scores are used to establish the "norms" with which subsequent test-takers scores are compared.

objectivity
Refers to the ability of the assessor to derive data and information about a student that is free of personal feelings or biases.

performance assessment
A general term for assessment of students' processes, products, demonstrations, exhibitions, or other overt evidences of learning.

performance standard
An established level of achievement, quality of performance, or level of proficiency that specifies what a student is supposed to know and be able to do at given points in time.

process portfolio
A method of collecting products of and documenting the emerging processes of children's learning.

problem solving/social decision making
The process by which children identify a problem and make decisions about how to solve the problem based on legitimate issues or situations that are meaningful to them.

prosocial behavior
Behaviors that are beneficial to others, such as sharing, helping, comforting, and defending.

psychosocial theory
A theory that emphasizes social and cultural influences on personality development.

random sample
A sample (objects, events, people) drawn from a population in such an unbiased manner as to assure that each member has an equal chance of being selected.

readiness
A developmental state in which the child is believed to be able to succeed with a particular learning requirement.

reflective thinking
The act of thinking about and giving careful consideration to various aspects of an experience or event, which can lead to deeper understanding and sometimes changed perspectives.

reliability
The consistency with which various tests or assessment strategies produce the same or similar results for an individual from one administration to the next.

rubrics
A list of descriptions or characteristics for each of the points on a fixed scale.

scaffold
A process by which an adult or more skilled child facilitates the acquisition of knowledge or skills in the learner through coaching or providing needed information.

self-efficacy
Is the feeling that what one does matters, and that one's efforts are worthwhile and effective.

social registers
A particular form of speech that is employed with certain listeners or in certain social settings.

speech networks
Groups of people who share similar ideas about the styles and uses of communication.

stakeholder
Individuals who have a substantial interest in the outcomes of school and student perfor-

mance—students, teachers, administrators, parents, policymakers.

standardized test
An instrument administered under prescribed conditions and scored in a predetermined manner, the scores from which are compared to those of a representative sample of a particular population, i.e., a certain age, grade, geographic location, or other definable group.

standards
Outcome statements that specify what children should know and be able to do.

summative evaluation
Summary information concerned with broad outcomes attained over time and usually compiled three times during the school year for use in collaborating with students and parents and providing summary reports for school or district evaluations.

synapse
The point of electrical and chemical interaction and contact between two neurons or between a neuron and a muscle fiber.

thematic units or projects
Learning experiences organized around a central idea or theme that reflects the integration of the subject matter content of the curriculum or developmental domains.

triangulated
Refers to merging information from several assessment strategies to reach a conclusion or draw inferences; is better than relying on one measure.

validity
The degree to which a procedure or test measures what it purports to measure.

verbal mismatch
Recurrent miscommunication between speakers of different languages, dialects, or social registers.

zone of proximal development (ZPD)
The level of development in learning a particular concept or skill in which assistance from an adult or more skilled child is needed but may soon be unnecessary.

References

Abbott, J. (1997). To be intelligent. *Education Leadership, 54*(6), 6–10.

American Academy of Pediatrics (1995, March). The inappropriate use of school "readiness" tests. *Pediatrics, 95*(3), 437–438.

American Association for the Advancement of Science. (1993). *Project 2061: Benchmarks for science literacy.* New York: Oxford University Press.

American Association for the Advancement of Science. (1990). *Science for all Americans.* New York: Oxford University Press.

American Association of University Women. (1992). *How schools shortchange girls.* Washington, DC: AAUW Educational Foundation.

American Educational Research Association, American Psychological Association, & National Council on Measurement in Education. (1985). *Standards for educational and psychological testing.* Washington, DC: Author.

American Federation of Teachers (1996). *Making standards matter: An annual fifty-state report on efforts to raise academic standards,* Washington, DC: Author.

Au, K. H., & Kawakami, A. J. (1994). Cultural congruence in instruction. In E. R. Hollins, J. E. King, & W. C. Hayman (Eds.). *Teaching diverse populations: Formulating a knowledge base.* Albany, NY: State University of New York Press.

Au, K. H., & Kawakami, A. J. (1991). Culture and ownership: Schooling minority students. *Childhood Education, 67,* 280–284.

Au, K. H., & Mason, J. M. (1981). Social organizational factors in learning to read: The balance of rights hypothesis. *Reading Research Quarterly, 17,* 115–152.

Au, K. H., & Mason, J. M. (1983). Cultural congruence in classroom participation structures: Achieving a balance of rights. *Discourse Processes, 6*(2), 145–167.

Ayers, J. (1991). *Sensory integration and learning disorders.* Los Angeles: Western Psychological Services.

Bandura, A. (1977). Self-efficacy: Toward a unifying theory of behavioral change. *Psychological Review, 84,* 191–215.

Banks, J. A. (1988). *Multiethnic education: Theory and practice,* (2nd ed.). Boston: Allyn & Bacon, Inc.

Baugh, J. (1983). *Black street speech: Its history, structure, and survival.* Austin, TX: University of Texas Press.

Baumrind, D. (1972). Socialization and instrumental competence in young children. In W. W. Hartup (Ed.). *The young child: Reviews of research,* (Vol. 2, pp. 202–224). Washington, DC: National Association for the Education of Young Children.

Bayer, A. S. (1990). *Collaborative apprenticeship learning: Language and thinking across the curriculum, K–12.* Mountain View, CA: Mayfield.

Beaty, J. J. (1998). *Observing development of the young child* (4th ed.). Upper Saddle River, NJ: Merrill/Prentice Hall.

Beers, C. S., & Beers, J. W. (1980). Early identification of learning disabilities: Facts and fallacies. *Elementary School Journal, 81,* 62–76.

Bentzen, W. R. (1993). *Seeing young children: A guide to observing and recording behavior.* Albany, NY: Delmar.

Berger, E. H. (1995). *Parents as partners in education.* (4th ed.). Upper Saddle River, NJ: Merrill/Prentice Hall.

Berk, L. E., & Winsler, A. (1995). *Scaffolding children's learning: Vygotsky and early childhood education. Washington,* DC: National Association for the Education of Young Children.

Black, J., & Puckett, M. (in press). *The young child: Development from prebirth through age eight.* (3rd ed.). Upper Saddle River, NJ: Merrill/Prentice Hall.

Bloom, B. S. (Ed.). (1985). *Developing talent in young people.* New York: Ballantine.

Boggs, C. (Ed.). 1990. *The cued speech journal.* Raleigh, NC: National Cued Speech Association.

Bohler, S. K., Eichenlaub, K. L., Litteken, S. D., & Wallis, D. A. (1996). Identifying and supporting low-literate parents. *The Reading Teacher 50*(1) 77–79.D

Bordrova, E., & Leong, D. J. (1996). *Tools of the mind: The Vygotskian approach to early childhood education.* Upper Saddle River, NJ: Merrill/Prentice Hall.

Borysenko, J. (1987). *Minding the body, mending the mind.* Reading, MA: Addison–Wesley.

Boyer, E. L. (1991). *Ready to learn: A mandate for the nation.* Princeton NJ: Carnegie Foundation for the Advancement of Teaching.

Bradbard, M. R., Endsley, R. C., & Mize, J. (1992). The ecology of parent–child communications about daily experiences in preschool and day care. *Journal of Research in Childhood Education, 6,* 131–141.

Brandt, R. (1992). On performance assessment: A conversation with Grant Wiggins. *Educational Leadership, 49*(8), 35–37.

Bredekamp, S. (Ed.). (1987). *Developmentally appropriate practice in early childhood programs serving children from birth through age eight* (Exp. ed.). Washington, DC: NAEYC.

Bredekamp, S., & Copple, C. (1997). *Developmentally appropriate practice in early childhood programs.* Washington, DC: NAEYC.

Bredekamp, S., & Rosegrant, T. (Eds.) (1992). *Reaching potentials: Appropriate curriculums and assessment for young children, Vol. 1.* Washington, DC: NAEYC.

Bredekamp, S., & Rosegrant, T. (Eds.). (1995) *Reaching potentials: Transforming early childhood curriculum and assessment, Vol. 2.* Washington, DC: NAEYC.

Bredekamp, S., & Shepard, L. (1989). How to best protect children from inappropriate school expectations, practices, and policies. *Young Children, 44*(3), 14–24.

British Columbia Ministry of Education (1990). *The primary program resource document.* Victoria, British Columbia: Author.

British Columbia Ministry of Education. (1991). *Supporting learning: Understanding and assessing the progress of children in the primary program.* Victoria, British Columbia: Author.

Bronfenbrenner, U. (1986). Ecology of the family as a context for human development: Research perspectives. *Developmental Psychology, 22,* 723–742.

Bronfenbrenner, U. (1989). Ecological systems theory. In R. Vasta (Ed.). *Six theories of child development: Revised formulations and current issues. Annals of Child Development, 6* (pp. 187–249). Greenwich, CN: JAI.

Brooks-Gunn, J., & Duncan, G. J. (1997, Summer/Fall). *The future of children: Children and poverty.* Los Altos, CA: Center for the Future of Children, The David and Lucile Packard Foundation.

Brophy, J. (1983). Conceptualizing student motivation. *Education Psychologist, 18*(3), 200–215.

Brophy, J. (1992). Probing the subtleties of subject matter teaching. *Educational Leadership, 49*(7), 4–8.

Brown, W. H., & Conroy, M. A. (1997). *Including and supporting preschool children with developmental delays in the early childhood classroom.* Little Rock, AR: Southern Early Childhood Association.

Bruner J. (1978). The role of dialogue in language acquisition. In A. Sinclair (Ed.). *The child's concept of language.* New York: Springer–Verlag.

Bryant, D. M., Burchinal, M., Lau, L. B., & Sparling, J. J. (1994). Family and classroom correlates of Head Start children's developmental outcomes. *Early Childhood Research Quarterly, 9,* 289–309.

Buriel, R. & Cardoza, D. (1988). Sociocultural correlates of achievement among three generations of Mexican American high school seniors. *American Educational Research Journal, 25*(2), 177–192.

Buros, O. K. (1999) *Tests in print*. Highland Park, NJ: Gryphon Press.

Burriss, L. L. (1997). Safety in the cybervillage: Some Internet guidelines for teachers. in *Association for Childhood Education: Focus on Elementary, 10*(2), 1–6.

Bursuck, W. D., Polloway, E. A., Plante, L., Epstein, M. H., Jayanthi, M. & McConeghy, J. (1996). Report card grading adaptations: A national survey of classroom practices. *Exceptional Children, 62*(4), 301–318.

Burts, D. C., Hart, C. H., Charlesworth, R., Fleege, P. O., Mosley, J., & Thomasson, R. H. (1992). Observed activities and stress behaviors of children in developmentally appropriate and inappropriate kindergarten classrooms. *Early Childhood Research Quarterly, 7*, 297–318.

Byrd, R. S., Weitzman, M., Auinger, P. (1997). Increased behavior problems associated with delayed school entry and delayed school progress. *Pediatrics, 100*, 654–661.

Caine, R. N., & Caine, G. (1994). *Making connections: Teaching and the human brain*. New York: Addison–Wesley Publishing Company.

Caine, R. N., & Caine, G. (1997). *Education on the edge of possibility*. Alexandria, VA: Association for Supervision and Curriculum Development.

Campbell, F. A., & Ramey, C. T. (1995). Cognitive and school outcomes for high-risk African American students at middle adolescence: Positive effects of early intervention. *American Educational Research Journal, 32*(4), 743–772.

Campione, J. (1983). Cited in Cazden, C. B. (1988). *Classroom discourse: The language of teaching and learning*. Portsmouth, NH: Heinemann.

Carnegie Corporation of New York. (1996). *Years of promise: A Comprehensive learning strategy for America's Children*. New York: Author.

Carnevale, A. P., & Golstein, H. (1983). *Employee training: Its changing role and an analysis of new data*. Alexandria, VA: American Society for Training and Development.

Cazden, C. B. (1988). *Classroom discourse: The language of teaching and learning*. Portsmouth, NH: Heinemann.

Center for Media Education (1996, November). *Connecting children to the future: A telecommunications policy guide for child advocates*. Washington, DC: Author.

Cetron, M., & Davies, O. (1989). *American renaissance: Our life at the turn of the twenty-first century*. New York: St Martin's Press.

Charlesworth, R. (1989). "Behind" before they start? Deciding how to deal with the risk of kindergarten failure. *Young Children, 44*(3), 5–13.

Checkley, K. (1997). The first seven—and the eighth: A conversation with Howard Gardner. *Education Leadership, 55*(1), 8–13.

Children's Defense Fund. (1998). *The state of America's children: Yearbook 1998*. Washington, DC: Author.

Clarkson, P. C., & Galbraith, P. (1992). Bilingualism and mathematics learning: Another perspective. *Journal for Research in Mathematics Education, 23*(1), 34–44.

Clay, M. (1977). *Reading: The complex patterning of behavior*. London: Heinemann.

Cole, M., & Cole, S. (1993). *The development of children*. New York: Freeman.

Cole, P. A., & Taylor, O. L. (1990) Performance of working class African–American children on three tests of articulation. *Language, Speech, and Hearing Services in the Schools, 21*, 171–176.

Consortium of National Arts Education Associations (1994). *National standards for arts education*. Reston, VA: Music Educators National Conference.

Corcorran, M. E., & Chaudry, A. (1997, Summer/Fall). *The future of children: Children and poverty*. Los Altos, CA: Center for the Future of Children, The David and Lucile Packard Foundation.

Cummins, J. (1976). The influence of bilingualism on cognitive growth: A synthesis of research findings and explanatory hypotheses. *Working Papers on Bilingualism, 9*, 1–43.

Cummins, J. (1986). Empowering minority students: A framework for intervention. *Harvard Educational Review, 56*(1), 18–36.

D'Amato, J. (1988). "Acting": Hawaiian children's resistance to teachers. *Elementary School Journal, 88*, 529–544.

de Melendez, W. R., & Ostertag, V. (1997). *Teaching young children in multicultural classrooms: Issues, concepts, and strategies.* New York: Delmar Publishers.

Delpit, L. D. (1986). Skills and other dilemmas of a progressive black educator. *Harvard Educational Review, 56*(4), 379–385.

Delpit, L. D. (1988). The silenced dialogue: Power and pedagogy in educating other people's children. *Harvard Educational Review, 58*(3), 280–298.

Delpit, L. D. (1995). *Other people's children: Cultural conflict in the classroom.* New York: New Press.

Delpit, L. D. (1997). What should teachers do?: Ebonics and culturally responsive instruction. *Rethinking Schools: An Urban Educational Journal, 12*(1), 6–7.

Derman-Sparks, L., & The ABC Task Force. (1989). *Anti-bias curriculum—Tools for empowering young children.* Washington, DC: NAEYC.

Developmental Studies Center (1996). *Ways we want our class to be: Class meetings that build commitment to kindness and learning.* Oakland, CA: Author.

DeVries, R., & Kohlberg, L. (1987). *Programs of early education: A cognitive developmental view.* New York: Longman.

DeVries, R., & Zan, B. (1995). Creating a constructivist classroom atmosphere. *Young Children, 51*(1), 4–13.

DeVries, R., & Zan, B. S. (1994). *Moral classrooms, moral children: Creating a constructivist atmosphere in early education.* New York: Teachers College Press.

Diamond, M. (1967). Extensive cortical depth measurements and neuron size increases in the cortex of environmentally enriched rats. *Journal of Comparative Neurology, 131*, 357–364.

Diamond, M., & Hopson, J. (1998). *Magic trees of the mind: How to nurture your child's intelligence, creativity and healthy emotions from birth through adolescence.* New York: Dutton.

Diaz, R. M., Padilla, K. M., & Weathersby, E. K. (1991). The effect of bilingualism on preschooler's private speech. *Early Childhood Research Quarterly, 6*, 377–393.

Duckworth, E. (1987). *The having of wonderful ideas and other essays on teaching and learning.* New York: Teachers College Press.

Dunn, R. (1996). *How to implement and supervise a learning styles program.* Alexandria, VA: Association for Supervision and Curriculum Development.

Dunn, R., Beaudry, J. S., & Klavas, A. (1989). Survey of research on learning styles. *Educational Leadership, 46*(6), 50–58.

Dunn, K., & Dunn, R. (1987). Dispelling outmoded beliefs about student learning. *Educational Leadership, 44*(6), 55–62.

Dunn, L., & Kontos, S. (1997). Research in Review: What have we learned about developmentally appropriate practice? *Young Children, 53*(3), 4–13.

Eggen, P. D., & Kauchak, D. (1992). *Educational psychology: Classroom connections.* Upper Saddle River, NJ: Merrill/Prentice Hall.

Eisner, E. (1992). The misunderstood role of the arts in human development. *Phi Delta Kappan, 73*, 591–595.

Elias, M. J., & Tobias, S. E. (1990). *Problem solving/decision making for social and academic success.* Washington, DC: National Education Association.

Elkind, D. (1979). The curriculum disabled child. In D. Elkind (Ed.), *The child and society: Essays in applied child development* (pp. 223–236). New York: Oxford University Press.

Elkind, D. (1986). Formal education and early childhood education: An essential difference. *Phi Delta Kappan, 67*, 631–636.

Elkind, D. (1987), *Miseducation: Preschoolers at risk.* New York: Knopf.

Ellison, L. (1992). Using multiple intelligences to set goals. *Educational Leadership, 50*(2), 69–72.

Engel, B. (1990). An approach to assessment in early literacy. In Kamii, C. (Ed.), *Achievement testing in the early grades: The games grown-ups play* (pp. 119–134). Washington, DC: NAEYC.

Erikson, E. H. (1963). *Childhood and society.* New York: Norton.

Erickson, F. (1987). Transformation and school success: The politics and culture of educational attainment. *Anthropology and Education Quarterly, 18,* 335–356.

Evarts, E. V. (1979). Brain mechanisms of movement. *Scientific American, 241,* 98–106.

Feeney, S., & Kipnis, K. (1989). The National Association for the Education of Young Children code of ethical conduct and statement of commitment. *Young Children, 45*(1), 24–29.

Feldhusen, J. F. (1995). *Talent identification and development in education.* Sarasota, FL: Center for Creative Learning.

Feldhusen, J. F. (1998). Programs for the gifted few or talent development for the many? *Phi Delta Kappan, 10*(79), 735–738.

Fennema, E. (1996). Mathematics, gender, and research. In G. Hanna (Ed.). *Towards gender equity in mathematics education.* Dordrecht, the Netherlands: Kluwer Academic.

Fennema, E., Carpenter, T. P., Jacobs, V. R., Franke, M. L., Levi, L. W. (1998). A longitudinal study of gender differences in young children's mathematical thinking. *Educational Researcher, 27*(5), 6–13.

Fleege, P. O. (1990). *Stress begins in kindergarten: A look at behavior during standardized testing.* Unpublished doctoral dissertation, Louisiana State University, Baton Rouge.

Foyle, H. C., Lyman, L., & Thies, S. (1991). *Cooperative learning in the early childhood classroom.* Washington, DC: National Education Association.

Fraser, K. (1997). *Early childhood champions: Exceptional administrators of school-based programs for young children.* Alexandria, VA: National Association of State Boards of Education.

Freire, P. (1996). *Pedagogy of the oppressed.* New York: Continuum.

Frick, T. W. (1991). *Restructuring education through technology.* Bloomington, IN: Phi Delta Kappa Educational Foundation.

Frost, J., & Wortham, S. C. (1984). Frost/Wortham developmental checklist. In S. C. Wortham (Ed.), *Organizing instruction in early childhood: A handbook of assessment and activities.* Boston: Allyn & Bacon.

Gallahue, D. (1993). *Developmental physical education for today's children* (2nd ed.). Madison, WI: Brown & Benchmark.

Gallahue, D., & Ozmun, J. C. (1995). *Understanding motor development: Infants, children, adolescents, adults.* Dubuque, IA: Brown & Benchmark.

Gardner, H. (1982). *Art, mind, and the brain.* New York: Basic Books.

Gardner, H. (1983). *Frames of mind: The theory of multiple intelligences.* New York: Basic Books.

Gardner, H. (1983). *Frames of mind: Theory of multiple intelligences.* 2nd ed. New York: Basic Books.

Gardner, H. (1991a). Assessment in context: The alternative to standardized testing. In B. R. Gifford & M. C. O'Connor (Eds.), *Changing assessments: Alternative views of aptitude, achievement and instruction.* Norwell, MA: Kluwer.

Gardner, H. (1991b). *The unschooled mind: The theory of multiple intelligences.* New York: Basic Books.

Gardner, H. (1993a). *Creating minds: An anatomy of creativity seen through the lives of Freud, Einstein, Picasso, Stravinsky, Eliot, Graham, and Gandhi.* New York: Basic Books.

Gardner, H. (1993b). *Multiple intelligences: The theory in practice.* New York: Basic Books.

Gardner, H. (1997). The first seven . . . and the eighth. *Education Leadership, 55*(1), 8–13.

Gardner, H. (1998). Reflections on multiple intelligences: Myths and messages. In A. E. Woolfolk, *Readings in Educational Psychology,* (2nd ed., pp. 61-67). Boston: Allyn and Bacon.

Gay, J., & Cole, M. (1967). The new mathematics and old culture: A study of learning among the Kpelle of Liberia. New York: Holt, Rinehart & Winston.

Gilbert, A. G. (1977). *Teaching the three R's through movement experiences.* New York: Macmillan.

Gilmore, P. (1984). Research currents: Assessing sub-rosa skills in children's language. *Language Arts, 61,* 384–391.

Gleason, J. B. (1997). *The development of language.* Needham Heights, MA: Allyn & Bacon.

Gollnick, D. M., & Chinn, P. C. (1990). *Multicultural education in a pluralistic society,* (3rd ed.). Upper Saddle River, NJ: Merrill/Prentice Hall

Good, T. L., & Brophy, J. E. (1987). *Looking in class-rooms* (4th ed.). New York: Harper Row.

Goodman, Y. (1978). Kid watching: An alternative to testing. *National Elementary Principal, 57*(4), 41–45.

Grace, C., & Shores, E. F. (1991). *The portfolio and its use: Developmentally appropriate assessment of young children.* Little Rock, AR: Southern Early Childhood Association.

Graves, D. (1983). *Writing: Teachers and children at work.* Exeter, NH: Heinemann.

Gredler, G. R. (1984). Transition classes: A viable alternative for the at-risk child? *Psychology in the Schools, 21,* 463–470.

Gredler, M. E. (1996). *Program Evaluation.* Upper Saddle River, NJ: Merrill/Prentice Hall.

Greenberg, P. (1991). *Character development: Encouraging self-esteem and self-discipline in infants, toddlers, and two-year-olds.* Washington, DC: National Association for the Education of Young Children.

Greenspan, S. I. (1997). *The growth of the mind: And the endangered origins of intelligence.* Reading, MA: Addison–Wesley Publishing Co.

Gunnar, M. R. (1996). *Quality of care and the buffering of stress physiology: Its potential in protecting the developing human brain.* University of Minnesota Institute of Child Development.

Hakuta, K., & E. Garcia (1989). Bilingualism and education. *American Psychologist, 44*(2), 374–379.

Hale, J. (1991). The transmission of cultural values to young African American children. *Young Children, 46*(6), 7–15.

Hale, J. (1992). Dignifying black children's lives. *Dimensions, 20*(3), 8–9, & 40.

Hamilton, D. L., & Sherman, S. (1994). Stereotypes. In R. S. Wyer & T. K. Scrull (Eds.). *Handbook of social cognition* (pp. 1–68). Hillsdale, NJ: Lawrence Erlbaum.

Hanna, J. L. (1992). Connections: Arts, academics and productive citizens. *Phi Delta Kappan, 73,* 601–607.

Hannaford, C. (1995). *Smart moves.* Arlington, VA: Great Ocean Publishing Co.

Hastings, C. (1992). Ending ability grouping: A moral imperative. *Educational Leadership, 50*(2), 14.

Healy, J. (1990). *Endangered minds: Why our children can't think.* New York: Simon and Schuster.

Heller, J. I., & Gordon, A. (1992). Lifelong learning. *Educator, 6,* 4–19.

Herman, J. L., Ashbacher, P. R., Winters, L. (1992). *A practical guide to alternative assessment.* Alexandria, VA: Association for Supervision and Curriculum Development.

Herman, J. L., & Winters, L. (1994). Synthesis of research: Portfolio research: A slim collection. *Educational Leadership, 52*(2), 48–55.

Hilliard, A. (1975). The strengths and weaknesses of cognitive tests of young children. In J. D. Andrews (Ed.), *One child indivisible.* Washington, DC: NAEYC.

Hurd, P. D. (1997, November 12). Science needs a "lived" curriculum. *Education Week, XVII*(12), 48.

Hymes, D. L. (1991). *The changing face of testing and assessment: Problems and solutions.* Arlington, VA: American Association of School Administrators.

International Reading Association & National Association for the Education of Young Children (1998). Learning to read and write: Developmentally appropriate practices for young children: A joint position statement. *Young Children, 53*(4), 30–46.

Isenberg, J. P., & Jalongo, M. R. (1996). *Creative expression and play in the early childhood curriculum* (2nd. ed.). Upper Saddle River, NJ: Merrill/Prentice Hall.

Jacobs, H. H. (Ed.). (1989). *Interdisciplinary curriculum design and implementation.* Alexandria, VA: Association for Supervision and Curriculum Development.

Jensen, E. (1998). *Teaching with the brain in mind.* Alexandria, VA: Association for Supervision and Curriculum Development.

Jones, E., & Nimmo, J. (1994). *Emergent curriculum.* Washington, DC: National Association for the Education of Young Children.

Kamii, C. (1985). *Young children reinvent arithmetic.* New York: Teachers College Press.

Kamii, C. (1989). *Young children continue to invent arithmetic: Second grade.* New York: Teachers College Press.

Kamii, C. (Ed.). (1990). *Achievement testing in the early grades: The games grown-ups play*. Washington, DC: NAEYC.

Katz, L. G. (1980). Mothering and teaching—some significant distinctions. In L. G. Katz (Ed.), *Current topics in early childhood education* (Vol. 3, pp. 47–63). Norwood, NJ: Ablex.

Katz, L. G. (1987). *What should young children be learning? (ERIC Digest)*. Urbana, IL: ERIC Clearinghouse on Elementary and Early Childhood Education.

Katz, L. G., & Chard, S. (1989). *Engaging children's minds: The project approach*. Norwood, NJ: Ablex.

Katz, L. G., Evangelou, D., & Hartman, J. (1990). *The case for mixed-age grouping in early education*. Washington, DC: National Association for the Education of Young Children.

Katz, L. G., & McClellan, D. E. (1997). *Fostering children's social competence: The teacher's role*. Washington, DC: National Association for the Education of Young Children.

Katz, L. G., McClellan, D. E., Fuller, J. O., & Walz, G. R. (1995). *Building social competence in children: A practical handbook for counselors, psychologists and teachers*. Greensboro, NC: University of North Carolina at Greensboro, ERIC/CASS Publications.

Kellogg, J. (1988). Focus of change. *Phi Delta Kappan, 70*, 199–204.

Kempermann, G., Kuhn, H. G., & Gage, F. (1997, April). More hippocampal neurons in adult mice living in an enriched environment. *Nature, 38*, 493–495.

Kilmer, S. J., & Hofman, H. (1995). Transforming science curriculum. In Bredekamp & Rosegrant, T. (Eds.). *Reaching potentials: Transforming early childhood curriculum and assessment*. Washington, DC: National Association for the Education of Young Children.

Kohn, A. (1993). *Punished by rewards: The trouble with gold stars, incentive plans, A's, praise, and other bribes*. Boston: Houghton Mifflin.

Kohn, A. (1996). *Beyond discipline: From compliance to community*. Alexandria, VA: Association for Supervision and Curriculum Development.

Kolb, G. R. (1996). Read with a beat: Developing literacy through music and song. *The Reading Teacher, 50*(1), 76.

Kozol, J. (1991). *Savage inequalities: Children in America's schools*. New York: Crown.

Krashen, S. (1992). *Fundamentals of language education*. Torrance, CA: Laredo Publishing.

Krashen, S., Long, M., & Scarcella, R. (1982). Age, rate, and eventual attainment in second language acquisition. In S. Krashen, R. Scarcella, & M. Long (Eds.). *Child–adult differences in second language acquisition*. Rowley, MA: Newbury House.

Kuhl, P. (1994). Learning and representation in speech and language. *Current Opinion in Neurobiology, 4*, 817–822.

Kuhl, P., & Meltzoff, A. N. (1996). Infant vocalizations in response to speech: Vocal imitation and developmental change. *Journal of Acoustical Society of America, 100*(4) 2,425–2,437.

Lancy, D. F. (1983). *Cross-cultural studies in cognition and mathematics*. New York: Academic Press.

Lareau, A. (1989). *Home advantage: Social class and parental intervention in elementary education*. Philadelphia: The Falmer Press.

Leonard, A. M. (1997). *I spy something!: A practical guide to classroom observations of young children*. Little Rock, AR: Southern Early Childhood Association.

Lewelling, V. W. (1992). *Linguistic diversity in the United States: English plus and official English*. Washington, DC: ERIC clearing house on Literacy Education for Limited-English-Proficient Adults.

Locust, C. (1988). Wounding the spirit: Discrimination and traditional American Indian belief systems. *Harvard Educational Review, 58*(3), 315–330.

Loucks-Horsley, S. (1989). Science assessment: What is and what might be. *Educational Leadership, 46*(7), 86–87.

Lucas, T., Henze, R., & Donato, R. (1990). Promoting the success of Latino language minority students: An exploratory study of six high schools. *Harvard Educational Review, 60*(3), 315–340.

Lyon, G. R., & Rumsey, J. M. (1996). *Neuroimaging: A window to the neurological foundations of learn-*

ing and behavior in children. Baltimore: Paul H. Brookes Pub. Co.

Mallory, B. L.. & New, R. S. (Eds.). (1994). *Diversity and developmentally appropriate practices*. New York: Teachers College Press.

Marsden, D. B., Meisels, S. J., Steele, D. M., & Jablon, J. R. (1993). *The Work Sampling System: The portfolio collection process for early childhood and early elementary classrooms*. Ann Arbor: University of Michigan, Center for Human Growth and Development.

Marzano, R. J., & Kendall, J. S. (1996, February). *Issues in brief: The fall and rise of standards-based education*. Alexandria, VA: National Association of State Boards of Education.

Mathematical Sciences Education Board (1994). *Measuring what counts*. Washington, DC: National Academy Press.

Matute–Bianchi, M. E. (1991). Situational ethnicity and patterns of school performance among immigrant and nonimmigrant Mexican-descent students. In M. A. Gibson and J. U. Ogbu (Eds.), *Minority status and schooling: A comparative study of immigrant and involuntary minorities*. New York: Garland.

McCarthy, B. F. (1981). The 3 MAT System: Teaching to learning styles with right/left mode techniques. Arlington Heights, IL: Mark Anderson and Associates.

McCarthy, B. F. (1997). A tale of four learners: 4MAT's learning styles. *Educational Leadership, 54*(6), pp. 46–51.

McCracken, J. B. (1993). *Valuing diversity: The primary years*. Washington, DC: National Association for the Education of Young Children.

McDonald, D. T., & Simons, G. M. (1989). *Musical growth and development: Birth through six*. New York: Schirmer Books.

McLean, M., Bailey, D. B. Jr., & Wolery, M. (1996). Assessing infants and preschoolers with special needs (2nd ed.). Upper Saddle River, NJ: Merrill/Prentice Hall.

Medina, N., & Neill, D. M. (1990). *Fallout from the testing explosion: How 100 million standardized exams undermine equity and excellence in America's public schools* (3rd ed.). Cambridge, MA: National Center for Fair and Open Testing.

Meisels, S. J. (1986). Testing four- and five-year-olds. *Educational Leadership, 44*, 90–92.

Meisels, S. J. (1987). Uses and abuses of developmental screening and school readiness testing. *Young Children, 42*(2), 68–73.

Meisels, S. J. (1989). *Developmental screening in early childhood: A guide* (3rd ed.). Washington, DC: NAEYC.

Meisels, S. J. (1992). Doing harm by doing good: Iatrogenic effects of early childhood enrollment and promotion policies. *Early Childhood Research Quarterly, 7*, 155–174.

Meisels, S. J. (1993). Remaking classroom assessment with the Work Sampling System. *Young Children, 48*(5), 34–40.

Meisels, S. J., Jablon, J. R., Marsden, D. B., Dichtelmiller, M. L., Dorfman, A. B., & Steele, D. M. (1994). *The Work Sampling System: An overview*. Ann Arbor, MI: Rebus Planning Associates, Inc.

Meyer, C., Schumann, S., & Angello, N. (1990). *Northwest Evaluation Association white paper on aggregating portfolio data*. Lake Oswego, OR: Northwest Evaluation Association.

Michaels, S. (1981). "Sharing time": Children's narrative styles and differential access to literacy. *Language in Society, 10*(3), 423–442.

Michaels, S. (1986). Narrative presentations: An oral preparation for literacy. In J. Cook-Gumperz (Ed.), *The social construction of literacy* (pp. 94–116). New York: Cambridge University Press.

Ministry of Education. (1991). *Supporting learning: Understanding and assessing the progress of children in the primary program*. Victoria, British Columbia: Author.

Minnesota Fathering Alliance (1992). *Working with fathers: Methods and perspectives*. Stillwater, MN: Nu Ink Unlimited.

Morris, C. G. (1988). *Psychology: An introduction* (6th ed.). Upper Saddle River, NJ: Merrill/Prentice Hall.

Munk, D. D., & Bursuck, W. D. (1998). Can grades be helpful *and* fair? *Educational Leadership, 55*(4), 44–47.

Murphy, D., & Baker, O. (1990). The approach of a state department. In C. Kamii (Ed.), *Achievement testing in the early grades: The games grown-ups play.* Washington, DC: National Association for the Education of Young Children.

National Association for Bilingual Education (1991). The NABE No-cost study on families. *National Association for Bilingual Education News, 1,* 7.

National Association of Early Childhood Specialists in State Departments of Education. (1987). *Unacceptable trends in kindergarten entry and placement: A position statement.* Lincoln, NE: Author.

National Association for the Education of Young Children. (1988a). *Appropriate education in the primary grades: A position statement.* Washington, DC: Author.

National Association for the Education of Young Children. (1988b). *Position statement on standardized testing of young children three through eight years of age.* Washington, DC: Author.

National Association for the Education of Young Children (1996). NAEYC Position statement: Responding to linguistic and cultural diversity—Recommendations for effective early childhood education. *Young Children, 51*(2), 4–12.

National Association for the Education of Young Children & National Association of Early Childhood Specialists in State Departments of Education. (1991). Guidelines for appropriate curriculum content and assessment in programs serving children ages three through eight. *Young Children, 46*(3), 21–38.

National Association for Sport and Physical Education (1995). *Moving into the future: National physical education standards: A guide to content and assessment.* Reston, VA: Author.

National Association of Elementary School Principals. (1990). *Early childhood education and the elementary school principal: Standards for quality programs for young children.* Alexandria, VA: Author.

National Association of State Boards of Education. (1988). *Right from the start: The report of the NASBE task force on early childhood education.* Alexandria, VA: Author.

National Association of State Boards of Education. (1995). *Creating good schools for young children: Right from the start: A study of eleven developmentally appropriate primary school programs.* Alexandria, VA: Author.

National Association of State Boards of Education. (1997). The full measure: Report of the NASBE Study Group on Statewide Assessment Systems. Alexandria, VA: Author.

National Center for Fair and Open Testing (1998). High-stakes test do not improve learning. *Fair Test Examiner 12*(1), 1, 4–5.

National Commission on Excellence in Education (1983, April). *A nation at risk: The imperative for educational reform.* Washington, DC: U. S. Department of Education.

National Commission on Social Studies in the Schools. (1989). *Charting a course: Social studies for the twenty-first century.* Washington, DC: National Council for the Social Studies.

National Commission on Testing and Public Policy. (1990). *From gatekeeper to gateway: Transforming testing in America.* Boston College, Chestnut Hill, MA: Author.

National Council for the Social Studies. (1981). *Global education position statement.* Washington, DC: Author.

National Council for the Social Studies (1989). *Social studies for early childhood and elementary school children: Preparing for the 21st century.* Washington, DC: Author.

National Council of Teachers of Mathematics. (1989). *Curriculum and evaluation standards for school mathematics.* Reston, VA: Author.

National Council of Teachers of Mathematics (1994). *Assessment Standards for School Mathematics.* Reston, VA: Author.

National Education Goals Panel. (1991). *National education goals report: Building a nation of learners.* Washington, DC: Author.

National Forum on Assessment (1995). *Principles and indicators for student assessment systems.* Cambridge, MA: National Center for Fair and Open Testing.

National Research Council. (1989). *Everybody counts: A report to the nation on the future of math-*

ematics education. Washington, DC: National Academy Press.

National Research Council. (1996). *National science education standards*. Washington, DC: National Academy Press.

National Task Force on School Readiness and the National Association of School Boards (1991, December). *Caring communities: Supporting young children and families*. Alexandria, VA: Author.

Neill, D. M., & Medina, N. J. (1991). Standardized testing: Harmful to educational health. *Phi Delta Kappan, 73*, 688–697.

Neill, M. (1997) *Testing our children: A report card on state assessment systems*. Cambridge, MA: Fair Test: The National Center for Fair and Open Testing.

Nelson, K., & Lucariello, J. (1985). The development of meaning in first words. In M. Barrett (Ed.), *Children's single word speech*. New York: Wiley.

Nelson, N. (1993). *Childhood language disorders in context*. Upper Saddle River, NJ: Merrill/Prentice Hall.

Neugebauer, B. (Ed.). (1992). *Alike and Different: Exploring our humanity with young children*. Washington, DC: National Association for the Education of Young Children.

Neuman, S. B., & Roskos, K. (1992). Literacy knowledge in practice: Contexts of participation for young writers and readers. *Reading Research Quarterly 32*, 10–32.

Newberger, J. J. (1997). New brain development research—A wonderful window of opportunity to build public support for early childhood education!. *Young Children 52*(4) 4–9.

Nieto, S. (1996). *Affirming diversity: The sociopolitical context of multicultural education, 2nd Ed*. White Plains, New York: Longman Publishers.

Northwest Regional Educational Laboratory. (1991). *Alternative program evaluation ideas for early childhood education programs*. Portland, OR: Author.

Ogbu, J. B. (1983). Minority status and schooling in plural societies. *Comparative Education Review, 27*, 168–190.

Ogbu, J. B. (1987). Variability in minority school performance: A problem in search of an expla-

nation. *Anthropology and Education Quarterly, 18*, 312–334.

Okagaki, L., & Frensch, P. A. (1998). Parenting and children's school achievement: A multiethnic perspective. *American Educational Research Journal, 35*(1) 123–144.

O'Neil, W. (1997). If Ebonics isn't a language, then tell me, what is? *Rethinking Schools, 12*(1), 10–11.

Palmer, L. (1980, September). Auditory discrimination through vestibulo-cochlear stimulation. *Academic Therapy 16*(1), 55–70.

Patton, M. M., & Kokoski, T. M. (1996). How good is your early childhood science, mathematics, and technology program?: Strategies for extending your curriculum. *Young Children, 51*(5), 38–44.

Perkins, D. (1992). *Smart schools: From training memories to educating minds*. New York: Free Press.

Perlmutter, J., Bloom, L., Rose, T., Rogers, A. (1997). Who uses math? Primary children's perceptions of the uses of mathematics. *Journal of Research in Childhood Education, 12*(1), 58–70.

Perrone, V. (1991). On standardized testing: A position paper of the Association for Childhood Education International. *Childhood Education, 53*, 9–16.

Perry, T., & Delpit, L. (Eds.). (1997). The real Ebonics debate: Power, language, and the education of African-American children. *Rethinking Schools, 12*(1). (Special Issue).

Pflaum, S. W. (1986). *The development of language and literacy in young children*. Columbus, OH: Merrill.

Piaget, J. (1926). *The language and thought of the child*. New York: Harcourt, Brace & World.

Piaget, J. (1952). *The origins of intelligence in children*. New York: Norton.

Piaget, J. (1963). *The psychology of intelligence*. Patterson, NJ: Littlefield, Adams.

Plyer v. Doe, 457 U.S. 202 (1982).

Powell, D. R. (1995). *Enabling young children to succeed in school*. Washington, DC: American Educational Research Association.

Price, G. G. (1989). Mathematics in early childhood. *Young Children, 44*(4), 53–58.

Puckett, M. B., & Diffily, D. (1999). *Teaching young children: An introduction to the early childhood profession*. Fort Worth, TX: Harcourt Brace College Publishers.

Ramey, C. T., & Ramey, S. L. (1996). *Prevention of intellectual disabilities: Early interventions to improve cognitive development*. Birmingham: University of Alabama Civitan International Research Center.

Ramphal, D. K. (1983). *An analysis of reading instruction of West Indian Creole-speaking students*. Unpublished doctoral dissertation. Ontario Institute for Studies in Education.

Ravitch, D. (1995). *National standards in American education: A citizen's guide*. Washington, DC: Brookings Institute.

Read, C. (1971). Pre-school children's knowledge of English phonology. *Harvard Educational Review, 41*(1) 1–34.

Renzulli, J. (1994). *Schools for talent development: A practical plan for total school improvement*. Mansfield Center, CT: Creative Learning.

Resnick, L. B. (1987). Learning in school and out. *Educational Researcher, 16*, 13–20.

Reynolds, A. J. (1992). Comparing measures of parental involvement and their effects on academic achievement. *Early Childhood Research Quarterly, 7*, 441–462.

Roach, V., Ascroft, J., Stamp, A., & Kysilko, D. (Eds.). (1995, May). *Winning ways: Creating inclusive schools, classrooms and communities*, Alexandria, VA: National Association of State Boards of Education.

Roderick, J. (Ed.). (1991). *Context-responsive approaches to assessing children's language*. Urbana, IL: National Conference on Research in English.

Rodriquez, J. L., Diaz, R. M., & Duran, D. (1995). The impact of bilingual preschool education on the language development of Spanish-speaking children. *Early Childhood Research Quarterly, 10*, 475–490.

Rosegrant, T. (1989). Cited in NAEYC & NAECS/SDE. (1990). Guidelines for appropriate curriculum content and assessment in programs serving children ages five through eight. *Young Children, 46*(3), 21–38.

Rosegrant, T. & Cooper, R. (1986). The talking text writer: Professional Guide. New York: Scholastic.

Sadker, M., & Sadker, D. (1994). *Failing at fairness: How America's schools shortchange girls*. New York: Charles Scribner's Sons.

Sample, B. (1992). Using learning modalities to celebrate intelligence. *Educational Leadership, 50*(2), 62–66.

Schunk, D. H. (1990). Goal setting and self-efficacy during self-regulated learning. *Educational Psychologist, 15*(1), 71–86.

Schunk, D. H. (1991). Self-efficacy and academic motivation. *Educational Psychologist, 26*, 207–232.

Schweinhart, L. J. (1987, Summer). Child-initiated activity: How important is it in early childhood education? *High/Scope Foundation Newsletter*, pp. 1, 3.

Schweinhart, L. J., Barnes, H. V., & Weikart, D. P. (1993). *Significant benefits: The High/Scope Perry Preschool study through age 27*. Monographs of the High Scope Educational Research Foundation, no. 10. Ypsilanti, MI: High/Scope.

Schweinhart, L. J., & Weikart, D. P. (1998). Why curriculum matters in early childhood education. *Education Leadership, 55*(6), 57–60.

Seefeldt, C. (1997). Social studies in the developmentally appropriate integrated curriculum. In C. H. Hart, D. C. Burts, & R. Charlesworth (Eds.), *Integrated curriculum and developmentally appropriate practice: Birth to age eight*. New York: State University of New York Press.

Shane, H. G., & Tabler, M. B. (1981). *Educating for a new millennium*. Bloomington, IN: Phi Delta Kappa Educational Foundation.

Sherman, A. (1997). *Poverty matters: The cost of child poverty in America*. Washington, DC: Children's Defense Fund.

Shepard, L. A., & Smith, M. L. (1985). *Boulder Valley kindergarten study: Retention practices and retention effects*. Boulder, CO: Boulder Valley Public Schools.

Shepard, L. A., & Smith, M. L. (1986). Synthesis of research on school readiness and kindergarten retention. *Educational Leadership, 44*(3), 78–86.

Shepard, L. A., & Smith, M. L. (1987). Effects of kindergarten retention at the end of first grade. *Psychology in the Schools, 24*, 346–357.

Shepard, L. A., & Smith, M. L. (1989a). *Escalating kindergarten curriculum (ERIC Digest).* Urbana, IL: ERIC Clearinghouse on Elementary and Early Childhood Education.

Shepard, L. A., & Smith, M. L. (1989b). *Flunking grades: Research and policies on retention.* Philadelphia: The Falmer Press.

Shore, R. (1997). *Rethinking the brain: New insights into early development.* New York: Families and Work Institute.

Shreeve, J. (1996). Possibly new skeleton gives path from trees to ground an odd turn. *Science, 272,* 654.

Sigel, I. (1990). What teachers need to know about human development. In D. Dill & Associates (Eds.), *What teachers need to know* (pp. 76–93). San Francisco, CA: Jossey-Bass.

Sigel, I., & Saunders, R. (1979). An inquiry into inquiry: Questions asked as an instructional model. In L. Katz (Ed.), *Current topics in early childhood education* (Vol. 2, pp. 169–193). Norwood, NJ: Ablex.

Slavin, R. (1983). *Cooperative learning.* New York: Longman.

Slavin, R. E. (1991). Synthesis of research on cooperative learning. *Educational Leadership, 48*(5), 71–81.

Sleeter, C. E. (1991). Introduction: Multicultural education and empowerment. In C. E. Sleeter (Ed.), *Empowerment through multicultural education* (pp. 1–23). Albany: State University of New York Press.

Smith, E. C., & Dowdy, C. A. (1998). Educating young children with disabilities using responsible inclusion. *Childhood Education; Annual Theme Issue, 74*(5), 317–320.

Smith, F. (1992). Learning to read: The never-ending debate. *Phi Delta Kappan, 73,* 432–441.

Smitherman, G. (1986). *Talking and testifying: The language of Black America.* Detroit, MI: Wayne State University Press.

Smitherman, G. (1997, Fall). Black English/Ebonics: What it be like? *Rethinking Schools: An Urban Educational Journal, 12*(1), 8–9.

Southern Early Childhood Association. (1990). *Developmentally appropriate assessment: A position paper.* Little Rock, AR: Author.

Sperry, R. W. (1964). The great cerebral commissure. *Scientific American, 210,* 42–52.

Stiggins, R. J. (1997a). *Student-Centered Classroom Assessment* (2nd. ed.). Upper Saddle River, NJ: Merrill/Prentice Hall.

Stiggins, R. J. (1997b). Quoted in: Using assessment to motivate students. *Education Update, 39*(8), 6.

Stipek, D., Feiler, R., Daniels, D. & Milburn, S. (1995). Effects of different instructional approaches on young children's achievement and motivation. *Child Development, 66,* 209–223.

Stipek, D., Recchia, S., McClintic, S. (1992). *Self-evaluation in young children.* Monographs of the Society for Research in Child Development, Serial No. 226: 57(1). Chicago: The University of Chicago Press.

Suarez–Orozco, M. M. (1987). "Becoming somebody": Central American immigrants in U.S. inner city schools. *Anthropology and Education Quarterly, 18,* 287–299.

Swick, K. (1991). *Teacher-parent partnerships to enhance children's school success.* Washington, DC: National Education Association.

Sylwester, R. (1995). *A celebration of neurons: An educator's guide to the human brain.* Alexandria, VA: Association for Supervision and Curriculum Development.

Sylwester, R. (1997). The neurobiology of self-esteem and aggression. *Educational Leadership, 54*(5), 75–79.

Sylwester, R. (1998). Art for the brain's sake. *Educational Leadership, 56*(3), 31–35.

Takaki, R. (1993). *A different mirror.* New York: Little Brown & Co.

Taylor, D., & Dorsey-Gaines, C. (1988). *Growing up literate: Learning from inner city families.* Portsmouth, NH: Heinemann.

Tchudi, S. (1991). *Planning and assessing the curriculum in English Language Arts.* Alexandria, VA: Association for Supervision and Curriculum Development.

Texas Association for the Education of Young Children (1997). *Early childhood literacy development: A position statement of the Texas Association for the Education of Young Children.* Puckett, M. (Ed.). Austin, TX: Author.

Thomas, A. (1989). Reviews of research: Ability and achievement: Implications of research for classroom practice. *Childhood Education, 65,* 235–241.

Thompson, C. M. (1995). Transforming curriculum in the visual arts. In Bredekamp, S., & Rosegrant, T. (Eds.). *Reaching potentials: Transforming early childhood curriculum and assessment* (Vol. 2.). Washington, DC: National Association for the Education of Young Children.

Tomlinson, C. A., & Kalbfleisch, M. L. (1998). Teach me, teach my brain: A call for differentiated classrooms. *Education Leadership, 56*(3), 52–55.

Treffinger, D. J. (1998). From gifted education to programming for talent development. *Phi Delta Kappan, 79*(10), 752–755.

United States Bureau of Census (July 1993). *Monthly News.* Washington, DC: U. S. Government Printing Office.

United States Bureau of Census (1993, September). *Foreign-Born Population in the United States.* Washington, DC: Government Printing Office.

U. S. Department of Education & the National Endowment for the Arts. (1992). *America 2000 Arts Partnership.* Washington, DC: Author.

U. S. Department of Education, Office of Educational Research and Improvement. (1997). *Father's involvement in their children's schools.* Washington, DC: Author.

U. S. Department of Health and Human Services, Centers for Disease Control and Prevention, National Center for Chronic Disease Prevention and Health Promotion, and The President's Council on Physical Fitness and Sports (1996). *Physical activity and health: A report of the Surgeon General.* Washington, DC: Authors.

U. S. Department of Labor, The Secretary's Commission on Achieving Necessary Skills (SCANS). (1992). *Learning a living: A blueprint for high performance.* Washington, DC: U. S. Government Printing Office.

Valencia, S. (1990). A portfolio approach to classroom reading assessment: The whys, whats, and hows. *The Reading Teacher, 43,* 338–340.

Vygotsky, L. (1934/1962). *Thought and language* (E. Hanfmann & G. Zakar, Trans.). Cambridge: MIT Press.

Vygotsky, L. S. (1930–1935/1978). *Mind in society* (M. Cole, S. Schribner, V. John-Steiner, & E. Souberman, Trans.). Cambridge: Harvard University Press.

Waggoner, D. (1994, September 15). Language-minority school-age population now totals 9.9 million. *National Association for Bilingual Education News, 18*(1), 24–26.

Waggoner, D. (1993). The growth of multilingualism and the need for bilingual education: What do we know so far? *The Bilingual Research Journal, 17,* 1–12.

Walsh, D. J., Ellwein, M. E., Eads, G. M., Miller, A. K. (1991). Knocking on kindergarten's door: Who gets in? Who's kept out? *Early Childhood Research Quarterly, 6,* 89–100.

Weinberger, N. M. (1998). The music in our minds. *Educational Leadership, 56*(3), 36–40.

Westberg, K. L., Archambault, F. X. Jr., & Brown, S. W. (1997). A survey of classroom practices with third- and fourth-grade students in the United States. *Gifted Education International, 12,* 29–33.

White, K., Hohn, R., & Tollefson, N. (1997). Encouraging elementary students to set realistic goals. *Journal of Research in Childhood Education, 12*(1)48–57.

Wiggins, G. P. (1993). *Assessing student performance: Exploring the purpose and limits of testing.* San Francisco: Jossey-Bass Publishers.

Wiggins, G. P. (1998). A response to Cizek. In A. E. Woolfolk, *Readings in Education Psychology,* (2nd ed., pp. 227-231). Boston: Allyn & Bacon.

Willer, B., & Bredekamp, S. (1990). Public policy report: An essential requisite for educational reform. *Young Children, 45*(5), 22–24.

Williams, R. I. (1975). *Ebonics: The true language of black folks.* St. Louis, MO: Institute of Black Studies.

Winter, S. (1997). SMART planning for inclusion. *Childhood Education, 73*(4), 212–217.

Wolfe, P. (1998). Revisiting effective teaching. *Educational Leadership 56*(3), 61–64.

Wolfe, P., & Brandt, R. (1998). What do we know from brain research? *Educational Leadership 56*(3), 813.

Wong Fillmore, L. (1991). When learning a second language means losing the first. *Early Childhood Research Quarterly 6*(3), 323–346.

Wortham, S. C. (1995). Measurement and evaluation in early childhood education (2nd ed.) Upper Saddle River, NJ: Merrill/Prentice Hall.

Wortham, S. C. (1984). *Organizing instruction in early childhood: A handbook of assessment and activities.* Boston: Allyn & Bacon.

Zaslavsky, C. (1998). Bringing the world into the math classroom. *ENC focus for mathematics and science education*: Multicultural approaches in math and science. Washington, DC: United States Department of Education.

Name Index

Subject Index